The Absolute Bourgeois

'He has no wide horizon; the absolute bourgeois hems him in, and he is a bourgeois himself without poetic ironies, to whom a big cracked mirror is given.'

Henry James. Daumier, Caricaturist.

The Absolute Bourgeois

Artists and Politics in France 1848–1851

T. J. Clark

with 109 illustrations

Thames and Hudson

To N. and M.

© 1973, 1982 Thames and Hudson Ltd, London
First paperback edition 1982

Printed and bound in Great Britain

Contents

Preface 6

1 The Picture of the Barricade 9

2 The Art of the Republic 31

3 Millet 72

4 Daumier 99

5 Delacroix and Baudelaire 124

 Conclusion 178

 Appendix 183

 Brief Chronology 187

 Notes 189

 Select Bibliography 209

 List of Illustrations 219

 Index 221

Preface to the New Edition

This book and its companion volume, *Image of the People*, were written for the most part in the winter of 1969–70, in what seemed then (and still seems) igno-minious but unavoidable retreat from the political events of the previous six years. Those events haunt the books' best and worst pages, and provide throughout the main frame of reference for the history of a distant revolution and its cultural dimension. Today, therefore, they are bound to seem dated, though whether to their detriment or ours is open to question. Certainly they seem to me to have been misunderstood in their main drift by commentators of Left and Right, and the misreadings have become the more bland and comprehensive as the 60's slipped away and the academic world returned to its old habits. It would be tempt-ing to use the term 'recuperation' here were I not aware that the books themselves already took part in some such process. They were unashamedly – or at least unapologetically – academic, though less so, I hope, than they have lately been made to appear. The truth is that Left and Right were, and remain, ill-equipped to recognize the books' main line of enquiry: the Right because it wished to have them be a 'contribution' to some dismal methodological change of gear (how much I regret now the ironic courtesy intended to Arnold Hauser in the title 'On the Social History of Art'!); the Left because it went on pining either for the simplicities of socialist realism or the happy life on the avant-garde reservation. (Nowadays the latter has heavier semiotic furnishings than ten years ago, other-wise nothing has changed. A few young bucks have left for the city.)

So I owe it to the reader, confronting these relics of a slightly better time, to state again what I took to be the books' chief problem. They wished to establish what happened to art when it became involved, however tangentially, in a process of revolution and counter-revolution: in other words, when it lost its normal place in the machinery of social control and was obliged for a while to seek out other spaces for representation – other publics, other subjects, other idioms, other means of production. As my Jamesian title was meant to imply, one could hardly have expected the story, in an order already irredeemably capitalist, to be other than one of failure to find such space. Bourgeois society is efficient at making all art its own. The conditions for a rendezvous between artistic practice and the only class which henceforth could produce and sustain alternative meanings to those of capital did not exist in 1850, and have only existed in botched and frag-mentary form in the century since – against the grain of the Bolshevik Revolution, around the edges of the Workers' Councils in Berlin, Barcelona or Turin, and

nowadays perhaps in the struggle of the Polish working class to reimpose soviet rule. Art may in any case be a victim of these circumstances, not a beneficiary. Yet the story told in these two books is none the less not simply futile: it has its incidence of grotesquerie and bad faith but also its moments of grandeur. The tone of the chapters on Courbet seems to me now to suffer from an occasional access of elation, but the narrative itself can largely stand. A bourgeois artist is shown to fail to make his art 'revolutionary', but his failure is in its way exemplary and at least serious: it provides us with a touchstone for other such attempts or claims, and in particular it suggests the way in which a struggle against the dominant discursive conventions in a culture is bound up with attempts to break or circumvent the social forms in which those conventions are embedded. That effort in turn seems to me necessarily to involve some kind of action against the place of art itself, as a special social practice in bourgeois society. The results of such action have undoubtedly been inconsistency, unseriousness and waste: so many diversions from the main line of art followed in due course by crestfallen, half-hearted returns to grace. But in saying this we say no more than that we have to do so far with failures. That is testimony to the hold of art and its capaciousness, but it does not mean that the original impulse was misconceived.

One of the moments I most enjoyed when the books first came out was being chided by a reviewer in a respectable art-history magazine – reviews in such places were unfailingly, nay hypnotically daft – for having dealt with Baudelaire in unkind fashion, since, though he 'may not have cut much of a moral figure [in 1848], only the most unregenerate discreditor could any longer care to deny his astonishing capacities as a poet and as a critic. (Along with the rest of us, Mr Clark should envy his powers.)' I feel embarrassed on the contrary, and apologize to the reader, for having steered too close to hero-worship in my treatment of the old *faux dévot*. The apology is all the more necessary because Baudelaire presents himself so insistently in 1981 as the only possible hero of my story. How could we fail to warm in the present circumstances to a strategy of *déclassement* and duplicity, of hiding, self-regard and self-destruction? It appears to be the appropriate heroism of the modern life which remains to us; yet I still would wish to present that of Courbet – to whom the same list of qualities applies, but with a relentless, off-putting *outwardness* added to them – as an alternative model, more difficult to emulate.

Cambridge, Massachusetts, 1981.

Preface to
the First Edition

I am especially grateful to two people: John Golding, who supervised the research for this book in its earlier stages, and who has been patient and encouraging right up to the present, and Theodore Zeldin, without whose help and advice the book would certainly not have been completed; now it is, he will disagree with many of the things I have written. My thanks to Professor Francis Haskell and Professor Robert L. Herbert, who helped me at various stages of the research; and to Irene von Reitzenstein and Yoshio Abe, with whom I often discussed 1848 and after. I would like to thank John Barrell, who was the first to read and comment on the book, and Michael Podro, who read and criticized the manuscript at a later stage. And my thanks are due to Alan Bowness, Lewis and Hazel Brodie, John Bull, Claudine Decostre, Gerhard Fries, Noella Smith, David Stewart, and John Whiteley, who helped in different ways to make the book possible.

I should like to acknowledge aid from the Central Research Fund of London University, and the Research Fund of Essex University. In 1966–67 I was a research fellow of the Centre National de la Recherche Scientifique in Paris, and in 1969–70 I was Alistair Horne research fellow at St Antony's College, Oxford. My thanks to Mr Horne and St Antony's for their help.

This book will be accompanied by a study of Courbet in the Second Republic. Each book stands on its own, but there are many links between them – the friendship of Baudelaire and Courbet, for example, or the question of Courbet's relations with the Bureau des Beaux-Arts, are matters which are broached in both volumes. The two books add up, I believe. But their subjects are separable and different: just how separate, is part of my argument in what follows.

1 The Picture of the Barricade

'The February Revolution was the *beautiful* revolution. . . . The June Revolution is the *ugly* revolution, the repulsive revolution, because deeds have taken the place of phrases . . .'

Karl Marx in the *Neue Rheinische Zeitung*, 29 June 1848.[1]

'For three days now the population of Paris has been wonderful in its physical beauty. They wanted, the scum, to make the bourgeoisie in their own image – all stomach and paunch – while the People moaned from hunger. The people and the bourgeoisie have shaken from the body of France the lice of corruption and immorality. Whoever wants to see beautiful men, men six feet tall, let him come to France.'

Charles Baudelaire, in *Le Salut public*, 27 February 1848.[2]

'The cannon roars, limbs are flying . . . the groans of victims and the shrieks of those who conduct the sacrifice can be heard . . . it is Humanity, in search of happiness.'

Charles Baudelaire, notes for a prose poem, 'La Guerre civile', no date.[3]

This book is concerned with the 1848 revolution, and the four years which followed. They are the years of the Second Republic in France, which end, on 2 December 1851, in *coup d'état*, fiasco, and a second Empire under a new, third-rate Napoleon. I do not want to write history first, and then art history later – that arrangement begs all the questions. The real history of the Republic will be found in context, in the body of the book, in the reactions of Delacroix or Baudelaire to the events of 1848–51. (Those events are summarized, in chronicle form, in the chronology at the end of this book.) The aim of this chapter is to explore the contrast Karl Marx made in June, in the heat of the moment, three days after the civil war had ended, choosing instinctively the language of aesthetics. Was there an art of February and an art of June? And do they correspond to the terms of Marx's equation or Baudelaire's? But to answer those questions – to explain the difference between the ugly and the beautiful revolutions, between physical beauty and flying limbs – we need after all a brief history, by way of preliminary. The history here is preface, not foundation, to the one that follows.[4]

The February revolution lasted three days, overthrew the monarchy and replaced it by a republic.[5] It was made by an odd, almost accidental, alliance of classes; made for very different reasons by its various participants. First, there was the respectable shopkeeper, the draper or hosier from the Faubourg Saint-Denis.

He was comfortably off, but not rich enough to qualify for the vote in the July Monarchy; and the vote was what he wanted above all, as the complement to his bourgeois dignity and self-respect. His political opinions, such as they were, tended vaguely towards Republicanism; he read the opposition paper, *Le National*, and put his trust in the caste of gentlemen who edited it. Possibly in February he fought on the barricades; but most probably he simply refused to defend the monarchy, to fight with the National Guard against the insurgents. His abstention was crucial; it helped bring down the regime. Then there was the skilled artisan, the craftsman or the small trader, often selling goods he had made himself: a cabinet-maker or carpenter from the Faubourg Saint-Antoine. He read perhaps the more radical newspaper *La Réforme*, and was more interested in revolution – the revolution of universal fellow-feeling. He was hard hit by the crisis in trade and industry during 1847; he resented the tight elite of bankers and landowners that ran the July Monarchy (the respectable draper shared his resentment on this point); he listened to Lamartine attacking in a speech in 1846 'industrial concentrations' which were one of the nation's gravest 'disorders'; he toyed with Louis Blanc's or Cabet's solutions. Last, there was the machinist, the skilled hand in the small workshop or even the new factory; the compositor or the builder's navvy, or the proud artisan who had been hard hit by industrialization.

A confused mass of workers and craftsmen, wage-earners and the small masters of back-street forges – not, assuredly, a proletariat; but something quite different from even the meanest and most insecure bourgeois. They read, if they could read, Babeuf and Buonarroti, the old insurrectionary gospel of the first Revolution; or – and the two tastes often coexisted in one man – they read the workers' paper, *L'Atelier*, gentle, cautious, preaching thrift and workers' cooperatives. More important than papers or books, they were often involved in secret societies; they were organized, and they wanted a revolution with a social dimension. The right to work, the reorganization of labour, an end to competition, an attack on the problem of poverty – this, for many men, was the promise of the barricades. They had fought in 1830 with many of the same things in mind, and had seen that revolution go monstrously sour. They had read the caricaturist Grandville's message [1]: 'The People has won a victory; these gentlemen share the spoils.' Only now they were better organized, more determined; this time they would fight harder for the revolution they had made.

From the start, then, the 1848 revolution was ambiguous.[6] It was revolution from above, and from below, the two forms curiously distinct. The men of *Le National* drew up their own list of an acceptable Provisional Government in advance, on the morning of 24 February; later that day they were forced to delete the most reactionary names, and add Lamartine, Louis Blanc, Flocon, Crémieux, even a veteran of the secret societies, a button-maker named Albert. The men of *Le National* wanted to proclaim the Republic with provisos, with a kind of apology for revolution: faced with the crowd outside the Hôtel de Ville they dared not read the script they had drafted, and said what the mob wanted to hear. The revolution was a triumph for the bourgeoisie, yet it struck fear into its heart. In Paris

and the provinces the bourgeois joined in the rejoicing, blessed the tree of liberty, looked forward to suffrage at last; but he was also afraid for his profits and his property, he took his money out of shares and put it under his bed, he began almost at once to talk of excesses and danger.

The bourgeois revered the People: the fighters of February, the honest men who had bowed to the crucifix while they sacked a palace, the respectable poor who had killed the looters and protected the king's soldiers from massacre by the angry populace. (Both these images are specific. Séguin [9] showed a sentinel in a worker's smock standing by a looter's corpse. Léon Cogniet had painted the worker shielding a soldier with his own body during the 1830 revolution.) The People was everyone except king and aristocracy; it was the Third Estate to which the bourgeois himself belonged. But the People was also something quite different from this; it was that mass of men whom poverty had deprived of true human status, the mass outside the body politic, the class whom the bourgeois knew as his enemy and opposite. The People were the new Barbarians, 'outside the city', waiting restlessly for entry but only granted it 'after they have passed through the novitiate of property'.7 'Each manufacturer', wrote Saint-Marc Girardin in a famous commentary on the first working-class uprising, in Lyons in 1831,

lives in his factory like the colonial planters surrounded by slaves, one against a hundred, and the sedition at Lyons is a kind of rising at Santo Domingo. . . . The middle class should realize its position: it has beneath it a population of proletarians who agitate and tremble without knowing what they want, without knowing where they are going. What does it matter? It is bad. It wants change. From there can emerge the Barbarians which will destroy it.8

The question recurred with a vengeance in 1848. Were the People savages or heroes? When they manned the barricades, were they serfs fighting their masters' battles? 'Let the bourgeois settle their own quarrels': in the debates on the eve of February more than one working-class leader had argued that way. Or were they Barbarians storming the city? No one could be sure until June.

In the first few weeks of March, there was a period of ecstasy, lyrical illusion, a comedy of high ideals. There was infinite hope in a future of union and brotherhood, a rhetoric which mixed religion and politics, a trust in science and industry (even Théophile Gautier wrote an article in praise of machines!). On the night of 22 February, a young journalist named Philippe Faure, a follower of the utopian socialist Fourier, had written his testament before he went off to the barricades. What he wrote sums up the mood, and the language, of the weeks that followed.

I am going to fight for Liberty, not for a party. From men and from parties I expect nothing. My hopes are in the action of Providence, in a religious transformation to regenerate society. But Justice is under attack. It is my duty, as a journalist, to take up arms. . . . Forgive us, Divine Jesus, if we, disciples of the eternal Gospel, cannot, like you, prefer martyrdom to combat.9

The ecstasy did not last. The alliance on which it was built – of people and bourgeoisie, of shopkeeper and craftsman, artisan and mechanic – began to break up.

And the two great problems which the revolution had posed began to divide men and create parties. On the one hand there was universal suffrage, the Republic's great legacy to France; on the other there was *la question sociale*. The first became, in a matter of weeks, the field of combat between Left and Right; the Right realized that if it organized, if it used the old power of landlord and 'notable' in the countryside, it could use democracy to confirm its rule; and the Left realized the same thing, that the mass of voters were illiterate peasants, under the sway of priest and gentry, ready to sabotage the revolution. Universal suffrage was from the start a question of timing and organization: whether to rush the vote, while the euphoria of revolution lasted, or put it off till the Left-wing clubs and the Government's *commissaires* had worked on the minds of the people; how to draw up lists of candidates and present a clear choice to the electors; how to discover the issues that mattered to the countryside and channel the peasant resentments which had already broken out in February, in the old way, burning ricks, invading seminaries, sacking châteaux, attacking the Jewish money-lender.[10] The date of the election, the role of the *commissaires*, the propaganda of the clubs – by the middle of March these were issues that embittered men and brought them once more on to the streets. When the vote came, in April 1848, the Right triumphed.

But politics was only part of the matter. As Proudhon put it later, 'the proletariat votes in 52, as it did in 48, on an empty stomach'.[11] (Not quite. The peasant at least went to the vote with the communion wafer in his belly, straight from his Easter Mass.) Behind suffrage was the social question; that question stuck in the throat of the bourgeois revolution, and became more imperative and more dangerous as the economic crisis deepened. It was the social question that led to the June Days.

The Republic of February had dreamt of National Workshops for the unemployed, of the ten-hour day, of nationalization of the railways. All these matters were set in motion, and in the months that followed they divided men further. There was at the Luxembourg a 'Commission du Gouvernement pour les Travailleurs', powerless but sinister, where Louis Blanc explored the problems of Socialist organization. It was allowed to do nothing except mediate in a few strikes and encourage a few cooperatives – but its mere existence affronted the men elected in April. There was a National Workshop, starved of funds and given no jobs to do, nothing more than the old charity workshops under a new name. This was not Socialism, or anything remotely like it; but the existence of idlers, lounging on the Champ de Mars, discussing Communism, getting their pittance out of public funds: that fantasy alarmed and infuriated the 'men of good will'. And there was, even worse, a plan to buy the railways for the State.

By the middle of June, the Right and the moderates had adopted a policy of defiance over the social question: they were out to crush the railway plan, they mustered their forces to put an end to the National Workshops, their watchword had become *Il faut en finir*. What, exactly, they wished to finish is not quite clear. For some the task was to preserve the sane and reasonable Republic, to save it from the extremists. For others it meant the restoration of confidence and prosperity,

the money coming out from under the mattress again. And others had grimmer and more accurate ideas. 'I had always thought', wrote Alexis de Tocqueville looking back, 'that we should not expect to *settle* February by degrees, in a peaceful fashion – it would only be stopped all at once, by a great conflict . . . it was desirable to seize the first opportunity to give battle.' For men like Tocqueville, what had to be finished was the Parisian working class.

On the morning of 22 June, the *Moniteur* published the law dissolving the National Workshops. By the evening of the next day, a long line of barricades, stretching more or less due south from the Faubourg Poissonnière, cut the city in two.[12] The whole of eastern Paris, the Paris of the working class, was in arms against the Republic – perhaps as many as 50,000 men and women were in arms. For a day or two things hung in the balance; at first the insurgents gained ground; a wave of terror spread through bourgeois Paris. And then slowly but surely the troops and the Garde Mobile moved forward, the big guns were wheeled from barricade to barricade, and the insurrection was beaten. It was all over by the morning of 26 June, and the shootings and the deportations began.

Tocqueville called the June Days 'a class battle, a sort of slave war'. That verdict, which was echoed by Marx, is both true and false. False, because the classes of Paris were still, in 1848, confused and shifting; because there were workers on both sides of the barricades, and a monstrous confusion over who was fighting and for what (so that Proudhon, for one, wandered like a dazed *flâneur* through the insurrection, unable to reject the rebels, yet unable to join them); false because the master of the forge or the workshop fought alongside his employees, because the target was not yet the employer or the capitalist. True because, however much we can qualify the opposition, everyone knew that worker fought bourgeois, that the Barbarians had risen to salvage *their* revolution.

The forces of June, like the forces of February, were a coalition. On the one side were our shopkeeper from the Faubourg Saint-Denis, terrified now of what the revolution had brought him, the liberal professions and the intellectuals, the men of *Le National*, the functionaries, the merchants, the landlords, the bankers. And they had strange allies: the miserable and dangerous scum of Paris, recruited into the Garde Mobile; and the provinces, landlord and peasant together, who boarded the trains for Paris, determined at last to teach the city a lesson. On the other side, beyond the barricades, were our cabinet-maker, our joiner, our mechanic; the men who had made the February revolution, their ranks swelled with workers from the quarries and the building sites, workers on the railways and in the engine-shops, dockers, metalworkers and machinists from the factories of La Chapelle.[13] The new working class combined loosely and informally with the old. The cadres of revolution were part traditional – the units of the National Guard in the eastern districts – and part new-fangled – the different sections of the National Workshop itself. There were no acknowledged leaders, no agreed slogans, no single enemy; a hundred flags, red, black, and white. But the issue, the sense of what was at stake in June, was perfectly clear to everyone.

Tocqueville tells a story of the eminent economist Adolphe Blanqui, who

overheard his servant-boy and his kitchen-maid, both of them children, saying, 'Next Sunday it'll be us who'll eat the chicken-wings', and 'We'll wear fine silk dresses too.' That was on day two of the revolution: the terrified Blanqui was afraid to let on that he had overheard, lest their prophecies should come true. But after the victory he walked the two children back to the slum from which he had, out of charity, rescued them – and left them there.[14] The story sums up the mood of June – the upsurge of fear and hatred on both sides, the feeling that perhaps the whole social order was about to collapse. The press orchestrated these emotions in the usual way; atrocity stories proliferated, the man in the smock became not sentinel but bandit and assassin, and it was enough in some areas of Paris to be seen dressed like a worker to risk being executed on the spot. The June Days became a holy war, a battle for civilization; a kind of class struggle, certainly, but one in which the bourgeois firmly believed in his own rectitude, his moderation. *He* was the democrat, and the rebels were in arms against the Republic, against the verdict of universal suffrage.

The politics of June confirmed the hatred of one side for the other, since right, in terms of votes and constitutions, was on the side of the big batallions. The workers of June stepped outside politics, and fought on the grounds of the social question. That is why the verdict of the Christian Socialist Robert de Lamennais on what followed, 'What we see is assuredly not the Republic . . . but around its bloodstained tomb the saturnalia of reaction', is both unjust (General Cavaignac, leader of the forces of repression, was a devoted Republican) and deadly accurate.

The June Days ended the first phase of the Republic. The workers of Paris were defeated and silenced; repression of the press and the clubs began. Paris was a lost cause: what mattered now were the provinces, the peasants who had voted in April as their masters told them, and had come to Paris in June to defend their masters' Republic. So politics changed ground, the propagandists and organizers left for the countryside, and the battle for peasant allegiance began.[15]

Already in August 1848 there were signs of revolt: in certain areas the local elections went against the notables, and dangerous men took charge of the town hall. And then in December Louis-Napoleon was elected first President of the Republic, swept into power by the vote of the peasantry, against the advice of the press and the influence of the gentry, against the 'official' candidate of the Republic, General Cavaignac. At the time, no one knew what that victory signified. Was it a victory for the Party of Order against Cavaignac the wild Republican, 'M. Proudhon's candidate' as the Right-wing press described him?[16] Or was it a populist victory over Cavaignac the candidate of the notables? Was it the victory of the author of *L'Extinction du Paupérisme* (Louis-Napoleon's early, sententious stab at the social question) over the 'Butcher of June'? Was Proudhon right when he talked on 15 December of the 'name of Napoleon which, for the people, was and still is today, no less than the Revolution incarnate, or as Mme de Staël put it, Robespierre on horseback'?[17] Or Marx when he called 10 December the 'day of peasant insurrection'? Were those peasants in earnest when they greeted the election results with the old cry, *A bas les riches*?

None of these questions could be answered for sure. But one thing was certain. The peasants had disobeyed their masters, had voted against the Republic, and had arrived as a political force. They hated the regime because it taxed them and gave nothing in return; and as the crisis in the countryside deepened in 1849, they began to hate the lawyer, the notary and the landlord. There was plenty of fuel for revolution in the countryside: land hunger and land shortage, usury and hope-less peasant debt, disputes over common land and forest rights, falling prices, evictions, litigation in which the rich man won. It was a question not of finding issues but of suggesting solutions, in terms the peasant would understand; of finding ways to erode the old structures of deference and control, calling on old resent-ments and memories of the great Revolution, organizing in secret, devising a politics that was Parisian no longer.

Both sides began to do this. The Right had a head start, but the Left had certain things in its favour. In the next three years, almost from month to month, there were victories for one side or the other – elections lost and won, a flood of tracts and pamphlets, secret societies, show trials, arrests, threats, and above all the myth of '1852'. That was the year of the next elections, for the Assembly and the Presi-dent – and hence it would be the year of the Peasant Republic, the *République Démocratique et Sociale*. Each side trembled in fear or anticipation. The forces of Order gathered behind Napoleon; he became a man of the Right, as the Left grew stronger in the countryside and the divisions grew clearer.

There had always been two histories of the Second Republic, one political, one social. Now they were separate in space: the one fought out in Paris, between President and Assembly, in laws which destroyed universal suffrage, gave the schools to the Catholics, silenced the press, muzzled the revolutionary clubs; the other fought out in the provinces, for the most part in secret, working on fears and grievances which were intensely local – often going no further than the next field or the town at the end of the valley – but had in the end a national resonance.

These were separate histories, but as 1852 came nearer they seemed to inter-twine: the substance of politics became the hidden struggle in the countryside. In the winter of 1851 they almost cohered. Louis-Napoleon offered the return of universal suffrage as the price of dictatorship, and part of the provinces refused the bribe, took up arms against his *coup d'état*, and tried for social revolution. In the south and south-east there was something like a real peasant insurrection, this time with guns against Napoleon not votes in his favour. There were pro-grammes and proclamations quite different from the old wordless rage of the Jacquerie; there were signs of a peasant politics, a rural Socialism in the making. None of this lasted; it was still too local, too much in need of arms and organiza-tion to take on the State. The revolt was crushed by the Army; a plebiscite voted Yes; and the Second Empire began.[18]

The Second Republic was a failure, but it was not, as is often written, pathetic or futile. That is the verdict of hindsight, which understands nothing of the texture of revolution or reaction. The remarkable thing about the Republic is not its failure, but the speed with which revolutionary politics adapted its forms to a

mass electorate and a deeply archaic society; to the contest of peasant and notary, the price of grain, the rate of interest or the ploughing-up of the common. These were not matters the Left knew well. The keenness of the contest is the surprise; not the victory of the traditional rulers, clustering round a symbolic nonentity. What matters is how long the nation stood in the balance; how clouded was the future in 1850 or 1851, and how great the fears. We shall not understand Delacroix or Daumier or Baudelaire until we put back the doubt into revolution; put back confusion and uncertainty, a sense that everything was at risk. All the signs could be read two ways. Even the Empire was ambiguous, at least at the beginning. Proudhon welcomed it as the quickest way to clarify matters and lead on to social revolution; Baudelaire agreed, in much the same terms.[19] They were wrong, of course, but their guesses were reasonable, in 1852.

What are the symbols of working-class Paris? The red flag, cholera, the common grave, the public execution – 'Those criminals, obscure and numerous . . . that proletariat of blood which went through its last agonies on the Place de Grève in the final years of the Restoration – in spectacles where the actor resembled the spectators in many physical and moral details: a theatre of the common man, put on for the crowds of common men'.[20] All these, certainly, but most of all the barricade. Most appropriately, because it was a disputed symbol; because – for a time – the bourgeois claimed it as his own. Most accurately, because it was a nineteenth-century revival; the barricades that went up around the Hôtel de Ville on 19 November 1827 were the first that Paris had seen for two centuries.[21] The great Revolution had built no barricades and had left no imagery of them. They were a phenomenon of the nineteenth century, as much a part of Paris in the July Monarchy as its distinctive bourgeois images: the arcades, the Bourse or the dioramas. (In 1830, after the great bourgeois revolution of the July Days, diorama and barricades combined: Louis-Philippe and his family visited Bouton's *Diorama du 28 Juillet,* and saw the show through several times.[22] This, surely, was the essential image of revolution as the bourgeois saw it. Unfortunately, but aptly, it is lost to us; produced for sale and dismantled when sales dropped off.)

The barricade was quickly represented. The makers of popular prints added a few stones and spars to the old format of the battle scene, placed a mass of men on top, and the barricade was done. It was the barricade as stage rather than barrier; not something which blocked roads and concealed men, not even a backdrop. And the painters, for the most part, followed the printmakers. The barricade is scattered and destroyed, or out of sight in one corner; it is something implied, on which the fighters stand. It is rarely *present:* only Manet [2], sketching the Commune when the image of the barricade was almost extinct, portrayed it as a solid wall behind his figures, and that was because he already had a format: he used the wall behind his own *Execution of Maximilian,* over which spectators peered, and made the Emperor a Communard. And in any case this is the barricade seen in a flash, out of the corner of one eye: it is worlds away, in the space of forty years, from the wild theatre of 1830.

After the 1830 revolution, prints and lithographs flowed from the presses; the Musée Cosmopolite gave over its rooms to paintings and drawings of the three Glorious Days, and the Louvre followed suit. The bourgeois believed for a moment in revolution, revelled in his victory at the barricades; he had defeated tyranny and fought for a constitution; he had revived the tradition of 1789, but this time tempered with rationality and good-will. The people and the middle class had fought together, arm in arm, to institute a new kind of nation, enforce the rule of liberty, define humanity in a different way. The bourgeois was a revolutionary, and the barricade was his symbol; it was all the legitimacy that the new regime possessed or needed.

This, in barest outline, was the first myth of revolution – the self-made man's idea that the Nation, now, was self-made. These were the newspaper phrases of Paris in the autumn and winter of 1830, and they crept into the common tongue; the People repeated them for a while. They conjure up, of course, the first great painting of the barricade, done in these months, and shown in the Salon of 1831, Delacroix's *Liberty Guiding the People* [6]. Conjure up, but do not quite define; for Delacroix's painting is at once a statement of the myth and a contradiction of it. It obeys the myth, but subverts it, using its terms to say something different which the bourgeois did not want to hear. This is the paradox of *Liberty* – no picture is more open, more compliant to the ideas and phrases of its time, and yet no picture proved more offensive. In the telling, symbol and anecdote turned sour.

The picture has a hundred sources, none of them exact.[23] It is part of the current of Paris late in 1830, one of a thousand pictures, verses, True Accounts; and there are echoes and reflections wherever you choose to look. It repeats the forms of the artisan engravers who flooded the market with popular images of the barricade. Only compare it with the same subject as Thiébaud drew it for a Nancy engraver [3]; look at the pose of the fallen corpse at left or the man of the people in open-necked shirt and slouch hat, cutlass in hand, pistols stuck in his belt. Delacroix has changed and dramatized – his workman swings the cutlass instead of leaning on it, his face is wilder and more desperate, there is no child clasped to his side – but he has used the same pyramid of stones and spars and people; he has copied the details of guns and smocks and uniforms. (And like the prints he has made the barricade a stage – a thin layer of debris under the feet of Liberty, with the street still visible in the foreground.) He read the literature of revolution, and learned in tracts and woodcuts of the courage of a working woman called Marie Deschamps. Perhaps he read Barbier's poem 'La Curée', and remembered the poet's image of Liberty:

> *C'est une forte femme aux puissantes mamelles,*
> *A la voix rauque, aux durs appas,*
> *Qui, du brun sur la peau, du feu dans les prunelles,*
> *Agile et marchant à grands pas*
> *Se plaît aux cris du peuple, aux sanglantes mêlées . . .*[24]

Perhaps he preferred the Bonapartist version, by Delavigne; Liberty marching

beside the ghost of Napoleon on the Pont d'Arcole, and the ghost rolling the tri-color around him.

And yet the sources are quite unlike the image that replaced them. The sources repeat the commonplaces of 1830; their imagery is either vague or prosaic: the heroic gesture of Barbier or the scrupulous illustration of the popular engraver. Delacroix's picture is abstract and yet accurate, almost matter-of-fact. It combines myth and history with a peculiar certainty: it puts them together, literally, with a kind of calm, side by side. The picture is allegory, but it is allegory appearing in one place, on one particular day. We know from an early drawing that the painting began as a record, a view of the Pont d'Arcole on 28 July; the towers of Notre-Dame and the houses of the Ile de la Cité are still in the background, to mark the spot; the final charge across the barricades, towards the troops, has just begun. At that moment, Liberty appears and leads the charge. But she is Liberty in context: she is myth, but myth tempered and restrained by its setting.

We can see how this developed in the drawings Delacroix left for the figure of Liberty. She begins as an image straight from Delacroix's private vocabulary – a lithe twisting torso, assertive and yet fragile, a sexual body still close in feeling to the women of *Scios* or *Sardanapalus*. In the next drawing [5], she is squarer, more massive; and in the painting itself her body is turned towards us, flattened out by the hard light which falls on her side, the chest seemingly much broader than the breasts it carries, the arms thrown into shadow, thin and match-like in comparison; the face less feminine, turned into profile and harshly lit, like a face on an antique medal or a low relief. All of these changes work one way: they rob the figure of its sexuality, and this in a context which had, for Delacroix, a particular erotic force. A woman cries havoc, in a setting of death and destruction – that corresponds almost too closely to the demands of Delacroix's fantasy. It is a subject which he works and reworks the whole of his life. And yet here he refuses the imagery of fantasy, the pliant forms that flow from the pencil, the mixture of beauty and aggression. It is not, of course, that the final Liberty is sexless, far from it. But her sexuality is a public one; her nakedness is not one with which Delacroix was, endlessly, familiar; her breasts and shoulders are those of Marie Deschamps. No wonder the *Journal des artistes* in 1831 found her skin dirty, her form gross, her whole aspect 'ignoble'.[25] For this was Liberty as a woman of the People, one of the crowd that surrounded her. It was Barbier's image made flesh, with Barbier's own conclusion:

> *C'est que la liberté n'est pas une comtesse*
> *Du noble faubourg Saint-Germain.*[26]

She is, as Balzac saw clearly in *Les Paysans*, more like a peasant girl than a countess. This is Balzac on one of his peasant heroines, turning instinctively to Delacroix's picture as a point of comparison:

Catherine was tall and strong. In all respects she recalled the models selected by painters and sculptors for their figures of Liberty, as the Republic once did in days gone by. Her beauty, which so charmed the young men of the Avonne valley, was of the same full-

bosomed type, she had the same strong pliant figure, the same muscular legs, the brawny arms, eyes that flashed sparks of fire, the proud expression, the hair twisted in thick handfuls; the masculine forehead, the red mouth, the lips that curled back with a smile which had something almost ferocious about it – such a smile as Delacroix and David d'Angers caught and rendered so admirably. Dark-skinned and ardent, the very image of the People, the flames of insurrection seemed to leap from her clear yellow eyes; there was the insolence of a soldier in their piercing gaze.[27]

A just description, perhaps; but not the image of the People, or of Liberty, that the bourgeois wanted.

Delacroix's picture, for all its violence, is literal, scrupulous. Men talked of the alliance of bourgeois and People, so he painted that alliance point by point. Opposite Liberty, he placed the young bourgeois – perhaps his friend Etienne Arago, ardent Republican, director of the Théâtre du Vaudeville – dressed in top hat, waistcoat, and cravat; he drew the workman and the National Guard, the student of the Ecole Polytechnique in his distinctive uniform, men and boys in rags or borrowed plumes or cocked hats, carrying a weird assortment of weapons. This is the alliance in detail: its terms are the same as the print from Nancy, with its proud trio of Polytechnicien, bourgeois veteran of the National Guard, and bare-chested man of the People. The terms are the same; the effect is totally different. For in Delacroix's *Liberty* it is the worker and the street-urchin who predominate. The National Guard lies dead in the foreground, his tunic torn and his helmet off; the cocked hat and immaculate jacket of the Polytechnicien are glimpsed in the background, over the young bourgeois's shoulder to the right. And around Liberty cluster the student and the mob; there are five figures close to us, and four of them are the *canaille*, the rabble.

That was the trouble with the bourgeois myth of revolution. The very terms of the myth – the story the bourgeois told of himself – suggested its own dissolution. If you took it seriously and gave it form, the bourgeois disappeared. If the new revolution really was heroic and universal, if it went to make a new definition of man, if people and bourgeois were true allies, then the People must be *represented* – and the bourgeois was going to find himself in their midst, one against four, or one against a hundred, a colonial planter surrounded by slaves.

A painter like Louis Boulanger solved the problem easily. His Liberty [4] – done in the aftermath of 1830 – is Delacroix's domesticated, his People vague and out of focus, his barricade has shrunk to a few paving-stones in the foreground. Nothing is defined, so nothing is risked. But Delacroix wanted definition; he wanted to show exactly who was included in the new definition of man – he was himself a displaced person, one of the old Napoleonic functionary class, neither bourgeois nor aristocrat. He had much to hope for from a new alliance.

But by the time the picture was hung in the Salon of 1831, it was hopelessly out of date. The alliance was over, and the National Guard was on the streets of Paris, putting down the People. Instead of a constitution, the Paris mob wanted bread and higher wages; they wanted France to go to the aid of Poland and help the Belgian insurrection. All through the winter, as the economic crisis deepened,

the People clashed with the forces of order. And the forces of order replied: 'Security and tranquillity must be restored.' The old myths went out of favour, the July 1830 revolution became 'in some respects a conservative revolution', and what it conserved was privilege, the separate identity of the bourgeois.[28] Hence the critics' revulsion, in the following May, against *Liberty Guiding the People*. 'Was there only this rabble . . . at those famous days in July? If you ask me, this M. Lacroix seems to be *crucifying us*.'[29] Where, they asked, were the lawyers, the doctors, and the merchants; where were the men of fashion who strode the barricades? Why were there only 'urchins and workers, and a peculiar kind of amphibian'?

In 1848 Delacroix's picture was taken out of store, where it had languished all through the July Monarchy (the King had bought it, as a gesture to the Left, and then had never dared to put it on show). But in a month or two it was out of favour again; it was never exhibited to the public. The explanation lies, once more, in bourgeois susceptibilities.

The February Days were the polite revolution, when the workers joked with the soldiers as the barricades went up: 'You won't shoot without letting us know?' 'Don't worry, we have no orders yet.'[30] Bourgeois and worker fought together, and some of the first barricades appeared in the heart of fashionable Paris, on the rue de Rivoli and the rue Duphot. By the third day there were 1,600 barricades in Paris. 'Everything went off very politely, with courtesy,' wrote the Comtesse d'Agoult (Daniel Stern). 'They stopped the public or private carriages, helped out the people inside, unharnessed the horses and handed them over to the coachman – then the carriage was overturned and they began to dig up the paving-stones all round it.'[31] For a while the insurrection was almost a joke, and the barricades were laughable. 'You call a hackney-cab overturned by two young rascals a barricade!' said Louis-Philippe to his courtiers.[32] There was plenty more banter on the same subject.

The People, as usual, were admirable and terrifying. 'The worker is better than his leaders; he is gay, brave, agreeable and honest at the same time': that was Proudhon's comment, but it stood for a general delight.[33] The city was in the hands of the workers, but they were calm and gentle; they did not want to use their strength. 'The Parisian populace was in a more dangerous frame of mind in 1789, and even in 1830.'[34] The cafés were open, and men drank and chattered between the fusillades. And yet at certain moments the People showed its other face, drunken and destructive: 'At one point, humane, courageous, full of gentleness; at another, brutal and senseless: honour or scourge of civilization, hope or terror of the future.'[35] The next few months would sharpen that contradiction.

The art of February avoids the barricade, and disguises the revolution. There is a new flood of prints and lithographs, repeating the themes of 1830 – but with a kind of cautious decorum. The lithographs of February put the Republic on a barricade [7], but she is moon-faced and neatly draped, the fighting is over, and the barricade swarming with people. The classes are neatly balanced: an urchin with

a rifle, next to a dying student and his friends; a man in a frock-coat and top hat clasping a man in a smock; the Polytechnicien on horseback, the Guardsman embracing the worker. A familiar cast, but arranged with a cynical tact. The People of course are still the majority, but the bourgeois and the student are somehow, visually, their equals.

The two great images of February are not of insurrection – and not, certainly, of the bourgeois as revolutionary – but of play and display, of the People's strange talent for theatre as well as bloodshed. The first is the procession of corpses on the evening of 23 February; the second, most vivid of all, is the invasion of the Tuileries and the revelry that followed.

The painter of the first is Andrieux, Delacroix's pupil, who put down in charcoal and watercolour his memory of the 23rd [8]. He has simplified the image, turning a horse-drawn cart filled with corpses into a single trestle bearing a single naked figure. He has raised the man at the rear, who cries vengeance and jabs an arm towards the corpse, so that he seems to sit on the edge of the trestle, though that cannot be. He has put the scene in a guttering, fitful light: the corpse livid, the gloom behind intense. This is melodrama, but no more so than the procession itself. There, as Daniel Stern records it, a young man rode on the cart beside the bodies and raised the corpse of a woman for the crowds to see in the torchlight. It was a procession with a purpose – to stir up resistance, to gather arms. But it was also a spectacle, a 'funeral procession which seemed to be led by the Furies of the People'.[36] 'Only Dante's Inferno', wrote Stern, 'has scenes of such mute horror. The People is a poet – an eternal poet with nature and passion as his inspiration; producing, quite spontaneously, his own beauty and pathos. Only with the greatest difficulty can art reproduce these grandiose effects.'[37]

Andrieux looks back on the poetry of the People from the other side of the June Days. He wrote 'February' as his first caption to his picture, but then preferred 'December'. He had already done studies of the June revolution, of rebels marching in stolid lines towards the jail, and soldiers looking on with a tired indifference.[38] His painting of February is a retrospect, a wish – the People when they were still poets and Furies, not murderers and scum.

As for the Tuileries episode, that was theatre pure and simple. The People tried out the throne for size, the women larded themselves with rouge and poured bottles of perfume on their hair; they dressed in silk and velvet, and played the instruments of the royal orchestra in a vast and awful cacophony: 'Improvising their various roles they imitate, with a high-comic gravity, the solemnities of official receptions.'[39] On the wall of the throne-room, someone had written: 'The anger of the people is the lesson of kings.'[40]

But it was also a lesson for the bourgeois, something fearful as well as absurd. The bourgeois verdict on the Tuileries is confused and circumspect, mixing disgust and admiration; it is best expressed by Flaubert in *L'Education sentimentale*, in the image of Liberty as a common whore: 'In the antechamber, bolt upright on a pile of clothes, stood a woman of the streets, posing as a statue of Liberty – immobile, her great eyes open, terrifying.'[41] Or in the reaction of Hussonet,

journalist and bohemian: 'Hussonet was thoughtful: the Revolution's eccentricities surpassed his own.'[42]

But this was written long after the event. The first artist of the Tuileries was Daumier, and his lithograph *The Urchin in the Tuileries* [15] shares none of Flaubert's doubts and reservations. Daumier's image, done at full speed in the first week of March, is the invasion from the invaders' point of view: a new view of Liberty, quoting Delacroix's prototype with a casual disrespect. The urchin himself may have come from *Liberty Guiding the People*; he wears the same costume; but his face is coarser, more insolent. The man beside him mimics, clumsily, the gesture of Liberty herself. And the whole rectangle of the lithograph is crammed with forms, a density of line as if to suggest the crush of bodies and the thickness of the atmosphere. ('The heroes do not smell good,' Hussonet's comment outside the throne-room.) It is, as we shall see later, a peculiarly definite, confident image in the context of Daumier's art at this time – a burst of enthusiasm, which wanes very quickly.

A fortnight was as long as Daumier's ecstasy lasted. After that, when he attempted to record the revolution in oils, his imagery was more anxious and uncertain. He was almost the only artist who did try to paint the violence of February. He began three pictures of the revolution: the first, of a man in a smock rousing a crowd in a city street; the second, a workman with his family on the barricades; the third, another version of orator and crowd, this time the movement less dramatic and the crowd less anonymous. We know very little about these works. We do not know when they were done, before or after the June Days. We cannot be sure that Daumier completed any of them; only the first seems entirely his, only the father's head in the second, and perhaps only the general outlines of the third.[43] But one thing is clear. Daumier struggled, painfully and incompletely, to give form to the revolution; to represent the alliance of worker and bourgeois in the Paris streets, and the peculiar dignity of the People in those days: 'Sleepless nights and fatigue make bodies wilt; but the feeling that rights have been won back strengthens them again, and makes men hold their head high' (Baudelaire in *Le Salut public*).

In Daumier's first version of *The Uprising* [10], worker and bourgeois are next to each other, filling the picture space – the bourgeois in top hat and frock-coat, his body following the worker's gesture, perhaps rocking back on his heels, perhaps drawn forward by the movement of the crowd. His face is strangely attentive, tense, wide-eyed (he is taken from a lithograph of two bourgeois 'Alarmists'[44] and the alarm is still present in his gaze). There seems to be no word spoken in this picture, simply a gesture and a hard line of white light which leads towards it in a long diagonal. And faces in the crowd behind, which seem to snap at a bait like fish, their hair blown backwards by the effort. This is an abstract revolution; revolt condensed into one motion, and one simple contrast of frock-coat and smock, *habit* and *blouse*. It is as if the student and the figure of Liberty had been prised from Delacroix's picture and put together in a single rhythm, black against white – robbed of their detail, deprived of everything that makes them

different, made to move in step. Daumier's painting is poster art, conveying one message with maximum force; it insists, it does not quite describe. (Description, by the time this picture was done, was all but impossible. A painter either chose an icon, a summary of complex matters; or, as in Daumier's second version of *The Uprising* [12], he left the work unfinished for forgers to complete.)

The *Family on the Barricades* [11] has a different purpose, perhaps closer to apology. It smells of February, and the stories of women handing cartridges to their men. It recalls the sad letter of Madame Chiron, whose husband 'made me go down at six in the morning to accompany him on the barricades, reminding me of the promise I had made him before God'. He followed the National Guard, shepherding his wife and two sons, saying, 'Come, if I or your sons should perish, you will be proud to say: They died for justice and the fatherland.'[45] And die he did; we know of him because Madame needed charity and wrote to the Compensation Commission.

Daumier's family is botched and repainted, but we are sure at least – from an oil study and a sketch in black chalk – of the central head, bald and white-haired, the face furrowed and the eyes in shadow. This is the workman as Daumier saw him, with an expression between grimness and concealment, looking back towards light, perhaps conflict, somewhere in the rear. The rest was never more than blocked in: the boys' faces and the mother's head are someone else's invention. The picture proved intractable, and Daumier abandoned it. He abandoned many works for many different reasons; but perhaps the reasons here were more than technical: perhaps the subject itself came to nothing. That confident linking of People and Family, that domestic image of the barricade (in which, as usual, the barricade is absent), was destroyed by events.

After June, worker and barricade were seen differently. If the rebel had a family it was one torn, not united, by the fight, and the womenfolk shriek at their man as he goes off, gun in hand. The painter of June was Adolphe Leleux, and his family portrait *The Departure* [13],[46] is the antithesis of the *Family on the Barricades*. Instead of a group of four, with the father's head in the centre, dominant and watchful, Leleux displaces the father, marches him off the canvas edge – he leaves behind, like the blur of a passer-by in a photograph, his triple signature: rifle-barrel, bayonet, and leg. Instead of an abstract setting, lit by fire or sunset, he paints the doorway of a slum. And the women, in the words of one reviewer in 1851 (he believed the women were urging conflict, not pleading for it to stop; it was, in a way, an understandable mistake), are 'abominable furies . . . without even the solemn expression of the antique furies . . . vixens, toothless and wild with fury, who have neither heart nor sex – women that the worker, the honest worker, rejects with disgust, whatever his opinion in politics'.[47]

There is such a thing as the art of June, to put alongside the art of February. But the one is not dramatically different from the other; it does not arrive overnight. For a while the June Days seemed no more than a monstrous aberration. They seemed so to some of the best Republicans. And to the Right and Centre,

all forms of revolution became anathema. So that when Adolphe Leleux exhibited his *Password* [16] in the Salon of 1849 – it seems to me one of the great works of June, and certainly had the June Days as its subject – several critics took it to be a painting of February; and this did nothing to moderate their anger and distaste.[48] Nevertheless Gautier was right when he wrote that June had produced its own art of revolution. 'These terrible and disastrous days of June,' he wrote in *La Presse* on 8 August 1849, 'will have produced two masterpieces – Leleux's *Password* and Meissonier's *Street* (*The Barricade*) [14]. On this heap of paving-stones and corpses, art has made two flowers take root, sad flowers, bent and stained with blood, which will be all that remains of that terrible slaughter.'[49]

The imagery of bloodstained flowers, and of art surviving ruin and death, is Gautier's own. It points to the poet's own concerns, and not to Leleux's and Meissonier's version of the barricade. But the choice is right. These are the master-pieces of June, and they are, too, strangely detached from the slaughter they describe. It is not the detachment of a flower or a cameo, but instead a deliberate deadpan in the face of horror, and a new accuracy, almost an intimacy with the worker and the barricade.

No pictures could be further from the normal imagery of their time. They stand apart from the imagery of the press, the pamphlet and the popular print. They are not simply better; they are of a different kind. Before we can assess them, we need to know something of the norm: the ordinary image of the People and the barricade in June, the common language these painters contradicted.

On 15 May 1848 – it was the climax of many such conflicts in the months which followed the February revolution – the People staged a new invasion. This time it was not the palace but the Parliament [19]. The People came to ask for a debate on Poland, and stayed to demand a levy on the rich. They ended by declaring Parliament dissolved, and founding a new revolutionary Government in the Hôtel de Ville. It lasted an hour or two, until the troops arrived, for the People were mostly unarmed; they had not come expecting revolution that day.[50]

There was the same atmosphere of festival and theatre as in the Tuileries: a red-faced fireman climbed the walls of the chamber and hung from the balcony, the crowd applauding; a great sweating crush of people, in the space reserved for their rulers, shouted and pushed for hours on end. And the rulers themselves were terrified, or impressed, by the manners of the People. They either shared the blank hysteria of Tocqueville, casting round for words to describe the revolutionary Socialist Louis-Auguste Blanqui (and finding, naturally, words like 'sewer', 'evil', 'mouldering corpse'), or they repeated the cynical congratulations of the British Ambassador: 'One of them, warned that the bayonet he carried was frightening the ladies, put it at once underneath a seat. Another asked with great politeness if one would be so good as to point out M. Lamartine, Louis Blanc, etc.'[51] But this was at least the *presence* of the People, face to face with their representatives. The worker emerged for an hour from his anonymity, his beard and his smock; even Tocqueville, with a kind of naive delight and surprise, had to recognize his qualities:

I had occasion . . . to remark with what vivacity and precision the mind of the people receives and reflects images. I heard a man in a smock beside me, say to his companion: 'Do you see that vulture down there? How I'd like to wring his neck!' Following the direction of his arm and eyes, it was easy to see that he was talking of Lacordaire who could be seen seated in his Dominican habit at the top of the benches on the Left. The sentiment struck me as villainous, but the comparison was admirable.[52]

That passage from the *Memoirs* epitomizes 15 May and the bloody weeks that followed. It was the confrontation of men who knew nothing of each other: it produced horror but also amazement. This was how the people looked; here they were, on the sacred stage of History, in the foreground for a moment.

Six days later, and they would be part of the background again, moving in order across the Champ de Mars in the revolution's Festival of Concord, sending their virgins on to the stage to swear allegiance, aping the manners and servility of Rome. This *Fête de la Concorde* summed up the official festivals of the Second Republic. The Left despised it, and even the crowd burst into derisive laughter at the Chariot of Agriculture and the unfinished Colossus of the Republic.[53] The whole affair was a festival of obedience, organized movement in the space the rulers allowed. The Festival in 1848 was a reactionary form, a force which aped the Great Revolution and sabotaged the wild gaiety of the Tuileries and of 15 May. In any case the Festival was uneasy, a conscious anticlimax after the events a week before. The 15 May invasion had already changed the image and temper of the People, and the old deference was somehow incidental.

Artists, of course, preserved the status quo: in engravings of the invasion itself, the worker was still an anonymous spectre in smock, soft hat, stubble and grimace. And that format survived; it was easily drawn and easily recognized; it crops up all through the nineteenth century, and beyond. There were other schemata too, just as false and comforting – men in strange, flowing smocks, with trousers that clung to their thighs and buttocks; figures with wild beards and flowing hair. These men – in one print of the June Days they cluster round the Archbishop of Paris, who was killed by a stray bullet as he pleaded for peace [18] – are operatic figures, part rococo, part medieval; they are no different from the mob which arrested President Molé during the seventeenth-century Fronde rising. (And Raverat, who drew the lithograph in question, may have taken his design from a famous eighteenth-century painting of that arrest, by Vincent,[54] and adapted his drawing from the techniques of Romantic book illustration.) But in both these cases – the crude print of May and the more ambitious lithograph of June – we are dealing with art which does not really claim to be description. These are both pegs on which the public could hang its emotions; the emptier the form, the stronger the anger.

The verbal imagery of June is rather like the drawings we have just described. It is vacuous, hysterical, vile, inflated. It often produced a kind of parody of the old heroic forms. Delacroix's Liberty appeared again on the barricade:

a young woman, beautiful, dishevelled, terrible. This woman, who was a whore, lifted her dress up to her waist and shouted to the National Guard: 'Fire, you cowards, if you dare,

on the belly of a woman!' A volley of shots knocked the wretched woman to the ground. She fell, letting forth a great cry.[55]

According to the papers, she was not the only whore on the barricades. Another, arms bared, dressed in silk and lace, takes up the tricolor, 'passes across the barricade and advances towards the entrance to the rue de Cléry waving her flag and provoking the National Guard with every word and gesture'. She was shot in her turn.[56]

This is the language and imagery of myth; but a myth travestied and made obscene. The travesty is part deliberate invention, and part response to the real cruelty and exaggeration of June. The image of the whore and the tricolor was not simply a lie or a piece of propaganda; the last report appeared in a Left-wing newspaper, La Démocratie pacifique. It was, in its clumsy way, an attempt to match the horror of events.

And there were artists who adopted the same strategy for much the same reasons; their response to the 'ugly revolution' was to burlesque the old symbols. Jean-François Millet, who may have fought in June alongside the sadistic rabble of the Garde Mobile,[57] had already painted a figure of the Republic for a contest held in April; he had made her mild, more or less anodyne. But some time later, perhaps in response to June, he drew a second version [17]. He put Liberty on the barricade again, bared her breasts and gave her the Phrygian cap. But now her movement was awkward and headlong, stumbling over corpses; the Phrygian cap became a helmet, forced down on a pinched vindictive face; she gripped a sword in one hand and with the other dragged a woman's body by the hair – a woman with wizened face and slack, exhausted breasts, perhaps an old woman of the People. The pastel is small, and the strokes are rapid, excited, sometimes clumsy; it seems like an image put down at full speed. It was not done for sale, even for display. It was most probably some kind of private memorandum; Millet's footnote to Liberty Guiding the People, half ironic, half disgusted.

In this sense, it goes with the other great image of the 'ugly revolution', Rethel's New Dance of Death [20].[58] Rethel's series was propaganda. It was drawn in Dresden after the insurrection of 1849, and was almost immediately published in France. Champfleury reviewed it enthusiastically in L'Artiste[59] and Baudelaire certainly admired it. The engraving Death on the Barricade is the most probable source of Baudelaire's notes towards a prose poem on Civil War, with which this chapter opened. They are, if you compare them with Rethel's print, a piece of fairly straightforward description. In Rethel's series the parody is open and deliberate. Death rides into town and foments revolution, weighing a pipe against a crown in a false pair of scales, carrying the Republican standard on the barricade, and riding off in triumph when the revolt is suppressed and the town lies in ruins.

But the engraving itself is more complex than its ideology: Rethel's image of the barricade is something quite new, quite alien to the French tradition. His point of reference is not Liberty Guiding the People, but certain violent, cynical episodes in Holbein's Dance of Death. He takes the wildest and most complex

prints of that series – the *Waggoner* [21], the *Gamesters*, the *Mendicant Friar* and the *Soldier*[60] – and repeats their style of drawing and their bizarre sense of design. He takes over the devices of Mannerism and adapts them to the barricade. He uses a composition built of fragments: forms which cut off and confuse each other, forms which are cut by the picture frame, a network of shapes without a single focus. In *Death on the Barricade* he makes an image where violence and assertion add up to nothing, because they go in contradictory directions – the thrust of the bayonet against the falling bodies and the flying spar, the gesture of defiance hidden by the standard and the man who takes aim and fires. Death presides, with his back to the action: his stance and costume have much in common with another image of the *agent provocateur*, Daumier's statue of Ratapoil.[61]

Millet and Rethel are one end of the spectrum – reactionary artists, who know how to enforce their vision of the barricades. They thrive on the rhetoric of the time, though their imagery transcends it. They confront the claims of revolution with their own view of its realities: it is the horror of the confrontation that counts. Leleux and Meissonier adopt a different strategy. They were both, as far as we know, on the side of order in June. Meissonier was a captain of artillery in the National Guard at the time, and was present at the scene he painted.

When the barricade in the rue de la Mortellerie was taken, I realized all the horror of such warfare. 'I saw the defenders shot down, hurled out of windows, the ground strewn with corpses, the earth red with the blood it had not yet drunk. 'Were all these men guilty?' said Marrast to the officer in command. . . . 'I can assure you, *M. le Maire*, that not more than a quarter of them were innocent.'[62]

Meissonier's intention in the *Barricade* is clear – to paint a picture of civil war as a sober warning to the rebels of the future. And Leleux had much the same idea: he painted *The Departure* as a modern equivalent to David's *Intervention of the Sabine Women*, as a plea for home and family against the strife of factions. He became a docile servant of the Empire, and in 1855 he received the Legion of Honour.[63]

But these facts are in a way incidental. For the *Password* and the *Barricade* are both unique episodes in their authors' careers. They were doubtless begun with exemplary thoughts in mind, but the pictures themselves are different from the intentions. When Auguste de Thierry reviewed the *Barricade* in 1851, he had his own ideas on its message. He seized on the fact that the dead insurgents have no rifles, and suspected 'an unfortunate thought, an unfortunate accusation – almost a slander. . . . One does not counsel peace by insulting the victors and speaking in anger to the vanquished. One does not persuade men of the horror of civil war by calling for vengeance'.[64] This is fantasy, of course; but it points towards the distinctive quality of both these pictures.

They record a revolution emptied of meaning, of conflict and heroes, of two sides facing each other across the barricade. The barricade is scattered and the action is over; three men whisper a password, other men lie like rubbish in the street, ready for the common grave. This is a mute revolution – revolution as banal rather than ugly. Gautier was right when he wrote of the *Password*: 'Was it a judgment or a protest

that the artist wished to make? Neither one nor the other; he saw and he painted, as was his right; the painting has the mute impartiality of nature.'[65] But he was wrong if he thought impartiality here was natural. On the contrary, the 'fact' of revolution is prised apart from its value; we are given, on purpose, pictures without significance, where meaning is precisely what we look for; to call these paintings commonplace is to praise them, to indicate their particular image of the revolution.

We have two versions of the *Barricade* – a watercolour [14] which Meissonier gave to its greatest admirer, Delacroix, and an oil [1] which he withdrew at the last minute from the Salon of 1849 but put on show two years later.[66] In both versions, the picture is built from a simple contrast. In the upper half there is a long perspective of a street, in grey and black and brown, shutters closed, dull, ordinary, a little squalid. In the lower half, the colour is jewel-like and the forms are complex – paving-stones, smocks of red and blue and white, stains of blood, a cap on the kerb-side, and one face in the centre staring upwards into space. The men and the street are somehow out of phase, in proportion as well as in colour: the shop doors seem impossibly tall in relation to the men beneath them.

The oil perfects the contrast between the blank funnel of the street and the intricate mosaic beneath, a mosaic which is not exactly out of focus, but in which the eye works in vain for a clear point of vantage. It is not that the bodies are blurred. They are like the stones in the foreground, picked out with the clarity of enamel. But the ruffles of a smock, the tears in a jacket and a pair of trousers, the marks of blood, the arms dislocated and entwined – it is because all these are seen with an even clarity, 'indifferent as a daguerreotype', that the eye cannot hold them. A Fourierist critic in 1851 expressed this well when he wrote:

What is most cruel in this painting is that, because of the indecision and the lack of energy or effects, we are obliged to look at it for a long time, detail by detail. It is not possible to see it in one glance and pass on. The flesh and the clothes are confused with the paving-stones; the red and blue cloth seems to have been washed by rain for six months on end.[67]

But 'cruel' here is not exactly a term of praise: there is such a thing as humanity, says the critic, and there are some things we should not be obliged to look at. The *Barricade* is nothing more than an *omelette d'hommes*.[68]

But an omelette of men is what happened in the rue de la Mortellerie. Men are equal here, mere matter, all the signs of difference eradicated – no standards, no guns and pistols and swords, no leaders, not even a slogan traced in blood on the wall, as Tony Johannot imagined in his picture of June.[69] Even the street is a blank, with no signs or tradesmen's names or shop windows. And this is not the anonymity of a cipher, of the man in the smock in the print of 15 May. This is the real anonymity of the People, a *created* sameness, the result of violence and not a 'natural' fact. That is the point of the scrupulous painting, the care taken to articulate every detail of the men in the road. Each of these men is distinct from his neighbour, every face different, every body has a weight of its own and has died in its own private agony. These are not anonymous men. They become anony-

mous only because they are confused with each other, only because they have been killed and have fallen together in a heap. Some such confusion is what always makes the People anonymous, to its masters.

Leleux's *Password* is a lesser picture, closer to anecdote. But once again its anxious opponents suggest its qualities. As F. de Lagenevais wrote in the *Revue des deux mondes*:

The *Password* certainly has solid qualities, life, movement and harmony; but for God's sake! What does the choice of such a subject mean? What opportunities do the damp and leaden days of February in Paris give the colourist and how can he make this revolutionary get-up poetic, however hard he tries? The Paris street-urchin is a type which should not tempt any artist. He is generally ugly, small, sickly; his intellectual faculties are only developed at the expense of his puny body. What is more, in our filthy mud, poverty is disgusting and rags are horrible! Since M. Leleux likes rags and tatters, I advise him to keep to those of Spain and the Orient; there at least a splendid sun stains them crimson and gilds poverty with gold.[70]

The rules were rarely stated so explicitly. Why should they be? It was rare enough for anyone to break them, to paint 'our' poverty instead of theirs. Our poverty was, precisely, disgusting, dreary, the opposite of the picturesque; and for once (apart from *The Departure*, he never did it again) Leleux painted it directly. There is a grey wall scarred with bullets, a few old posters, the edge of a barricade. And in front, two men exchanging the password, a third standing with a vacant stare, leaning on his gun. The whole thing is almost monochrome; the gestures, such as they are, are automatic: the password of insurrection (what a phrase for the journalists to play with!) is not so much a sinister mystery as another drab formality.

The men themselves are part of this decor; they are understated but precise. Leleux was a limited painter. He started from the cliché and he rarely got beyond it; painting the People, he chose the urchin, the wild man with the pug face, beard and uncropped hair (the man from Raverat's lithograph), and a youth with a Spanish-looking face. (He was normally a painter of Breton and Spanish scenes.) But for once the clichés do not hold him. The wild man slouches, clumsy, intent on the password, pedantic almost; the *guerrillero* is tired, hand in pocket, standing on the edge of his shoe. And the urchin in the middle is better still – a stock property transformed. The gaiety, the chic costume, the cheeky face are gone. The costume is dirty and plain; the huge peaked cap is no longer rakish, but simply an ugly cast-off; the hands are clenched on the gun until the knuckles go white, and the face is sallow, heavy-lidded, mean. This is the adolescent of the streets, sure enough; but hard-faced and scrawny-necked. Once again he derives from *Liberty Guiding the People*; but once again that image has gone sour. No victory, no animation, hardly movement at all; but instead three men who are defined by more than a smock, who are for once separate and visible. That was in itself an achievement. Not many men – writers or politicians or painters – gave faces to the People in the nineteenth century. They were the mass, the invisible class; they all looked alike, in their jungle.

Tocqueville wrote, on the eve of the June Days, a curious passage in his *Memoirs*

which tells us a little of this. He had been to a dinner party and had seen George Sand (for the one and only time in his life).

It was the first time I had had direct and intimate contact with a person who could and would tell me, in part, what was going on in the enemy's camp. One side never knows the other: they approach each other, they crush against each other, they grasp each other bodily, but they do not *see* each other. Madame Sand described in great detail and with a singular vividness the condition of the workers of Paris, their organization, numbers, arms, preparations, their thoughts and passions; their terrible determination. I thought the whole picture was overdone, and it was not; what followed will show that clearly enough.[71]

One should distrust Madame Sand on the thoughts and passions of the People; but that is not the point. The point is the pathos of Tocqueville's confession, and the truth of his verdict on himself – the sides clashed without seeing each other, and continued to do so.

Trotsky once wrote that the barricade does not play in revolution the part which the fortress plays in regular warfare. It is instead the physical and moral meeting ground between the army and the people.

It serves the insurrection, because, by hampering the movement of troops, it brings these into close contact with the people. Here on the barricade, for the first time in his life, the soldier hears honest, courageous words, a fraternal appeal, the voice of the people's conscience; and, as a consequence of this contact between soldiers and citizens, in the atmosphere of revolutionary enthusiasm, the bonds of the old military discipline snap.[72]

He spoke from experience, and he was probably right. The barricades were places where men came face to face for the first time: in 1905, that meant the peasant in uniform, meeting the worker of Moscow and St Petersburg; in 1848, the respectable member of the National Guard, meeting the worker of La Chapelle. All the more curious that the imagery of the barricade is marked, with certain exceptions, by ignorance and stereotype. As if art, as usual, led the counter-revolution, the long march away from a sight of one's enemies. And that leads us to a simple conclusion: it takes more than seeing to make things visible. It is not that fear and anger necessarily stand in the way of vision: think, for example, of the accuracy of caricature. But the barricades are different. Even a caricaturist is not often in fear of his life: one against a hundred, like a planter suddenly surrounded, in a Paris street, by slaves with guns in their hands.

2 The Art of the Republic

'We should like to see organized great camps and armies of painters, working at speed but immaculately, producing the vast works which will decorate the buildings of the Republic – the buildings we dream of, designed for the gigantic life of the future. Alongside these armies even the great schools of Italy, with their hosts of pupils, would seem like private clubs.

No doubt individualism would suffer, and a few would lose their little originality, their mastery of details; but the great works of art are almost all collective. No one knows the names of those who built and chiselled the cathedrals: Raphael himself, despite his personal value, sums up a civilization and closes a cycle of painters whose very existence blends into his.'

Théophile Gautier: 'Art in 1848', printed in *L'Artiste*, 15 May 1848.[1]

'The daylight passing through the simple windows slants across the benches arranged at right angles to the wall; here and there a piece of straw matting is nailed up, with these words underneath in big letters: Mr So-and-So's pew. Further on, at the spot where the nave narrows, the Confessional stands beside a statue of the Virgin, dressed in a satin robe, crowned with a veil of tulle sown with silver stars, and with cheeks painted red like an idol from the Sandwich Islands; finally, a copy of the *Holy Family*, *gift of the Minister of the Interior*, dominating the high altar between four candelabra, closes in the perspective at the end. The choir stalls of pine wood have been left unpainted.'

Gustave Flaubert: description of the church at Yonville-l'Abbaye, *Madame Bovary*, 1857.[2]

Gautier, as usual in his prose, gave voice to the fashionable hopes of 1848, and Flaubert to the dreary realities that followed. State patronage was an old problem, an old joke in the studios – the Government commission for a picture to decorate a church in the provinces was the last refuge of the painter down on his luck, or the spinster daughter of distressed gentlefolk. In the Republic, so the papers and the General Assembly of Artists declared, things would be different. There would be an end to jobbery and government handouts, an end to mediocrity. Instead, the State would decorate the nation, paint vast murals in the railway stations and the new free libraries, patronize the new men – the landscape painters, and the avant-garde whom the Salon jury had victimized in the 1840s. Let the artists choose their judges and their bureaucrats; let there be a contest for a new Athene Polias, 'Our own dear Koré who is among us' (Plato's phrase), an image to give form to the Republic. Let there be a museum of revolutionary art, tracing the history of 1789, 1830, and 1848;[3] but let art escape from the museums, since, as Proudhon wrote in his notebooks,

A museum is not the destination of works of art; it is simply a place for *study*, a clearing

house, a collection of antiques, of things which for some reason cannot be placed anywhere in particular. They are invalids, beautiful things, that the march of civilization puts out of use.[4]

A Panthéon with murals to illustrate the history of mankind, great festivals of Concord and Fraternity, with new symbols for new emotions;[5] a giant eagle on top of the Arc de Triomphe, or, as David d'Angers suggested, a bronze colossus of Liberty which would make the Arch *republican* at last ('for they were pure Republicans, these immortal heroes who carried the standards of France so gloriously. They ceased to be invincible when their ambitious leader, son and parricide of the Republic, turned victory sour with his despotism').[6]

All of these were actual plans or projects, and some of them bore fruit. But by and large the art of the Republic – its official efforts to find an image of itself – was a failure. There were festivals, but the crowds laughed at them. There were attempts to reorganize the arts, but they came to nothing. The Panthéon was not decorated, the Arc de Triomphe stayed as it was, the contest for an image of the Republic petered out in scorn and excuses. This is not to say that the State had no successes. The Republic contest produced Daumier's sketch, although he never did the large-scale version he was paid for. The Salon jury made up for the lost decades, and made room for Préault and Rousseau. But even this it did with some reluctance. In 1849 the jury needed two sessions before it said Yes to a Rousseau sketch, and the same year it sent back two of Préault's entries – this after fifteen years of refusals in the July Monarchy.[7] The Government's Bureau des Beaux-Arts gave work to the landscape painters and the specialists in genre, but it went on commissioning those *Holy Families* for the churches in the provinces; it went on ordering bad copies of Murillo;[8] the kind of art it paid most for was Cavelier's *Truth* [22].[9] Put Daumier's *Republic* against Cavelier's *Truth*; put Courbet's *After Dinner at Ornans* against Dehondencq's *Bull-fight* [23]; put the 500 francs paid to Daubigny for his *Banks of the Seine* [24] against the 3,000 paid Rosa Bonheur for her *Animals in a Meadow* [25] – and you will have some idea of the art of the Republic.[10]

It is hardly surprising that the State bought bad art as well as good – and I do not want to accumulate anecdotes of failure, or collect photographs of the second-rate. Patronage is a haphazard game at best; in a time of social confusion, it becomes even harder to succeed. That much is obvious. But what needs explaining is the particular nature of the Republic's failure in the arts. Why did it proclaim one policy, and follow fifteen, or none? Why were its blunders and successes so weirdly incompatible? Why did it not reorganize, rethink? Everyone talked of a new kind of State patronage, armies of painters, an end to individualism, a beginning to artistic democracy. The State agreed with them on paper. Why was nothing done?

The reasons are various, but I shall list them roughly, straight away. First, the revolution meant the collapse of the art market, and the State became more than ever a charitable organization. Second, the attempts to restructure the system of patronage – to break the power of the notables, and institute a form of workers'

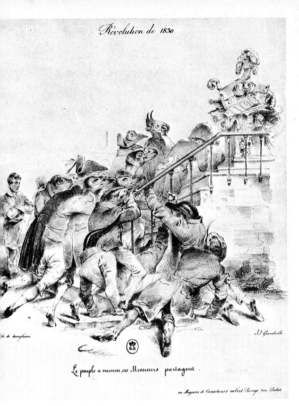

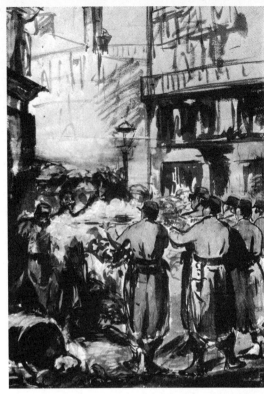

J. J. GRANDVILLE 'The People has won a victory; these gentlemen share the spoils' 1831

2 EDOUARD MANET
The Barricade 1871

ANONYMOUS Fighting in Paris c. 1830

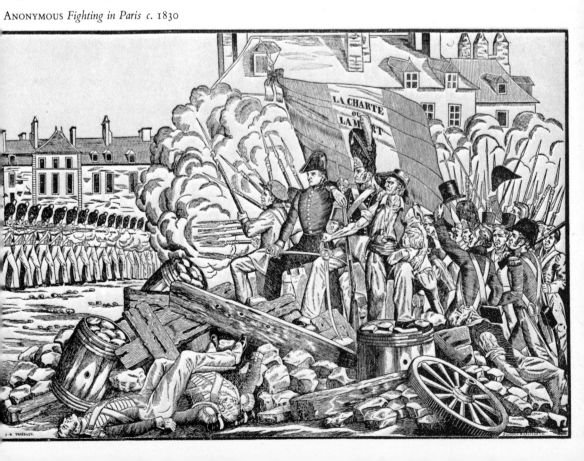

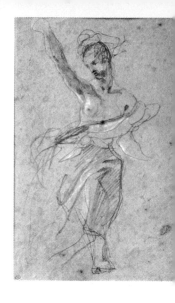

4 Louis Boulanger *Allegory of July 1830* 1831

5 Eugène Delacroix
Study for *Liberty Guiding the People* 1830–31

6 Eugène Delacroix *Liberty Guiding the People* 1831

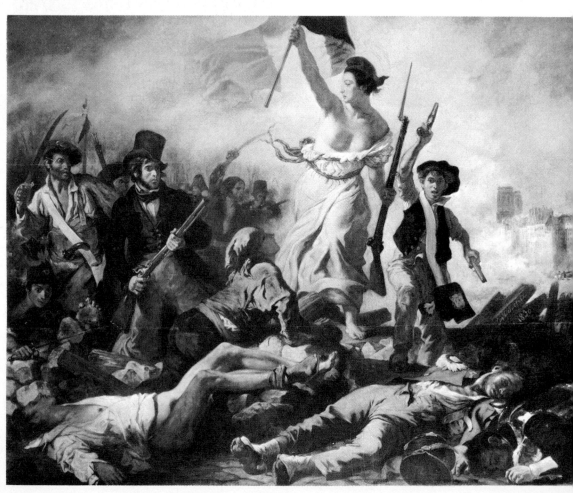

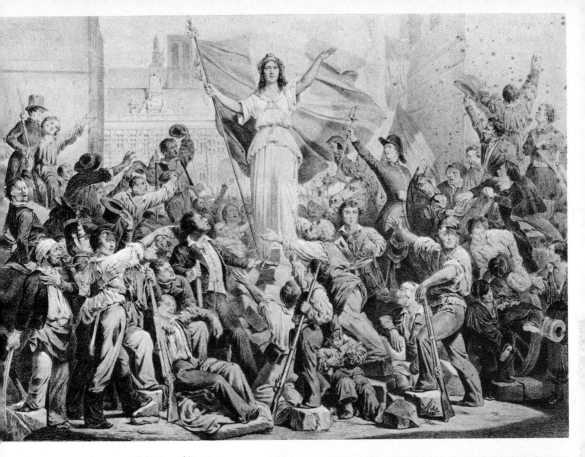

Anonymous *Proclamation of the Republic* 1848

Pierre Andrieux
Men Carrying a Corpse, 23 February 1848 1848

Gérard Séguin *The Sentinel of February* 1848

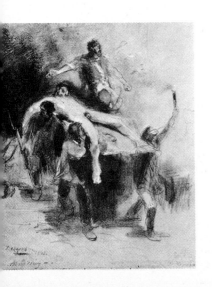

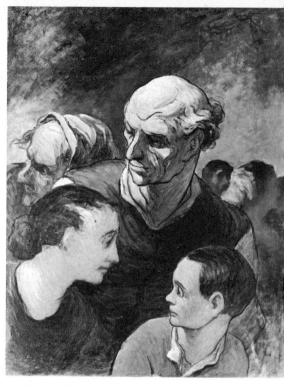

10 HONORÉ DAUMIER *The Uprising c.* 1848

11 HONORÉ DAUMIER *Family on the Barricades c.* 1849

12 HONORÉ DAUMIER *The Uprising c.* 1849

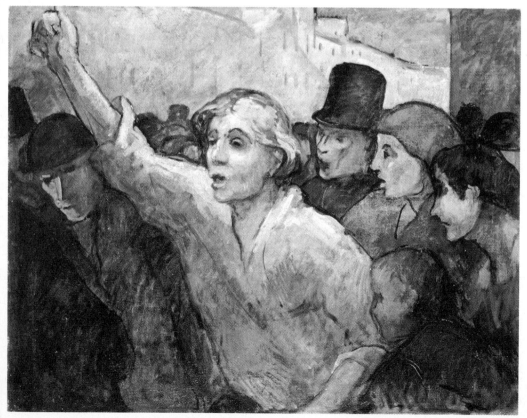

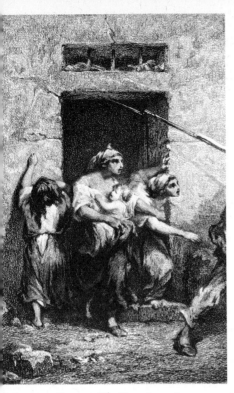

13 ADOLPHE LELEUX *The Departure* 1850

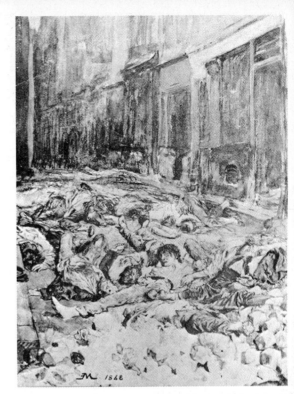

14 JEAN-LOUIS-ERNEST MEISSONIER *The Barricade* 1849

15 HONORÉ DAUMIER
The Urchin in the Tuileries 1848

16 ADOLPHE LELEUX *The Password* 1849

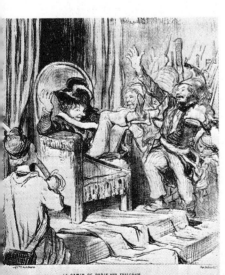

LE GAMIN DE PARIS AUX TUILERIES.

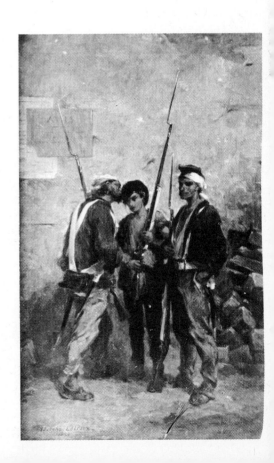

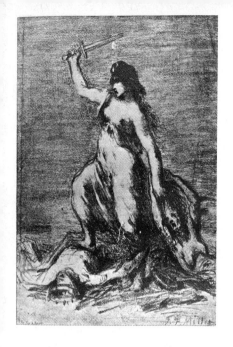

17 Jean-François Millet
Liberty on the Barricades c. 1848

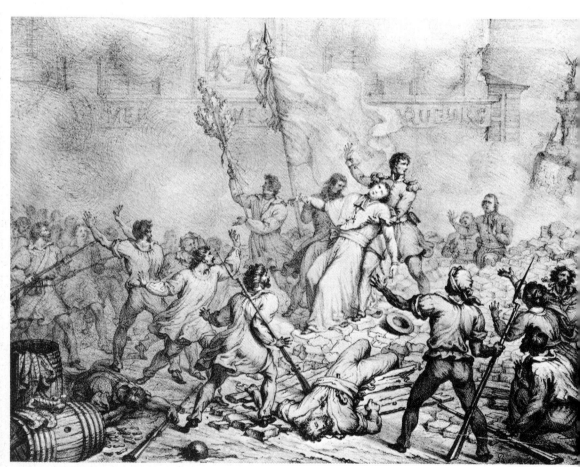

18 Raverat *Death of the Archbishop of Paris* 1848

19 ANONYMOUS
Invasion of the Assembly, 15 May 1848

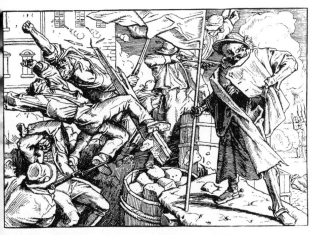

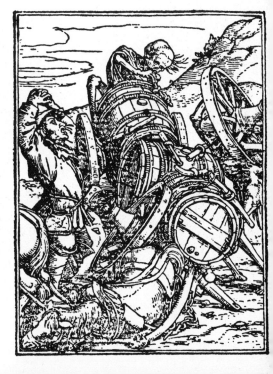

20 ALFRED RETHEL *New Dance of Death* 1848

21 HANS HOLBEIN
The Waggoner – from The Dance of Death c. 1538

22 PIERRE-JULES CAVELIER *Truth* 1849–53

23 ALFRED DEHONDENCQ *Bull-fight* 1849–50

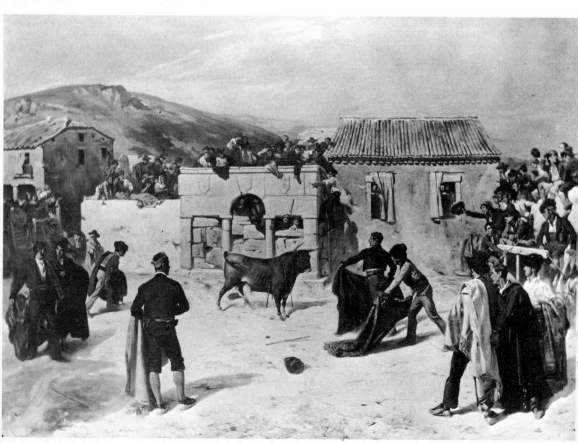

24 CHARLES DAUBIGNY *Banks of the Seine* 1850

25 ROSA BONHEUR *Animals in a Meadow* 1849

26 ANONYMOUS (Provincial workshop)
Popular Image of Jesus Christ 1848

27 PIERRE JEAN DAVID D'ANGERS
Christ writing on the Globe c. 1848

28 THOMAS COUTURE
Enrolment of the Volunteers in 1792 c. 1848–50

29 Auguste Préault
Silence 1848?

30 François Rude
The Marseillaise 1832–34

31 François Rude
Monument to Godefroy Cavaignac 1845–47

32 Auguste Préault *Ophelia* 1876

33 PAUL CHENAVARD
Romulus and Remus c. 1850–52

34 ANONYMOUS
*The Funeral Procession for the
Victims of the June Days* 1848

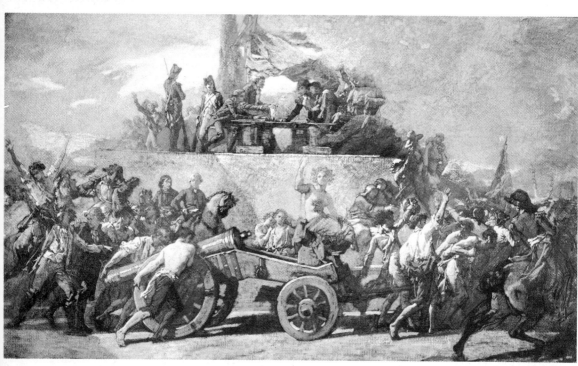

35 THOMAS COUTURE *Enrolment of the Volunteers in 1792 c.* 1848–50

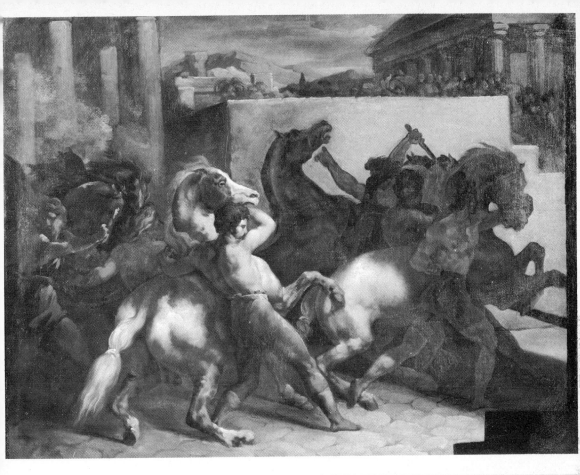

36 THÉODORE GÉRICAULT
Roman Horse-race 1817

37 AUGUSTE PRÉAULT
Gallic Horseman 1850–53

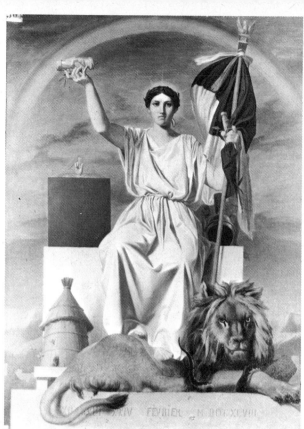

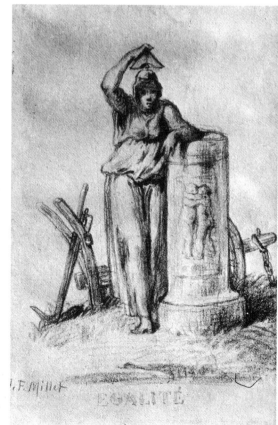

ÉGALITÉ

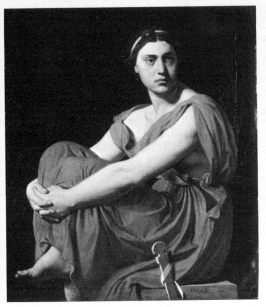

42 JEAN-AUGUSTE-DOMINIQUE INGRES
The Iliad c. 1848–49

43 CHARLES-LOUIS MULLER
Lady Macbeth 1849

44 THÉODORE ROUSSEAU
The Avenue 1849

38 CHARLES LANDELLE
The Republic 1848–49

39 ARMAND CAMBON
The Republic 1848

40 JEAN-FRANÇOIS MILLET
Mother and Children c. 1848

41 JEAN-FRANÇOIS MILLET
Equality c. 1848

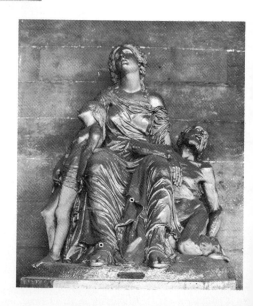

45 FRANÇOIS BONVIN
The School for Orphan Girls 1850

46 JEAN-LÉON GÉRÔME
Anacreon, the Child Bacchus and Love 1847

47 ANTOINE ETEX
*The City of Paris Beseeching God on behalf
of the Victims of Cholera* 1848–52

control in the arts – came to nothing. Third, as a result of this, the Bureau des Beaux-Arts stayed vulnerable to political pressures of the old kind; pictures were still a reward for services rendered. Charles Blanc, who was Directeur des Beaux-Arts for most of the Second Republic, tried to evade these pressures, but failed. Fourth, the politics of the Republic changed from day to day, and the political image of the Republic was blurred and contradictory. This uncertainty infected the arts: the history of the 'Republic' contest, or the great, aborted commission for the *Enrolment of the Volunteers in 1792* by Thomas Couture, are evidence of this. Fifth, the idea of a public art never came in focus. There was not enough money for the truly revolutionary schemes, and those that went ahead – the festivals, the funerals, the murals in church and Panthéon – were essentially retrospective in form, imitating the symbols and the methods of the past. Sixth, and most pervasive of all, there was inside the Bureau des Beaux-Arts a radical confusion about what kind of art was wanted. Should it be a new religious painting, treating the Scripture as some kind of political tract? Should it be the scrupulous, independent study of landscape? Or a revival of classicism, taking up the work of patriotic instruction where David had left off? Or an art of direct political allegory, of *Liberties* and *Republics*? All these were tried, and more. The Republic never made up its mind.

In one way, it never had a chance. The bare economics of art were against it. After the revolution, the bourgeois bought no more easel paintings for a while; in a market so carefully attuned to their tastes, that spelt disaster. Prices slumped. When Narcisse Diaz staged a sale of eighty of his pictures in March 1849, they fetched on average between 100 and 150 francs apiece, and the top price, for his *Gathering of Gipsies*, was a paltry 740 francs.[11] Here as elsewhere, the State came to the rescue. The next month, in April 1849, it gave him a commission to paint *The Assumption of the Virgin* and paid him 4,000 francs – that was closer to his old prices. (He never bothered to paint the *Assumption*, and in the end the Bureau settled for a landscape from his studio.)[12]

What was true of Diaz and the fashionable avant-garde was true of everyone. The dossiers of the Bureau des Beaux-Arts filled with pleas for help: 'February killed the humble artist, and cholera . . . brought with it only honourable debts. A copy would make up the lost ground.'[13] Or again, in more strident tones, 'Since the Republic is an instrument of Progress for the Salvation of all . . . will artists be less protected than before? How is it possible? And yet today artists lack work, almost all of them are in dire straits! The very men who marched in the June Days for the defence of Order!'[14]

The Bureau could not ignore these letters, least of all that last magic reference. Everyone was affected by the slump, not just the lady copyists, but the skilled entrepreneurs who had been in the Salon for twenty years. When a painter like Champmartin – the very epitome of the *juste milieu* – wrote for help, it meant that the whole structure of the market had collapsed.[15]

So State patronage went the way of the National Workshops. The plans in both cases were noble: a new kind of organization, financing new projects,

using the unemployed on new public works, gathering them together in workers' cooperatives. And in both cases, the plans never got off the ground: funds were lacking, the Right was hostile, the need for simple charity was too great. So the National Workshops became nothing more than a variant on the old charity workshops, and the Bureau des Beaux-Arts went on with its discreet handouts to the middle class. Delacroix, who sat on the Salon jury and was a member of the puppet Commission Permanente des Beaux-Arts, summed it up in a letter to Charles Blanc:

How can we make an artist into some kind of butcher who snatches food out of the mouths of widows and orphans; speaking for myself I cannot do it, and the same goes for many others; but we *must* find some way to get beyond our feelings of pity, faced with bad copies.[16]

A way was never found, and the bad copies rolled into the storehouse and out again to Yonville-l'Abbaye.

This was the root of the trouble, but between root and branch there was the problem of organization. The need for charity was a dead weight on any innovation or experiment, but even more deadly was the rusty, hierarchic structure of patronage itself.

For a while after February there was no structure, and the politicians improvised with advice from their friends. A painter named Jeanron, a Bonapartist and a revolutionary of sorts, was put in charge of Museums and Fine Arts.[17] He put a guard on the Louvre to protect it from the people (Préault and Jongkind were two of the artists to do duty), and he organized a Salon – the first ever without a jury – on 15 March. He was a friend of the Minister of the Interior, Ledru-Rollin, and for a while the Minister took a direct hand in patronage. It was Ledru-Rollin, leader of the Left in February, who agreed to a Salon without judges; and later, in April, it was he who chose an unknown artist called Chenavard to decorate the Panthéon.[18]

When Government improvises, so do its subjects. On 3 March, only a week after the barricades, the artists of Paris met for the first time in a General Assembly.[19] What they wanted is not quite clear. Some were prepared to follow their masters and let the State manage its own affairs; some would have been satisfied with representation, a simple reform of the old channels of influence and persuasion – so that artists could state their case without depending on the signature of Ingres, or Delaroche, or the Prefect, or the mayor. But others wanted more than this. One petition to the Provisional Government – it was signed by Diaz, Barye, and Couture – proposed 'that those functionaries, who, by the nature of their job, have an immediate and direct effect on the fine arts should be elected by the whole body of artists gathered in a general assembly.'[20] And that soon became, in the months that followed, a protest against the lack of democracy in the arts, and a demand for a kind of workers' control. As the Sculpture Section put it on 6 April (in protest at the new regulations for the Arts, which put an end to improvisation and the power of Jeanron, and put Museums and Fine Art under separate management):

Already all the workers' corporations have felt the benefit of the Republic; whatever the issue, industry is represented by delegates of its own choice; are the artists alone to be denied this right?[21]

The question was rhetorical, but the answer proved to be yes. Early in March, in the first flush of victory, Armand Marrast had told the artists of Paris, 'Organize yourselves.'[22] By the end of May that mood was over, Charles Blanc was in power in the Bureau des Beaux-Arts, and the bureaucrats were fighting for their privileges. The painters – and their presidents were no less than Delacroix and Decamps – had asked for the power to intervene in all matters that concerned them [48].[23] On 26 May, Charles Blanc drafted a reply to their letter:

The elected Commission of painters can hardly doubt that I am ready to listen to its opinions, and that I put a high price on the advice it will give me. Nevertheless, and doubtless this never entered the heads of those who signed the proposal, I could never consent, at a time like this, and on an issue at once so delicate and so important, to let the initiative pass out of my hands. From time immemorial, this initiative has been the property of the Administration: I could never consent to abandon those prerogatives which have been granted to the Bureau, in the interests of art and in the interests of artists.'[24]

This is the language of reaction, polite, vague, completely obstructive. In other words, things would stay as they were 'for all time'. The Government made its cynical obeisance to workers' control and set up a Commission Permanente des Beaux-Arts in October – the body had vague functions and no power. And even then it was too much for Cavaignac to stomach. In December he purged the Commission of its Left wing – David d'Angers, Pradier, Clésinger, and Jouffroy – and left the rump to argue over its competence and do the spade-work for the Salon of 1849.[25]

The man with power inside the Bureau – the man with control of the purse-strings – was Charles Blanc. How did he use it? He was a man of good will; the mild, artistic brother of Louis Blanc, half a Socialist, half a connoisseur. He had written artistic journalism in the 1840s, and had seen the Socialist message in all manner of paintings; in the Salon of 1845 he had made out a case for Decamps's *Samson* series as a form of political allegory. He admired the great caricaturists, and he had written in favour of a new art of working-class life; he liked the Le Nains, he shared the general enthusiasm for Géricault. But he hedged his bets. He was pragmatic, almost conservative, in his theories of art; he was conventional in his tastes. After all, a tincture of Socialism and a liking for peasant painters were fashionable attitudes in the 1840s. And he never pushed things too far. Raphael was still the great example, and Ingres remained the greatest living painter. Blanc praised Ary Scheffer as much as Diaz; he defended the Ecole des Beaux-Arts; and the Prix de Rome still seemed to him a passport to artistic importance. He was a man with an open mind, a vessel for the fashions and opinions of the day. It was just that openness that proved disastrous.[26]

Even in the 1840s the Bureau des Beaux-Arts had not been simply moribund.[27] It had been more 'liberal' than Salon juries: it had given work to Préault during

the years of his exclusion from the Salon.[28] The work it gave was not the kind that Préault wanted – commissions for uncongenial *Christs* or garden statues for the Palais du Luxembourg – but it was bread and butter none the less. At any rate Préault did better than most: in general, the Bureau's policy before the revolution had been dreary, timid, stereotyped. It had been quite directly an agency of the State. Those who asked for its services stressed their good family, their support of the regime, their influential backers. If they wished to clinch their case they dropped political hints – 'We are overwhelmed by Legitimism, it is having a field-day.' 'The affair of this picture has taken on a truly political flavour.' 'The best reason of all is that the small town of Evron houses a large number of Legitimists, and the Mayor and his officials have been brave enough to carry on the fight against them in favour of the principles of our July revolution.'[29] There was also the need to pacify the working class, and that theme became more popular as the 1840s continued. It was time for the Government to show its concern for the cities, to give 'a mark of sympathy to a moral and religious association . . . which fills the danger-ous leisure-hours of young people in an industrial town', or reward the devotion of 'the large numbers of the labouring classes who attend this church', in the grimy outskirts of Lyons.[30] The regime was conscious of its duties. In 1846 it even bought a picture by Guermann-Bohn called *A Woman of the People*.[31]

But that was a single incident. What it bought in the main was *Holy Families*, copies of Winterhalter's portrait of the King, a few history paintings and a steady quota of landscapes. Who painted them, and where they went, was very largely a matter of politics, decided by battles among the 'notables', the local gentry.

Charles Blanc tried hard to change this, and in some respects the Second Republic *was* different from the July Monarchy. If we compare not just the kinds of pictures that the two regimes commissioned, but how they were commissioned and by whom, certain things emerge very clearly. (I have given the statistics on which this comparison is based, in my Appendix.) The Bureau des Beaux-Arts made a real attempt to end the stranglehold of the notables over State patronage. Blanc tried to end the Bureau's role as handmaiden and entrepreneur to the notables: he re-fused to accept the artists they recommended, he refused to provide the subjects they wanted or buy the pictures they had spotted in the Salon. Where their requests could not be ignored, he simply provided them with a picture from stock – one of the great hoard of bad copies in the Louvre attics, or one of the pictures he had bought from the Salons or the studios on his own initiative. The idea of giving the gentry pictures from stock was not exactly an innovation, but Blanc did it more often than his predecessors, and in a more off-hand way. He sometimes ignored requests for specific pictures or jobs for the local boy, and sent the Prefect or the Mayor what the attics contained at the time!

In this way he made some space for himself. He began to introduce a kind of face-to-face, informal patronage. Apart from the copyists, the most usual means of patronage in the Republic was a straight purchase after a formal request from the artist; in some cases this was charity in a thin disguise. Before the revolution this all went on at a distance: the bargain was struck by letter, and the more deputies'

48 Petition to Charles Blanc, signed by Delacroix, Decamps, Corot, Nanteuil, Perignon and Dauzats 1848

au Citoyen ministre de l'intérieur.

Citoyen Ministre

Les soussignés élus en assemblée Générale par leurs
Confrères, les artistes peintres, ont l'honneur de vous faire
savoir qu'ils se sont constitués sous le titre de
Comité de la section de Peinture.

Leur mandat est de veiller aux intérêts de l'art et des
artistes.

Leurs rapports avec le gouvernement étant un moyen
d'action nécessaire a l'accomplissement de ce mandat, les
soussignés se tiennent dès à présent a votre disposition
pour toutes les occasions ou vous aurez besoin du concours, de
leurs lumières et de leur expérience.

L'intervention des artistes est indispensable dans toutes
les circonstances ou il s'agit de leur situation, de l'emploi
de leurs talents et de la Gloire de la Peinture française.

Cette intervention, les soussignés l'exerceront en :
vertu d'un droit issu du principe et de l'action
démocratique; ils ont la Confiance qu'il sera tenu compte
des démarches qu'ils feront auprès de vous au nom et dans
l'intérêt de leurs Commettants.

Les soussignés sollicitent de vous, citoyen Ministre,
de leur donner acte de la présente notification.

Salut et fraternité.

Eugène Delacroix
Président.

Decamps Président

C. Corot Vice Président,

Célestin Nanteuil
vice Président

Perignon Secrétaire

A. Dauzats.
Secrétaire

signatures and seals that the artist could collect, the better his chances. Blanc's tactics were different; he would go down to the studio, or give the artist his word; the dossiers catch up with something that had already happened. This was innovation but still on a tiny scale. It was paltry compared with the copyists, the decorative projects, and the routine purchases from the Salon.

Like its predecessor, the Republican Government paid homage and hard cash to the mural painters and the sculptors who thought, but usually could not work, on the grand scale; both regimes were eclectic in their choices, traditional in the subjects and sites they chose, confused as to the purpose of public art in an industrial state. The Republic encouraged a form of political art, though even here it vacillated – it wanted, in effect, a substitute for Winterhalter's portraits of the King, and the pictures it commissioned were on much the same level.

The truth was, the space Blanc made for himself in the patronage system was filled up by two things: new kinds of political pressure, and his own uncertainty about what he wanted. The politics can be dealt with briefly: Blanc kept the notables at bay, but other powers replaced them.

Those who asked for pictures still beat their Republican, or later, Napoleonic breasts; but for a while, in the first months of the revolution, there were new voices and new signatures on the letters. Early in June the Bureau received a letter from the town of Graulhet in the Tarn, signed by eighty people in a great page of scrawls and copperplate, and stressing a new right to the State's benevolence [49]: 'The Parishioners of this Church are mainly workers and above all peasant farmers. We hope that this will entitle us to your just benevolence.'³² The men of Graulhet wanted, of course, a *Holy Family*; and the Left-wing *commissaire* of the Republic backed their claim. They got what they wanted, a copy of Prud'hon. But the Graulhet letter, and the kind of democracy it stands for, had no sequel.

By the beginning of 1849 the language of patronage had reverted to its old forms. Religious paintings were ordered *for* the working class, not by them. They had nothing to do with 'the person of the proletarian of Galilee', 'the great revolutionary who mounted the cross so as to be seen by the whole world and cry to all the oppressed: Rise up!'³³ The days of fusion between religion and revolution – the time when Lamartine could remark to Ledru-Rollin, on their way to the Hôtel de Ville on 24 February 1848, 'My dear fellow, we are going up to Calvary' ('*Mais mon cher, nous montons au Calvaire*') – those days were over. If there ever had been a chance that religious painting would change its form and its function, adapt itself to the Christian rhetoric of 1848, it was ended by June. There would be no more popular prints of Christ trampling the hydra of reaction [26], no more visions – like the strange gouache that David d'Angers sent to his friend Lamennais, priest and democrat, on the eve of revolution – of Christ writing Liberty, Equality, Fraternity on the globe [27]. The prints which sold on the streets in March, and the gouache exchanged between friends, were one more aspect of the art of February; they were soon out of date. After June the Church changed its mind: the priests blessed no more Trees of Liberty and conducted no more workers' masses. 'Society has need of slaves,' said Veuillot. 'The dogma

49 Page of signatures of the parishioners of Graulhet (Tarn), petitioning for a picture for their church 10 June 1848

of the Church', said the great Catholic politician Montalembert, 'is summed up in two words: abstinence and respect.'[34]

These changes did not come overnight, and as long as the Republic lasted, religion, like the revolution itself, was something with a disputed significance. But where Montalembert led, the letter-writers to the Bureau des Beaux-Arts followed. 'On 24 February,' wrote one artist in search of work,

I took command of the first company of the fourth batallion of the 1st Legion. I was fortunate enough to prevent the building of several barricades and stop the multitude invading the barracks of La Pépinière.[35]

He saw clearly enough that after June *any* act of counter-revolution was a good recommendation. He was given an *Assumption* to copy.

The dossiers are full of the same language. 'The mayor's faith has banished the [revolutionary] red cap' ('*La foi du maire a fait enlever le bonnet rouge*'). 'The Socialists are hard at work in this area. A favour from the Government would make a good impression at the moment.' 'The commune of Sainte-Césarie . . . by its devotion to ideas of order and its feeling for religion, deserves the favour that it solicits.'[36] Slowly but surely, religious painting was robbed of its ambiguity, and given a single meaning. It became a political tool, a weapon of anti-Socialist propaganda. As the struggle in the countryside grew fiercer, so did the insistence of Prefect and Deputy.

In 1850 the Republic did not actually step up its orders for religious work; it did not need to. (From start to finish – in 1848 as much as 1850 – *Holy Families* and *Assumptions*, *Lives of the Saints* and *Martyrdoms* were its staple diet, the single biggest category of work.) But towards the end of the Republic, the orders for religious works became stereotyped and perfunctory. Artists like Daumier or Diaz, who had chosen in 1849 to do their own version of the Gospel, lost heart in the climate of 1851. The Bureau des Beaux-Arts became once again, against the will of its director, a simple agency of counter-revolution. When Blanc was dismissed in February 1850, and replaced by the Bonapartist Guizard, there was hardly a ripple on the surface of State patronage. The politicians had already had their way.

The art of the Republic was not spoiled only by outside pressures, by the victory of reaction. These hurried on the process of decay, but the Bureau des Beaux-Arts was already a sick animal. What matters most is the doubt and confusion inside the Bureau. And the reasons for *that* are not simply political. Or rather, in the realms of art, political confusion bred aesthetic confusion, and it did so from the very start.

On the face of it, Blanc's plans were comprehensive and his tastes were advanced. On 10 October 1848 the *Moniteur universel* published a statement of policy by Blanc, a 'Rapport au citoyen ministre de l'Intérieur, touchant les beaux-arts et l'avenir qui les attend dans la République'. It rehearsed the popular theories of the day. Times were bad for artists, but the Republic would come to their rescue,

and the history of art proved that democracy was a good friend of painters and sculptors.

The only forms of government which have favoured the grandeur of art, are absolute monarchies or vigorous democracies, with this distinction: monarchies made art a slave or a flatterer, whilst democracies almost always gave it a heroic purpose.

Art had flourished in the Republics of the past – in Greece and Etruria, in Florence and Venice, in the Dutch republic of the seventeenth century, in the time of Jacques-Louis David and the first French Revolution. Art was 'the expression of a particular society' (fatal phrase, already current), and none more closely than the art of the regime that had just been destroyed.

The constitutional system encouraged in men's minds only the love and tolerance of mediocrity. It was a system of division and isolation, and it withered every branch of the arts. The architect was asked for comfortable homes, the painter for easel-paintings, the sculptor for statuettes, the engraver for illustrations. . . . The townsman's house became smaller as the century grew older, was divided and sub-divided like society itself, so that there was room only for art in miniature. Physical greatness was as impossible as moral greatness; space was out of fashion, so was enthusiasm.[37]

Substitute 'capitalist' for 'constitutional' in the first sentence, and you have a fair and familiar example of one kind of art history. In 1848 the genre was rampant. At the Collège de France, Michelet's son-in-law Alfred Dumesnil was lecturing on the Italian Renaissance from much the same point of view, telling his students:

how Italian art, which was born in the fresco as a result of municipal liberties, was enriched at the end of the fifteenth century by the invention of oil painting; how it reached its height at the start of the sixteenth century when great artists harmonized fresco and oil painting; how it ended dismally as an art of the courts.[38]

Nothing was more popular than these confident equations between techniques and patrons, between political liberty and artistic health. The social history of art was in vogue.

Blanc's remedies in his 'Rapport' were as neat as his diagnosis. An end to individualism in the arts; vast projects for industrial architecture; sculpture rescued from the whim of private patrons and given back its public role. The State must invest in lithographs and engravings to propagate its message in the countryside; it must revive painting on the grand scale, murals for the railway stations, frescoes for the temples and palaces of the new Republic. It should encourage cooperatives to buy paintings and distribute them, and it should favour landscape and genre painting.

It is hard to say how much Blanc believed in what he said; in any case, most of the plans were never tried simply for lack of funds. So the question becomes: if he were forced by circumstances to abandon the visionary side of his plans, if he had to go on buying art in the old way, what would he choose to purchase? What was Republican art, in visual terms? Was there any such thing in 1848? And if we can find examples, do they suggest a style for the State to patronize?

Look first at two pieces of Republican art, both either conceived or executed in the last years before the revolution. Those years, remember, were the hey-day of a certain kind of romantic Republicanism – they were the years of excitement, when the monarchy was crumbling before one's eyes. They were a time when heroic gestures were still made and believed in: one night in the early 1840s, in the apartment of General Cavaignac's brother Godefroy, a group of Republicans imitated the action of David's *Horaces*, and swore on the sword to take the life of kings.[39]

The first of the two is a memorial to that same Godefroy Cavaignac, a tomb sculpture done by François Rude in 1847 [31]; the second is Couture's *Enrolment of the Volunteers in 1792*. Rude's sculpture was an act of political opposition. It was put on show in Rude's studio in June 1847, and *Le National* itself published an article in its praise.[40] It was an extraordinary image; a great ruffled mass of drapery, sharp-edged and unkempt, with Cavaignac's head put against it in a very different style, that of blunt and uncomfortable description, with the lines of throat and shoulder already tightening in *rigor mortis*. It put Rude in contact – in direct rivalry – with the most controversial sculptor of the time, Auguste Préault. Perhaps Préault's *Silence* [29], another tomb sculpture, shown in the Salon of 1849, was a response to the Cavaignac monument; perhaps the monument itself repeated the broken forms of Préault's *Carnage*, or the active surface of the *Ophelia* relief [32], which had found a way to suggest liquid, sodden drapery, waterlogged face and limbs.[41]

In any case, Rude's statue offended the conventional; David d'Angers called it 'a disfigured corpse'.[42] But it seemed, for a moment, on the eve of the Republic, that Rude was moving towards a new kind of classicism, one which escaped from the firm contours and simple planes of dogma. He had made a sculpture that was rhetorical, extreme, even Romantic: one which might be put to political purposes. His art – as David d'Angers had suggested in his notes on Rude's most famous sculpture, the *Marseillaise* [30] – was a matter of 'passion grimacing in the moments of maximum energy',[43] of enthusiasm which did not mind being ugly in the process. David d'Angers found the passion false and the grimace ridiculous, but then he was trapped inside a cold aesthetic. For younger men – perhaps for Christophe, who chiselled some of the drapery for the Cavaignac monument, and went on to do macabre fantasies which Baudelaire admired in his *Salons* – the sculpture of Rude and Préault must have seemed the beginnings of a new alphabet.

The sad thing was, it did not turn out that way. Rude himself was miserably treated by the Republic. (Préault fared little better, as we shall see.) In 1848 Rude was commissioned to do a statue of Marshal Ney, the victim of royalty; and then in 1850, when times had changed, his brief was altered, and he was ordered to portray Ney not as a victim but simply 'in military dress'.[44] The sculpture that he did was lifeless and awkward, every inch the State commission. In the first months of the revolution he designed a colossal statue of the Republic to stand in front of the Panthéon during the *Fête des Ecoles*. It was put in place; a huge stand-

ing figure in a Phrygian cap, pike in hand, a beehive by its side as a symbol of industry. It lasted a month; in the June Days, a cannonball knocked it over.[45]

So the Cavaignac monument stands for what might have been: Republican art before the Republic, an example which proved too brilliant and eccentric for the State to imitate. Couture's painting *Enrolment of the Volunteers in 1792* [28] is almost the exact opposite. It was projected before the revolution, but the idea was sold to Blanc, for 12,000 francs, on 9 October 1848.[46] It was meant to be a major work; and what Couture produced was a kind of synthesis of official enthusiasms, lively, exciting, effective even, but never finished. It was a painting that lasted as long as the fashions it promoted; by 1851, when volunteer armies and revolutionary passion were out of favour, Couture had already lost heart.

The subject is simple enough. In 1792 France was threatened by the other powers of Europe, who were both frightened and angry at the new revolutionary regime. So she raised a volunteer army, the first in modern history, to protect the Nation and the Revolution. The volunteers were mostly peasants, and the army they formed was for a while ferociously effective. It changed warfare from a profession into a crusade, and for twenty years the professionals were confounded.

The enrolment of the volunteers was an event with complex implications for the new Republic. In June 1848 the peasants had formed a new volunteer army, this time to crush the working class of Paris; yet that did not make 1792 a safe subject. It raised the question of aid to other nations fighting for their rights; it reminded its viewers of the Polish question and the invasion of 15 May; it put the normal arrangement of military power in question. The fact was, neither Left nor Right would have welcomed a new 1792: the Left because of June, the Right because of Poland.

But if this was a subject with dangerous connotations, Couture's achievement was to neutralize them, to make a painting which avoids the particular, and offends no one. The *Enrolment of the Volunteers* has areas of realistic description: certain heads done in meticulous detail, the muscles of the workmen pulling the cannon, painted from life. But they jar against the rest, and are not, in any case, historically accurate. Nor were they meant to be. The peasantry have disappeared from 1792, and the men who cavort in front of the platform are dressed in vague and romantic uniform; they are part of a costume drama. Some are in shirtsleeves and some in cocked hats; but the differences do not matter. What matters is the general movement of men, the impulse across the canvas; the way in which men follow the figure of Victory and in the process share the blurred outlines of allegory. In this sense Couture's painting is the opposite of Delacroix's *Liberty*. There allegory and history are distinct; they have met in one place, but they are quite different from each other. Here history is converted into allegory. In the *Volunteers* there is not so much an alliance as a disappearance of classes; a piece of magic in the face of the enemy.

The style is attuned to the purpose. It is a compound style, built from artists then in fashion; it takes the art of Rude and Géricault and makes an approximate mixture, leaving out anything in their styles that is obdurate or particular. The

main source is Géricault. Couture takes from him not only the leaping hussar on the far right – which comes from a painting Louis-Philippe had owned – but the whole format of half-naked men straining their muscles against horse or cannon, in front of a great blank platform. The men and the platform are adapted from Géricault's *Roman Horse-race* [36]. When he turned to Rude, Couture was more blatant still. In the first oil sketch for the *Volunteers* [28], he lifted the whole group of *The Marseillaise* and used it to close his picture at the left; a gesturing man, arms outflung, was put in place of the sculptor's Victory. In the final work [35] the borrowing is more open but less complete: Victory herself puts in an appearance, floating tamely across a gap in the composition, but her followers are gone.

What is skilful here is not so much the borrowings as what Couture did not borrow. He combined Rude and Géricault, leaving out the essentials of both. All the ugliness of Rude's Victory, all the violence of her gesture, is quietly disposed of. All Géricault's tense equivocation – between the wild, indefinite brushwork of the horse and rider at left, and the sharper more ponderous forms of the man and horse in the centre – is turned into blunt distinction: on the one hand muscular nudes painted from studio models, on the other 'ideal' figures borrowed from the Rococo. Géricault, we feel, could not make up his mind between styles, and tried to combine them in a single image; Couture took the master's hesitation as a good excuse, and laid out the two styles side by side, without transition.

The result is what the regime wanted – a generalized image, powerful from a distance, imprecise or disjointed close to. Couture could design very well, in the old way. He organized the forward movement of his figures from left to right; he contained the rush by making a gap in the centre of his procession; in the final canvas he used a standard bearer, perhaps adapted from a figure in Ingres's *St Symphorian*, to lean backwards against the press, and a flag-pole to reinforce the break. At the right-hand edge the rearing horse and rider do much the same work. And above the gap in the centre float the Victories, continuing the movement of the whole. This was the ABC of grand painting, and Couture knew it very well. The picture he made is superbly accomplished, a performance by an actor at the top of his powers.

It is all the more curious that he never finished it; and he took care in later life to compound the mystery. He said in his memoirs that he was a victim of the *coup d'état*, that in 1852 the Duc de Persigny ordered him to stop work on his 'tableau de démagogues'.[47] But the Empire went on paying for the picture after 1852, and the Bureau went on asking for delivery. Perhaps the picture collapsed under its own internal stresses; perhaps the apparatus of allegory, which gets heavier from sketch to final version, finally seemed too cumbersome; perhaps the mixture of life studies and costume drama seemed too careless even for Couture.[48] There are no outward signs of strain, no marks of indecision in the actual handling; only a failure to complete.

The truth is that the *Volunteers* was a fragile compromise, which depended on a certain time and taste. Style, subject, iconography, degree of imprecision: they were all a kind of speculation, attuned precisely to the demand of one particular moment,

one brand of Republicanism. Perhaps the picture was a victim not of overt repression so much as of a shift in the emphasis of myth. The Empire had its own view of 1792 – after all, the peasant army had produced the first Napoleon – and had in time its own paintings of the subject.[49] Couture's version would not have been unacceptable, only dated. And that, for Couture, was probably the worst kind of failure.

What happened to the *Volunteers* is typical of political art in the Republic. It is a series of dead-ends, of failures or omissions. And most of the failures are ambiguous; we cannot be sure whether they came to nothing because of political uncertainty or artistic loss of nerve.

The festivals are the best example of this. Is the ponderous imprecision of the design of the hearse which carried the official victims of the June Days [34] to the Madeleine a political or an artistic matter? In a way, it is both. The Republic wanted an art which used the old symbols and avoided the new context of politics; it did not want the truth behind Concord or Fraternity, least of all the circumstances of this particular death and mourning. So it plundered the past; it magnified the symbols of a private bereavement; it discovered no new forms. And when it used the People as part of the drama, the contrast between the actors and their roles became absurd. Tocqueville speaks with malice when he describes the procession of virgins in the *Fête de la Concorde*, but what he writes was echoed by most observers, however sympathetic:

Each of them had been given a big bunch of flowers which they gallantly threw us as they passed. As they were ladies with strong arms, more accustomed, I think, to beating carpets than scattering flowers, these bouquets fell on us like a heavy and tiresome hailstorm.

A large young lady came out from their ranks, and stopping in front of Lamartine, recited a hymn to his glory; little by little she grew more animated as she spoke, her face became terrifying, and she began a series of frightful contortions. Never did enthusiasm seem closer to epilepsy; nevertheless, when she had finished the people wanted Lamartine to kiss her; she held out two fat cheeks running with sweat, and Lamartine brushed them with his lips, with obvious reluctance.

The only serious part of the festival was the military parade.[50]

In such a context, few artists even tried to devise a new kind of public style; and the few that did were criticized. All that remains of the *Fête de la Concorde* are the four statues on the Pont d'Iéna, which were done originally in plaster for the festival.[51] The best by far is Préault's *Gallic Horseman* [37]: this is Géricault's *Roman Horse-race*, but compressed (almost literally, it seems: the stone looks distended with the effort) and simplified, not slavishly transcribed. In Préault's sculpture, the horse and its barbarian rider are carved roughly, in a kind of blocked-in relief; the chest and shoulders of the man are flattened so that they seem part of one surface which continues in the horse's neck and forequarters. Between horse and rider there is a single continuous curve - the mane, the man's hand and forearm, the drapery that takes up the movement of the mane. And this curve too is in two dimensions, so that it seems parallel with horse's neck and man's shoulders. Even the drapery which makes a recess between horse and rider seems level with

them, incised in low relief. What Préault has done is leave the solid block of stone in evidence, implied by the shapes that are carved from it. He has left a great swathe of drapery to fill the space between the horse's legs and give the man a ground to stand against. He has forced the horse's head down into a vertical, which recalls the edge of the original block; he has carved the horse's features formally, like the conventional signs drawn on the head of a rocking-horse.

All these devices, needless to say, were despised by the officials. In 1853 the architects Labrousse, Hittorf and Visconti reported on the Iéna statues, and singled out Préault's for attention.

This group of the Gallic horse and his guard seems to us to indicate, in its composition and execution, so little Study and such Exaggerations that we were reluctant to consider it as a finished work.[52]

Préault was ordered to re-carve the statue on its pedestal, more than a year after he had written to say it was finished. What he did – or whether in fact he altered anything – we do not know. But the air of fiasco and misunderstanding is enough. We cannot of course blame the Republic for a verdict passed in 1853. But we can wonder if the change of government made much difference. The Empire approved the other three statues, the decent mediocrities; the Republic had ordered them. Préault's originality was not very welcome: apart from the Iéna statue, all he received from the State between 1848 and 1851 was an order for a bust of Poussin, and money to repeat an earlier *Crucifixion* in bronze.[53]

There were other disappointments. The most bizarre was Paul Marc Joseph Chenavard, who was commissioned in April 1848 to decorate the walls of the Panthéon. He was a scholar and an unknown, a lover of Germany, a friend of Charles Blanc, a great talker, a great persuader of men. He sold his project to the Republic, and was promised 30,000 francs and an army of painters to help him. Things went wrong from the start. His fellow artists drew up a monster petition of protest against the commission – the way it had been awarded had little to do with democracy – and he himself began to change his mind. He had a vast programme in words, but the form in which it was to be executed was uncertain. At first he planned a set of murals; then in 1849 he 'renounced the use of any kind of painting' and decided to do the whole thing in grisaille.[54]

Théophile Gautier (who later wrote an obscene poem on Chenavard's sexual habits)[55] published an essay in September 1848 in praise of the artist's ideology, or rather his lack of one:

Looking at the pictures you could not guess his religion, his nationality, not even the age in which he lived – except that a few figures which are more or less contemporary give you an idea of the date.[56]

Chenavard had, it was true, a vision of the future: the end of art, the animalization of man, a long epoch of sterility and decomposition, ending in fire. The original plan included that vision, beginning with an idiot capitalist leaning on a bale of cotton and counting money amid broken symbols of the arts.[57] That scheme

did not last long; Chenavard changed his designs to satisfy the Government. But what remained was bad enough [33]; its very neutrality was what angered the critics.

As the temper of politics changed, the Catholics mustered their forces; by 1851 Chenavard was writing replies to a critic in the Catholic paper *L'Ami de la Religion*, pointing out that the pictures contained no 'scenes that the pen refuses to describe' and did not preach the 'revival of the flesh'.[58] In the chamber Montalembert waxed sarcastic about Chenavard's accounts; four days after the *coup d'état*, the Panthéon was made a church again; a few months later the Archbishop of Paris cancelled the plans for Chenavard's decorations.

So much is farce, and the fragments of Chenavard's design that remain are uniformly dreary and dispirited - a sad memorial to the French enthusiasm for the Nazarenes. But there were other projects where failure came as more of a surprise. The most important was the contest, announced in March 1848, for a painting, a sculpture and a medallion of the Republic.

The contest was not a success in its own terms. When the entries were shown to the public on 27 April, the public laughed and the critics scoffed; there were no prizes, and the number of 'winners' was raised from three to ten, and finally to twenty.[59] (These select few were shown again in June.) Even the winners were half-hearted and confused: the first choice, Hippolyte Flandrin, never produced a version of his sketch on a larger scale;[60] Cambon spoiled his sketch by pointless alterations;[61] Daumier ignored the pleas of his friends and never went back to the subject. When a third exhibition, of those winning entries which had been enlarged to full scale, was staged in October, the judges decided to award no one the prize.

What exactly went wrong with the Republic competition? The regulations were fairly simple: on 18 March the Government invited artists to compete for a symbolic figure of the French Republic. Entries were to be done in a hurry, with the deadline for the sketches on 10 April; they were to be exhibited anonymously and judged by a jury chosen by the Administration. Everyone approved of anonymity (though it did not count for much in the brasseries of the Latin Quarter), but there were protests at once about the time limit and the jury.[62] The limit was extended to 27 April, and the jury swelled by painters elected in the artists' General Assembly. The result was a hybrid of politicians, officials and artists, but it was in the end very fairly balanced – between Left and Right, and between Line and Colour. (The painting jury was composed of Ledru-Rollin, Cocon, Lamartine, Félix Pyat, Etienne Arago, Jeanron, Thoré, d'Albert de Luynes, Ingres, Delaroche, Delacroix, Decamps, Léon Cogniet, Schnetz, Robert Fleury, and Meissonier. Too many people, but a formidable list.)

The problem was not judges and regulations, but the nature of the subject itself. What was the Republic, and how should it be represented? When artists asked for advice, they were given either vague rhetoric or pedantic instructions. For Ingres, in May 1848, the Republic was either dream or nightmare: 'the Republic that everyone wants, but that so many infernal angels would make red,

whilst we would like it in the image of Astraea, beautiful, virginal, noble and pure.'[63] For Thoré, another judge, in the same month, the Republic was dream and nightmare at the same time: 'Three months ago we drove out the cursed race and the Republic stood before us, chaste and radiant, on a throne of paving-stones and corpses.'[64] The one notion that Thoré and Ingres share is virginity; and it proved a difficult theme to handle pictorially without descending to bathos. Daumier and Millet have, presumably, ignored it.

The trouble was, as *L'Artiste* wrote in its commentary on the final judgment in October, nothing was more complex and abstract than the notion of the Republic,[65] and no concept was more ambiguous, more in dispute in the first month after the revolution. The answer for most painters was simple obedience to the man in power. Some time in March a sculptor asked for guidance, and a Ministry spokesman – perhaps Ledru-Rollin himself – replied with a curious 'programme'.[66] The important thing, he said, was thought; the conception of the Republic came first, execution afterwards. And as to the thought, the Minister considered he could advise in detail:

Your composition should unite in a single person Liberty, Equality and Fraternity. This trinity is the chief characteristic of the subject, and the signs of these three powers should appear in your work.

Your Republic must be seated in order to suggest the idea of stability to the spectator.

If you were a painter I would tell you not to dress your figure in the tricolor if artistic considerations were against it; but to let the national colours predominate in the picture as a whole.[67]

And so it continued; even the Phrygian cap was recommended. We do not know whether the sculptor followed instructions; but we do know, from the entries that remain, that there was a strange uniformity among the images shown in April. It seems as if the Minister's letter became common knowledge. A few painters had their own ideas: Daumier added children to the seated figure, Diaz produced a nymph escorted by Cupids. But the rest painted in a monotone: a single female, classically draped, seated on a stone throne, or standing in front of it, carrying the symbols of the Republican trinity. The Minister had not described these in any detail, and the painters had to cast about in the books of iconography – embracing children, olive branches, swords, sheaves of corn, set-square and plumb-line, the tricolor, the tables of the law, the broken chains of tyranny, the scales of justice, the lion, the rainbow. All these symbols jostled each other, none of them quite to the purpose.

When the show opened, the reaction was violent. The cartoonists had a field-day, and the critics were unanimous in disgust. 'The public laughs, our artists blush, the French school is disgraced. Imagine any piece of grotesque vileness, and these sketches will surpass it. We shall not stoop to rummage among the chaos and try to make distinctions.'[68] More than seven hundred painters had tried their hand; and Thoré invited five hundred of them to adopt another profession. 'In a decent social organization, each should work according to his abilities and be rewarded according to his needs.'[69]

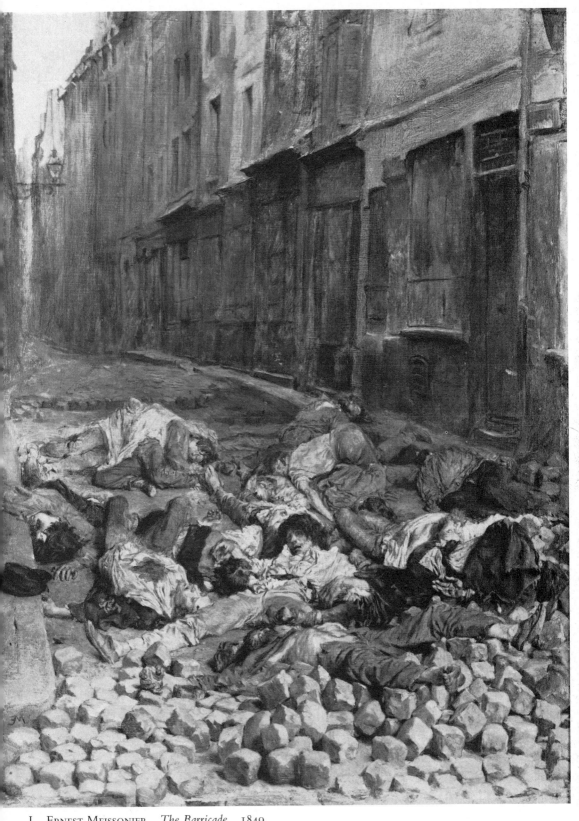

I ERNEST MEISSONIER *The Barricade* 1849

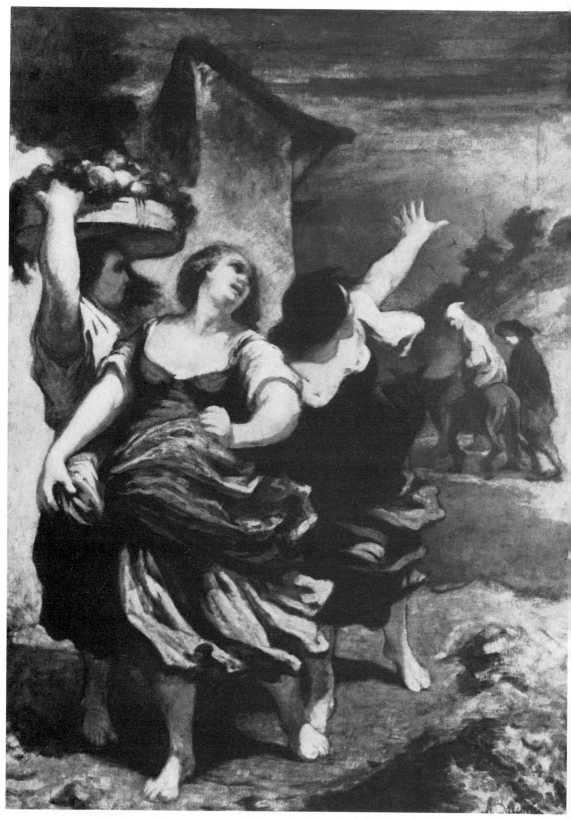

II Honoré Daumier *The Miller, his Son and the Ass* c.1848–49

Thoré as usual kept his temper and cracked some good jokes. Other critics had no such coolness, and there is something specious about their blanket condemnations. If we look a bit closer at what they wrote, either it is vague and diffuse – the comments of a quick stroll through the galleries – or it fastens on opposite qualities to attack. For one school of critics the Republic was milk and water; for others she was a vulgar Maenad, the prostitute posing in the tricolor in the anteroom of the Tuileries. 'Most artists', said Daniel Stern in retrospect, 'had made the Republic a fury with wild eyes and windswept hair, brandishing the torch or pike above a heap of ruins . . . some, not even rising to the idea of a type, had simply reproduced one of those essentially Parisian faces, strange and vulgar at the same time, in which greed is mixed with a cynical *ennui*.'[70] (Did she mean Daumier? None of the other entries that remain resemble her words even remotely.)

In all this, there is an air of fantasy; as if the critics were prey to their own private fears, or their own utopian expectations. When we look at the paintings themselves, the truth is more banal. There was a general mediocrity, and there were respectable winners – men whose style was not disguised by the convention of anonymity.[71] Flandrin, the most distinguished and pious of Ingres's pupils, was top of the list of twenty: Picon was second (his Republic, now lost, was deep in thought, and the critics compared it with Michelangelo's Sibyls; perhaps it was closer to the Odyssey figure in Ingres's *Homer*). Third was Papety – classicist by training, Fourierist and utopian by conviction. And behind them, the various lions of the 1840s: Cornu, Cambon, Leloir, Hesse, Ziégler, Landelle.

None of these names means much to us now, but the two *Republics* I have chosen, by Landelle and Cambon, define their style fairly well. Landelle was a student of Delaroche and Scheffer, a friend of those young painters, led by Gérôme and Hamon, who talked of a Greek revival and a new kind of classicism, more accurate and refined than the last. Cambon was a pupil of Ingres, a more isolated figure, a provincial artist who stayed faithful to the ideals of his master.

Landelle's *Republic* [38] is in fact the less 'Greek' of the two, if we mean by Greek the flat shapes and delicate line of the vase painters. She stands with one foot on the yoke and chains of tyranny, leaning on a massive sword, with an olive branch in her hand. A wreath of laurel, a white dress, Greek pilasters for the two arms of her throne, with the figure of Equality – holding the eternal set-square – drawn there in fine line, by way of reference to the style of the vases. All this may seem cumbersome, but the figure itself is clear and simple; the details of allegory are subdued, almost effaced, by the contrast of white and blue in the drapery, and by the face itself, which for once is austere without being vacant.

In this respect, Cambon is less successful: his *Republic* [39] has a doll-like face, and the lines of her dress are creased like cardboard. But the allegory here is less conventional, and more effective. The Republic's throne is a plain white block of marble with a dark cube resting upon it at the left; from the cube, a hand points upwards. The throne is set against a vast sky, clouded, with a rainbow forming an arch at the top of the canvas; and against its arc the Republic holds a symbol of Fraternity: two sculpted hands, grasping each other. The image has other details

– a flag, a helmet, a lion, a beehive – but they do not disturb this basic equilibrium. What dominates is the dark cube, the clasped hands and the open sky; and the fact that each is painted with a certain scrupulous deadness, like a study from an imaginary still-life, only makes them more effective. (That contrast, between extraordinary objects and calm, literal handling, is the best device of Metaphysical painting, in 1920 or 1848.) These are symbols which are weird and obscure, but they make up a consistent world, where even the sky has an air of unlikeness. They enforce one view, private and bizarre, of the Republic.

At the very least, pictures like this make the efforts of Daumier on the same theme more comprehensible. What Daumier has done is adopt the classical language of his competitors, for it was not a dead language in 1848, and painters like Cambon and Landelle still used it with conviction; it was even a natural language for certain kinds of public statement. Daumier knew the idiom well: he reduced the business of allegory to a minimum, made his symbols into thoughtful or greedy children, made the setting abstract and uniform, bathed face and drapery in a harsh light which simplifies the forms. He pared the style to the bone, but it was still a style his judges could recognize. His figure was chosen as number eleven of the twenty: this, after all, by a jury which included Ingres and Delaroche.

Alongside the contest, after the event, and perhaps as a form of commentary upon it, certain artists did their own versions of the Republic. Some time in 1850 or thereabouts, Ingres repainted the figure of the Iliad [42] from his *Apotheosis of Homer*; some time in 1848, Millet did a drawing of *Equality* [41], and later still perhaps he painted a *Mother and Children* [40] which seems to imitate Daumier directly. These are curious, accidental fruits of the contest itself, and whether Ingres or Millet had the Republic in mind we cannot say. They had both been involved, one as judge and one as competitor, in the contest itself. And in any case it is hard not to see the Iliad figure, or the *Equality*, as answers, right answers, to the problems posed in March. In the group of *Mother and Children*, Millet repeated Daumier's performance, as if to fix that version of classical painting in his mind.[72] In the drawing of *Equality*, he was completely original. He drew a consistent allegory, one in which the elaborate balance of the three Republican qualities was jettisoned in favour of a single one – and that the most dangerous. The figure itself is adapted to the simple brutal message it propounds. It holds the set-square awkwardly over its head, like a portrait on an Egyptian frieze, displaying its attributes to the best advantage. And the shadow of the set-square falls across the eyes and forehead; the face seems tough, plebeian; the body massive and clumsy inside the flimsy drapes. The plough confirms our suspicions: Millet's Equality is a woman of the countryside, and the plough is there for use not decoration. Put the Equality alongside Millet's drawing of Liberty on the barricade, and you have a new version of political art. Liberty and Equality are the issues that count; Fraternity is reduced to a formal relief of kissing children, which only underlines the strangeness of the figure that stands next to it. Liberty and Equality are demands, not sacraments; they are matters in dispute, and the faces of their partisans are violent and obstinate, not calm and graceful.

These were things that could be drawn only in private. The Republic contest itself was a public event, but the best things that came from it were personal, secret, unfinished. And this is typical of the art of the Republic.

In a very short time, Blanc cut his losses and tried to encourage a more varied and exciting private art; he became the friend of landscape and genre painting. In the Salon of 1848, thirty-six prizes went to painters of genre, and forty-three to landscapists; the history painters carried off only fifteen.[73] This side of his patronage was a success. Landscape became in 1849 and 1850 the second most important form of art bought by the State, and the interest in landscape persisted into the first years of the Empire. For many painters this was a definite release; after years of drudgery on copies and altarpieces, they were allowed to paint what they wanted.[74] For others it was their first experience of official favour: Théodore Rousseau, for example, suddenly found himself paid 4,000 francs for a picture to join the modern masterpieces in the Luxembourg, and in the Salon of 1849 he was awarded a first-class medal.[75] In a way this was merely catching up with fashion, Rousseau had been a favourite of the private collectors for years. But the money and the medal counted for something; there were still critics who fumed at pictures like the *Avenue* [44] ('What disorder in the brushwork, and what an absence of the least sign of a method! This work is a veritable chaos, without light, without spontaneity, flaunting its own pretensions'[76] – that was the comment of one A. Galimard at the Salon of 1849), and even the Jury had hesitated over Rousseau's most casual sketch, *Terrain d'automne*.

Blanc sometimes hesitated, for no apparent reason. He bought a minor work from Charles-François Daubigny in June 1848, and then marked time for a year.[77] All Daubigny received from the State was two hack commissions, etchings after the Claudes in the Louvre. Finally Blanc plucked up courage, bought the *Banks of the Seine* from the 1849 Salon, and commissioned another landscape to hang in the Minister's office.

Daubigny's *Banks of the Seine* [24] is an example of Republican art at its best. It is simply constructed, with a dominant sky which owes much to the Dutch tradition;[78] its handling changes casually from place to place, according to what is painted – thick impasto on the dark bank at the right, smooth colour on the sides of the houses, the sky dabbed on with a coarse brush whose marks are plainly visible, the peasant and sheep in the foreground sketched with a skittish economy. It is short on 'style', and that was a blessing in 1849. It is a painting concerned with the particular, the light and atmosphere of one place and time of day; and that was a rare enough subject. Blanc bought the picture, and for a month or two Daubigny was less dependent on the chores of book illustration.

In genre painting, the Bureau was more confused. It approved of the painting of common life and wanted to foster it; but here, more than anywhere, it was at the mercy of fashion. Genre painting was by its nature speculative art, done for the market, responsive to the latest tides of taste. And the State followed the speculators: the best price it paid for a picture from the Salon of 1849 was 6,000 francs for Muller's *Lady Macbeth* [43].[79] There is not much to say about the painting

itself. It is a perfect compromise, a piece of salesmanship: it mixes Delaroche and Delacroix in just the right proportions, enough to animate the former and neutralize the latter.

From the same Salon, the Bureau bought Courbet's *After Dinner at Ornans*, but even this was not a risky choice. For a while in 1849 Courbet was a fashionable painter; when he went out of favour in 1851 the State left him alone. It retreated to François Bonvin as its model of the new realism, and even here its officials were cautious and unkind. 'M. Bonvin's picture is completely finished; it is not without qualities as far as colour effects, but its overall appearance is dreary and uninteresting.'[80] So commented a Ministry inspector, Garraud, on *The School for Orphan Girls* [45], a picture which proved to be a Salon favourite; it was praised by almost every critic in 1851.

The fairest example of what the Republic meant by genre is Dehondencq's *Bull-fight* [23]. It is unpretentious; its detail is crisply painted, and it is done with evident pleasure. During the 1840s Dehondencq had produced no less than six religious paintings for the State: four copies and two originals. At last, in August 1848, he was allowed to choose his own subject; two months before, as his backing letter emphasized, he had been wounded in the attack on the barricade at the Porte Saint-Denis. There was no better claim on the Bureau's charity. It accepted Dehondencq's literary offering, *Virginie Discovered Dead on the Beach*, paid him 1,500 francs, and in 1849 commissioned the *Bull-fight*.[81] The picture itself is dated 'July 1850, Madrid': in other words, a record of a holiday, of a June Days convalescence. The *Bull-fight* becomes an appropriate symbol: its subject-matter is fashionable (the taste for Spain was unabated in the 1840s); it is profoundly escapist; it is a reward for political services rendered. It stands very well for the tastes – and the functions – of the Bureau.

But even the *Bull-fight* will not do, if we want a picture to epitomize what the State commissioned. If we wanted a typical painting it would have to be a devotional subject; and if we wanted a work to sum up the Republic's ambitions, it would have to be Gérôme's *Anacreon*, or Cavelier's *Truth*, or even Etex's statue *The City of Paris Beseeching God on Behalf of the Victims of Cholera* [47].[82] The first was bought from the Salon of 1848; the second was commissioned in 1849, for 12,000 francs; the third was an old project, which Etex had first conceived in 1832, after the greatest of all nineteenth-century epidemics. It was soon to be topical again.

The point of the trio is its incoherence. In 1848 and 1849 there was something like a classical revival – a fashion for the *néo-Grecs*, a new respect for David the Republican, a desire to reinvent the art of myth and allegory. In general terms, everyone agreed on a programme; but in terms of style, in terms of a choice of particular masters and forms, there was total confusion. Gérôme and his friends talked of a strict revival of the Greeks (though *Anacreon* [46] is a delicate amalgam of figures from Ingres and Poussin, with the style of the vase-painters once again relegated to a single urn at Bacchus's feet). Cavelier went on with the ponderous 'Roman' style of the Academy, and was admired by the connoisseurs. In the Salon of 1849 the painting jury chose him – in preference to all the painters who had shown that

year – as the winner of the Grand Medal of Honour.[83] And then there were men like Etex – men who drew like Flaxman and sculpted like no one in particular. Etex, after all, was a decent Republican, something of a radical in his way (he showed a bust of Proudhon in the 1851 Salon, and in December that year he marched with Hugo to resist the *coup d'état*).[84] He was a friend of the Blancs, both Charles and Louis; he had designed the Chariot of the Revolution for the funeral of the victims of February; he had studied in Rome, and had waited fifteen years for a chance to do the work he planned. It hardly mattered if the work itself was clumsy, obscure, badly carved; the State could hardly refuse the offer.

Etex, Cavelier, Gérôme: this was classicism in 1849. The Bureau shared, even magnified, the chaos. It believed in the classical revival, but it had no sense of what the phrase meant in practice. It approved of Gérôme, and finally gave him a small set of murals to paint in 1850.[85] But it did not decide to patronize a single school or even encourage a particular style. In 1849 – after the first flush of contests and festivals – Blanc cast around for 'classical' work; he ordered a long list of mythical and allegorical pieces. The intention is clear enough: this was the kind of art, serious, durable, universal, that was appropriate to the new Republic. And yet when he came to choose the artists for the job, he was trapped inside the structure he had preserved. He had defended the Ecole de Rome, so its well-mannered pupils had to be given work.[86] He had left the Academy with its powers intact, and now those powers were put to use. The lists of commissions make dismal reading. For every Gérôme there are twenty Caveliers, fifty Etexes, and a hundred more whose names and subjects – dancing fauns, noble Gauls, statues with titles like *Meditation* or *Ingenuity* – have gone down to total darkness.

I seem to have ended on a querulous note, which may be unkind but is not unprovoked. State art was a failure. It failed to find a form for the revolution, it failed to decide on a style for public statement, it never escaped from a stifling tradition.

If we want to discover the response to revolution in the arts we have to look elsewhere: at paintings done in retreat or obscurity, designed for a very different kind of patron. The art that counts, the only art that comes to terms with 1848 and its consequences, is done under cover, in various disguises. The State appears with a handout or a dud commission; its help is incidental, a nuisance or a joke. The histories we trace in the rest of the book – of Millet, Daumier, Delacroix and Baudelaire – are all in their different ways stories of privacy and evasion. These men produce an art of revolution, but it is quirky and unexpected, comic or disillusioned; its strategies are indirect, almost sly. Many of its images are made in sullen retrospect, or in a spirit that is close to counter-revolution. They are accurate, but they are not well-meaning. And the State above all wants men, and works of art, with their hearts in the right place. It does not like surprises; it wants 'novelty' or 'innovation', it does not want cunning or farce. Even when such art serves the cause of revolution – and in Daumier's case that was in a sense true – this is not a version of politics, or painting, that committees will understand.

3 Millet

'My dear Lucien,

Le Figaro has just published two letters by the great Millet; these letters show the painter in a very peculiar light and clearly indicate the petty side of this talented man. It is very discouraging. . . . The great Millet indignantly protests against the Commune, whom he characterizes as barbarians and vandals; he concludes with a dig at good Courbet, who, as I see it, can only be aggrandized by this attempt at belittlement. Because of his painting *The Man with the Hoe*, the Socialists thought Millet was on their side, assuming that this artist, who had undergone so much suffering, this peasant of genius who had expressed the sadness of peasant life, would necessarily have to be in agreement with their ideas. Not at all . . . I was not much surprised. He was just a bit too biblical. Another one of those blind men, leaders or followers, who unconscious of the march of modern ideas, defend the idea without knowing it, despite themselves !'

Camille Pissarro, letter to his son, 2 May 1887.

Looking at an etching like the *Woman Carding Wool* [50], which Millet did at some time in the early 1850s, it is difficult to see why his art was ever out of favour with later generations. Looking at a painting like *Men and Women Trussing Hay* [51], which he showed in the Salon of 1851, it is easy. Both pictures have as their subject human labour, and in both labour is given the form, and the weight, of ritual. Work, for Millet, is not usually a process which changes or shapes the surrounding world, not a matter of making or assertion. It is a series of actions endlessly repeated, a spell, an incantation, magic which the magician does not expect to work. It is a gesture once learnt, now automatic; a task which subdues the performer, lulling her to the edge of sleep, turning him grim-faced and brutish; 'a complex of wheels in which one is crushed'[1] (an industrial metaphor which Millet once used to describe art itself). But where the *Woman Carding Wool* is still a person, still somebody, though almost effaced by the job she does, the harvesters are lay-figures, soft and compliant. They do no more than illustrate their tasks, they are created to grasp the hay or wield the pitchfork (and reflect the light which conveniently rounds their shoulders); they are not so much anonymous as perfunctory. The etching celebrates the privacy of labour – in the sense of privation as well as cloacal calm; it finds form for the delight of work as well as its monotony. Carding is commonplace and in some way terrible; the image states that carefully, meticulously, through pose and expression and objects, in an undertone. The painting has none of this complexity. It imposes the sublime upon the ordinary

without finding it there, in a gesture or a detail observed and rendered for its own sake.

Men and Women Trussing Hay is the kind of painting which deserves the critics' scorn – the judgment of Saint-Victor on *The Gleaners* in 1857: 'They are too conceited, they betray too clearly their claims to a pedigree from Michelangelo's Sibyls, and their certainty that they wear their rags more superbly than Poussin's reapers wear their draperies',[2] or Baudelaire's remarks two years later: 'Instead of simply distilling the natural poetry of his subject, M. Millet wants to add something to it at any price. In their monotonous ugliness all these little pariahs have a philosophic, melancholy, Raphaelite pretentiousness.'[3] As a commentary on the *Woman Carding Wool*, this would be beneath contempt. As criticism of *Men and Women Trussing Hay* it would still be fairly accurate.

The problem was difficult; that was why Millet sometimes failed. He had to convey, in a single image, a sense of the particular nature of a task, and its anonymity. He had to suggest that work was tragic, in the old sense of that word, as well as ordinary. He wanted a nature which was intimately known and bitterly resented. Here he is, writing of his home landscape on the Norman coast, in a journal he kept in 1865:

The cliffs, which drop steeply to the edge of the sea, are rough, bare, and, one might say, emaciated, with enormous heaps of rocks sticking out as hard and stiff as steel, like the skeletons of the earth. These heads of rock have a primitive and fantastic appearance. One of these rocks, the biggest, ends in two blocks which have a superb physiognomy; it makes one think that it must have been on heights such as these that Prometheus was chained. The areas between the rocks are dry grass, interspersed with bare tufts of gorse and heather. You can see a few very wild-looking sheep grazing there, which belong to the poor folk. They are exceedingly ferocious, since they are brought to the village only once a year to be shorn of the little wool they have.[4]

This is Millet's world. There is first a nature which is harsh and barren, supporting gorse and heather and a few wild sheep; but nature with a physiognomy of its own, with a surface like some worn and naked body, fleshless and emaciated, bones showing, head worn in fantastic shapes. This is landscape as Millet saw it, especially in his later pictures like *Spring* or *Man with a Hoe* [52]. Second, there is at the centre of any adequate description a transition to classical myth, to Prometheus as a figure to sum up the horror of the place. And third, there are the 'poor folk' in the village, absent but represented by their sheep, and no less ferocious.

These are the transitions – from nature to physiognomy, from landscape to myth, from there to the people of the place – which prose can handle easily. Less so painting, where the analogies and disjunctions implied here would be ponderous just because they would be permanent; not narrated, passed over, replaced by other symbols. In the Second Republic Millet is in search of a style to enforce these transitions; in search of images of landscape, and ways to place his people against them; and in search of a balance of myth and commonplace. He was already, in 1846 and 1847, a painter who could switch between the two: he had painted quarrymen at work, a winnower, a woman churning butter, and he had shown

Oedipus Cut down from the Tree. In the Salon of 1848 he displayed the two aspects of his art side by side, almost programmatically. First *The Winnower* [53], then the *Captivity at Babylon*, complete with soldiers in Roman costume and a strange composition filled, according to Gautier, with 'convulsive energy'. The problem was to reconcile the two; and the next four years are ones of hesitation and experiment, in which a style is formed.

Gautier had this to say of Millet's painting *The Winnower* in 1848:

M. Millet's painting has everything it takes to horrify the bourgeois; the bourgeois with the smooth chops, as Petrus Borel the Lycanthrope called them. He trowels on to his dishcloth canvas, using no oil or turps, great masonries of colour, paint so dry no varnish could quench its thirst. Nothing could be more rugged, ferocious, bristling, and crude.[5]

This was, as usual with Gautier, only part of the truth. Sure enough, *The Winnower* was a painting of a plain man about his business, and Ledru-Rollin had bought it in the first fine days of the Republic. But what it looked like we can only guess, from later versions which are probably plainer and less captivating, and from Gautier's description:

The red kerchief on his head, the blue patches on his ragged clothing, are done exquisitely, full of zest and caprice. The powdery effect of the grain that scatters as it flies upwards, could not be better done; it is a very moving picture.[6]

The red kerchief and even the blue rags are gone in the later versions; the paint avoids the capricious or the exquisite, it is deliberately sombre and indistinct. *The Winnower* of 1848, we might guess, was still close to Diaz and Decamps; it made up in effects of colour and refinements of brushwork what it lacked, for the bourgeois, in terms of the picturesque. There are other examples of this compromise which have survived: even the *Quarrymen* [54], for all the manic energy of the men at work, has a careless, liquid paint surface which takes the edge off not only the forms but the subject-matter. Perhaps *The Winnower* looked something like this, or like the bending boys in *Men and Women Trussing Hay*.

Was this compromise or hesitation? Perhaps a bit of both. Millet, after all, had juggled with styles in the 1840s, imitating the eighteenth century, repeating the portrait style of Chassériau, putting on paint like Diaz or Couture. He had worked his way towards one version of the classical – the dry, emphatic, organized painting which poured out of the best studios in the 1840s – and it would take time to disengage and make his own.

In the meantime his best work was often private and eccentric. Sometime in 1847 or 1848 he painted *The Shooting Stars* [VIII], a tiny picture, oddly shaped, and within that shape strangely composed; it had something to do with Dante's *Inferno* and the punishment of Paolo and Francesca, though it did not press the point (it was not even accurate, since the two in Dante are swept by the wind in 'a place void of light', with no stars in the background). In a subject like this, Millet's loose, fluid drawing suddenly has a point, for these are bodies all but released

from gravity and stretched by the wind that carries them; so does his harsh, sharp-edged lighting, since these are figures lit unnaturally, perhaps giving off light themselves. Even the way the figures interact – the man launching upwards from the woman's shoulders, with his calf muscles and heel curling round her body – is, unusually in Millet's early paintings, erotic without being coy. In other words, classical form works best when yoked to the improbable: the Millet of *The Shooting Stars* seems far away from a style to suit and yet ennoble the commonplace, or a means to force home the analogy between the cliff-face and Prometheus. In 1848 only the *Equality* drawing suggests how that might be done.

But Millet's difficulties were not simply stylistic. He had plenty of reasons to conceal his real direction, to compromise on purpose, and produce what people wanted. He was poor, and the revolution made him poorer. Later on he played a game – a shifty game – with poverty: he kept a maid at Barbizon at the same time as he applied for a State handout for the 'unfortunate'.[7] But there was no game about his finances in 1848. He had been a painter for almost fifteen years, nine of them in Paris, but he still lived in a common lodging-house – more or less a slum – with his common-law wife and bastard children, and he still had to produce quite specifically for the market. In March he painted a *Republic* and did not get a mention. In June he turned his hand to sign-painting, and was paid thirty francs. He carried a gun against the insurrection in the same month – was it with the solid, citizens of the National Guard, or the wild *Lumpenproletariat* of the Garde Mobile? – and had a hand in pulling down a barricade or two in the rue Rochechouart.[8] Later that year he did a frontispiece for a novel (one which mixed Legitimist politics with romance), aping the anonymous illustrators' style of the day and producing a neat pastiche of Gavarni and Célestin Nanteuil.

In 1851 he was still doing signs for fancy-goods shops and drawings for books about the Wild West.[9] These last were superb, as it happens; but the painter did them grumbling, much against his will. The whole of this period is a scramble for money and patrons, and Millet took almost any job that came to hand. (This makes it all the stranger that he sent no major picture to the Salons in 1849 and 1852. To miss the Salon was a disaster for a struggling painter; it was the great shop-window, the main chance for a quick sale and a sudden reputation.)

Whatever the reasons, Millet's art marked time for the first months of the Republic. Then early in July he began work on a picture for the State: he had obtained the commission through the efforts of Jeanron, and he was paid a good price, 1,800 francs. That meant the State expected a work of some importance: not a Salon showpiece, a *grande machine*, but not, certainly, a landscape or a genre study. Millet was left the choice of subject, and he chose *Hagar and Ishmael in the Desert* [55]; he may have sent in a sketch for the Ministry to approve; he was paid 600 francs on account on 14 August. As far as we know, he worked on *Hagar* throughout the winter, and the next April he wrote to claim payment:

I have finished the painting which you were good enough to commission from me; I have done it as carefully and conscientiously as I could: I must show it at the exhibition where it may be judged.[10]

He asked for the rest of his money, and said he needed it in a hurry: on 12 May he was paid 1,200 francs, and the Bureau's note of payment mentions *Hagar* by name. Thus far things are clear, but between the letter written on 30 April and the meeting of the Salon jury on 22–23 May, things went wrong. *Hagar*, in spite of what Millet had promised the Minister, and in spite of his own need for the Salon shop-window, was never sent to the jury. Instead he gave notice that he would submit two pictures, *Haymakers Resting* [57] and *Seated Peasant Girl*: the first a major work, and the second a tiny panel.

The *Haymakers Resting* never reached the exhibition; it may not have got as far as the jury.[11] Most probably it was withdrawn at the very last minute by Millet himself; just possibly, it was rejected. The evidence in any case suggests indecision, almost panic, on the painter's part. In the course of a month, Millet had abandoned the picture he had been working on as a State commission: he had decided, in spite of his need for sales, not even to show it in the Salon. He had planned instead to show his first large-scale painting of the peasantry, and then for some reason this second plan collapsed. The end of the sequence is well known. Just a week after the Salon opened, he packed his bags and left Paris for Barbizon, taking with him his family and a Republican friend, the engraver Charles Jacques.

Barbizon lies thirty miles south of the city, hidden on the northern edge of the Forest of Fontainebleau: it was the village to which Théodore Rousseau had retreated a year earlier after the June Days. That walk of thirty miles was for Millet the decisive retreat: escape from revolution, since on 13 June there had been another abortive uprising in Paris; escape from cholera, which as so often before provided the background to insurrection; escape from poverty, since Barbizon would at least be cheap; escape from a Salon fiasco, from the city and all its works.

The move to Barbizon marks a new stage in Millet's art, and with it comes the gradual crystallization of a new style and new subjects, the victory of the 'peasant painter'. But the real reversal had already happened, in Paris, in the month or two in which *Hagar* was abandoned and the *Haymakers* put in its place. We do not know why the reversal was so sudden: Sensier tells the story that Millet was persuaded to change his mind by hearing two passers-by outside the dealer Deforge's describe him as a specialist in nudes;[12] but that story is too neat, too much in tune with Sensier's legend of Millet as peasant moralist. But it must have been, certainly, a crisis, something Millet felt was decisive for his art – why else would he refuse to send *Hagar* to the Salon?

For *Hagar and Ishmael in the Desert* is not a failure. On the contrary – and this perhaps was what alarmed its maker – it is a definitive success. It closes one period in Millet's classicism, just because it abbreviates and simplifies what had gone before, discards the baggage and displays the essentials of a style. There is no more fussy larding of paint, and no more interlocking gestures. Instead there are two figures, each drawn in hard outline against a plain background of sand and sky. Both assume curious, uncomfortable poses, and Ishmael is put in abrupt perspective. The poses and the perspective are conveyed in terms of simple light and shade, and nothing breaks the sharp silhouette of woman and child; the painting works

almost entirely by a bleak contrast of figure and ground. This is classical painting as Millet's teachers in Cherbourg must have preached it – and none the worse for that. It goes back to the fountainhead of classicism, to David's sketch for *The Death of Bara*, with its fallen naked figure placed close to us, wedged against a neutral backdrop. But it combines David with an unlikely partner, Delacroix. It twists the posture of the fallen torso just enough to echo certain figures in the foreground of *Massacre at Scios*.

So far, so correct. But there is nothing correct, and nothing derivative, in the picture's most powerful device, its use of space – the way it places a second person behind Hagar's outstretched body, in the same space but hovering somewhere between foreground and background, its scale and its distance from us left un-certain. That device is used for a purpose: it makes the void of the desert, and its ambiguous distances, without having to resort to piece-by-piece description. For in the desert there is nothing to describe: no trees, no landmarks, no space-marks, simply space itself.[13] The desert is a closed backdrop, because featureless; but it is also a place of deceptive distances, spaces which appear and disappear – the space of the mirage. That presents peculiar problems for the painter, and Millet solves them brilliantly. He suggests both space and flatness with complete economy, by putting two figures together, and warping the distance between them. Once that is done, space is inferred from a few clues, a couple of horizon lines; and flat-ness (lack of 'physiognomy') is enforced by the strip of canvas – the mere distinc-tion – between Ishmael's back and Hagar's thigh.

The best use Millet made of classicism was to portray emptiness: that is appro-priate. *Hagar* was a full stop. It pared a style down to its essentials, and one could go no further that way. It was time instead to use the style on a different subject, a different world altogether. That was what the *Haymakers* tried to do.

It is easy to see that the new picture was painted around the same time, because the women's faces are not that far away from Hagar's face, and the man sprawled out in the foreground is Hagar reversed and changed in sex; one need only look at wrist and hand and forearm, and the way they are painted, to see the style persisting. (There is another source for the man on the ground: a group of harvesters in a mural Chassériau had just finished in the Cour des Comptes, with one man in much the same pose.)[14]

But what matters is the deliberate restraint of the style, the grimness of the colour, and the obstinate uncouthness of the bodies and gestures. Even before it was damaged,[15] the *Haymakers Resting* must have been a sombre picture: in the back-ground a blue-grey, empty sky, and the standing woman's blouse faintly marked with pink; apart from these, dark blues and greys and browns. Against these colours, a tight and simple composition, depending still on hard outlines – the edge of the rick against the sky, punctuated by a single pole, the black silhouette of the middle woman, the curve of the pitchfork leading to the sharp contour of the standing woman, and that culminating image of bowl and head, both simplified to wedge-shapes, in an odd symmetry. Plenty of work has been done since Millet's first sketches [56], with their ragged and over-emphatic drawing: the edges of

things have been defined, the bowl has replaced a clumsier pitcher, the whole composition has turned round. But the effect of the imagery is much the same: a kind of sullen savagery in the forms, a pastoral turned sour and taciturn.

This is the countryside as Millet saw it: his world defined before Barbizon, painted first on the banks of the Seine, in the industrial suburbs of Paris. Sensier tells us that Millet sketched for the picture at Saint-Ouën, and quotes a single comment on what he saw: 'All the women I see here are suburban; what I need is a woman of the soil.'[16] But it seems right that Millet's first peasants should be women of the suburbs, the *banlieue*, the no man's land of factories and farmland which ringed Paris in the mid-century, and which was one of the homes of the *classes dangereuses*.[17]

Millet had already painted the workers of the *banlieue*: the *Quarrymen* is a study specifically of that location, and of an industry which depended on peasant immigrants for its labour force. (The quarry workers were notorious for radical politics and violent unrest, and the quarries of Saint-Denis had been the last stronghold of the June insurgents.) But when Millet painted the *Quarrymen*, some time before 1848, he was still in search of distinctive imagery of men at work: he did not find it until *Haymakers Resting*.

If these men and women are the workers of the suburbs, neither Parisians nor natives of Barbizon, then their dour ferocity was a fact many observers had noted. Two years later, in 1851, the economist Adolphe Blanqui described the basic process thus:

The peasant, attracted by the deceptive charm of our suburbs, is, thanks to the facility of communications, little by little abandoning his village, wanting as it is in those many comforts which are stored in the towns.[18]

It did not take long for the immigrant to see he had been deceived. And everyone knew what the worker of the *banlieue* – peasant or factory-hand – was like. This is Chale's description of Port-Marly, in a piece of sociology written a few years later:

The itinerant workers who come singly and in all seasons of the years are, on the contrary, almost always driven from their homes by their vices, their wrong-doings and misconduct. It is they more than anyone who have introduced in this part of the *banlieue* those deplorable symptoms of degeneracy to which I have drawn attention in the present monograph.[19]

That is of course part fantasy, but it is a fantasy the bourgeois had in common. Once Millet reached Barbizon his imagery of the peasant went through many transformations, but its basic tone, its peculiar savage 'physiognomy', was established in *Haymakers Resting*. And the women of Saint-Ouën – in fact Millet's experience of the Parisian working class – did much to define that image, and provide its force.

There is no sudden change in Millet's art once he arrives in Barbizon. It took him years to assess his new surroundings and devise an imagery of its landscape and its people. That is not surprising: Barbizon was an outpost in a weird and alien

countryside, a closed society whose strangeness had been noted even by the officials who filled in the Government *Enquête* of 1848.[20]

For a while, Millet's imagery is retrospective:[21] the *Sower* is set in a Normandy landscape, in the hills of Gruchy; the *Men and Women Trussing Hay* and *Ruth and Boaz* are both reworkings of *Haymakers Resting*, the first softer and more delicate, the second more elaborate and organized, but in the end more brutal still. In none of these is landscape much more than a backcloth; there is no picture yet of Barbizon's open plain, strewn haphazard with discarded tools, stunted trees, ragged flocks of crows; and no imagery of Barbizon's forest, a uniform, solid screen which closes the landscape or disgorges women with wood on their backs. These images – the distinctive images of Barbizon – begin to crop up in sketches in 1850 and 1851. The great Boston drawing of faggot-gatherers is one of the first, and Millet painted a small panel of the same subject for a sale of his works in February 1851. But it is not until much later that Barbizon in particular, in detail, is the subject of Millet's main paintings for the Salon.

Barbizon in 1849 was not exactly a respite from conflict. The forest of Fontaine-bleau, like every area of woodland around Paris, had been in turmoil since the revolution.[22] It had voted for Bonaparte in December 1848, but for a Bonapartism of its own devising – its candidate for the Assembly had promised that Napoleon would smash the landlords and give the forests back to the people. In the Ile de France, the centre of agitation in 1848 was not the open farmland but the woods:

forests or woodlands in which there lives a small population of woodcutters and artisans, more or less deprived of land. Most important of all were those districts in the Paris Basin where great wheat-producing estates lay between broad areas of forest – here, in 1848, the proletariat of the woods came to reinforce the proletariat of the fields, just as they had done in 1793.[23]

Barbizon, where plain met forest, fits that description precisely.

One thing is certain: in the middle years of the nineteenth century the forest was no place to go looking for an idyll. The woodcutters and the faggot-gatherers were struggling for survival, often violently, all through this period. They were, as Chevalier puts it, the 'proletariat of the woods': men without land, who depended for their livelihood on the faggots their wives could gather from the forest, the pigs or cows they grazed on the commons at the forest edge, the gleaning rights their women got at harvest-time. Gleaning had declined from custom to concession, most often granted by now to the poorest of the poor. Balzac knew this well: 'You could glean only if you had a certificate of indigence granted by the mayor of the commune, and most important, the communes could give no one but the poor of their own parish gleaning rights on their land.'[24]

Slowly but surely many of these rights came under attack: faggot-gathering was forbidden by law, and forest guards drove off the pigs and cattle. The peasants replied with fire, or blows, or subterfuge. They hung on to existence, until they too left for the quarries and factories of Paris. And Millet's pictures, especially

those done from 1853 onwards, are a careful record of this struggle for survival, and its hopelessness. Look at the titles of the great pictures from the 1850s – The *Gleaners, The Diggers* [58], *Death and the Woodcutter, Women Gathering Faggots* [59], *Man with a Hoe, Killing the Pig, Peasant Woman Grazing her Cow*, even, in the grim sense Millet intended, *The Angelus* itself. They are, unexpectedly, a systematic description: picture by picture they indicate the key tasks and situations of this particular society. They are a portrait of a class, and a society, in dissolution. But not, for that reason, without a kind of despairing and aggressive class-consciousness of its own. The historian Georges Dupeux writes:

As for the workers of the forest, faggot-gatherers, woodcutters, and charcoal-burners, they are recruited by the owners of the forest or the timber-contractors for only a few months of the year: during the summer they look for work as day-labourers. They live a life which is both isolated and collective: isolated because they work in the woods, cut off from any contact with the population; and collective because they do the work in teams and eat their meals in common, and because the working group becomes a veritable community. In this sense the proletariat of the forest is not altogether dissimilar to the industrial proletariat.[25]

That paragraph puts Millet in a new light, and so do Dupeux's conclusions. In the prosperous years of the Second Empire, from the late 1850s onwards, the forest workers were almost the only class in the countryside not to benefit from economic progress. Everywhere else the landless peasant managed to buy a plot of ground, particularly a plot to grow vines; and gradually political unrest simmered down (the reports of Procurers and Sub-Prefects are unanimous on this). But the forests were different.

The workers of the forest could never reasonably expect to own the land which provided a living for themselves and their families; from the forest, trapped inside their old inferior status, they could see the gap between themselves and other social groups widening steadily, as the others made rapid progress. Their class-consciousness, already awakened in the Second Republic, remained acute, and their attitude at the various polls and plebiscites showed that they had kept their old convictions intact.[26]

Whether this was true in detail of the woodcutters of Fontainebleau is not clear. But it was true of many parts of France, and profoundly disturbing to the powers-that-be. Perhaps that explains why Millet's works became more unpopular as the Empire grew older: why two of his entries to the Universal Exhibition of 1855, *A Woman Burning Grass* and *A Man Binding Faggots*, were rejected by the jury; why in 1857 one critic glimpsed in the background of the *Gleaners* 'the pikes of the popular risings, and the scaffolds of 1793', why *Death and the Woodcutter* was rejected from the Salon two years later, and the critics cried in chorus against the 'solemn and melancholy cretinism' of *Woman Grazing her Cow*; why, finally, in 1861, the Baron de Nieuwerkerke himself, Directeur des Beaux-Arts, 'repeats that he does not like your painting (one would think you produced art for ruffians) and he carries his ill will as far as to decide that your two figures should be displayed somewhere in the Himalayan heights of the gallery.'[27]

In the late 1850s Millet took on Courbet's mantle. He was the Socialist trouble-maker, however much he protested the contrary. And, among other reasons for the change, there is a good historical one: in the course of a decade, Millet's subject-matter *became* dangerous, the one bone left in the gullet of the Empire, the one class not to get its pickings from the economic boom. Dumas was right – precisely right – when he wrote in 1859, 'Millet's woodcutter. . . . is not the peasant of 1660, but the proletarian of 1859.'[28]

But this has taken us far from 1849. For the rest of that year, in fact for the rest of the Second Republic, Millet moved tentatively between styles and subjects. He was still, whether he liked it or not – and there is some evidence that by 1851 he was finding it a chore – a painter of classical subjects.[29] These were the paintings Millet could sell, and he went on producing them. They become, if anything, more frankly titillating – *Nymph Riding on a Faun*, stick in hand, whacking her steed on the backside: *Nymph in the Reeds*, but not far enough to hide her charms: *Nymph Dragged along by Cupids* [60], in the process losing her cloak. These are pictures, especially the first, with a certain erotic force: not just exercises, though eminently saleable. And Millet's drawings from the nude – some, like *The Lovers* [61], perhaps as late as 1850 – have not much to do with the market. They are restrained, scrupulous, and *The Lovers* is designed like a Renaissance cameo; they reveal an artist fascinated by physical love, and capable of drawing it with a fine understatement. Later on, in the 1870s, drawings like this embarrassed the peasant painter and his serious American pupils, but in 1850 he put his nymphs in the saddle with a definite relish.

I have mentioned other sidetracks, which in fact are more than sidetracks. Some time in 1851 or 1852, Millet did several drawings of the American West, and intended to illustrate Fenimore Cooper and a *Histoire des premiers colons de l'Amérique*.[30] Again, they were done strictly for money; again, they are drawn with a care and a sense of excitement which suggest that money was not the only impulse. Compare two drawings in black chalk and pencil, both of them done perhaps in 1851 – *The American Mazeppa* [63], strapped to his horse in a forest haunted by redskins, and *The Waggon* [62], one of the first drawings in which Barbizon is drawn in detail, complete with faggot-gatherers and forest outskirts.[31] Both are drawings which almost disintegrate under the force of Millet's pencil – and perhaps of his emotion. In both, forms are crammed together as if the draughts-man wanted, once the image was started, to get everything in, to fill every inch with distinctive forms. This is something that often happens in Millet's drawing, and which he learnt to resist. If you look at his sketch-books, there are sometimes pages in which all his symbols and obsessions – crows, harrows, the screen of the forest's edge, stunted trees, spiky grass – are put together in a crazy unison, like a map or a jigsaw. Those pages tell us something of the discipline that went to make *The Angelus* or *The Man with a Hoe*.

In spite of this pressure, both drawings depend on older masters. *Mazeppa*, with its broken outlines and its splashing strokes of chalk, is Millet's homage to the painting style of Delacroix: *The Waggon* goes back further for its sources, to a

plate from Holbein's great series *The Dance of Death* [21]. It seems to take the print in which two skeletons upturn a cart on a lonely road, and imitates the format quite directly: taking the waggon and the stumbling horse, and putting in the hillside at the right; adapting the print's wild to-and-fro of line, especially in the network of poles and reins and limbs at the centre; and echoing, perhaps, the whole atmosphere of doom and dislocation.

In a sense these drawings are two versions of the same theme: and it is a theme close to the centre of Millet's art. One gives the forest the form of melodrama, and the other makes Barbizon in the image of the *danse macabre*. But both are concerned with violence, with the peculiar terror of the countryside and country people. In 1850 Millet was still ready to draw that terror directly. In his later works he tended to suppress it: there were no more redskins in the forest, and no more twisting lines and contorted postures. But there was always violence, as an undertone to plain description: Death visited the woodcutter, grass smoked like pyres in the landscape behind the Man with a Hoe: an abandoned harrow, a flock of crows or a misshapen tree stood for more than themselves, an *abstract* menace which grew more sinister as Millet grew older.

The best picture Millet painted in the period of the Republic – and his first master-piece – is *The Sower*. As far as we know, it was begun in 1850, soon after the trip to Barbizon, and it was intended from the start as a Salon picture. There are many stages to its growth: here as elsewhere Millet moved between myth and reality, went back to the Bible or to memories of his childhood landscape, took up an old theme and changed it, pushed towards an image of open violence and then painted another, more still and more constricted. *The Sower* is typical of Millet at work.

He had painted it first in 1846, on a small panel, in dull colours: at this stage the Sower was small in relation to the land all round him, viewed from above, with his body cramped and his outflung arm painted softly, almost weakly.[32] When he took up the theme again, it was probably with Matthew 13:24–43 in mind. Some time after 1848 – we cannot be sure whether it was before or after the painting for the Salon – he did a sketch of the *Devil Sowing*, as if to fix the allegory on paper (or rather, the *explanation* of the parable, which Jesus gave with such marked reluctance).

The field is the world; the good seed are the children of the kingdom; but the tares are the children of the wicked one;
 The enemy that sowed them is the devil; the harvest is the end of the world; and the reapers are the angels.

Not that the drawing itself is apocalyptic: on the contrary, it is intimate, almost humorous. All the grimness of Christ's interpretation, all its millennial atmosphere, are transferred instead to the first of the two 1850 versions [64]. Here the Sower dominates the picture space, head and shoulders breaking the skyline, the legs splayed further apart and the body leaning backwards; the throwing shoulder braced upwards, and the arm now definite, foreshortened with a clenched fist,

III HONORÉ DAUMIER *The Republic* 1848

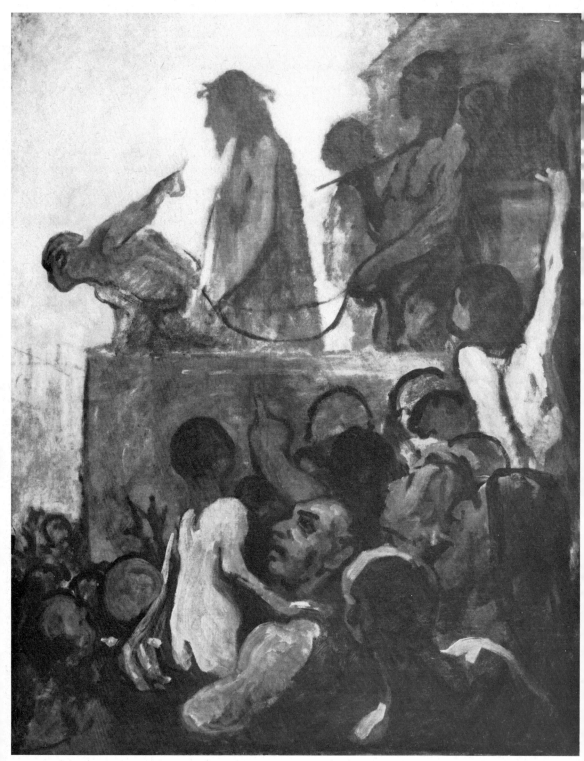

IV HONORÉ DAUMIER *We want Barrabas . . .* c.1850

50 Jean-François Millet
Woman Carding Wool c. 1855

51 Jean-François Millet
Men and Women Trussing Hay c. 1849–50

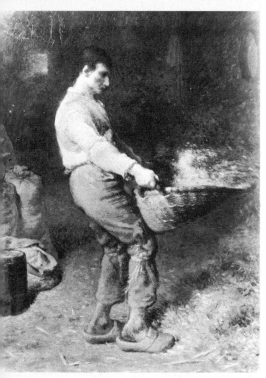

52 Jean-François Millet *Man with a Hoe* 1859–62

53 Jean-François Millet *The Winnower* c. 1848

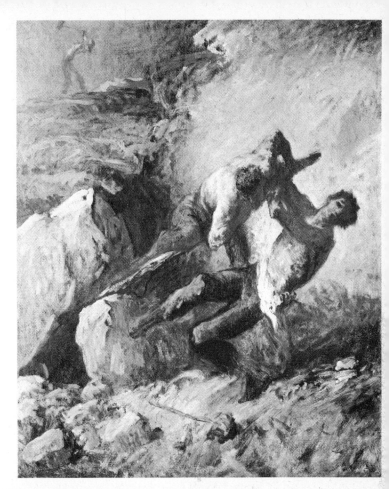

54 JEAN-FRANÇOIS MILLET
The Quarrymen c. 1846

55 JEAN-FRANÇOIS MILLET
Hagar and Ishmael in the Desert 1848–49

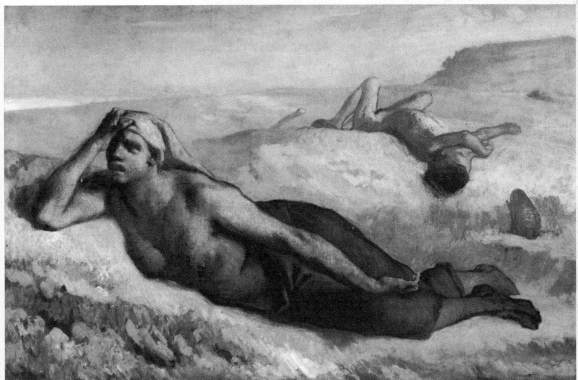

56 JEAN-FRANÇOIS MILLET
Sheet of Studies including a
Haymakers Resting *c.* 1849

57 JEAN-FRANÇOIS MILLET
Haymakers Resting 1849

58 After JEAN-FRANÇOIS MILLET *The Diggers c.* 1855

59 JEAN-FRANÇOIS MILLET *Women Gathering Faggots* 1850–51

60 JEAN-FRANÇOIS MILLET
Nymph Dragged along by Cupids 1851

61 JEAN-FRANÇOIS MILLET *The Lovers* c. 1846–50

62 JEAN-FRANÇOIS MILLET
The Waggon c. 1851

63 JEAN-FRANÇOIS MILLET
The American Mazeppa c. 1851

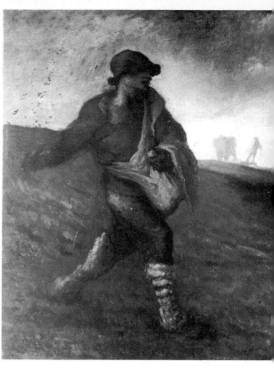

64 JEAN-FRANÇOIS MILLET *The Sower* c. 1849–50

65 JEAN-FRANÇOIS MILLET *The Sower* 1850

66 JEAN-FRANÇOIS MILLET Sketch for *Ruth and Boaz* later called *Harvesters' Meal* 1851–52

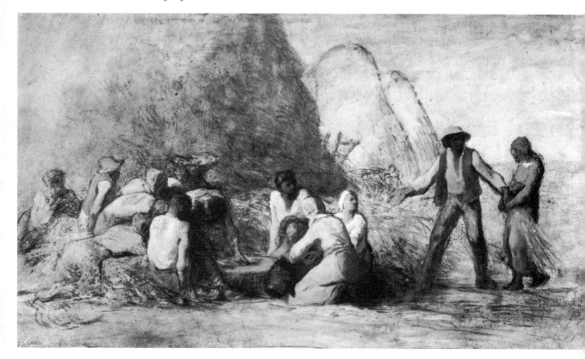

sharply painted. This is a Sower not just from Christ's apocalypse, but more specifically from Michelangelo. It is an image of complete brutality, the shaded face and the skull-like cap carrying on, to an extreme, the imagery Millet had first tried in *Haymakers Resting*. It is also an image of assertion, of a body which lurches forward down the hillside, and a fist from which the flock of crows seems to explode like black grain.

He finished it, but he did not send it to the Salon. Why not is still uncertain: Sensier said he found the image too crowded, with the hand touching the edge of the frame (but is the hand that close to the edge? and why was the picture brought to a conclusion if the fault was so obvious? why, later, was it sold?). In 1850 there were plenty of other reasons for trepidation. Some critics, when a corrected version was shown later in the Salon, found that provocative and socialistic: who knows what they would have said to the painting which stayed in Barbizon? Who knows if the Government would have provided more money, more commissions? Millet needed both, and he was well aware of the State's and the market's sensibility. When he wrote to Sensier in February 1851, describing in the simplest terms his preference for the human aspects of art, he knew he did so 'at the risk of being considered even more of a Socialist'.33 Another year or two, and he would allow himself sarcasm on the subject, at least in private.

Here is the drawing for the secretary of the Directeur des Beaux-Arts. I don't think this composition could be found to be fiercely demagogic, although, all things considered, an old sock might give off very popular odours. You will let me know your opinion.34

Whatever the reasons, Millet prepared another version: doing first a large drawing, then a full-size sketch where the new outlines were tested and established: then the Salon painting itself [65].35 Putting the two versions side by side, we can see that Millet moved back towards the image of 1846: he tried to contain the energy, the continuous contours, of the painting he had just done, and reinstate something of the first panel's awkwardness. The figure is less sculptural, and the pose becomes once again more constricted, difficult. The shoulder no longer juts upward, the body is more upright but more insubstantial because of it; the throwing arm is lower, scattering the grain in a smaller arc, and the back leg no longer kicks into the earth with such force. All these changes are minor ones, but together they change the weight of the image. And inside the contours of the figure, everything is altered in the same direction. Where in the first picture the parts cohered, the bag of grain seeming to join in the forward movement, now they are heavy, separate, painted in a flatter and more abbreviated way. The man stands more towards the centre of the canvas, moving neither forward nor back, the horizon line is altered, and even the crows seem slightly softer and more dispersed, balanced now more clearly by two oxen on the right.

What this adds up to is a more constrained and static figure: a less coherent image than the first, but one which is closer to labour as Millet conceived it. The sower's gesture is finally cramped and automatic: it combines weakness with the shadow of assertion: it does not operate on the world. In the first version

the peasant thrusts across the picture, and the land; the crows seem his creation. In the final image, this is somehow altered, neutralized: the lie of the land and the particular line of the horizon contradict the figure, and his motion is not mimicked in the brushwork, or echoed in the distance.

In other words, in this second *Sower* figure and ground do not answer each other. Later in life, in the landscapes of *The Angelus* or *Man with a Hoe*, he paints an environment which corresponds to the men and women in the foreground – but there is no traffic between them. The diggers do not change the land, they turn the topsoil over and wait. (Trees, Millet once remarked, are like people who 'don't speak the same language'.)[36] If men and landscape are connected, then we feel at most that the men have assumed the forms of nature, unchangeable, animal, unconscious. And the making of *The Sower* seems to have crystallized that notion of work.

When it reached the Salon, along with *Men and Women Trussing Hay*, the picture got a mixed reception. Part of the matter was politics, and reaction to *The Sower* followed political lines: papers of the Left and Centre were charitable, papers of the Right were angry and embittered.[37] (Twelve critics wrote in Millet's favour, six disapproved, one sat on the fence. Compared with Courbet, this was a good press but poor coverage; many writers never gave Millet a mention.)

What did they like, and what did they hate, about *The Sower*? The question is difficult to answer. Almost everyone was critical of Millet's technique, of his exaggerated *empâtements* of paint, of a drawing which they found soft and indecisive. (Mantz alone admired the paint handling: it reminded him of Decamps.) For most critics this was a pity, but it did not spoil the picture altogether. For some, like Geofroy and Delécluze, it was their main reason for ruling the picture out of court: technical failures deserved only a few lines.

Almost everyone – those who liked the picture and those who despised it – recognized its savagery. 'A savagery that makes an impression', said a critic of the Centre; 'an ingenious savagery', said a critic of the Left.[38] The violence of the image was perfectly visible, and many writers found words to describe it.

Why this crudity, why all these black tints and monochromes? Wherever has M. Millet encountered such a vicious-looking labourer, such a dark sky, or such a desolate landscape at seed-time?[39]

And certain critics, even those who regarded *The Sower* as heroic or beautiful, had an eye for the sinister detail.

Alone, in the middle of bare and newly turned ground, as if he understood the grandeur of his mission . . . this man who, like a minister of God, holds in his hands the riches of the earth, and with the faith of an apostle throws them to the wind; and then, in the distance, under that cloud, a flock of birds of prey, whose screech is like an irony, a threat.[40]

The odd thing was – and this passage illustrates the point perfectly – that the violence and grimness of Millet's picture seemed to the critics a kind of optional extra. They were *there*, they were in a sense disagreeable, but they need not disturb

the even tenor of the critic's style. It was possible to see them as an oversight, a momentary lapse of taste – and pass on to the poetry of nature. For most critics, *The Sower* was a pastoral image, which altered but did not discard the pastoral tradition. Most critics described it in these terms; only the men of far Right and Left were obliged to react to its savagery, and strive for a reading in terms of politics. (In this respect the reaction to Courbet is quite different. Only a very few critics stuck to the pastoral reading of Courbet; and men of every political persuasion, including the aesthetes or the writers of the Moderate Centre, were forced into an account that mixed political and aesthetic language.) One hostile critic sneered at Millet's 'Socialism':

But why does M. Millet give us these wan, sickly, miserable workers? Look what he lets himself in for! In their compromising admiration, certain critics have gone so far as to see in the work of M. Millet the personification of the modern proletariat: predictably enough, they have discovered it to be a protest. And there they go, trotting out the old democratic commonplaces about *Men and Women Trussing Hay*. Poor M. Millet! He only wanted to create something fanciful, and now he's convicted of Socialism. Such cruel punishment disarms our severity.[41]

He was telling, deliberately, less than the truth. The fact was that only one critic, Sabatier-Ungher, invoked the proletariat; and only one other, Rochéry in *La Politique nouvelle*, mentioned the social problem even indirectly. The typical phrases about *The Sower* – I have chosen them from critics on every point of the political spectrum – are these: 'the poetic truth of nature', 'an energetic and well-animated study', 'the grandeur and style of this figure with its violent gesture', 'the melancholy aspect of rustic labour'.[42] 'How greatly I prefer', wrote Philippe de Chennevières, 'his Sower to Courbet's peasants! And in this great farm-lad, painted in thick impasto, what beauty, poetry and grace!' Or, a Left-wing variation on the same theme by Rochéry: 'M. Millet's picture is certainly painted from life, like M. Courbet's, but one can sense greater spontaneity and depth in the painter's impressions, a truer love of country life and country people.'[43]

There were critics who exploded.[44] One of them, the anonymous 'N.' of *Indépendance belge*, thought Millet as bad as Courbet: at least Courbet fixed his contours, and did what he thought ('the things are there, ugly and repulsive as they are'). Millet was different: 'he applies the sloppy, indecisive style – the *fluffy* style, to use the current slang – to all sorts of scum whom he calls peasants.'[45] But N. was in any case a natural hysteric; his language and his anger are not typical of the reaction to *The Sower*. Most critics saved their epithets for Courbet's *Burial at Ornans*.

The question is: why were the critics so gentle? Or rather, why did the savagery not annoy them more? There is no single answer to this. But part of the explanation is obvious. *The Sower*, especially when it was accompanied by *Men and Women Trussing Hay*, repeated the commonplace imagery of the pastoral, though it gave it a brutal turn for the worse. And where the tradition survived, the critics saw the tradition more easily than its transformation. They compared Millet

with George Sand, and praised the frankness and honesty of both.[46] The painter had done a new version of pastoral, but poetic and naive nonetheless. And this manœuvre was easier for the critics because Millet still obeyed most of the rules of their aesthetic.

Why did the critics think he aimed at movement and expression, when *The Sower* seems to us an image which effaces both – especially in its final version? They *were* obtuse, no doubt of that; not one of them sensed strain or constraint in the sower's gesture, or even appreciated the picture's deadpan. (The best they could do was this, from La Fizelière: 'There is, in the very bitterness of the execution, a kind of abrupt, nervous style, which conveys the feeling of labour and poverty.'[47] The words 'abrupt' and 'nervous' seem well chosen.) But they had excuses. After all, Millet had not jettisoned the basic tricks of the trade; it was just about accurate, if stupid, to admire 'the breadth of his drawing and the immensity of the space'.[48] Accurate because something of both remained, stupid because so much of both had been abandoned, and the question was *why*. According to Pierre Petroz – but he was looking at the *Men and Women Trussing Hay*, and what he says makes more sense about that picture – Millet could actually give lessons in perspective to 'our modern makers of clumsy painted screens'. (Who does he mean, Gérôme or Courbet?) Millet's figures are 'shrouded in the distant vapours of the horizon'; he is a master, in the words of another critic, Dauger, of a '*mise en scène* which pushes back his characters and keeps them at a decent distance'.[49] Compared with Courbet, this is true. Even *The Sower* has light and shade, the normal clues for space and atmosphere: sloping field, vague horizon, foreshortened limbs, twisting body. The connoisseur is still in the world he understands; he has plenty of difficulties to play with.

For us, *The Sower* stands at the end of this order of things. There is not much space, and what there is is vague and perfunctory; the drawing is deliberately awkward, and the man is half-flattened into sections on the canvas surface; the paint is not thick in order to emphasize solids and highlights, on the contrary it is dark and uniform, made up of a palette of 'two or three tones, coal-black and dirty'.[50] Deliquescent, one malicious critic called it,[51] which is a fine word for Millet's paint at this time. All these things add up to an ending, a closure. A painter is stifling the old devices, slowly but surely. But where there are straws to clutch at – shadows, literal or otherwise, of the great tradition – critics will clutch with the best of them. When Courbet hangs in the next room, even *The Sower* is reassuring. Call it savage or exaggerated, but read it in the old way: it aims at the things we critics understand, and the populace does not. The critic need not feel – as he came to feel in front of the *Burial at Ornans* – that the picture makes fun of his basic assumptions; that it uses a different language, and speaks to somebody else.

Millet was not subversive yet. But in the space of the Republic, he had almost discovered a style and a subject-matter. By 1851, when his oil panel *Going to Work* was done, and the great canvas of *Ruth and Boaz* pushed on towards completion, he was already able 'to use the trivial to express the sublime: that is the true power'.

Ruth and Boaz still displays the effort involved, but *Going to Work* [VI], which he did for sale in February, is somehow effortless, resolved: the work of a painter in command of his resources. It is a painting which manages, in Millet's particular way, to be brutal *and* delicate. Look at the contrast of woman and man: on one hand the nervous, broken edge of the man's hat and profile, sharp chin, pursed lips, fine nose; on the other the swollen, stolid outlines of the woman, her head shaded and pulled out of shape by the basket she wears as a hat, her breasts and thighs thickened by a bag which hangs down from her far shoulder. They are opposites, and complementaries: the pitchfork, which has antennae rather than prongs, stands as the sexual counterpart of the woman's pannier. They are held in by a fine-drawn line, an edge to things which Millet sometimes puts down in brown oil-paint – along the back edge of the man's leg, along the woman's sleeves. It is a painting which depends on drawing and outline for its main effect, but which uses colour with extraordinary sureness: it avoids richness, and suits the pigment to the task in hand. (As Van Gogh wrote later, Millet's peasants seem painted with the earth they till. But an earth with many colours besides brown.) The sky moves from a muted blue-green to a white tinged with green and grey, then finally to a blue above the horizon. The earth is scumbled black and brown, then lighter brown below, mixed with green and relieved by a few touches of ochre towards the edges of the figures. It is an image where tense drawing and sombre colour are held precisely in balance: where Millet avoids the picturesque, and yet avoids also any 'monotonous ugliness', any of what Baudelaire calls his 'melancholic, Raphaelesque pretentiousness'. This is instead – to use a later, juster comment Baudelaire made on *Man with a Hoe* – an image of 'La Bruyère's beast of burden, his head bent towards the earth'.[52]

In *Ruth and Boaz* – what I show is a sketch towards the final painting [66], which Millet worked on late in 1851 – the fight for that image still goes on. Almost always it involves a move towards the particular, away from the approximate sublime. Often it means putting things in opposition that started off in harmony – man and landscape, line and colour, even the handling of man and woman. It means making the appearance of inevitability: the sense that these are people 'destined to their station in life' and that 'it is impossible to imagine they should ever have the idea of being anything except what they are'.[53] (That formula corrects an earlier remark that Millet made to Thoré, that it should be impossible for *us* to think of them otherwise.[54] But we can see oppression, even if they cannot. Perhaps we are shown it, and expected to react.)

It involves keeping anonymous gestures in tension with actual faces, different cuts of crude cloth. Model the groups, as Millet did in *Ruth and Boaz*, on Michelangelo or Poussin; but work towards a final threatening awkwardness of form – a form which intimates, in spite of Millet's ideology, peasant resentment as well as peasant fatalism.

That took time. Millet had nothing ready for the Salon of 1852; whether due to eye failure or dissatisfaction we do not know. *Ruth and Boaz* took a further year to paint; in the process it lost its biblical title, and gained a clumsier, more distinct

physiognomy. It marks the point where classicism is finally assimilated, and Millet's Realism is fully fledged. That Realism, as he later explained to Sensier, would be different from Courbet's.[55] It would have a narrower focus; it would centre on an intense, almost at times a lunatic, desire to reinvent the force of the Bible's phrase: 'In the sweat of thy face shalt thou eat bread.'

That was Millet's favourite quotation, and his art is formed to illustrate it over and over again. In the same letter as he defines his Realism, he tells a lie about his own life – and that too is typical. He boasts that he remained a labourer till he was twenty-one; that he knew the Bible's dictum at first hand. In fact he was the son of a wealthy peasant farmer, and at eighteen he was sent off to Cherbourg to study art. So whether Millet's art was a compensatory myth – whether he tried to redefine a peasant status he had lost, or never had; whether it was a way to forget the actual context of his poverty, the long years of painting nudes for the market and feeding bastards in a Paris slum – that is an open question. The strength of his art, in any case, came in the tension of the tragic and the ordinary; and the sense of both was something Millet learned, by hard work. He was more literary that he pretended, but he was also more specific in his references. He painted in the shadow of Virgil or La Bruyère; but also in the shadow of the forest guard and the 'certificate of indigence'. His peasant was the farmer of the *Georgics*, but also 'the proletarian of 1860', or the peasant in the *banlieue* in the spring of 1849.

4 Daumier

'We feel that Daumier reproduces admirably the particular life that he sees because it is the very medium in which he moves. He has no wide horizon; the absolute bourgeois hems him in, and he is a bourgeois himself without poetic ironies, to whom a big cracked mirror is given. His thick, strong, manly touch stands, in every way, for so much knowledge.'

Henry James: *Daumier, Caricaturist*.[1]

Like many others, Daumier was prepared for the 1848 revolution. Writing home to his mother on 30 June 1847, Champfleury reported Daumier's views thus:

Everyone is uneasy; no one believes in the Government, not even those who have made good use of it. I can't be certain, but there is revolution in the air; if the winter of 1848 is as terrible as the last, we'll be in for trouble.

It's not the *People* you should be afraid of: if *they* revolt, they will be gunned down soon enough. But I was chatting on Sunday with one of the strongest men of the day—this may surprise you, but it was Daumier, a caricaturist—and he said that the rue Saint-Denis is not happy. If the bourgeoisie are mixed up in it, things are serious – for in our time the bourgeoisie is the new royalty.[2]

That was accurate analysis, and accurate prediction – about the bourgeois and the people. It is one of the few times we hear Daumier speaking of politics, or speaking at all; he did not say things for posterity. The politics is in the lithographs, and then only from time to time, when the regime permitted, or when Daumier's line agreed with *Charivari*'s.[3] When one or other did not, he drew other subjects, or what he drew was not published. About the June Days, for example, he said nothing, while the rest of *Charivari* chorused about criminals and scum. Only, two days after the insurrection, he published a lithograph of two crabbed, rather dilapidated bourgeois, talking in an empty, sunlit street – 'Railway shareholders talking dividends'.[4] (The proposal to nationalize the railways had been due for discussion on 22 June; the attack in the Assembly on the National Workshops was to have led on to the debate on the railways, and the triumph of free enterprise in the final vote. Now that was no longer necessary. The June Days had killed nationalization stone dead.) And one week later, another lithograph on the same theme [68]: three sleeker, more fashionable bourgeois consulting their newspaper with quiet smugness:

'Everyone told the Government to get a move on, so naturally they had the idea of taking over all the railways! . . .'
'That was wanting to go too fast!'[5]

A gentle joke, but the bellies and the raised eyebrows of the bourgeois are enough. This was as close to comment on the June Days – the new royalty and their quickness on the draw – as *Charivari* would allow.

For the most part, Daumier chose silence, or allowed himself the occasional gesture: refusing the cross of the Legion of Honour from Napoleon in 1870, but even that in secret; shouting, uncharacteristically, at his wife and child in the street when they wished to watch the Emperor pass by; sitting on the Arts Committee of the Commune.[6] If he was given his head, allowed in certain circumstances to draw what he wanted, the gentle Daumier was most often an extremist; the fact embarrassed the Realist novelist and critic Champfleury when he came to write Daumier's history.

I have before me a print from *La Caricature*, so provocative that it makes one shudder, for art can give force to the most lying accusations. . . . Never was Daumier's crayon more sinister. He responded to the virulent passions of the moment by making the High Court of Justice an assembly of inquisitors and hangmen.

For myself, I will have no part of caricature which is hateful and poisonous. . . . Law, majority, force, Government: they had to be accused of every crime in the book, and a young artist acted as the instrument of political passions, for he could put down what the most vicious pens could not fix on paper – with his crayon he drew things more sharply still.[7]

That seems to me an honest reaction, if a disagreeable one. The lithograph in question is captioned 'You have the floor: explain yourself; you're free.' [67] And it still arouses anger and hatred, one way or the other. It is still 'unfair', 'indefensible'; like some of the best caricature, it does not describe, but instead discharges emotion. It is not accurate. It is a reply to Power – 'law, majority, force, Government' – in its own terms, appalling and cynical; 'something more', to quote the Press Laws which put a stop to it a year later, 'than the expression of opinion; it is an incitement to action not covered by article 7'.[8]

Daumier's politics – perhaps the whole of Daumier's art – had a simple basis. He was the son of a glass-maker from Marseilles. His father, Jean-Baptiste Daumier, wrote verse in the classical style, published a volume or two, came to Paris in search of his fortune, and did not find it. By 1830 he was out of work, and Daumier was the family's only support;[9] three years later he left home to live with fellow artists in the Rue Saint-Denis.[10] Perhaps his father returned to his trade, perhaps he still lived off his son. Whatever he did, he was mad by 1850; he was committed that year to the asylum at Charenton, and a few months later he died.

The life of Jean-Baptiste Daumier is, in a way, a typical one: typical of what happened to the artisan class as a whole in the early nineteenth century.[11] The artisan identity – proud, literate and often literary, certainly well-read; living inside a tight-knit community, with the world defined by one's trade and fellow tradesmen; radical, at times revolutionary – all this was in process of dissolution. The artisans were the first and most bitter victims of industrialization. They were the first proletariat, the leaders on the barricade (master or man, in many trades

it hardly mattered by this time; they went out together to fight the established order). And their anger was greater because they lost more than a job; they lost status, the respect paid them for a precious skill; they lost a whole culture of their own. Many more than Jean-Baptiste ended in the asylum or the workhouse; destitute, or bewildered, it was all one.

Daumier's attitude to this process is clear. He was the son of an artisan, and for a living he produced prints for mass production: lithography, even more than the photograph, was the first step in industrializing the arts, the beginning of the age of mechanical reproduction. Working the stone, he was not quite an artist any longer, and not quite a worker. So he would remain an artisan: he would cling to the identity that his father lost. In 1842 or thereabouts, he began living with Marie-Alexandrine Dassy, daughter of another glass-maker, seamstress by trade. In 1846 he married her, and began a private and tranquil married life. It was the end of experiment, of chafing at the family bit: in the 1830s he had tried the artists' community, the Bohemian life; he had even half-welcomed prison as a relief from existence 'chez mon papa'. In 1841 he was in debt, and his furniture was seized by the bailiffs.[12] But by the middle 1840s that was past, and 'the idea of my interior, that is to say my family' (a phrase used in a letter from prison in 1832) had finally won. It seems as if he reproduced, almost deliberately, the conditions of an artisan identity – marrying within his father's trade, staying poor but working doggedly, moving in the early 1840s to the Ile Saint-Louis.

That last move was a curious one, with contradictory implications. On the Quai d'Anjou, where Daumier lived for the next twenty years, there were still a few well-to-do families; and, for a few years in the mid-1840s, there were Baudelaire, Boissard and the Club des Haschischins. But that did not last long, and in any case it was only part of the story (and perhaps not the part which interested Daumier: in 1845 he did a lithograph on the hashish smokers;[13] that was his only comment on the whole business). There was another invasion of the Ile Saint-Louis, parallel to the Haschischins, but more pervasive and more permanent. Since the early 1830s the island had been invaded by workers from the slums around it. 'The bad element of the population,' wrote one disgusted commentator in 1843, 'forced out by demolitions in the Cité and around the Hôtel de Ville, is . . . replacing a less wretched population which is leaving the area.'[14] By mid-century the island had become just one more section of the notorious 9th Arrondissement: 'in all the other Arrondissements there are at least a few big fortunes, in the 9th there are none.'[15] On the quays, a few grand houses, a glimpse of the countryside beyond; for the rest, small shops and slum tenements, swarming with disease and crime.

So Henry James was right to put the stress on knowledge. Living on the Ile Saint-Louis did two things for Daumier. It put him in the middle of Paris; and not just any Paris, but at the heart of the proletarian city, the 'black centre' from which the bourgeoisie had fled in the 1830s and 1840s. He kept his contacts with the middle class – he was still in 1847 Champfleury's best informant on the mood of the rue Saint-Denis – but lived cheek by jowl with the mauvaises populations.

And yet the island gave him something else: as well as contact, a kind of detach-ment. It gave him space to preserve his artisan identity and keep at bay the 'world of art'. There were other artists living in neighbouring streets on the island, but every visitor recorded Daumier's privacy, the humdrum domesticity and the drudgery to meet *Charivari*'s next deadline. (Only a few unlikely friends got further than a token visit. When Daumier was ill in 1858, Baudelaire kept Madame Daumier company, sitting long hours and chatting with the glass-maker's daughter.) The Ile Saint-Louis was a hiding-place and a point of vantage; it suited him precisely.

I think that Daumier needed both these things: a place to hide as well as to see from, in close-up: detachment just as much as contact. James is wrong to call Daumier simply a part of the world he drew, a bourgeois talking to his peers. If he had been a bourgeois, perhaps the great cracked mirror would never have been given him. It is Daumier's equivocation that counts – the physical immersion in the life of the Paris streets, yet the social isolation, jealously guarded. It is the way Daumier is neither worker nor bourgeois, but in sight of both, with a detachment that has nothing to do with objectivity. (Daumier, we have seen, is partisan. But with him taking sides does not mean losing sight of the enemy. Daumier loves, and despises, the lawyer and the shopkeeper.) If he had not been an artisan – or pretended to be, or played at being – perhaps James's 'absolute bourgeois' would have hemmed him in, and made the rest invisible. But Daumier saw other things besides the Paris of the middle class.

What, after all, is the hallmark of Daumier's art? It is, perhaps, the amount he knows and knows how to represent. It is the ability to paint the crowd in the third-class carriage as well as the draper's bed-chamber. It is the range of vision, the knowledge of so many different styles of life. (The vision is not quite compre-hensive. Daumier is the opposite of the Prince in James's *Golden Bowl*: above a certain level it is as if he could not see. Apart from the paintings of connoisseurs he drew almost nothing of fashionable Paris and the world of the *haute bourgeoisie*. He left that part of modern life to Constantin Guys.)

This range of vision is rare at any time and most of all in the nineteenth century. The life of the Paris streets was increasingly what everyone saw but almost no one could find forms for. The case is clearest in the notebooks of David d'Angers. Day after day one reads notations like the following:

I have just seen, in the rue de Varenne, a kitchen-maid throwing on to a rubbish heap, at the door of a big house, a few fragments of bone, with some meat still on them. A dog got possession of this repast, and a poor man with wild-looking eyes seemed to covet his meal – there was a risk of his starting a terrible fight with the dog, which seemed a savage kind of animal. But some small change from me put an end to this envy.[16]

David d'Angers could not draw or sculpt any of this. He went on producing delicate cameos of friends, and deploring the violence of Rude's *Marseillaise*. For the Paris of his notebooks, shamefaced charity and all, there were no forms on hand. That stayed true for most of the century; painters avoided the streets because

life there was unpaintable. The Impressionists recorded the boulevards from a distance, as another form of landscape; the crowd stayed out of focus except when it took its pleasures, at Argenteuil or Asnières.

Yet Daumier was different. He could have drawn the scene from David's notebooks: look at the savagery of *The Soup* [70] for comparison, or the grimness of the faces gathered to listen to two street-singers in the dusk [92]. Because Daumier does it so plainly, without rhetoric or protest, it is easy to forget how rare such painting is. It is the matter-of-factness that needs explaining. And part of the explanation is Daumier's situation, in space and the social hierarchy: the way he moved between classes; the way he clung to an out-of-date identity, living in the interstices of the new social order; the first-hand knowledge he had of those invaders from the slums around the Hôtel de Ville.

After the revolution, we know almost nothing of Daumier's life. We know he was already painting: Gautier in his 1849 Salon mentions a painting of wrestlers that he had seen long ago in Daumier's studio.[17] And we know he shared the common resentment against the Salon jury: in 1847 he lent his name to a plan for secession and independent exhibitions, which was forestalled by the revolution. He kept in touch with the efforts at a new organization for the arts; in October 1848 Decamps invited him to meetings of the 'committee of the section of painting'. And he kept in touch with politics: one of his studies for *The Family on the Barricade* has a student paper, *L'Avant-garde, journal des Ecoles* – one of the voices of the Left opposition – pasted on the back.[18] Baudelaire was in contact with him; so was Champfleury, who dedicated *Les Excentriques* to Daumier in 1851, 'to you who, in a few free strokes of the crayon, give eternal life to those beings whom future historians will consult with joy, to discover the bourgeois exterior of our century'.[19] Bonvin and Courbet persuaded him to enter for the Republic contest, and he owned – perhaps already? – Courbet's charcoal *Man with Pipe*.[20] Like a good husband he sent his wife on holiday, away from the cholera, in 1849. He had visits from Delacroix, more dramatic ones from the historian Jules Michelet – tears, homage, plans to collaborate on a History of France.[21] Michelet went on his knees before Daumier's *Ratapoil* and told him he had done more for Republicanism with that one invention than the rest of the politicians put together. He wanted him to illustrate a new Republican history, but the plan never came to anything.

These are scraps, hints, clues to a life, which do not add up, and were not meant to. One cannot imagine Daumier keeping a journal, even writing a letter (as opposed to a note).

But from the lithographs, and the great paintings which began in earnest after 1848, some things can be surmised. Daumier, now he could draw politics again, was for the most part profoundly uneasy: in the next four years he would cast about, uncertainly, for targets and for heroes. Eventually he found his target, but heroes – even symbols of what should be fought for – were lacking.

He began in March with a single week of plain rejoicing: three lithographs,

The Paris Urchin, All is Lost and *The Last Council*,[22] which welcome the Republic and say good-bye to Louis-Philippe: all three – in contrast to the work Daumier had done in the months before the revolution – drawn fast, in a free, confident style. In the late 40s, most of Daumier's prints had been done within an uneven oval; for these three lithographs he draws right to the four corners, using every square inch of the stone; marking his spaces by an upturned chair, some steps to the throne, or the end of a gang-plank; putting in sharp verticals, and drawing his figures, especially their clothes and faces, with an abbreviating force. These are drawings done in haste, but with complete certainty; the lines emphatic and broken, but put precisely where they do the most work. Look at the kicking slippers of the urchin, one framing a woman's face, the other intersecting the black sleeve of the guardsman: both shapes are almost lost in the *mêlée*, but not quite. This is the kind of drawing Baudelaire had in mind when he wrote that 'what distinguishes Daumier is certitude'. (It is not, incidentally, Daumier's only drawing style. He knows how to hesitate in line, how to offset various readings of a face or a gesture, one against the other, within a single image.)

After the cartoons in March 1848, there was no more direct political comment until the first attacks on Napoleon at the very end of November. Perhaps Daumier did draw political cartoons, and perhaps *Charivari* turned them down: Baudelaire describes a lithograph on the Rouen massacre which was almost certainly not published.[23] Whatever the reasons – censorship, or uncertainty as 1848 went its erratic course – Daumier compromised. From April to June he drew a series called *Alarmists*, a kind of political reworking of his earlier scenes of bourgeois life.[24] In the *Alarmists*, worthy citizens take fright at a crowd of children marching in the street [69], at the falling share-prices, a knock at the door, the rising price of fish; or simply, in the best of all, at something which is not explained or even represented, something outside the frame, in our direction, towards which a woman casts a last glance as she runs off.[25]

In August, with Cavaignac watching the press, Daumier took up another old theme, the follies of the feminists. The prints he did of *Les Divorceuses* [71], from August to October, are brilliant and unjust.[26] The best of them is the first, where once again the whole of the space is active, organized by the sloping banister and the simple division of background into two areas of black and white: orator's hand, vivid white on black; chairman's bell, ineffectual grey on white. Daumier's drawing, as Baudelaire said, 'is naturally coloured . . . His crayon contains something else besides black to mark in contours'.[27] On the question of feminism – and remember, as the series title suggests, that the major demand of these women was simply for a divorce law – Daumier could feel at ease. It was the one issue where he was as reactionary as his newspaper, and his public. Early in 1849, a last lithograph celebrated Proudhon's refusal to admit women to the Socialist banquets; though one senses here, in the splendid drawing of the crestfallen ladies, that even Daumier is in two minds about who is laughable.

As for the worker, he appears seldom in the Second Republic; though when he does, Daumier's tone is as pointed as ever, his loyalties as obvious as before.

Some time in 1848 he did a lithograph of two men – perhaps one is a petty bour-geois, in battered top hat and frock-coat, perhaps the other, in shirt and Guard's hat, is a worker – consulting the Republic's proclamations stuck on a wall.[28] About the same time, he drew another with the contrast more explicit. A worker in cap and smock strides towards us, absorbed in reading a newspaper as he walks. By his side stands a bourgeois, belly in profile, gazing reflectively at the grapes and marrows in a shop window, his face intent, smiling, innocent.[29] This is, as James said of another bourgeois, 'as near as Daumier often comes to positive gentleness of humour'.[30] It is also as near as he comes – at least in the Second Republic – to a simple contrast of the classes, the worker devouring politics, the bourgeois minding his stomach. There is nothing mean in the contrast, no trace of anger or contempt. But the comparison itself was perhaps too much for 1848: the lithograph was never published.

After 1849, when Louis-Napoleon was President and the Assembly swung further and further to the right, Daumier's position was different. *Charivari* was an opposition paper once again: against the Catholic reactionaries, against the inroads made into universal suffrage, against Louis-Napoleon's ambitions. The paper gave Daumier his head. He took his opportunities, and in the end produced some of his greatest work; but he did so *slowly*, hesitantly, in an uncharacteristic way.

Typically, Daumier's political cartooning came in sudden, uninterrupted bursts of energy – a year or two when image followed image, all cohering round a single theme, each reinforcing the next, all done with an equal energy and con-viction. The great examples are the series against the July Monarchy in 1834 and 1835, and the cartoons on War and Empire in 1870 and 1871. In the Second Republic things were different. Daumier marked time in 1849: he drew a series of portraits called *The Representatives Represented*, which, by his own standards, are hack work, mechanically done. He did a few political cartoons, jibing at Bona-parte, at Hugo's useless international Peace Congress, at the phoney excitements in the Assembly. He was in search of targets, in search of a symbol. And also, perhaps, in search of a cause to support – a symbol of his own Republic, to put against the various counterfeits.

In 1850 he found his target. He invented Ratapoil, and began to sculpt and draw him: the great Napoleonic hustler, the 'hand-to-mouth demagogue, with the smashed tall hat',[31] old soldier, ex-crook, the man who led the cheers, bought the votes, beat up the opponents of the Emperor. Ratapoil was a great creation; when we look at the sculpture we shall see how great. But even *his* presence does not necessarily mean success: he is not, like the Pear-King (Louis-Philippe), or the swindler Robert Macaire, an image which gains force and associations print by print. At their best, the prints of Ratapoil are as fine as any Daumier did. The best are the simplest: Ratapoil and his henchman Casmajou [72] bemoaning the ingratitude of governments, their rags flared and tattered as extravagantly as the clothes in the sculpture, and Ratapoil striking the same pose as his portrait bust.[32] (It is not, significantly, a polemical image. It provokes a kind of affectionate laughter.) But there are plenty more where Ratapoil is lost in a crowd of

nondescripts – villains of the moment, given no single decisive form – or where, in competition with allegorical representations of Suffrage or the Republic, the drawing is slack and the allegory ponderous.[33]

This has to do, I think, with the impotence of the old symbols; the decline of Daumier's Republic figure – robust female with classical drapes and crown – from a symbol into a cipher. In the old days, when Daumier and Grandville had worked together on the same cartoon [73] using a common style which moved between fantasy and plain description, the woman had been a focus of meaning, a counterweight to the endless grotesque of her enemies. Once or twice in 1850–51 she sparks off Daumier's drawing and sense of clear design; in 'Neither the one nor the other' [74] she covers her ears against reactionary seducers, her forearms and elbows pushed against their faces, her face and chest thrown into shadow.[34] It is simple and effective; the design enforces the message. But usually her appearance is little short of dismal; in cartoon after cartoon, she is cursorily drawn, in mechanical contest with her midget opponents; sometimes a statue, sometimes come to rather dubious life.[35] In these two years, though Daumier often draws with his characteristic certainty, he is far from certain about his subject-matter. It seems as if he could find, in the confusion of 1850 and 1851, no viable symbol of the revolution or the majority. He cast about him for images: he tried a giant urn for Universal Suffrage; a sleeping or stirring Gulliver, tied down by pygmies, to stand for the same idea; he tried a bland giant in a smock, watching the politicians fight it out [76] – he was the People; an honest old woman with Opinion publique written on her back, a sun inscribed Février 1848, even a crippled Mercury to stand for Commerce.

Some of these drawings are powerful, but none of them develops into a running theme, a symbol which accrues force and meaning over the months. There are single great ideas: Thiers stalking towards the press with a club; a curious imp, like the Urchin of the Tuileries transformed, cocking a snook at the sleeping Thiers, and inscribed '1851, Year 4 of the Republic' [75].[36] (There is no image, curiously, of the feared and hoped-for '1852'; perhaps Charivari shared the fears.) And there is, occasionally, a glimpse of a new kind of hero, more appropriate to the time:[37] a peasant and his wife, cajoled by various reactionaries, and listening to their bribes with impassive faces; courted by Thiers, they break out in open laughter, hands in pockets; or, nudged by Ratapoil, the husband stands with 'canny scepticism in the ugly, half-averted face' [77].[38] When Ratapoil threatens the peasant with Communism, we are at the heart of politics in 1851; and when, in a strange print Daumier did in mid-1849, four workers lounge on a wall and idly chat about 'the fat Deputy over the road', [78] we are perhaps at the root of Daumier's uncertainty.

For this is the portrait of indifference, the tired innocence and cynicism of the Parisian working class after the June Days. We are worlds away, in the space of months, from the workman poring over his newspaper or piecing out the Republic's proclamations; further still from the awesome figure of the printer who clenches his fists in the great cartoon of 1834. And without that symbol, Daumier was lost

for alternatives. In a world where the real politics had moved out of Paris, and most of Paris did not care, Daumier was out of his depth. 'I shall have to see that' ('*Il faut que je voie cela*') was one of his few recorded remarks. In 1834, he *saw* politics; it happened a street or so from where he lived. In 1850, politics was somewhere else; and when it came back to Paris, in December 1851, the city was too tired and cynical to put up a fight. The old abstractions of Daumier's art – France, Republic, Charter, Constitution – had worked because they were confronted by the details of a real politics, one he knew at first hand. Now that he did not, the abstractions multiplied and the politics became increasingly second-hand; a politics of 'figures' and 'personalities', not a politics of the streets. No courtroom executions, and no rue Transnonain; instead the midget leaders of the Right, Thiers, Veuillot, Véron, Montalembert; all mocked and wounded, but taken, ultimately, at their own valuation.

Daumier made enemies, of course; he was still sharp enough for that. The Catholic publicist Louis Veuillot counter-attacked on 2 April 1851:

M. Daumier is only a sort of workman-buffoon, uninventive, lacking grace, with skilful fingers – from time to time he comes across a belly-laugh. But, what a laugh! what a smell of cheese and cheap wine! he's a writer of penny novelettes – Paul de Kock without the gauze wrappings.[39]

Let us hope, said Veuillot of *Charivari* in general and Daumier in particular, 'that this bestial laugh which you raise in the taverns does not echo over your corpse'.[40] That was Daumier as his opponents saw him, and by the end of the Republic they were the ones with power.

I have pointed to uncertainties, hesitations in Daumier's lithographs, but after all uncertainty was the stuff of politics in 1851: if Daumier could not find the Republic, no one else could. And he still had power to hurt, and used it – he was still, at his best, the most accurate voice from the Left.

We know that Daumier painted before 1848. He had probably done so for many years, but it was not until the Republic that he got any recognition, and it was probably then he began to paint in earnest. About his painting, like his life and opinions, we know very little for sure. There are eleven works (including sculptures and 'finished' drawings) which were almost certainly done in these four years; eleven more, probably done at the same time; and another twenty-five or so which seem from their style to come from the period.[41] It is only when – as happened quite often at this time – he came in contact with the State or the Salons, that we have a few hard facts on Daumier's career as a painter.

It began with the Republic competition. He had done his sketch under pressure from friends like Courbet and Bonvin, and his friends gathered round to praise it when it was shown. Thoré himself recognized Daumier beneath his anonymous number, and picked him as one of the few successes.[42] Champfleury praised him, Haussard thought only Diaz matched him – 'one is inscribed under number 361 and they say it belongs to our great caricaturist, Daumier, who is tormented

unceasingly by the demon of great painting, even in the midst of his joking lithographs'.[43] And a nameless critic in *L'Artiste* risked a (preposterous) judgment of style: 'it's a fine group, of proud appearance, touched with a master's hand – but a Venetian master's'.[44] The judges were not quite so enthusiastic. They preferred, as we have seen, an icier classicism, and placed Daumier eleventh, after Flandrin, Chenavard and the rest.

Eleventh place was good enough. The State paid Daumier 500 francs on 12 June to repeat the painting on a larger scale, six feet high.[45] With that commission, which the painter never fulfilled, begins a curious episode in Daumier's career – chapter of doubts and procrastinations, arguments with Government inspectors, pictures that were never done, or perhaps disappeared. Daumier got two more commissions from the State: the first later that year on 15 September, for the price of 1,000 francs, and the second on 10 February 1849, with slightly better terms, 1,500 francs. Both were, considering the state of the market after 1848, reasonable payments; and in both cases Daumier was left to choose his own subjects. He had to submit his choice for approval, and he had to send in a preliminary sketch – but that last requirement was often waived, and in any case nothing suggests that Daumier was pressed to paint anything in particular. He chose to paint, for both commissions, Christian scenes which centred on a single figure, nude or lightly draped; but this was *his* decision. It tells us something of what he thought the State expected, but even more about Daumier's own preoccupations as a painter in 1848.

After the *Republic*, with its hard edges of light and shadow, its massive and simplified anatomy, Daumier was to paint for a while in the same vein. Like Millet at the same moment – and the cases are in many ways very close – he thought first in classical and religious terms. Scenes from the Bible, or a Bacchic procession; Oedipus taken down from the tree (Daumier had done a picture of that subject as well, perhaps directly under Millet's influence); Hagar or the Magdalen, both with naked torsos, both in a desert landscape: this, for both painters, was a natural vocabulary. They eased their way out of classicism; they adapted it slowly to subjects without Greek decor or Greek decorum; they became, in their separate ways, painters of modern life. But classical form and Biblical action, for both of them, were a necessity: serious painting was unthinkable without one or the other, or both.

Some time in the winter of 1848, after a little prodding from the Ministry, Daumier decided to do *The Magdalen in the Desert* for his first commission. By May the next year the title was approved, and the 1,000 francs were paid; and some time the same month he wrote to the Salon that he intended to show the painting, now entitled *The Repentant Magdalen*, that year.[46] By that time, probably, the Ministry had seen his sketch [79]; but the work for the Salon would be the full-scale version. Then, as with Millet, confusion followed. The *Magdalen* was never shown in the Salon, and most likely the jury never saw it. Either, as Baudelaire suggested, Daumier could not bring it to a conclusion and withdrew it from his entry, or perhaps he was simply bluffing, and had never started in the first place.[47]

V HONORÉ DAUMIER *Saltimbanques Moving On* *c.*1855–60

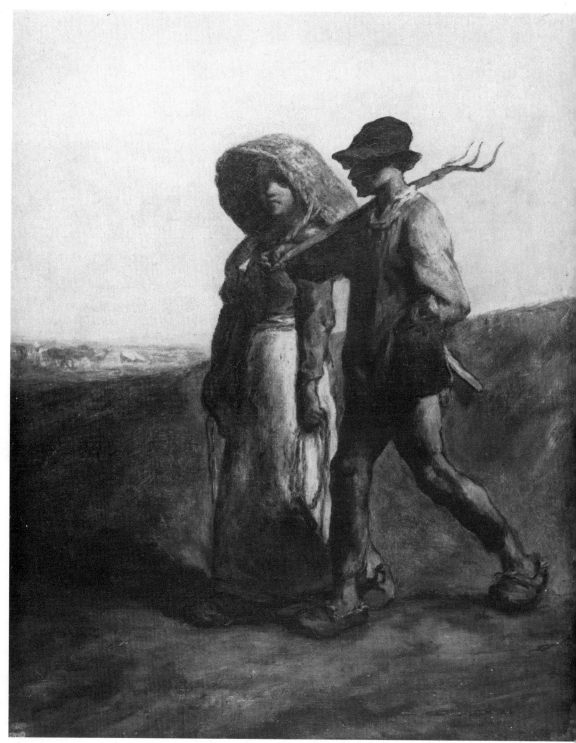

VI Jean-François Millet *Going to Work* 1850–51

Three years later, talking to Poulet-Malassis, he explained a little of his attitude to the Salon, and painting in general.

'Will you have any pictures in the Salon?'
'I've no idea. I don't count on it.'
'You have no time to lose.'
'I start everything over again twenty-five times. In the end I do the lot in two days.'[48]

In 1849 the two days were lacking, and the *Magdalen* was never painted. The inspector, Du Bois, called in 1850 to see how the picture was progressing, and again in 1853; as far as he could tell, Daumier had not even begun.[49] In the end the State made do with *Silenus* [80], a drawing that Daumier had done in 1850 and shown in the Salon the same year. It was not a work, wrote the inspector, which deserved 1,000 francs, but better a drawing than nothing at all (better anything, one senses from the inspector's letter, than another visit to the Quai d'Anjou, another round of embarrassment and excuses).

Before the *Magdalen* had ended in farce, Daumier was awarded another commission. He received the announcement on 10 February 1849, and three days later he announced his choice – *The Martyrdom of St Sebastian* – and said he was ready to send in his sketch. The history of this second commission is cryptic, but it seems to me that the *St Sebastian* probably was painted, and hangs even now, unknown, in some provincial church. It was not complete in July 1850, when Du Bois called for the first time in search of both pictures, and two months later the Directeur des Beaux-Arts wrote Daumier a stiff note reminding him of his obligations. If *St Sebastian* was finished, it was probably done in 1852. That was the time of the visit from Poulet-Malassis, and on that visit he noted down, 'On the easel is a sketch for a Martyrdom.' There exists a drawing which seems to come from around the same date: St Sebastian in profile [81], arranged in a classical pose and drawn with a thick, continuous contour. (Compare the other drawings from the early 1850s: the two lovers who fuse in *The Kiss*, the soldier who grips Archimedes [82] by the shoulder. In all of them the bounding line is smudged or thickened, and it moves in an unbroken circuit to contain the figure or group.) And later in 1852, on 30 June, Daumier was paid off: 900 francs to close the account. By that time the Ministry knew Daumier's habits; they had been badgering him to produce *something*, pointing out that he owed them 600 francs. If they paid him the rest, it suggests they had the picture. (And Du Bois, in his subsequent meetings with Daumier, is only interested in the absent *Magdalen*: the question of *St Sebastian* is never mentioned.)

Whatever the truth of this matter, certain things emerge quite clearly from the history of Daumier's commissions from the State. First and foremost, hesitation: chaotic, sometimes farcical, so persistent that it argues more than laziness; but as usual with Daumier, with nothing said in defence or explanation. Why did Daumier hesitate? Did he find the religious subjects cold and intractable, or was he disillusioned with the State and its patronage? Was oil painting on the grand scale something he could not yet handle, from a technical point of view?

Or did he need a newspaper deadline to spur him to finish anything, large or small? Hesitation itself was no new thing in Daumier's career: years before Banville had asked him for a vignette to head the newspaper *Le Corsaire*, and Daumier had warned him frankly of the dance he would lead him – the lies, the excuses, the promises that would never be honoured. Banville persisted, and the routine began; he got his vignette, in the end, by standing over Daumier as he worked.[50]

But the State commissions seem different from this. There is the same routine of procrastination; but at the same time there is a definite, unmistakable ambition on Daumier's part. This is not a matter of vignettes. There are pictures not finished, but others sketched or planned on a big scale, as big statements. Besides *St Sebastian* and the *Magdalen*, there is a small study of *Christ and his Apostles*, a massive oil sketch, *We Want Barabbas* [IV], which almost certainly comes from these years, and a drawing of *Christ and the Woman Taken in Adultery*.

None of these sketches shows any sense of strain or half-heartedness; on the contrary, *Barabbas* is Daumier at his most fluent and self-confident. He takes the composition from his own lithograph of the feminist orators, but changes it so that the figures fill the whole canvas and edge out the background. (He did the same in the *Uprising* drawing of 1850[86], and some of the poses are almost identical.) He adapts the accuser's pose, perhaps, from Delacroix's *Cicero Accuses Vero* in the Palais Bourbon; he goes to Rembrandt's great etching *Ecce Homo* for the silhouettes of heads and hands against the blank wall of the platform; he even repeats, in reverse form, Rembrandt's child balanced on its parent's arm for a better view. And all these sources he subdues and simplifies, turns to his own use and converts into his own language. He does a painting which, in its use of firm bounding lines and pungent gesture, is very close to his lithographs at their best (far closer than most of his paintings from this period). But he paints the Passion from a distinctive point of view: he is concerned not so much with Christ as with his audience; he fixes his gaze on the heads and faces in the crowd. And within the crowd, as usual, there are differences. Some strain upwards, childishly, for a view or a handhold; the backs of two children catch the light. And some seem almost indifferent: the man in the centre points Jesus out to his child with a ponderous, even gentle, deliberateness; his face and shoulders are massive but in a kind of repose, cradling the child and asking what he sees. These two are not involved in violence; the father's profile seems to repeat the strange, slack detachment of the soldier who holds Christ on a leash, and stands at ease.

Barabbas is a confident work, not a hesitant one; the same is true of the sketch for the *Magdalen* or the drawing for *St Sebastian*. The confidence is not surprising. The saints and the Passion were not, in 1849, obscure or esoteric images; they were the commonplace of everyone's speech; they provided metaphors for everything from medicine to politics. In the second Republic religion was a common language, but with as many meanings as there were parties or persuasions. By 1849, it was safest to clothe those meanings in Biblical garb; better to speak of Barabbas than Napoleon, since everyone knew that Christ *was* the Republic, the Great Proletarian,

the prophet betrayed by his people. When a saint was martyred, when St Sebastian was pierced by arrows, the overtones were not in the least obscure. Thoré had written in 1848:

The young Republic is still like a martyr, garotted and pierced with arrows. The holy women who will come to pluck out the arrows, and tend with healing oils the wounds of the martyred People, are Liberty, Equality and Fraternity.[51]

And this was not Thoré's private whimsy; in 1848 the whole of the Bible was politicized, as thoroughly as the schoolmen had once Christianized Aristotle, or moralized Ovid. When Daumier painted *St Sebastian* he doubtless had no such programme in mind, but he could not avoid – and probably did not want to – the overtone of the martyred Republic. The image was used *ad nauseam* in the Left-wing press. As if against the platitude, though on the same side as those who used it, Daumier staged his own burlesque version of the death of St Sebastian [85] in a lithograph of 1849, with the corpulent politician Louis Véron in place of the saint. Here, as so often, he laughs at a symbol which he uses elsewhere quite straight. And perhaps even as early as February 1849, St Sebastian had another meaning for Daumier. He was one of the plague saints, and cholera was abroad; in the summer of 1849 Paris had its last great epidemic of the century. In times of cholera the old legends were revived, and St Sebastian came back into favour with the people; that had happened in 1832, when a printer named Garnier in Chartres had brought out a new *cantique spirituel* to the saint.[52] Was Daumier's *St Sebastian* a kind of popular image, an invocation against disease, among its other meanings?

In any case, this is not a painter who is embarrassed by the Bible or the thought of stereotyped, traditional subjects; he was, as we have already seen, just as in-decisive when he tried to paint the uprising and the barricade, and there, quite clearly, his heart was in the matter. The issue, as Baudelaire explained to Dela-croix,[53] was 'finishing', not whether particular subjects were congenial.

The State, of course, was a hard task-master in this respect: it required finish, it respected craftsmanship, its standards were thoroughly traditional. The thought of judgment – of the visit from M. Du Bois, and his verdict of 'incorrectnesses' – may have been one factor in Daumier's indecision. But it had deeper roots. In the Second Republic, Daumier produced great masterpieces: he sculpted *Ratapoil* [83] and probably modelled the relief called *The Refugees* [84]; he painted *The Republic*, *We Want Barabbas*, the Rouart *Uprising*; he drew Silenus and the superb illustrations for Henry Martin's *Histoire de France*. But only one of these works is a finished oil painting. Sculpture, drawing, even gouache, were one thing; oil paint was another. In oils Daumier was still learning, still searching for a style, still unsure of basic points of technique. It is this process – finding a style, finding the means, the two inseparable, feeding each other – which is the central one in these years.

If we take the *Republic* figure and the Rouart *Uprising*, the sketch for the *Magdalen*, two small panels called the *Towman* and the *Water-carrier*, and certain of the sketches

of nude *Bathers* done in 1845–48 (for example, the one in Glasgow Art Gallery), and if we look closely at certain details in *The Miller, his Son and the Ass* (for example, the head and shoulders, the profile and breast of the woman who lunges towards the miller and his donkey), we can see the elements of Daumier's first style in 1848. In all these pictures the human body is the main subject; in all but *The Republic*, it is the human body engaged in effort or violent gesture. Effort and gesture are conveyed in simple terms; by placing against each other large plain blocks of light and shade in opposition; moulding the human form most often by a single area of light and a parallel shape in deep shadow. That way the bodies are plotted, briefly but effectively; and at the same time light and shade mimic the strain or the gesture. A highlight runs along the rebel's arm and shoulders, falls on the face and makes the outflung hand incandescent; the watercarrier's arm, held out stiffly for balance, is put down in black and its outline drawn with the brush; his other shoulder and the muscles of his upper arm, braced against the weight of the bucket, are bathed in white light. Light and shade reinforce the meaning of things. The edges of faces or bodies are sharply defined, sometimes drawn in black or brown paint; the edges of shadows are just as sharp, sometimes almost like second faces. In *The Republic* [III], the line between shadow and highlight makes a second face in profile on the first which looks towards us (a double image, an ambivalence of the kind Picasso used).

These devices are all matters of design, of drawing. They concern the use of black and white above all; they build the picture out of simple negatives, in a way which Daumier knew well from lithography. He would never abandon this style completely: the hard edges and the simple contrasts of tones recur all through his work. But he did, very quickly, try to change it. The first style was lithography in paint; which was all right for certain things, but awkward for others. If you look at the way oil paint is applied in these early canvases – its thickness, the marks of the brush, the handling of colour – the difficulties are obvious. On all these matters Daumier was undecided. Sometimes, in the *Magdalen*, and, as far as one can tell, in the Rouart *Uprising*, much of the paint is thinly applied, with the grain of the canvas showing through in places. In the thin paint of the *Magdalen*, the brush-marks are scratchy and almost aimless; on the face and torso the oil is thick and smooth; elsewhere it is summary, a colour note rather than a colour. In other pictures – in the Glasgow *Bathers* and even in parts of *The Republic* – the paint has been put on too diligently, too thick. The colour which results is hard to put a name to; it is nothing in particular except darkness. And that, surely, is not what Daumier intended.

All these difficulties come to a head in the picture Daumier sent to the Salon in 1849, once the *Magdalen* had gone into limbo, entitled *The Miller, his Son and the Ass* [II]. The Salon made painters brasher or more cautious, occasionally both at once. And Daumier's painting is a good example. It is large in scale, designed to hold its own on the Salon walls. It gives short shrift to its source material, putting the miller of La Fontaine's fable in the background and investing its energies in a group of jeering women. It tries, above all, to be bolder and more decisive

than usual, and more consistent in the way paint is applied. What results is dead-lock: a grating of intentions which Daumier could not yet reconcile. *The Miller*, as the best reviewers wrote at the time, is a compromise, curiously muffled for all its brassy patches of colour. Cailleux, in *Le Temps*, described it like this: 'touched with the verve of a great colourist, but cold in tone, and monotonous in colour'.[54] Gautier liked the picture, but criticized its timid brushwork and its sober tonality; Daumier must learn to avoid ending up with neutral colour harmonies; he must 'employ without fear the colours nature uses'.[55] He admired Daumier's sense of gesture, his bold use of Rubens as a model, his energetic line; but as a painter, he still had things to learn.

These are not inaccurate judgments. Daumier did become a great colourist; in his last works he puts pure colours against each other with all the assurance of those original shapes of black and white, he draws with colour, builds a solid out of a network of colour traces, each bright and distinct, but adding up to one surface, with its own shadows. But that mastery came slowly; in 1849 colour was the problem, and was far from a solution.

The Miller does open homage to Rubens, flirts with vivid colours, but ends up, as Gautier and Cailleux saw, grey and uncertain overall. In places the colour tries to be distinct and definite: the exploding fold of drapery round the hips of the woman nearest to us has been painted a rich russet, with highlights traced in yellow. But the device does not work, the yellow lights blur into the dark red, and the drapery ends up confused in contour and muddy in colour. Even the fruit in the other woman's basket is cautiously done, with touches of dark red and yellow, and a dominant dark green. These are the marks of overworking, of colours thickened and qualified until they merge with each other. They are not, certainly, the kind of colour that Rubens used, or that painters usually copied from him.

Rubens was a difficult master. Sure enough, as Gautier said, he taught Daumier a certain kind of exuberant drawing. The best parts of the *Miller* are those which we can read in terms of line and plane in low relief: the pattern of curves which runs through the heads and shoulders and plunging necklines of the three ladies, or the single edge of arm and sleeve and dress in the woman who turns towards the miller (this, in any case, is a figure taken, and changed very little, from the lithograph of the feminists). But when Daumier tries to model a solid with colour, all that drawing skill disappears: he has painted the left hand and forearm of the nearest woman with a blubbery, disastrous softness. The parts of the painting do not fit together – hesitant colour and ponderous modelling get in the way of line.

Years later, when he took a new look at his other great essay in the style of Rubens, the *Nymphs Pursued by Satyrs* which he sent to the Salon of 1850–51, Daumier saw the point. He worked over the whole surface of the *Nymphs*, painting in dabs of bright colour – green and blue in the background, white and red and gold on the figures – so that the old muted harmonies showed through, but as a ground for the new colour, the certain oppositions which he had learnt how to handle.[56] The best of the Rubens-like works is *Silenus*, where colour is all but absent, and

where drawing is moving away from the sharp contrasts of the 'first style' towards a sculptor's sense of solids and curving surfaces. The belly of Silenus was a good place to practise that new concern.

Sculpture was the next step. Daumier had done models for his lithographs from the start of his career, but in the Second Republic he began to do sculptures with a new kind of independence, not as models for drawing but as objects in their own right. And *Ratapoil* and *The Refugees* influence his painting in the same way as his terracottas of the deputies in 1834 had changed the course of his lithograph style. With *Silenus*, and especially the drawings for Martin's history of France, done in 1851, drawing begins to imitate sculpture; and eventually the paintings like *We Want Barabbas* follow suit.

But by itself sculpture is too vague a word; Daumier's drawings imitate Daumier's sculpture, and that is a very special and curious variety. The masterpiece of the Second Republic is *Ratapoil* – directly political in subject and intention, but in its style stepping out of the nineteenth century altogether. Apart from Death in Rethel's *New Dance of Death* – and this in itself is an image which imitates the past quite deliberately – there is no source for Ratapoil. The only parallels are with Mannerism at its most extreme and expressive: with the mercenary soldiers in the drawings of Urs Graf, or his crazy St George fighting the dragon; with the salacious skeletons of Hans Baldung or Niklaus Manuel Deutsch; with Holbein's *Dance of Death*; or even with certain figures by El Greco. All of these are approximate echoes, but they suggest the essential point: that Ratapoil is an image which stands in a complex relation to the art of the past, parodying tradition at the same time as it continues it.

Ratapoil is contemporary; the very name is a cluster of political associations. General Rapatel had been retired by the Provisional Government as politically suspect, had received a letter from Louis-Napoleon in June prophesying insurrection, and sure enough had been recalled to crush the June Days in the Faubourg Saint-Denis.[57] And General Hautpoul, a Legitimist, was made Minister of War and interim Minister of Foreign Affairs by Louis-Napoleon in October 1849. These were names that Ratapoil's admirers – the historian Michelet, for example – would know very well.

But Ratapoil is more than this. He is villain, but also hero; the servant of power but also its dupe; his clothes are ragged and threadbare; his face and beard are a death's head but also a comic mask. His closest brother in the literature of the time is Baudelaire's ragpicker in 'Le Vin des chiffonniers,' and more particularly the ragpicker as he appeared in Baudelaire's first version, the one he gave to Daumier at this time. In this version the ragpicker *is* a Bonapartist, murmuring broken words

Tels que ceux que vaincu par la mort triomphante
L'Empereur exhalait de sa gorge expirante[58]

and dreaming of armies led and battles won. And this is the image – jaunty and vicious, down-at-heel but somehow magnificent, frail and threatening at the same

time – that the sculpture suggests. The lithographs retain some of this ambiguity, though the comedy gets broader and the villainy more obvious. But the sculpted Ratapoil is not simply, as Michelet thought, militarism satirized. Ratapoil is, in meaning as well as visual form, a multiple image, grotesque but affectionate. That is why, I think, echoes of Ratapoil are found in Daumier's earliest pictures of Don Quixote.

In terms of technique, Ratapoil and the second version of *The Refugees* lead on directly to the drawings of 1851, and in particular the *Uprising* in the Ashmolean Museum, Oxford. Daumier did two versions of *The Refugees*; the second [84] (it is commonly called, to confuse matters, version one) is very close to Ratapoil. In the relief, the basic forms are massive and substantial, owing a lot to Michelangelo. But what matters nearly as much – it is the main difference between Daumier's two versions of the theme – is the working of the relief's surface. The whole of the plaster is marked and roughened by the knife and the sculptor's comb; the whole surface is active and broken, a mass of scars and facets which catch or disperse the light and play against the basic simple shapes of bodies and limbs.

Ratapoil is the logical conclusion of that technique.[59] In *Ratapoil* the broken surface, marked with the comb at every point, seems to eat into the solid of the figure, making it tenuous and fragile. That is why the sculpture conjures up skeletons and the dance of death: the wrinkled trousers and the great billow of the creased tail-coat are mimicked, on a smaller scale, by the folds and openings of every surface, so that there seems to be no flesh inside the clothes. (This is something the smooth bronze casts betray completely.)

The lessons of the sculpture were applied at once. Look at the tangle of bodies in the foreground of the Ashmolean *Uprising* [86] and you can see the techniques adapted to charcoal and gouache. Instead of the broad lights and deep shadows of the 'first style', a criss-cross of lines, shadows hatched or painted black or washed in a transparent grey; arms and back marked with muscle and bone; a head appearing at the very bottom, with a mask-like grimace, to fill in an empty space. This is a different kind of drawing from *The Republic*, or the 1848 study of a man's head for *Family on the Barricades*. In two or three years, the intention has radically changed. Now, instead of massive forms and broad modelling, there is a network of facets, an attempt to animate all parts of the picture surface, to give each an equal weight. In the *Uprising*, this is still only true of the foreground, but in later Daumier it is true of the picture as a whole. It did not appear overnight, and the sculpture was not its only source. There are parts of earlier lithographs which already have this kind of complexity, but in the paintings and the gouaches it was *Ratapoil* and the *Refugees* relief which seem to have opened the way.

In 1850 and 1851, Daumier was surrounded by sculptors; he had old friends in Préault, Pascal and Geoffroy Dechaume, and he made new ones in Feuchère and Clésinger.[60] He did not imitate his friends. *Ratapoil* owes nothing directly to his contemporaries. But sculpture itself – the problems of relief, the ability to shape a surface not metaphorically but in fact – had implications for all his art.

Daumier was never systematic, nor did he need to be. He changed his style

slowly, he digressed, he recapitulated. The *Uprising* gouache in the Ashmolean was part of a series, done in 1851, to illustrate a history of France. (The project came to nothing; perhaps the *coup d'état* saw to that.) But the other two studies from the series that survive have little or nothing in common with the Ashmolean drawing. One, of Camille Desmoulins rousing the people at the Palais Royal, is the Ashmolean drawing clothed and domesticated, a crowd of people in close-up, jostling each other, but grouped with an almost academic care, using a chair and a sword as *repoussoirs*. The other is a scene of revolution, but empty and spacious – a man pointing down the long, shadowy perspective of a street, and men on horseback looking after him, towards something we cannot see. Put these alongside the classicism of *The Kiss*, or *Archimedes Killed by the Soldier*, the loose brushwork of *We Want Barabbas*, or the harder outlines of the first version of the *Heavy Burden* [87] (another work Poulet-Malassis saw in Daumier's studio in 1852).

This is a mere catalogue, but at least it suggests the obvious: there is no clear 'development' in Daumier's style, and the movement I have suggested is tentative. He was, quite certainly, experimenting and changing in the Second Republic. A new style emerges, but how and when is a matter of speculation. And that leads on to an even more important and more puzzling question: the question of *meaning* in the various series of pictures on which Daumier began work at this time.

Daumier painted in series, did variations on a single theme. Most of these series have a picture or two which was probably painted in the Second Republic, but the themes crystallize and the imagery becomes more coherent in the course of the 1850s and 1860s. He painted *Don Quixote and Sancho Panza Going to the Wedding of Gamach* for the Salon of 1851, to accompany *Silenus* and the *Nymphs Pursued by Satyrs*.[61] He had probably already painted *Sancho Panza under a Tree*, and around 1850 he did a study of *Don Quixote and Sancho in the Mountains*.[62] But these are sketches, preliminaries; the real series, where picture echoes against picture and by purely visual means a complex relation of character is built up, seems to belong to the 1860s. The same is true of the pictures of railway waiting-rooms, of lawyers, of connoisseurs, of the theatre; there are first tries at all these themes, but the achievement probably comes later.

The two series that concern us, for different reasons, are the series showing fugitives or refugees crossing wild landscapes, and the series showing street entertainers (*saltimbanques*). The first, because it is more than any other a series which belongs to the Republic; the second, because it raises most directly the question of meaning and intention, the problem of Daumier's politics and their relation to his art.

The *Fugitives* [88] seem to stem from the relief sculpture *The Refugees*. They continue its subject-matter; and, by the time of the Wintherthur picture, which is perhaps the third in a series of five, they digest the lessons of sculpture in a very obvious way. (The groups of half-draped figures on the left come directly from the relief, with a few adaptations; and in painting style it carries on the techniques of the Ashmolean *Uprising*).

On another level the *Fugitive* paintings are a homage to Delacroix, to the mural of *Attila Followed by his Barbarian Hordes* [VII] which Delacroix had introduced to the public in January 1848. That image – profoundly reactionary in its politics, wild and disjointed in its composition, and completely skilful in its harmonies of bright pigment – seems to me one of Daumier's great exemplars. The *Fugitives* are his version of *Attila*; the first of the series, now in Montreal, is vivid in colour, wielding bright reds and yellows and blues in much the same way as a Delacroix, though still piecemeal in its drawing and composition. But instead of invasion there is flight, and instead of reaction, an act of mourning for the lost revolution. The key to the *Fugitives*, if there is any one key, is another entry in the notebooks of David d'Angers, sculptor and politician, friend of Daumier, caricatured by him in 1849:

Today, 2 March 1850, I am alone in the midst of this mass of restless youth, thinking of the Republic and of our poor friends who were deported. All at once the idea of making them a dramatic medal occurred to me. I shall represent a deportee tied to the Gonner bridge by a chain; Justice, veiled, holding her dagger in one hand and the scales in the other, but with no intention of weighing anything. She crushes a child, symbol of innocence, with her foot; the deported man raises his hands to heaven in prayer, since the justice of men is denied him.[63]

Justice, dagger, chains, innocence: Daumier's allegory is not so ponderous. But allegory of some kind it probably is, though whether its fugitives are the deportees of June 1848 or the exiles of December 1851, or simply the displaced persons of any war, any revolution, we have no means of knowing.

This is the problem of all Daumier's series. How specific are they? Do they hide meanings which time has blurred, or were they always abstract, generalized, describing a world which is both Paris and not Paris, both the nineteenth century and no century in particular? How pointed is their imagery? Do they have truck with politics and controversy, or are they a withdrawal from all the exact, destructive reference of the lithographs?

The *Saltimbanques* raise these questions directly. No one is sure when the great oil paintings and watercolours of the series were done: perhaps from the mid-1850s onwards, perhaps in the 1860s. The first painting of the series, the Washington *Saltimbanques on the Move*, was probably done before 1850. It is brightly coloured: a clown in the centre with a pointed hat and a tunic with pompoms, carrying a drum, his face averted, melancholic; a boy by his side carrying a chair; and a woman, her face left blank. It is a feeble picture: slapdash paint and commonplace sadness. Clowns like these crowded the walls of the Salon. But the rest of the series is different. The drawing sharpens and the paint gets darker (in some of the pictures there is no paint, except for a few patches of wash); the sad clown turns tragic, and a particular atmosphere, one we do not find anywhere else in Daumier's art, even in *Don Quixote*, an atmosphere of doom and despondency, takes over.

In one watercolour [89], a clown beats a drum and looks anxiously towards a

crowd across the street; they do not come his way. His wife sits beside him on an orange-box, her face in shadow, head on hand; a child spreads a mat and crouches upon it. Another clown in a different watercolour [90] beats a drum in front of a poster of the Fat Lady; the Thin Man, with cap and staff, stands rigid on a chair beside him; and the clown stares out at us with a face that registers, in a few hard lines and deep shadows, grimness, fatigue, the trace of something like contempt. In another the *saltimbanques* are on the move again [v], carrying off their chair and tambourine; there is a half-naked child with his bones protruding. In this version they move faster, and their faces are more wizened and covert. More clowns, in a drawing touched with wash, caper and shout in front of a backcloth; the same drummer has set up his stand in the city street with balls for juggling and cups for the three-cups trick; in twilight, surrounded by working men and women, a man works a barrel-organ [92] and sings (half his face is cut by shadow, the other half is twisted by the song into a grimace; the mouth is a black void, like a tragic mask); his wife leans on the organ and sings lustily.[64]

What these images share is grimness, an atmosphere of despair and misery. The question is, what is the source of that grimness? It is partly a matter of tradition, for Daumier is reworking a theme from the eighteenth century and earlier: the theme of the tragic clown, of Pierrot and Gilles, of the clown who sobs behind the greasepaint and sees the world too clearly for anything but despair. But what Daumier does is give that theme a location. He puts the clown in the streets of Paris, or among the cottages of a country village (that setting is suggested in the background [89] of one of the watercolours); he provides an audience in smocks and shawls, with faces that are anonymous but distinctive; he puts the *saltimbanque* among the People.

Daumier's clowns are popular entertainers. They are that mass of itinerants – tumblers, singers, puppeteers, sellers of patent medicine, miniature impresarios with eighteen attendants and ten horses, amateur and disastrous dentists – who appear in the reports of Prefects and Procurers General all through the nineteenth century. They were many and they were poor: 'this numerous and impoverished class of mountebanks and itinerant musicians', as one Prefect described them in December 1853.[65] And above all, they were dangerous; they were persecuted by the State and its servants. This had always been so, and when a poet (perhaps Baudelaire hiding behind a pseudonym) described a 'Jeune saltimbanque' in 1848 –

> *Quand tu couvais de l'œil, en tordant ton écharpe,*
> *Quelque athlète en maillot, Alcide fait au tour,*
> *Qu'admire le bourgeois, que la police écharpe*[66]

– he was probably thinking of a general harassment, the traditional dislike of the policeman for the beggar.

But in a year or two, those lines and Daumier's imagery took on a more specific meaning. In 1849, the Government declared war on the *saltimbanques*; they were the entertainers of the People, but they had become, at least in the Ministers' and Prefects' fantasy, its teachers of subversion, its singers of Socialist ballads and

sellers of Communist broadsheets. On 31 August, the Minister of the Interior sent a circular to all *départements*, demanding a register of aliens and a prohibition on selling pamphlets without a licence. He ended like this:

I think in addition that it would be most useful to apply the same prohibition to all the barrel-organ players, strolling musicians, etc., who are the natural auxiliaries of the Socialist establishments, and who in reality are nothing more than beggars.[67]

From that moment, the war was on against the *saltimbanque*. The high point of the campaign came in 1853, when the Government drafted a law against the whole profession, and ordered its Prefects to put it into force. This law was quite openly a matter of politics, and some of the Prefects saw its point quite clearly. One of them, in the Gers, added a clause of his own:

In their announcements to the public and in their parades, the *saltimbanques*, jugglers, etc., must abstain from any action contrary to the respect due to religion, good morals and common decency.[68]

But there was really no need to be so specific. It was enough that now the clown had to apply for a licence – many were refused – and submit his songs to the Prefect for official approval. That way the dangerous could be silenced and the safe given the blessing of the State: as one mayor put it in his testimonial for a local entertainer named Viault, 'he is a friend of order and, following the example of men of good will, he is attached to the Government of the Emperor – on whom his livelihood and everyone's happiness depend'.[69]

Viault got his licence, but others did not. And many were too poor to stop the only trade they knew. They went on performing, changing places often to avoid the police, skimping a living in remote villages or towns big enough to swallow them. Even those with a licence suffered. Under the new law, they could not move about the country without informing the Prefect. They could not sing songs the Prefect had not stamped. They could not perform after six o'clock in the winter, or nine o'clock in the summer, though the hours from six to ten were the only time when the clown could make money. The Prefects knew this very well, and one or two protested. The Prefect of the Loire-Inférieure wrote on 9 January 1854:

I have found it necessary to leave them the chance of plying their trade, at this time of year, up to eight o'clock in the evening. Their real day – the one which is lucrative for them – only begins in big towns like Nantes at seven in the evening when the factories close and the workers return home. To forbid the *saltimbanques* to carry on their trade after six o'clock in the evening would have been equivalent to a total prohibition.[70]

Exactly so: and there were few Prefects who thought it such a bad idea. Lastly – the moral core of the law, or so the Minister liked to think – the *saltimbanques* must not use in their show any child under sixteen years old; they must produce a birth certificate or parental consent for any child they had with them. This last was the neatest of all, combining high morality with the maximum nuisance to the clown's profession: the child had been abducted, was starving, was exploited, and

the child must be rescued.[71] But it was the child who brought in the money, taking the hat round and running through the patter; and if he was rescued, where did he go?

With all these laws in mind, look back on Daumier's paintings. Children, half-naked, are at their parents' side; singers perform in the half-dark of a city street; *saltimbanques* are on the move, changing places, tired and bitter. There is no doubt that Daumier's first audience would have taken the point – this is the *saltimbanque* as criminal, breaking the clauses of the law, avoiding the Prefect, singing tunes not culled from the regulation song-book. The series is more specific than it looks at first sight: it mixes politics with tragedy. But its meanings *are* general, at the same time. It is part of a theme which preoccupied Daumier throughout his life, and which animates the *Theatre* series, the series of *Artists and Sculptors*, the series of *Connoisseurs*; even the *Courtroom* pictures, where lawyers are actors of a perverted kind, and sometimes there are pictures of the Crucifixion or Cain and Abel on the wall. That theme is the place of art in the city and society: the space allowed to art, its different guises and its very different publics, its perversion in the courts and its suppression on the streets.

Art, in some of the *Theatre* pictures, where weary faces howl at a melodrama, is a kind of degradation; art, in the picture of two sculptors looking intently at a group in clay, is still a kind of mystery, a rite or a sacrament. Daumier seems aware, above all, that art is multiplying its forms, that the artist is no one person any longer. The clown is his hero, and his central image of the artist, just because he is an outcast. Once he acted as a critic and mocker of the social conventions because that was the role society gave him; he was the accepted, professional outsider. Now he is outcast in fiction and fact; society takes its revenge on his mockery, wags its finger at his naked children and his dirty songs, and hustles him off the street. The clown is both artist and worker, 'the son of a proletarian soldier'[72] as one petitioner described himself in 1854 (he did not get a licence); and that mixture, once tolerated, is now too dangerous to be allowed.

That mixture, of course, is Daumier's own. After the barrel-organ came the lithograph; the clown and the lithographer were not so very different; the son of a proletarian soldier is not so far from the son of a glass-maker poet. They were both harried by the State; they were both banned or jailed at times; both sold their wares to the anonymous mass, the *menu peuple* of Paris, the vast opposite of the connoisseurs. The problem with Daumier, as with the clown petitioner, is that he shares his public's anonymity – part by choice, part by necessity. He paints in secret, puts no dates on his canvases, exhibits little. He leaves us no clues to intentions, except the pictures themselves; the series repeat a message, extend it, qualify it, but for the most part we do not know whether they describe in particular or in general. The *Saltimbanques* are central to his work because here for a change we can fill in some of the blanks, tentatively write in a caption or two.

In the process the image of the artist becomes more pointed, more political; and we are brought back to the Daumier we began with – the man located at the

centre of Paris, the artisan with peculiar knowledge of worker and bourgeois, the draughtsman of 'You have the floor, explain yourself'. No need to foist meanings on the paintings, to make them more specific than they are. They simplify and generalize quite deliberately, and they are open to many different readings. But we can at least insist on the *continuity* of Daumier's art: that the same knowledge is at work in the paintings and the lithographs, the same intimacy with the city and its people. The *saltimbanque* stands for more than he is: he stands for the artist in general, the melancholy clown, the man born under Saturn. But he is also breaking the law. He is hungry, he is begging; in a straightforward sense he is one of the dingy crowd that surrounds him. The clown is a tragic hero, but part of his tragedy is the edict of 1853. And that conjunction – that paradox – is the essence of Daumier's art.

The reader may have recognized the refrain. What I wrote about Millet and Barbizon, in the conclusion of the last chapter, is transposed here to Daumier and the *saltimbanque*. And the repeat is deliberate. What I want to suggest in both cases is that the artist's power to generalize is founded on particular knowledge, on an accuracy which includes the facts, even the details, of politics. We do not know enough in either case about how these facts were gathered, although the 'how' seems all-important. It is hard to tell from what odd, equivocal viewpoint these painters saw the detail of the city or the forest. Daumier was silent, Millet more or less a liar; and what I have said about their origins and attitudes, in and towards the social body, can only be tentative for want of harder evidence. But the work of both artists is more peculiar than it has come to look, in the false perspective of art history. Taken out of that perspective this is painting that goes clean against the grain of its time. It looks straight at things which almost everyone else did not know, or chose not to notice. It fuses traditional forms with unlikely, obdurate subject-matter. Sometimes, as in Millet's *Man with a Hoe*, the two grate against each other, in an appropriate dissonance. Sometimes, as in Daumier's *The Soup*, the painter discovers Michelangelo's Sibyl in the guzzling, slack-breasted slum housewife, and simply gives us the fact, all in one piece, without even the salve of irony.

How strange an ability this is! Or perhaps it is stranger that no other painter had it, and that art in the nineteenth century showed everything of modern life except those who lived it. Whatever the explanation of that fact – and it remains the great fact, that needs explaining – Daumier and Millet are clearly special cases, in improbable contact with the commonplace. Wherever that contact is visible – in an old law for clowns and jugglers, or a set of census figures for the Ile Saint-Louis – it is worth disinterring.

5 Delacroix and Baudelaire

There is no sadder occasion in the Second Republic – at least in its private life – than Baudelaire's visit to Delacroix on 5 February 1849. What Delacroix wrote about the occasion has often been recorded, but the sadness of the encounter has not been commented on.

M. Baudelaire came in as I was beginning again on a little study of a woman *à l'orientale*, lying on a sofa, which I'm doing for Thomas, of the rue du Bac. He told me of the difficulties Daumier experiences with finishing.

He then ran on to Proudhon whom he admires, and calls the idol of the People. His views appear to me thoroughly modern and altogether in the line of progress.

Continued the little figure after he had gone and took up the *Women of Algiers* again.

In a very sad frame of mind. Today it is public affairs that are the cause. Another day it will be for some other reason. Must not we always be fighting off some bitter idea?[1]

We are concerned for the moment with Baudelaire as champion and admirer of Delacroix; and with the withering scorn for his admirer implied in Delacroix's 'He then ran on to Proudhon', his 'altogether in the line of progress', his 'idol of the people'. These are phrases which at first sight seem innocuous, but are most likely charged with contempt and spleen – even a little fear.

What could be more absurd and tragic than the sight of Baudelaire preaching Proudhon's ideas to Delacroix? What better image of 1848, and its strange alliances? For by the time of Baudelaire's visit, Proudhon stood for everything Delacroix hated and feared.

There is no talk of fresh trouble, although we've been in fear of it for several days . . . shall we ever have a little calm? If only, at the very least, one could go somewhere – anywhere – and not hear talk of Proudhon, or Cabet, or even the glory of France![2]

That was a letter to Madame de Forget, written in September 1848, one of many on the same general theme. Proudhon was laughable but dangerous.

Delacroix feared him enough to want answers to his strange philosophy; a month before he had asked Madame de Forget to lay her hands on a copy of Thiers's stylish, vapid *Rapport sur Proudhon*.[3] This was the establishment's reply to Proudhon's proposal for a Bank of Exchange; it was a pamphlet which would put the anarchist finally in his place. And Delacroix was eager to feast on its sarcasms: 'I would be most happy to have a copy.'

This whole letter is curiously uneasy and revealing; it ends with the following unique account of a dream:

I dreamed, this very night, that she [George Sand] gave me a present of a little hand made of a delightful substance, which resembled flesh but was in fact no such thing. It was a kind of toy, a trinket to put in one's box of curios; furthermore this hand responded to pressure, was endowed, in short, with sensibility, and I stopped there with the hand of my dream. When I awoke, I said to myself that a trinket like that would be very useful on journeys.

A fantasy of woman as perfectly compliant sexual object, a toy which merely responds to the touch, and carries with it no demand for passion or responsibility – as George Sand had done! No wonder Delacroix endorsed the idea on waking, with an irony which did not save him from pathos. His own imagined Bank of Sexual Exchange!

He was working at the time on an article about Baron Gros, in which he tried to articulate – the letter begins with an account of his difficulties – his feelings about the painting of subjects from modern history. In the article, when he finally published it, he mused on Gros' direct contact with Napoleon, on his popularity with 'workers . . . men of the People', on his 'poetry of details' and his power to elevate modern subjects to the ideal.[4] In the letter this conception of a new kind of history painting jostles the private fantasy, with Proudhon as a middle term. The wish for *both* – an unrestricted, extreme and private world, and a public world in which the painter confronts and serves his time – is typical of Delacroix. It is the contradiction which keeps his career alive.

Proudhon, and the Left in general, haunted Delacroix all through the years of the Republic. To him, Barbès and Blanqui are 'the race of second-rate writers, the wretched modern pestilence which calmly sacrifices a people to the ideas of a sick brain'.[5] Louis Blanc and his consorts dream of 'general pillage'; in consequence 'it seems to me that a little forgetfulness in such a time as this would be the supreme happiness'.[6]

Poor Baudelaire, blundering in with his talk of progress and the People! It was he who produced Delacroix's 'sad frame of mind'; it was Proudhon who stood for the 'bitter idea'. The whole encounter is a classic of misunderstanding; the disciple tells the master exactly what he least wants to hear, the dandy gives way to enthusiasm – of all things – and makes a complete *faux pas*.

What I want to explore in this chapter is the context of this small disaster, the separate responses to revolution which here come face to face. For both Baudelaire and Delacroix, 1848 was more important than they cared to admit, then or afterwards; both men took care to edit their past. They were good at that; both

were masters of the intimate journal which intimates just enough to back up what everyone knows. But occasionally the bones of crisis – a crisis in which public and private collide and complicate each other – show through.

Delacroix

'Delacroix, reactionary in his ideas, romantic in his talent, was in contradiction with his own works. . . . In my violent and frequent discussions with Delacroix . . I told him that his opinions were diametrically opposed to his painting: he agreed with me, and said his painting was a turpitude.'

Victor Hugo.[7]

Like everyone else, Delacroix greeted the February revolution with something like enthusiasm. 'Truly we have lived fifty years in a few days. Youths have become men, and I fear that many men have grown old and decrepit overnight.' This was to George Sand, a few weeks after the barrricades. And like many others he was quick to cool; in the same letter to George Sand he is excusing himself for a lack of involvement in politics: 'I have been very miserable, very low for some time; my whole disposition has been very much affected; that is the reason why these events have perhaps had less effect on me.'[8] In the months that followed, disillusion came quickly, the letters began to fill with bitter phrases, and Delacroix beat his usual retreat to the country estate at Champrosay.

But what matters, for the moment, is the extent of Delacroix's initial involvement – the extent to which he tried once again to repeat the experience of 1830. Whether he ever began a pendant to *Liberty Guiding the People* we shall never know: the Journal for 1848 is lost, and the letters are silent. But there was certainly a rumour that he had. Thoré in his 'Salon de 1848' did not merely suggest the project, he implied that it was already begun: 'It is said that he has begun *Equality on the Barricades of February*, for our recent revolution is the sister of the national revolution, immortalized eighteen years ago. . . . Make haste, Delacroix.'[9]

Whether that was fact or fantasy, the idea of Delacroix as the artist of revolution came naturally to men in 1848, and there were other suggestions. When Prosper Haussard described the scenes on the Champs-Elysées after the *Fête de la Fraternité* on 20 April, he could hardly resist the analogy with *Liberty Guiding the People*:

You should have seen the serried ranks of *montagnards*, with Caussidière at their head, with their proud bearing and energetic faces! You should have seen that brave Guardsman, wearing his working-man's costume, a blue smock, a scarlet belt and cravat, lit up in the red glow of a thousand flaming torches! Delacroix, why were you not there![10]

Compare Delacroix's opinion of the festivals of 1848, the icy sarcasm of his letter to Soulier a month later: 'I hear there is a festival in which we shall see the bull

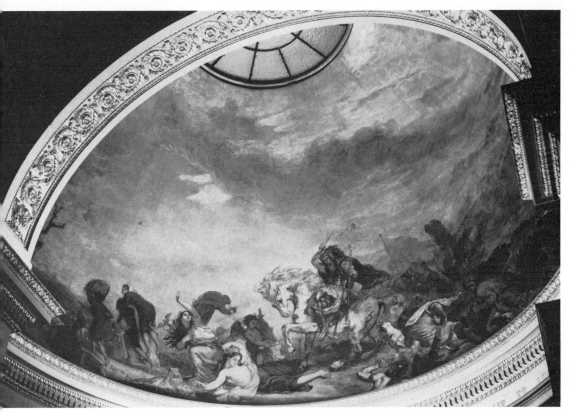

VII Eugène Delacroix *Attila Followed by the Barbarian Hordes Tramples Italy and the Arts* 1838–47

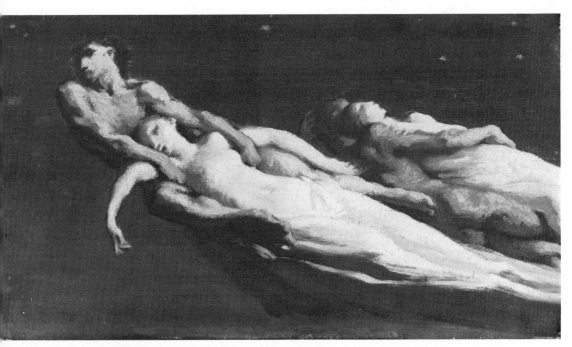

VIII Jean-François Millet *The Shooting Stars* 1847–48

IX Eugène Delacroix *A Basket of Flowers and Fruit on a Pedestal* 1849

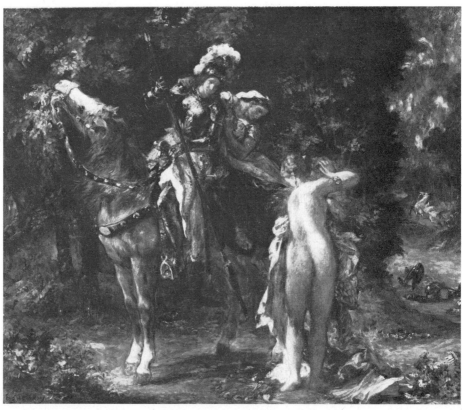

X Eugène Delacroix *Marphisa and Pinabel* 1852

Apis, triumphal chariots filled and followed by four to five hundred virgins. It needed another revolution to work such miracles.'[11]

The *Equality on the Barricades* was never painted, but Delacroix as much as his admirers was still under the spell of *Liberty Guiding the People*. It stood for the one moment of his life when his fragile detachment had been discarded, when the public world had seemed full of heroic imagery. He pined for that; he allowed himself a certain kind of nostalgia. 'As for Maurice [Sand], he is radiant,' he wrote to the boy's doting mother, George Sand.

He goes out as if he were drunk; I did not believe him capable of such exaltation; and besides he has stored up in his memory enough subjects for pictures to last him the rest of his life; for if he could develop a passion for the images of soldiers whom he had never seen, the real actors that he has before his eyes will open up a whole new career for him.[12]

Hard not to believe he was recalling his own excited, frightened wanderings in 1830, his glimpse of action on the Pont d'Arcole.

If he could not paint *Equality*, then he would try his hardest to get *Liberty* out of the attics (where it had languished since 1832) and into the Luxembourg. Only a week after the revolution, he was writing letters to the Minister of Fine Arts; three weeks later he was sending for a proof of the new lithograph of *Liberty*; as late as August he was still working to get the picture on display.[13] It seems as if the Government, as in 1831, at first agreed to show the painting and then had second thoughts; perhaps by June *any* image of the barricades and the people was unacceptable. Whatever the reason, the *Liberty* was sent off to Lyons in May 1848, with Charles Blanc's approval and Delacroix's rather reluctant assent. In Lyons an impressario named James tried to put it on show; he never paid Delacroix, and after months of waiting, the picture returned, unshown, to the attics of the Louvre.[14] It was still an uncomfortable image: a picture no government could stomach, as an image of its birth or its purpose; best to put it out of sight.

Delacroix himself looked for substitutes. He offered to do a bold, approximate pen-drawing of Géricault's *Raft of the Medusa*, 'in order to spread, by means of woodcut facsimiles, this important composition among the masses'.[15] The administration declined. He went off to see Dubufe's popular version of *The Republic* – and passed no comment in his Journals. Most of all he admired Meissonier's *Barricade*: 'horrible in its truth to life, and though one cannot say the thing is not exact, perhaps there is lacking that indefinable thing which makes of an odious object an object of art'.[16] (Exactly the same things had been said by his own critics in 1831.) He bought Meissonier's drawing; he more or less insisted on possessing it. Perhaps he saw in it the answer to Thoré's first demand: this was Equality on the barricades – the equality of death, the dead level of flesh and stones littered on top of each other.

Delacroix, more than he cared to remember, was a participant in 1848, making one last, half-hearted effort to identify with a revolution. On 3 March he became joint President of the Painting Section of the new General Assembly of Artists, and signed his name along with Corot, Nanteuil and Decamps, to a declaration of

principle [48] sent to the Minister – a declaration which stated that 'The intervention of artists is indispensable in all cases where their livelihood, the use of their talents and the glory of French painting are in question',[17] and which claimed that the artists' right to intervene in the closed system of State patronage issued 'from democratic principle and democratic action'. (It was a demand and a principle that Charles Blanc vigorously resisted.) Later the same year he became a member of the Government's Commission Permanente des Beaux-Arts and fought (with Ingres!) for a Salon jury elected by the artists themselves; one last campaign against the advice of the administration.[18]

It was this fact – this effort at involvement, this last flirtation with democracy – which made Delacroix's disillusion the more bitter. It is when reaction is tinged with disappointment that it takes the most withering form.

I have buried the man of former days, with his hopes and his dreams of the future, and at present I walk to and fro with a certain appearance of calm – as if it concerned somebody else – on the grave in which I have buried all that.[19]

The calm was only apparent; often he did not bother to hide his spleen, cursing the Left, despairing of a liberty 'purchased by dint of battles', and pinning his hopes, finally, on Louis-Napoleon, friend of the family and protector of order. As far as we know he did little painting in 1848, until in the winter at Champrosay he began his series of flower studies. He complained of his own discouragement more than once: 'I wonder all the time what use this is, in a time of barricades and false patriotism. They are not Muses calculated to inspire us.'[20] Or again, to his pupil Lassalle-Bordes, 'In Paris it was impossible to work; the disturbances, real or imaginary, all did their best to prevent it.'[21]

The answer, finally, was retreat from Paris to the countryside – to his house and small estate at Champrosay. To leave behind 'the dull and neglected aspect of this crowd' which Delacroix observed one Sunday on the boulevards; to go back to the land and act the part of the great landlord: that was the intention, at least. Champrosay was not many miles away. It was near the Seine, on the edge of the Forest of Senart, and Delacroix could sometimes take the morning train in for a day's work in Paris. But it was far enough for Delacroix to believe, for a while, that its people were immune to city diseases. If democracy had failed, then he would flirt with the ideals of the Legitimists:

The people, who will always be the majority, make a mistake in thinking that great estates are not of any great use. It is the poor who benefit by them. . . . My good cousin's easy-going ways were a great blessing to the poor people who collected ferns and firewood on his land. But when the petty bourgeois grow rich, they shut themselves up at home and barricade all their driveways.[22]

Above all, he would put his faith in the peasantry, like many another reactionary in 1848. After the May invasion of the assembly, the dream came true for a moment. Master and peasant joined forces to hunt the renegades escaping from Paris, and

Delacroix reported delightedly, 'We here, burgher and peasant alike, have been much occupied with the aftermath of all that. . . . We mounted guard and arrested several of those scoundrels.'[23] His language here is consciously archaic, with its coupling of *bourgeois et manants*, straight from the fifteenth century.

These two statements add up to a familiar dream: a harmony of master and man, the gleaner living off the great estate, the peasant running his pigs in the lord's wood, the two combined against the 'sharers' and the Communists. It never had been *true*, entirely; and at the end of the first set of reflections Delacroix regrets its decline: 'The poor, deprived completely of these resources, do not even benefit now from the pitiful rights that the Republican State awards them.' The poor suffered in silence, and the peasantry as a whole were refusing to vote in the new elections, in spite of pressure from the mayor. That was closer to the truth of 1849; but it would take some time for Delacroix to realize its implications. For the moment he fell back on the vision of 'burgher and peasant' – it was his consolation, the crucial consolation, for the disappointments of Paris.

In September 1848, in retreat at Champrosay, he began work on a new series of paintings: large-scale studies of fruit and flowers, sometimes in a setting of parkland, sometimes in a darkened interior, and occasionally filling the canvas so that the background is totally obscured. They were, finally, Delacroix's response to the events of revolution – a deliberate, grand withdrawal to a world of private sensation, a world of traditional, painterly problems. He was well aware of that significance; as he wrote proudly to Madame de Forget on 3 October,

I do not know what is happening in Paris – I don't inquire, I even avoid knowing anything. The enterprise I have on hand is so difficult, in view of the rapid change in the weather, that I do not want to be disturbed by the idea of public disorder.[24]

As the letter says, Delacroix began in a hurry, working direct from nature, afraid of the first frost and the end of the autumn. But after those first few hectic weeks in September, he settled down to a long process of 'finishing' and composition; he spent the winter bringing the sketches to a state fit for the Salon. He was quite explicit about what he wanted. Instead of the careful piece-by-piece description of the professional flower-painter, he wanted the details subordinated to the ensemble as far as possible; instead of the hackneyed setting of drapes or columns, forming a convenient backdrop to the main subject, he would proceed 'by great local divisions of line and colour'. 'I have tried', he says in the same letter, 'to do studies of nature as it occurs in a garden, merely by putting together inside the same frame – in a way which is not very probable – the greatest possible variety of flowers.'[25]

But did he do it? He himself lost his nerve at the last minute. Early in June 1849 he went to the Salon to assist, in his official capacity, with the hanging, and saw his flower studies in the light of day. He came away dispirited and ill, sad above all that the *brightness* of the studies when he had worked on them in his studio seemed to have disappeared. A few days later he asked a friend to withdraw the worst two from the Salon.[26] He had started with the idea of showing five; in

the end two remained, *A Basket of Flowers Overturned in a Park*, and *A Basket of Flowers and Fruit on a Pedestal* [IX].[27]

The very names suggest what had gone wrong. It was the old problem, for Delacroix, of keeping the energy of the sketch alive in the finished work, and this time he had failed. After a winter of arrangement and repainting, the original 'great local divisions of line and colour' had given way to a formal, almost a prim composition – the Basket of Flowers neatly overturned in a Claude-like landscape, complete with framing shrubs and distant 'prospect'. In the other picture, a curious mixture of formality and profusion: the basket set central on its stone base, framed and shadowed by two wings of foliage, a glimpse of landscape between; a colour which in the end is subdued, almost half-hearted, for all the brilliant reds and whites of the fruit. Somewhere along the line the subtle distinction Delacroix proposed – less detail, more variety – has been lost.

Of course we have the studies, and some of them live up to the ideas Delacroix put forward in his letter. In the best – the oil study on pasteboard now in Bremen, or the great study of geraniums in a vase – an active network of line and colour explodes from the picture centre, pushing towards the canvas edge, filling the corners or blurring into the ground behind. The setting of the flowers is hardly indicated – a sketched-in vase, an ambiguous backdrop of wall or sky. Where the flowers *are* is not important; what matters is to suggest their energy, give us an image of growth: the bending, resistant stems of the geraniums or the irregular bursts of colour in the Bremen study, leaves and blooms scattered to the corners of the picture, hardly connected or supported at all (what stems there are, force a way out of the picture, most of their flowers just beyond our range of vision). Here, as so often, Delacroix signals ahead to the end of the nineteenth century: to Van Gogh's sunflowers, in the dense criss-cross of stem and foliage in the *Geraniums* [91]; to Cézanne perhaps, in the way that background is summarized and invaded, and the way that setting in space gives way to those local divisions of line and colour, plotted across the canvas surface. (Given such radical ambitions, the studies were liable to collapse. In the worst, and the National Gallery in London has a bad one, the paint is glutinous and overcharged; the arrangement is merely ragged, not informal.)

After the flower studies, Delacroix's work returned to familiar ground. He worked steadily through 1849, though the paintings he did were for the most part frankly lightweight – an *Othello and Desdemona*[28] which unfortunately owes more to Rossini's opera than to Shakespeare; a rare and disastrous *Lady Macbeth*,[29] perhaps Delacroix's response to Muller's success with the same subject in the 1849 Salon. He did a new version of the *Women of Algiers*[30] – this was the picture he worked on after Baudelaire left him – smaller, more shadowy and spacious, owing more to Rembrandt than the first. The best pictures from that year are, significantly, two small religious works: *The Good Samaritan* [93] and the superb *Pietà* which Van Gogh was to copy much later, in the asylum at Saint-Rémy.[31] Neither of these is typical of Delacroix, least of all of his works on this scale.

In these smaller paintings which he produced for friends or for the market, the

human form is usually buckled and disjointed, supple and seemingly consistent, but 'ruled by a logic which is no less certain for eluding us'.[32] The subjects are most often violent and emotional; the bodies twisted by rage or trepidation; what the painter wants to show us, so it seems, are 'the bestial degradations, the animal origins of man'[33] – that was the knowledge he admired in Rubens. He developed over the years a kind of private typology of the human body; a world of images and gestures which is sealed off from the world outside, plundered from books and operas and memories of Algeria, already twenty years old. *Othello and Desdemona* is a fair example of that world at its worst.

But the two religious paintings are rather different. What characterizes them, and especially *The Good Samaritan*, is a harmony, almost an ease, in the arrangement of the bodies; a logic of anatomy, not emotion; an attention to weight and counter-weight, to the business of lifting – these are not things which concerned Delacroix very often. The result is very fine (close to Daumier in some ways; suggesting the pose of Rodin's *I am Beautiful . . .*), and quite isolated in Delacroix's work. Two years later, and the religious works would be once again assimilated to the private vocabulary: *The Agony in the Garden* [94] with Christ grovelling strangely on sloping ground, his limbs splayed awkwardly, head and shoulders pushed lower than his hip.[34] And by the time of *The Road to Calvary* in the Salon of 1859, the Passion is one more symbol, among many, of a vile and convulsive world: pathway, gestures and limbs all echoing each other's broken movement, even the cross warped in a strange perspective across the shoulders of Christ.

The year 1850 is, I think, a special one in Delacroix's life, or at least in the record he leaves us. He had had two years of hiatus, withdrawal; piecemeal activity, rage at public folly, peace at Champrosay. In 1850 that ended; he began his first sketches for the great murals in Saint-Sulpice – they would take ten years to complete – and he was given a major project by the Ministry, to provide a ceiling painting for the newly restored Galerie d'Apollon in the Louvre. It was, once again, a public project: one in which, in all the splendour and concealment of allegory, he could give form to his experience of revolution. But before he did so – or rather, right in the middle of his preparations for the ceiling – he passed through a bizarre and violent crisis. For two or three weeks, the delicate, guarded monotone of the Journals and the Letters ceases, and we have instead something like revelation – or as close as Delacroix would ever come to it. It is not, in these weeks, that Delacroix tells us anything new; it is rather that he reveals the nature of his feelings about familiar things; that the world of the writings and the violent world of the paintings seem, suddenly, continuous; they share a common structure, they work on the same material.

We want to know, for a change, what was specific about Delacroix's pessimism, which he clothed for the most part in second-hand terms – contempt for the idea of Progress, concern for the fragility of civilization, world-weariness, hypochondria, inability to work. It is not that anyone disbelieves that he held these opinions; it is rather that they can be held by anyone: they hardly connect with the extreme

and obsessive world which Delacroix put on canvas. We want to know what images come to hand when Delacroix wants to give form for himself, and not merely for posterity, to his general ideas. Almost always, in the Journals, he avoids imagery or metaphor; he saves that for the paintings. But here at least he needs metaphor for a while, to contain a strange and penetrating distress; instead of just referring to his ennui, his sadness (as he does so often), he deigns to put it down on paper. And for three weeks the gap between painter and diarist closes: we can see the structure of Delacroix's discontents.

Let me begin with a diagram of the three weeks in question: to indicate the themes of Delacroix's discourse, in his painting, his letters and his Journal; to

Date	Works in Progress	Journals	Letters
Probably in progress throughout period	*Marphisa* Female warrior/male warrior! Young woman/old woman!		
30 April		The indecipherability of Nature The separation of beings	Dumbness – speaking to no one Fear at Apollo ceiling project Copying from Voltaire
1 May		*Sur la réflexion et l'imagination données a l'homme* Nature/Man Man's Savage Instinct/ Man's Intelligence Barbarie/Lumière	
3 May	Two or three sketches in forest		
4 May	*Ugolino/children!*	Independence brings isolation	
5 May	*Ugolino/children!*		
6 May	*Ugolino/children!*	Nurseryman falsely claims payment Husband/wife! Mother/son!	Political worries – the election of Eugène Sue Peasantry/Proprietors! Countryside/Paris!
7 May	*Samson/Delilah!* *Apollo ceiling*: correspondence	Idea for a book of detached ideas	In praise of pupil Andrieux
8 May	Pastel of sunset – for *Apollo ceiling* La Lumière/les ténèbres, la révolte des eaux		
9 May		Benevolent nature/ 'general sadness'	

display, in a simplified form, the sequence of oppositions and transitions through which he moves. There seem to me two very different kinds of opposition in this sequence. The first is familiar to any reader of Delacroix: natural, inevitable oppositions, like that of barbarism and civilization, which are accepted with a stoical calm. The second type is more peculiar: oppositions which are violent, deformed, utterly unnatural, and which precipitate in Delacroix an unmistakable emotion. The first are indicated simply by a stroke; the second thus: 'Husband/Wife!'.

These are the bare bones of the crisis – a counterpoint of political fears and personal fantasy; an accumulating sequence of deformities, of relations broken,

Date	Works in Progress	Journals	Letters
9 May (cont.)		Preparations against a night attack (by whom?)	
11 May		Dreaming only of catastrophes. Violent extremes in his moods. Decides to stay in Champrosay. Countryside/Paris: 'ce brouhaha affreux'	
12 May			On his dumbness Sombre political horizon
13 May		Isolation and Silence	
14 May		Family – Isolation Husband/Wife! Father/Children!	
16 May		In Paris	
17 May	*Femme qui se peigne* Woman/Death becomes Gretchen/Mephistopheles! connected in first stages with Adam/Eve!	Fly/Spider!	
18 May	*Femme qui se peigne Michelange dans son atelier* Man/Woman! (Michelangelo as mid-term)	Jenny complains of smallness of Delacroix's estate. Sadness 'à cause de toutes les menaces du temps'	
19 May	*Le Chasseur de Lions* mentioned *Sketches for St-Sulpice* mentioned		
20 May		On women's *pantalons* Woman/man!	

malformed, threatened, de-natured. For the space of the crisis, the obsessions of the painting – violence of women against man, and man against woman, families where natural loyalties and natural hierarchy are thrown to the winds – invade the Journals. They almost, but not quite, stain the decorum of the Letters: there the anguish is political.

The sequence begins with dumbness and solitude: 'I still feel very weak in the voice. . . . But I am not speaking to a living soul,' as Delacroix writes to Madame de Forget on 30 April.[35] That silence lasts all through the three weeks, broken by the occasional social call or a talk with his housekeeper, Jenny le Guillou – it forms a background to the crisis. It is almost its precondition. 'The result of my dumbness', as Delacroix puts it on 12 May, 'is that I do not ask anyone how public affairs are going; I believe I have noticed that people are uneasy and the horizon is dark.'[36]

In the silence, Delacroix's thought takes on an unaccustomed staccato rhythm: the measured reflections on the world, and the brief asides on his mental distress, give way to sudden discharges of anger and pain: detached and mysterious outbursts about the family and womankind. On 6 May, after quarrelling with a local farmer about a claim for payment of an old debt, Delacroix suddenly notes in his Journal:

I have noticed more than once how many acts of a profound immorality were treated gently by our atheist Code of Laws. I remember one fact I read about, a year or two ago, in the newspapers. A poor wretch lodged a complaint against his wife – she was living, without a shadow of a doubt, as the concubine of her own son – and the wife threw him, the father and husband, out of the family home. The woman was condemned to a month or two in prison.[37]

It is an outburst à propos of nothing – sparked suddenly by a random memory from an old newspaper: the first of these family images, all to be marked by the same stifling disgust, a creeping of the flesh upon page or canvas. The same day, Delacroix had worked on the painting of *Ugolino and his Children* – the count locked in a tower with his sons and left to starve; the sons offering their flesh to keep their father alive, then dying one by one: 'whence I betook me, already blind, to groping over each, and for three days called them, after they were dead; then fasting had more power than grief'. (That last line in Dante has a deadly ambiguity. Whether it means that Ugolino died too, or took to eating his sons, is not quite certain; especially as in the next stanza, back in Hell, 'he seized the miserable skull again with his teeth, which as a dog's were strong upon the bone'.) The day after, Delacroix worked on *Samson and Delilah* [96].

Eight days later he turned to the topic of the family again, quoting for the second time in two weeks a sentence from Benjamin Constant's *Adolphe*: 'Independence has isolation as its consequence.'

Alas! the alternative of being bored and harrassed all one's life, as is the man caught in the bonds of a family, for example, or else of being abandoned by everything and everybody, because one would not submit to any constraint, that alternative, I say, is inevitable. There are men who have led the hardest of lives doing the imperious bidding of a shrewish woman, or enduring the caprices of a coquette with whom they had bound up their fate, and who

at the end of their days cannot even console themselves that their eyes will be closed or their thin broth will be given them by that creature who could at least serve to soften their last moments. They leave you or die just at the time when they could render you the service of preventing your being alone.[38]

One's children, after the cares of their childhood and their stupid youth, have gone too; one is left, in any case, with a 'frightful isolation'. Another nightmare image, the tone veering uncharacteristically between pathos and indignation. And three days later, on 17 May, the strangest entry of all, the battle of a spider and a fly which Delacroix saw in the forest of Senart:

I saw the two of them coming, the fly on its back and giving him furious blows; after a short resistance the spider expired under these attacks; the fly, after having sucked it, undertook the labour of dragging it off somewhere, doing so with a vivacity and a fury that were incredible. The fly dragged it backward across grasses and other obstacles. I looked on with a certain emotion at this Homeric little duel. I was the Jupiter contemplating the fight of this Achilles and this Hector. It may be noted that there was distributive justice in the victory of the fly over the spider; it was the contrary of what has been observed for so long a time. That fly was black, very long, and with red marks on the body.[39]

The fly lies on its back, but all the same defeats the spider; which, Delacroix remarks, is distributive justice. No wonder he saw the struggle immediately in terms of myth, a symbol of a thoroughly human conflict! Though one would have thought Samson and Delilah was a better equivalent to his description than Hector and Achilles. Or even the contest of Marphisa and Pinabel [x] – a subject from Ariosto which Delacroix used in another picture in progress at this time – in which Marphisa, the female knight, defeats the warrior Pinabel, and forces his arrogant mistress to strip off her finery and hand it over to Marphisa's lady, a wizened old woman whom she had picked up on the way. Mysterious three-way transaction: in which woman humiliates woman after defeating man; in which youth and beauty are humbled in favour of age; in which a man-woman pretends affection for a member of her own sex. Complex masquerade: in which the impertinent beauty is robbed of her adornment, but the transvestite goes undetected – her nudity would have been more humbling still! It is, in its way, the perfect Delacroix subject.

Lastly, a hilarious footnote. On the 20 May, the last day before the tone subsides, the Journals have this brief entry:

I went at about two o'clock to see [the Villots and Mme Berbier], until their departure at half-past four. I accompanied them as far as the railway station. I told Mme B. that the ignoble drawers that women wore were an attack on the rights of man.[40]

The final confusion of the sexes: woman's distributive justice; the new armour in which she mounts her attack on the rights of man! A comic end to four days in which Delacroix had worked on *Woman Combing her Hair* [98] (which he feared he was spoiling) and *Michelangelo in his Studio* [95].

The former painting had been begun in 1847 [97] as a study of Woman and Death: Death lends his comb, according to Delacroix's note at the time,

and peers from behind the mirror at right. (At that stage the subject appears in a sketchbook alongside a study of Eve reaching for the apple.)[41] Some time in 1850 Death became Mephistopheles, and Woman became, presumably, Gretchen. Perhaps this is the moment in Goethe's *Faust* when Gretchen finds the casket Mephistopheles has planted, tries on the jewels, and looks in the looking-glass. In other words the subject sharpens and becomes more definite; but the theme remains the same. Female beauty is duped by vanity; the grotesque and dwarfish man-devil peers with prurient interest on the nude, and plots her downfall as his second-rate revenge.

In the other work, self-identification is closer still. It is a portrait of Michelangelo 'withdrawing into a dark corner, suffering from a sickness which grew steadily worse, and plunged in the darkest despair' – the words are Delacroix's own, in his article on Michelangelo published in 1830.[42] A portrait of 'complete inaction', a mysterious laziness and chagrin, the state of mind which Delacroix invoked often enough in the Journals. 'There is in the greatest spirits a laziness which is just as great.'[43] A portrait of the artist between *Moses* and the *Virgin* ('the marbles gigantic, the figure of Michelangelo relatively small',[44] as he scribbled on an early sketch), a kind of middle term between mother and prophet, woman and man, his status defined by the looming forms behind him, and one massive fist clenched between his thighs. (In his essay of 1830, Delacroix seemed aware of Michelangelo's homosexuality, but uneasily, almost primly.[45] In the painting he finds a shape – a fairly clumsy one – for Michelangelo's ambivalence, and the primness is abandoned.) The sculptor is Sardanapalus in miniature, with much the same pose and expression, but without the Assyrian's obedient entourage.

I think this sequence is unique in Delacroix's career. Nowhere else do the work and the writing intertwine in this way; rarely does the passion of one invade the other. It is, as I said, a sequence of deformities – but even here the sequence is overlaid on a more familiar, controlled procession of 'necessary' oppositions. Here, as always, Delacroix muses on Man and Nature, on Savagery and Intelligence, on the contest of Light and Darkness, Civilization and Barbarism which the Apollo ceiling was to commemorate. He can be eloquent on these topics, he can be tedious. But he is almost always imprecise; in words, he normally stops short of the point – particular images, specific fears – where the painting begins.

Hence the importance of the sequence we have described. When, and only when, the comforting continuity of these Enlightenment antitheses (and the equally eighteenth-century stoicism which accompanies them) breaks up, then real verbal description begins.

Why not make a little collection of detached ideas which come to me from time to time completely moulded and to which it would thus be difficult to tack on others [*d'en coudre d'autres*]? Is it absolutely demanded that one produce a book, keeping within all the rules? Montaigne writes by fits and starts. Those are the most interesting works. (Journal, 7 May.)[46]

Delacroix has here defined his own procedure; for three weeks his thoughts

come to him fully shaped and self-sufficient, linked to others, but not tacked on to them. A series of detached ideas, springing whole from the unconscious – a kind of free association – takes over; and it is then that we glimpse, for once, a vital continuity between Delacroix's writing and painting.

This continuity is usually missing; I am tempted to say it is repressed. The greatness of the paintings is the ongoing struggle to give form to something other than the civilized moroseness and detachment of the Journals; what the intimate, personal material of that something else may be, comes to light on the page only momentarily, in times of defencelessness and disarray such as May 1850.

First, verbal defencelessness: being without speech leads on to being without one's familiar armoury of literary defences, one's certainty of an audience. Delacroix has spoken to no one. This is a great rarity and a significant one, for the tone of the Journals is most often determined by the tone of Delacroix's conversation. His diary, of course, is more serious than his remarks over dinner; but most of the time the reader is aware of a continuity: the same kind of cynicism, the same kind of decorum and disguise.

And second, social disarray: for this is the other theme of the crisis weeks. In May 1850, barbarism takes on flesh; the old fear for civilization becomes specific, threatening: Delacroix the landlord fears for his property, and fears at times for his life.

Politics do not reach this far, I am happy to say, that's one of the reasons that keeps me here perhaps a little too long. And politics are taking such a turn for the worse that I put off the moment of my return – back to the abyss in which they move and have their being. The peasants here appear detestable; but it's that cursed Paris that's the cause of their confusion.[47]

What a contrast with 1848, and Delacroix's happy, archaic chatter of *bourgeois et manants* combined against Parisian folly! Now Paris spreads to Champrosay; serfs become nineteenth-century peasants and turn detestable and dangerous. A week before, on 28 April, the Parisian electorate had given Eugène Sue, popular novelist and symbol of the revolutionary Left, an enormous majority: that was the 'turn for the worse', and Paris was the bottomless pit. On 9 May, Champrosay armed itself against attack, alarmed by a prowler that the servant had seen nearby. 'All evening we have been making grotesque preparations to defend ourselves in case of an attack at night.'[48] It was a false alarm, but indicative of everyone's state of mind. Times were bad: the Letters and the Journals repeat the message. Even the forest and the flowers serve only as 'contrast with the general sadness'; the horizon is sombre, and Villot comes and sits sadly with Delacroix for a while, both of them oppressed 'on account of all the threats of the present time'. Occasionally the countryside is still a consolation: 'this morning the sight of the fields, the sun, the thought of avoiding that frightful brouhaha of Paris for a little while longer elated me', but, by evening, 'I dreamt only of catastrophes.'[49]

It was part dream, part fact. The peasantry *were* changing, poisoned by ideas from Paris; but, more important, they were embittered by their own sufferings and turning their hatred against targets they knew at first hand: the same rural

bourgeois that Delacroix had mentioned in 1848. This was the crux of politics in 1850; and what Courbet thrived on, Delacroix feared. It was a process which alarmed or delighted everyone. In Delacroix's case, it threatened a consoling myth: the game of being landlord; the belief in an idyllic countryside, the perfect, virgin *opposite* to Paris. It seems as if, when this structure was threatened by events, other more intimate structures of consciousness foundered. It seems as if social fear and sexual fantasy intertwine in May 1850, the former releasing the latter, making it more overt and overpowering, lending it the accents of pathos, almost of panic.

Families deformed and cruel; woman administering her own distributive justice; peasants preparing to administer theirs. These are themes with obvious personal relevance to Delacroix – son of a cabinet-maker's daughter; uncertain who his father was, yet worshipping his putative father's power and probity; losing his father at the age of seven; until the age of sixteen, living as one of the new Napoleonic aristocracy, and then in one disastrous year losing his mother and his social status as the Empire collapsed; perfect bachelor, hiding his dry and shifty affairs, corresponding faithfully with his ex-mistresses; hoping, in 1850, that his old status would return with the new Napoleon (as it did, to a great extent).

There is plenty here to suggest why, in his fantasy, mothers slept with their children, abandoned their husbands, or, like Medea, took a knife to their offspring. Plenty to suggest the roots of Delacroix's imagery of woman – Delilah, Gretchen, Pinabel's mistress, or the ghoulish hand in his dream in 1848. And plenty to indicate why in 1830 he had tried to escape from this subjectivity, to identify himself with a heroic bourgeois history – to make, in the *Liberty Guiding the People*, a new status for himself. But I do not want to posit 'causes' for the crisis of 1850; its mere existence, its structure and the themes it works on, are enough.

Finally, this is the context of Delacroix's greatest achievement in the Second Republic, the painted ceiling for the Galerie d'Apollon. It is sometimes said that the Apollo ceiling is a painting of 1848, that the 'triumph of light over darkness and over the revolt of the waters' symbolized the victory of the revolution over monarchy. Nothing, I think, could be further from the truth; it would be better to say, if one wants political allegory, that the ceiling celebrates and prophesies the Napoleonic *coup d'état*.[50] When Delacroix wrote, in the description he sent with the private-view invitations in October 1851, 'The gods are angry to see the earth abandoned to monsters, impure products of the slime', I doubt if he was thinking of Louis-Philippe. The language is familiar to any reader of the press in 1851, and it refers to present dangers, not past victories. Compare, for example, his own 'abyss in which [politics] move and have their being'.

Delacroix is never quite a propagandist – at least, not in his paintings. The strength of his Louvre decoration lies in its detachment, its avoidance of any image of the present. He sticks close to the iconography laid out by Le Brun, two centuries before; he orchestrates the spaces and the gestures in the grand manner, broadly enough to hold off the gilt and glass of the surrounding decor (in his oil sketch for the ceiling [99] he puts in his own freehand version of the architecture, as if to

make certain that the design works in context); and, as always, he steers the subject towards his own obsessions, makes Apollo's horses rear and bristle, fills the sea with drifting bodies and the stain of serpent's blood.

This is an art closed against the world, in a double sense: private imagery, and painting which aims to continue the old tradition as if the nineteenth century did not exist. Of course that could not be done. No public painting, at least in 1851, could avoid the business of allegory altogether; the language of Delacroix's own description admits as much. But by now it should be clear what was meant, more or less against the painter's will, by the victory of light over darkness. It was not so much the victory of revolution over monarchy as that of Louis-Napoleon over Socialism. It is a reactionary metaphor, directed against 'the depredations of an egalitarian Attila' or 'the Attilas of demagogy' (both Baudelaire's phrases, both of them paying homage to Delacroix's mural in the Palais Bourbon, and neither of them to be trusted as an index of Baudelaire's own politics).[51] In the *Attila* mural [VII], unveiled in 1848, Delacroix had renegued on *Liberty Guiding the People*; though once again the barbarians had excited him once he began to paint them. The Apollo ceiling completed the course in self-discipline. It is Delacroix's rebuke to his own enthusiasm: revolt as the Greeks conceived it, formless and impotent, subdued by Apollo, the sea awash with corpses.

Baudelaire

'I am lazy, disgusted, a *flâneur*, and already I am dreaming of extracting myself from this confusion.'

Proudhon on the February revolution.[52]

'My frenzy in 1848.
 What was the nature of that frenzy?
 A taste for vengeance. A *natural* pleasure in demolition.
 Literary frenzy; memories of things read.
 15 May. – Again the taste for destruction. A legitimate taste if everything which is natural is legitimate.
 The horrors of June. Madness of the people and madness of the bourgeoisie. A natural love of crime.
 My fury at the *coup d'état*. To how many bullets I laid myself open! Another Bonaparte! What infamy!'

Baudelaire: *Mon cœur mis à nu.*[53]

About Delacroix, I told a story; about Baudelaire one cannot be so straightforward. The evidence is fragmentary and obscure: a few letters which give little away; a few stories told by friends, or enemies, years after the event; two or three newspapers, in which we guess what Baudelaire has written; an article on 'Wine and Hashish,' another on his friend the worker poet Pierre Dupont; a handful of poems; that bitter retrospect in the *Journaux intimes*. The evidence does not add up; nor does it have to. The Baudelaire it suggests is shadowy, confused, open:

fluid in his allegiances, hysterical in his enthusiasms, claiming the right to contradict himself. It is Baudelaire *in the interlude*, in a space between two poses, two closures on the world outside.

Interlude does not mean aberration; Baudelaire's actions and dreams in the Second Republic were not simply a mistake, a youthful folly (though it has given comfort to many critics to think so). Baudelaire was not 'immature' in 1848, or no more so than he ever was. All the elements of his philosophy and his aesthetic were already there; some of the greatest poetry had already been written. The poem 'Correspondances' itself was drafted, and the first poems of city life; in July 1848 he published his first article on Poe, whom he had first encountered, a year earlier, in the Fourierist paper *La Démocratie pacifique*; in 1849 he already knew and admired the music of Wagner – the Wagner of *Tannhäuser*, the revolutionary Wagner who had just been thrown out of Dresden.[54] He had written some great pages on Delacroix; he had already called for an art to celebrate the heroism of modern life; he had read Sade; he was probably reading de Maistre. All the dogmas were there, at least in outline; all the heroes were chosen, all the fixed points of Baudelaire's universe. And yet the important thing is that for four years nothing was fixed and everything was tried. Before we interpret the disillusion of 1852, we have to know the stuff of the previous illusions.

After the 1851 *coup d'état*, Baudelaire shuts up shop, covers his traces: 'The 2nd December has physically depoliticized me'. 'I have decided henceforth to stay aloof from all human polemics, and am more decided than ever to pursue the superior dream, of applying metaphysics to the novel.'[55] (Is he thinking already of *Le Spleen de Paris*?) But why does he welcome Napoleon, in the same letter, as the man who would sharpen conflict? Why does he say, 'In fact I should quite like to see only *two parties*, face to face, and I hate this pedantic and hypocritical *centre* which threw me in jail and gave me nothing but dry bread to eat. All that amuses me greatly'; and who are the 'two parties' in question? What did he mean in 1862 when he confessed to Sainte-Beuve that there still survived within him 'an old residue of revolutionary spirit'? And why did he write to Nadar in 1859, 'I have persuaded myself twenty times that I would not take an interest in politics any longer; and each time a serious issue arises I am seized with renewed curiosity and excitement'?[56]

There are no systematic answers. 'The classification of the constituents of a chaos, nothing less is here essayed': Melville on the whale species. To do it I shall use an arbitrary form, a commentary on the text with which we started – Delacroix's brief and contemptuous report on Baudelaire in 1849.

1. '*M. Baudelaire came in. . . . He told me of the difficulties Daumier experiences with finishing.*'

Daumier had been one of Baudelaire's heroes for some time. The best statement of that admiration, in the article 'Quelques caricaturistes français', was probably

in manuscript by 1846.[57] Then, some time after 1851, a few lines were added to the first draft, to bring the story up to date:

Since the February revolution I have seen only a single caricature whose savagery reminded me of those days of fine political frenzy; all the political pleas and counter-pleas put on show in the shop windows at the time of the great presidential election were nothing but the pale shadow of those produced in the time I have just described [i.e. Daumier's cartoons against the July Monarchy]. Daumier's print came shortly after the terrible massacres at Rouen. – In the foreground, on a stretcher, is a corpse, riddled with bullets; behind it are assembled all the town bigwigs, in uniform, well crimped, well buckled, well turned out, their moustaches *en croc*, and bursting with arrogance; and also present, necessarily, some bourgeois dandies who are off to mount guard or to take a hand in quelling the riot with a bunch of violets in the button-hole of their tunics – in other words, the ideal image of the *garde bourgeoise*, as the most famous of our demagogues once called it. On his knees before the stretcher, wrapped in a judge's robe, with his mouth open to show his double row of saw-edged teeth like a shark, F.C. is slowly passing his claws over the corpse's flesh and blissfully scratching it. – Ah! That Norman! he says, He's only shamming dead so as to avoid answering to Justice![58]

Baudelaire's description is all we have. The cartoon is lost, probably never published; very likely it was refused publication for political reasons. For this is a cartoon, like many others by Daumier, of the extreme Left, the recalcitrant, the unreconciled. The workers of Rouen had taken arms against the 'moderate' election result of March 1848; they were crushed in two days of street fighting by the local National Guard and the regular army, using artillery against the barricades. The Rouen rising was the first sign that the lyric illusion of 1848 had ended – the first appearance of the *enragés*, and the first alliance of men of good will against the danger from the Left. The parties in Paris interpreted it according to their lights; either as a bloody massacre, or as a defence of the Republic against its enemies, a blow struck for democracy and universal suffrage.

Baudelaire captures all of Daumier's uncompromising firmness. Notice the word 'bourgeois', twice repeated; notice especially the bourgeois dandy, sniping at insurgents with a violet in his buttonhole. A poignant image for Baudelaire since what he is describing and detesting is his own image – the ideal of the 'Dandy', the same that strutted the closing pages of the *Salon de 1846*, and became Baudelaire's obsession once the Republic had ended. As long as the Republic survived, that obsession was put in cold storage: poverty, and the poet's own erratic version of commitment, saw to that. Does a dandy put his mistress on the streets – on the streets of Dijon worst of all? Does a dandy hare off to the provinces, to edit a tenth-rate local gazette? Does a dandy fight, or talk politics, or believe? Baudelaire in 1848 did all these things. The dandy became Baudelaire's opponent, finally, when the poet chose to fight *with* the insurgents in the June Days; all respectable Paris, all fashionable society, all the intelligentsia of the Left Bank, stood against him on the side of Order. In the caricature, they are the 'bigwigs of the town'; and the corpse is Baudelaire himself, as a friend saw him, 'nervous, excited, febrile, agitated,' in the gardens of the Palais Royal.

I had never seen Baudelaire in such a state. He was ranting, making speeches, boasting, getting ready to make a martyr of himself: 'They've just arrested De Flotte,' he said. 'Is that because his hands smell of powder? Smell mine!' Then there followed Socialist slogans, the apotheosis of social bankruptcy, *et cetera*.[59]

All this was said to Philippe de Chennevières and Levavasseur, two worthy artists who had just done their turn on guard at the Louvre, preserving its treasures against the mob. The whole performance is marked, in a way which makes these reminiscences credible, with the dual stamp of revolution: alcohol and cold sweat, panic alternating with bravado, the threat of arrest as real as the sudden (mistaken) feeling that the social order was at an end.

Daumier was different. Like Pierre Dupont – Baudelaire's quiet companion during the June Days – he stood for a calm assurance in his hatreds. There was something *sane* in his laughter, in his very extremism; there was something deeply attractive in his ordinary isolation on the Ile Saint-Louis. No one could be further from panic or exaltation than Daumier; yet no one depicted the bourgeoisie with more savagery. As Baudelaire suggested at the climax of his account of Daumier in 'Quelques caricaturistes français'.

Look through his work, and you will see parading before your eyes, in all their fantastic and thrilling reality, all that a great city contains of living monstrosities. . . . The live and starving corpse, the plump and well-filled corpse; the ridiculous miseries of home and family, all the foolishness, all the pride, all the enthusiasms, all the despairs of the bourgeois – nothing is missing. Like nobody else, Daumier has known and loved (after the fashion of artists) the bourgeois, that last vestige of the Middle Ages, that Gothic ruin that clings to life, that type at once so banal and yet so eccentric. Daumier has lived in intimacy with him, he has spied on him day and night, he has penetrated the mysteries of his bedchamber, he has consorted with his wife and his children, he knows the form of his nose and the construction of his head, he knows what spirit animates the house from top to bottom.[60]

This is, I think, the crucial tribute to Daumier. At different times he was many different things to Baudelaire: the man who blasphemed and spat upon mythology in the series of caricatures *Ancient History*; the great draughtsman, the artist of peculiar certainty and endless invention, the colourist in black and white; the friend whom one visited when times were bad (after the *coup d'état*, for example, with Poulet-Malassis). But above all he was the anti-bourgeois. He was the one critic whose laughter could not be ignored, who loved and hated the bourgeois in ways that had nothing to do with artistic fashion. The disdain of the studios for the bourgeois was futile, self-congratulating; Baudelaire wanted nothing to do with it. In the same year, 1846, when he drafted his homage to Daumier he prefaced his 'Salon' with an address 'Aux bourgeois', a shifting, double-edged, elusive tribute, tinged with Fourierist respect for the new power, but laughing at its own deference. In any case, marked by contempt for the bourgeoisie's opponents: the disappointed aristocrats like Alfred de Vigny, or the great squad of artists who, as usual, were 'misunderstood'.

It was Daumier who suggested an alternative – a style which could be hostile

67 HONORÉ DAUMIER *'You have the floor: explain yourself; you're free.'* 14 May 1835
68 HONORÉ DAUMIER *'Everyone told the Government . . .'* 5 July 1848
69 HONORÉ DAUMIER *'Where can that band of armed men be going?'* 10 April 1848

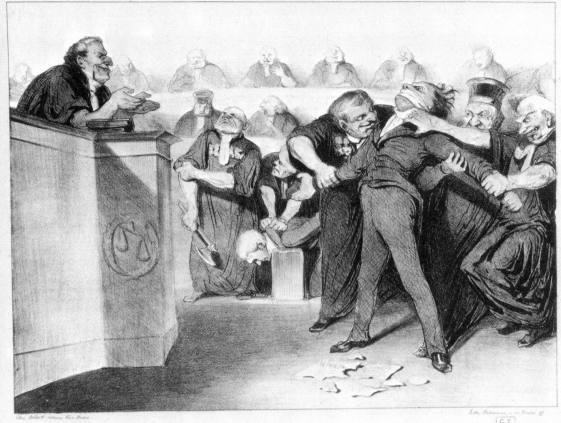

Chez Aubert Galerie Véro-Dodat Lith. Delaunois, r. des Noyers 27.

..... Vous avez la parole, expliquez-vous, vous êtes libre !

TOUT CE QU'ON VOUDRA. N° 48.

- On a dit au Gouvernement qu'il ne marchait pas, alors, naturellement, l'idée lui est venue de
prendre tous les chemins de fer !
- C'est vouloir aller trop vite !

..... Où peut aller cette bande d'hommes armés !..... rentrons ma femme, c'est effrayant

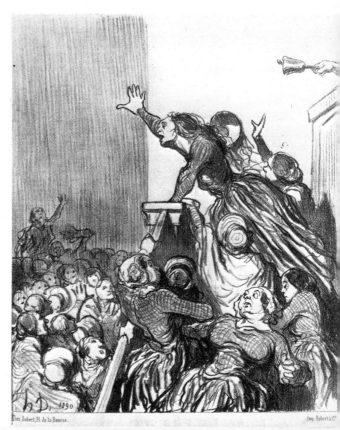

70 HONORÉ DAUMIER
The Soup c. 1860

71 HONORÉ DAUMIER
Les Divorceuses 4 August 1848

2 HONORÉ DAUMIER
Ratapoil and Casmajou
1 September 1851

3 HONORÉ DAUMIER
*'Blow, blow, you will never
extinguish it'* 1835

Soufflez, soufflez vous ne l'étandrez jamais.

— Ni l'un, ni l'autre!

ACTUALITÉS.

Un Cauchemar d'un bon petit bourgeois de la Place St. Georges.

74 Honoré Daumier
'Neither the one nor the other'
24 October 1851

75 Honoré Daumier
'1851, Year 4 of the Republic'
16 January 1851

76 Honoré Daumier
'The People holds the Ring'
18 November 1851

77 Honoré Daumier
Ratapoil Making Propaganda
19 June 1851

78 Honoré Daumier
'The fat Deputy over the road . . .'
21 August 1849

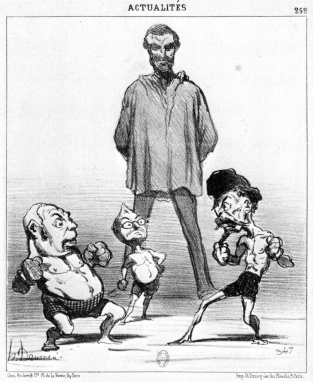

Le peuple juge les coups.

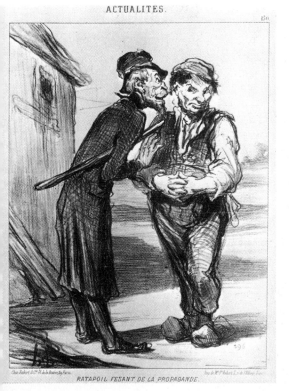

ACTUALITES.

RATAPOIL FESANT DE LA PROPAGANDE.

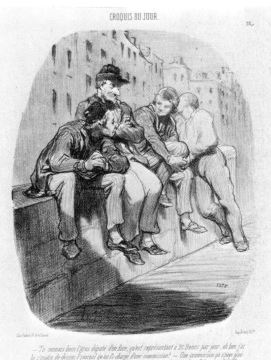

CROQUIS DU JOUR.

79 HONORÉ DAUMIER
The Repentant Magdalen c. 1849–50

80 HONORÉ DAUMIER
Silenus 1850

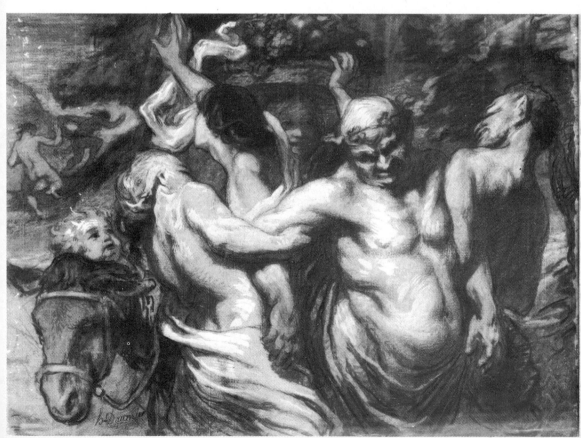

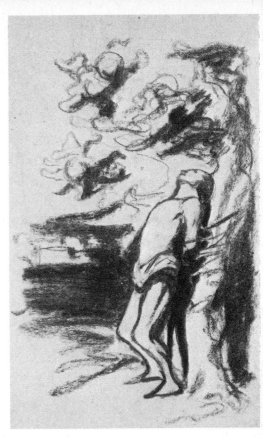

81 HONORÉ DAUMIER
St Sebastian c. 1849–50

82 HONORÉ DAUMIER
Archimedes and the Soldier c. 1850

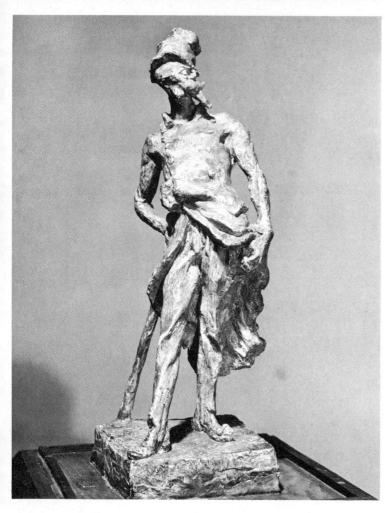

83 HONORÉ DAUMIER
Ratapoil c. 1850–51

84 HONORÉ DAUMIER
The Refugees c. 1850

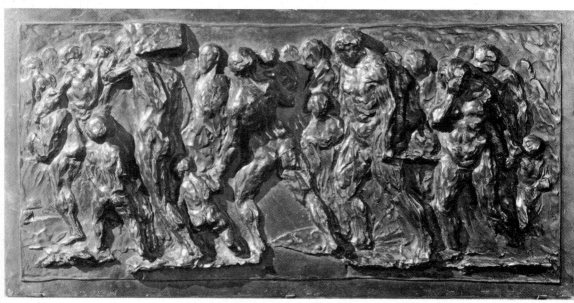

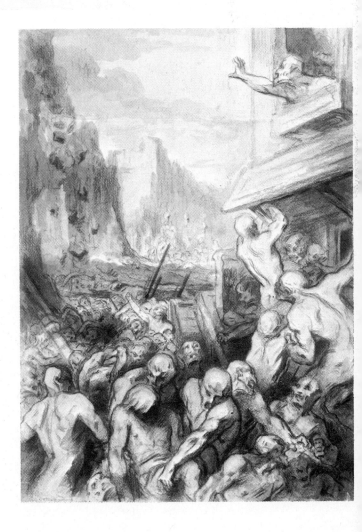

85 HONORÉ DAUMIER
The New St Sebastian
25 December 1849

86 HONORÉ DAUMIER
The Uprising c. 1850

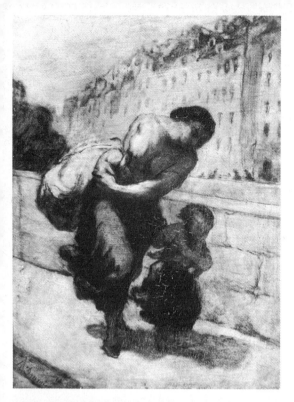

87 HONORÉ DAUMIER *The Heavy Burden* c. 1850–55

88 HONORÉ DAUMIER *The Fugitives* c. 1853

89 HONORÉ DAUMIER *The Saltimbanques* c. 1855–60

90 HONORÉ DAUMIER *A Saltimbanque* c. 1855–60

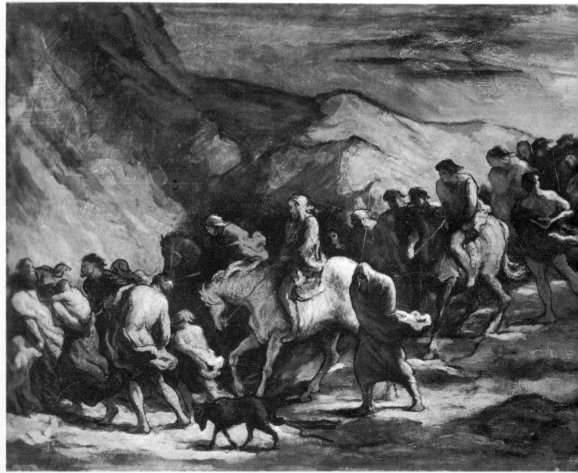

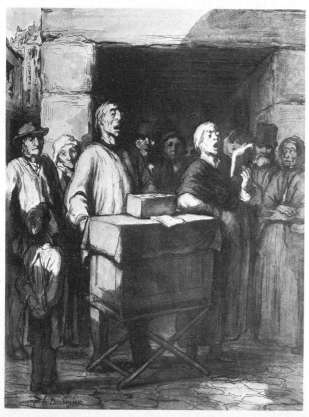

91 Eugène Delacroix *Geraniums* 1849

92 Honoré Daumier *Street Singers* c. 1855–60

3 EUGÈNE DELACROIX *The Good Samaritan* c. 1849–50

4 EUGÈNE DELACROIX *The Agony in the Garden* 1851

95 Eugène Delacroix
Michelangelo in his Studio 1850

96 Eugène Delacroix
Samson and Delilah 1849

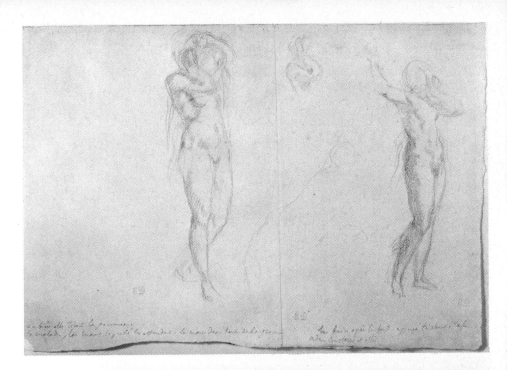

7 Eugène Delacroix
Studies for *Woman Combing her
Hair* and an *Adam and Eve* c. 1847

8 Eugène Delacroix
Woman Combing her Hair
1850

99 Eugène Delacroix Sketch for *Apollo Victorious over the Serpent Python* c. 1850–51

but not petulant, which could mock the bourgeois without carping. By the end of 1851, Baudelaire the journalist was producing his own kind of caricature, laughing at 'that decent bourgeois lady, cooing amorously on the shoulder of her man and making languid eyes at him, as in all the novels she has read'; or depicting a theatre audience full of lawyers, pleased with the 'common sense' of a certain playwright and 'acclaiming the author because he treats them as equals and on their behalf takes vengeance on all those scoundrels who have debts'.[61] Compare Baudelaire on the bourgeois five years earlier in 1846:

Often enough we have heard young artists complaining about the bourgeois, and making him out to be the enemy of everything great and beautiful. – That is a mistake that it is time to put right. There is one thing a thousand times more dangerous than the bourgeois, and that is the bourgeois artist, who was created to stand between the public and the genius: he hides them from each other . . . If we got rid of the bourgeois artist, the grocer would bear Eugène Delacroix in triumph. The grocer is a great thing, a celestial man who should be respected, *homo bonae voluntatis!*[62]

Perhaps in essence Baudelaire never changed his mind. But by 1851 he had less time for sympathy with the shopkeepers and their hidden aspirations. The bourgeois artist still held the centre of the stage, the sweating grocer carried Napoleon, not Delacroix, in triumph. There were now 'two parties, face to face' – *bourgeoisie* and *peuple*, no less – and it was time to take sides. 'All that amuses me greatly.'

Finally, Daumier taught Baudelaire to look at 'all that a great town contains of living monstrosities'. He was one of the forces that made Baudelaire a poet of the city. Some time before 1851, Baudelaire gave Daumier a present, a fair copy of a poem called 'Le Vin des chiffonniers' ('The Ragpickers' Wine'). It was the first version of a poem which would go through many transformations before *Les Fleurs du Mal*: done into prose in 1851 as part of 'Du vin et du hachish', appearing in 1854, alongside some prose by Pierre Dupont, in *Jean Raisin, Revue joyeuse et vinicole*.[63] But it remained Daumier's poem: not, probably, derived directly from Daumier's painting *The Ragpicker*,[64] but sharing the subject, and aiming at something of the same effect. To combine the prosaic with the extraordinary, to see in the sordid and absurd the remnants of a human stance, to put the monstrous and the pathetic in contact: this was the aim of Baudelaire's city poems, and Daumier was one example of how it had been done. The progress of 'Le Vin des chiffonniers' is from a plainness of diction – with metaphor inserted uneasily into a prose structure – to a verse which shifts from the ordinary to the fantastic, line by line, phrase by phrase.

Compare three versions of the opening lines. The present to Daumier:

> *Au fond de ces quartiers sombres et tortueux,*
> *Où vivent par milliers des ménages frileux,*
> *Parfois, à la clarté sombre des réverbères,*
> *Que le vent de la nuit tourmente dans leurs verres,*

> On voit un chiffonnier qui revient de travers,
> Se cognant, se heurtant, comme un faiseur de Vers,
> Et libre, sans souci des patrouilles funèbres,
> Seul épanche son âme au milieu des ténèbres.[65]

The prose-poem of 1851: after a long description of the ragpicker's job itself, 'living so to speak, on the refuse of our great cities':

Le voici qui, à la clarté sombre des réverbères tourmentés par le vent de la nuit, remonte une des longues rues tortueuses et peuplées de petits ménages de la montagne Sainte-Geneviève. Il est revêtu de son châle d'osier avec son numéro sept. Il arrive hochant la tête et butant sur les pavés, comme les ʲeunes poètes qui passent toutes leurs journées à errer et à chercher des rimes. Il parle tout seul; il verse son âme dans l'air froid et ténébreux de la nuit.[66]

And the poem of *Les Fleurs du mal*:

> Souvent, à la clarté rouge d'un réverbère
> Dont le vent bat la flamme et tourmente le verre,
> Au cœur d'un vieux faubourg, labyrinthe fangeux
> Où l'humanité grouille en ferments orageux,
>
> On voit un chiffonnier qui vient, hochant la tête,
> Buttant, et se cognant aux murs comme un poëte,
> Et, sans prendre souci des mouchards, ses sujets,
> Epanche tout son cœur en glorieux projets.[67]

There is no simple 'improvement' in this sequence: least of all between the prose-poem and the stanzas of 1857, where the differences are attuned to a sense of what prose and verse can do. But Baudelaire has been fastidious for a reason. Between the manuscript he gave to Daumier and the version he finished for *Les Fleurs du mal*, what he cut out of his poem is a sense of narrative, gradually unfolding – from time to time a person walks towards us, down one street, into our field of vision. In *Les Fleurs du mal* the opening adverb *Souvent* telescopes the description because it demands an event, which is then held back for four lines, and comes in its turn with complex, lurching syntax. (The two versions are quite different here. Compare the steady, cumulative effect of *Au fond . . . Parfois . . . On voit . . .* in the Daumier manuscript with the final arrangement. Notice, in the final version, the doubling of *Et* in stanza two, each time with a distinct syntactic force; and the deliberate awkwardness of the second main verb *épanche*, far from its subject, echoing the opening sound of the line before, and deprived of its softening false subject *seul*.) The diction also changes: it contrives to be, phrase by phrase, either more accurate or more succinct; and at the same time outlandish and splendid, in a way quite alien to the first draft. In Baudelaire's poetry accuracy and strangeness usually go together; the briefest possible statement is hyperbole. Hence between the prose-poem and *Les Fleurs du mal* he is mainly concerned to discard anecdote and visual detail. In 'Du vin et du hachish' the story turns on the weird shawl made of osier; it reappears in the final moments, when the ragman imagines he is Bonaparte dying on St Helena: 'It seems that the number seven has changed

into an iron sceptre, and the osier shawl into an imperial mantle.' In the final poem the shawl and the mystic number are suppressed, and the simile of the stumbling poet is tightened to the form of an aside; the district of Sainte-Geneviève is turned into *un vieux faubourg, labyrinthe fangeux*, a more savage image, but less particular.

And, as so often in Baudelaire's city poems, there appears a clinching metaphor which hints at a kind of travestied class relationship: the night police patrols from the first version are reinstated, but become the ragman-emperor's subjects; the narks turn servile, the drunken pariah rules at last, in fantasy and isolation.

This is the point of the changes, the workmanship: to make a verse in which inner and outer worlds are shuffled, where the city appears indirectly, in the course of an intensely private narrative – but appears in its real form, all the more oppressive for not being described. The city in Baudelaire can only be given form in fantasy: it is the world in which 'new palaces, scaffoldings, blocks, old suburbs, to me all becomes allegory'; it is a 'setting like to the actor's soul', a setting which in its turn warps the actor to its own shape. 'Le Vin des chiffonniers' is the prototype of this kind of poetry; and in the years round 1860 – above all, perhaps, in the prose poems of *Le Spleen de Paris* – Baudelaire brought it to perfection. This is the core of his 'modernity': that there are no ways to describe the city, no forms to give it, but the refractory imaginings of the outcast or the melancholic. *Le Spleen de Paris* means two things finally – that Paris produces its own *spleen*, and that *spleen* produces its own Paris. The city of *spleen* may be a caricature, but at least the poet can enumerate its features, pass ironic judgment. From the mountain, in the epilogue to the prose poems, the poet looks down with a kind of contentment:

> D'où l'on peut contempler la ville en son ampleur,
> Hôpital, lupanar, purgatoire, enfer, bagne,
>
> Où toute enormité fleurit comme une fleur.[68]

Hell, the whorehouse, and the paupers' hospital: Paris as the ragman sees it.

2. He then ran on to Proudhon whom he admires . . .

We have other verdicts on this admiration. A few months later, Jean Wallon, a Bohemian philosopher (drawn by Courbet in 1848), published his review of *La Presse de 1848*. His verdict on Baudelaire, whom he knew at close quarters, was succinct:

Charles Baudelaire, or Baudelaire du Fays, or Pierre Defays, has done two volumes of criticism on the Salons of 1845 and 1846, a short novel *La Fanfarlo*, a lot of verse and sometimes fine verse; today we see announced in *L'Echo des marchands de vin*: *Limbes*, to be published on 24 February at Paris and Leipzig. They are doubtless Socialist verses, and in consequence bad verses. Yet another new disciple of Proudhon, due to *too much* or *too little* ignorance. . . . For the last few months everybody seems to have lost his head, nobody believes in literature any longer, everyone has rushed into Socialism – without seeing that Socialism is the absolute negation of art.[69]

This was deliberately unkind, but not all that improbable. Why should not *Les Limbes* (Baudelaire's title for *Les Fleurs du mal* at this period) have been Socialist? With a title like that, full of Fourierist overtones (the 'Limbic periods' in Fourier's theory were times of industrial unrest and social advance); timed for publication on the first anniversary of the Republic; announced in a Socialist newspaper (and wine-merchants, one should remember, were the traditional propagandists of the Left, the regular leaders of insurrection); and accompanied in the same issue by the poem 'Le Vin de l'assassin' – why should not Wallon fear the worst? He had presumably read this poem, disliked its simple diction and its ballad-form, misunderstood its mixture of Sade and Pierre Dupont, its strange humour, 'cynical and dismal as a popular song', as Georges Blin described it.[70] (It seems to me Baudelaire's best attempt to use the forms, and adopt something of the attitudes, of popular art. This was something he tried several times around this date, and which puts him closest to Courbet's concerns at the time. The phrase from Georges Blin I quoted could be applied with almost equal justice to Courbet's *Burial at Ornans* – and phrases very like it were used by the critics in 1851. There are various versions or echoes of Realism in Baudelaire's work: 'Le Vin de l'assassin', and the closely related melodrama *L'Ivrogne* which he planned in 1854, are the closest he comes to Courbet's variety. In any case we can sympathize with Gautier when he called the poem, by mistake, 'Le Vin de l'ouvrier'.)

All this was anathema to Wallon. The year before, in collaboration with the novelist Champfleury, he had edited his own 'popular' paper, *Le Bonhomme Richard* – the title indicates its attitudes to popular art. (Richard was the archetype of acceptance and submission, the *bonhomme misère* who bore his poverty bravely, who preached from the obvious text that 'The poor ye have always with you.') All the more reason to dislike those who seized on other, more subversive aspects of the art of the folk; all the more reason to condemn *Les Limbes* in advance.

Wallon was wrong about *Les Limbes*, of course. They were not Socialist, and by late 1851 Baudelaire was as suspicious of *l'école socialiste* as he was of *l'école bourgeoise*: since they both shrieked Moralize! moralize! with the fervour of missionaries. But Wallon was right about Proudhon. In 1848 Baudelaire *was* a disciple, and the encounter with Proudhon marked his work and his attitudes for the rest of his life.

It was, as Baudelaire ruefully acknowledged later, the most unlikely of all confrontations. Proudhon: superbly uncouth; pettiest of petty bourgeois in his views of the family and woman (though this latter condescension must have appealed to Baudelaire); improbably fertile in half-ideas, improbably skilful as a writer of prose; provincial, anarchist, enemy of God, bogey of the bourgeoisie, epitome of revolution. ('His one aim,' shrills Jean Wallon, 'his only preoccupation, is the destruction of the social order.'[71]) What stranger master for the dandy Du Fays, the author of 'Correspondances'? Yet the enthusiasm leaves its traces all through these years. 'Proudhon is a writer that Europe will envy us for all time', he writes in 1851; and a few months earlier in his introduction to the collected verse of Pierre Dupont he sees a secret affinity between Dupont and

that sublime passage from Proudhon, full of tenderness and enthusiasm: he hears some men humming the song from Lyons,

> Allons, du courage,
> Braves ouvriers!
> Du cœur à l'ouvrage!
> Soyons les premiers,

and he cries: 'Yes, go to work singing, race of the future, your refrain is more beautiful than that of Rouget de Lisle.'[72]

This is not the Baudelaire we know. Still less is this one, scribbling a letter from a corner café to his hero in 1848, warning him breathlessly of a threat to his life:

A devoted and unknown friend *wishes absolutely to see you*, not only to educate himself and to use a few minutes of your time, as perhaps would be his right, but also to inform you of certain things you might not know, relative to your safety. . . .
 I have struggled for a long time with my own laziness in order to write you a very long letter; but I have preferred to dare to tackle you directly. . . . If you don't find it eccentric that a wretched unknown should ask for an immediate reply from a man like yourself, with so much work and so many things to do – in case you do, I shall wait *indefinitely* at the café-restaurant on the corner of the rue de Bourgogne.[73]

For this Baudelaire, Proudhon was the leading light (*le grand bouc*) of the revolution. 'He who writes these lines has absolute confidence in you, and so do many of his friends who would march blindly behind you in return for the evidences of knowledge [*les garanties de savoir*] that you have given them.'[74] The friends in question could only be Dupont and Courbet.

This Baudelaire, in spite of being 'a wretched unknown', had certain ideas on political strategy, certain suggestions to make to the leader. There was room for improvement in Proudhon's newspaper – 'for example, in the weekly edition' – and it was time that back numbers were reprinted. It was time, above all, that Proudhon and his men printed 'an immense poster . . . printed in enormous quantities and COMMANDING the people not to make a move. Your name is at present better known and more influential than you think. An insurrection can start by being Legitimist and finish by being Socialist; but it could happen the other way round.'[75]

This last advice – from a man who had fought in June – was subtle and correct. It puts Baudelaire's retrospective disgust with the June Days in a new light. At the time, he turned against the idea of insurrection because he had seen it fail: because he had seen the 'madness of the bourgeoisie', the bloodbath of repression. Another insurrection without a programme and without organization would once more be crushed by the army, or fall prey to the Right; there had been white flags, the emblems of the Legitimists, on some of the June barricades. If one can infer a policy from these letters, it is one of commitment to the people but opposition to a premature uprising. Now was the time for politics, journalism, organization, the building of a party, the improvement of a newspaper. In August 1848, with Cavaignac firmly in the saddle, it was not bad tactics.

But why did Baudelaire and his friends put their faith in Proudhon? Why did the opposites meet? – for they did meet some time that year, over one of Proudhon's seven-course meals. The reason was this: Proudhon, more than any other man, stood for opposition to the dreams and vagueness of February, the lyric illusion of the young Republic, promising everything and offering no single concrete proposal. And this is the one fixed point in Baudelaire's politics, from March 1848 until paralysis and death. After the first fortnight of revolution, and the fine phrases of *Le Salut public*, he became and remained an opponent of February. He fell out of love with the Republic in a matter of weeks. By the time of the election campaign he was heckling Alphonse Esquiros, poet and novelist, who like every Parisian candidate was bemoaning the sad condition of the workers. Baudelaire asked him, first, 'if the interests of the small trader did not seem to him as sacred as those of the working class?'; second, 'Since we're talking about commerce, what is your opinion on free trade – this all-important question which could be regarded as the keystone of the social edifice?'[76] No wonder Esquiros blushed, stammered, and left the platform to sit with his wife! These were not the questions of February; though they were questions familiar to any reader of Proudhon. This is heckling à la Proudhon – free exchange, cooperation between small trader and worker: these are the coping stones, if not of the social edifice, at least of Proudhon's great work, published two years earlier, *Système des contradictions économiques*, or *Philosophie de la misère*.

This book was Proudhon's *summa*: the codification of his ideas on economics and society, but also on God, Hegel, the family, art, morality; every topic that touched his vast, incoherent train of thought. As a textbook of Socialism, and an imitation of dialectic, it was lamentable; and Marx's searing reply in the *Misère de la philosophie* was accurate enough. But as a bran-tub of details and ideas, as a corrective to the utopian prophecies of Fourier and Pierre Leroux, it had its uses. And Baudelaire, reading it in ways rather different from Marx, made good use of it. He sought in it confirmation – in an unfamiliar context, and in a language which was powerful but lugubrious – of his most personal concerns. Some time in these years he copied down the following paragraph from Proudhon's book:

Art – in other words the search for the beautiful and the perfecting of truth, in his own person, in his wife and children, in his ideas, in what he says, does and produces – such is the final evolution of the worker, the phase which is destined to bring the Circle of Nature to a glorious close. Aesthetics, and above Aesthetics, Morality, these are the keystones of the economic edifice.

It is a strange enough fragment. It comes from the concluding chapter of Volume II, called *La Population*, in which Proudhon mounts an argument against free love, George Sand, and eroticism in general. If I quote the paragraphs on either side, the relevance of the argument to Baudelaire should be clear:

By the very fact that labour is divided, it becomes specialized and determines itself in each of the workers [a typical half-Hegelian turn of phrase]. . . . Every specialization in work is a

summit from whose heights the worker looks down and dominates the whole field of social economy, making himself the centre and inspector of it. . . .

In the same way, in marriage love comes to an end and becomes personalized; once again by the purification of his feelings, by the worship of the object to which he has devoted his existence – it is in this way that man must triumph over the materialism and monotony of love.[77]

Then the paragraph Baudelaire took down. Then the conclusion:

The whole field of human activity, the progress of civilization, the tendencies of society, bear witness to this process. All that makes a man, all that he loves and hates, all that affects and interests him, becomes for him a matter of art. He composes it, polishes it, harmonizes it, until by the prestige of his work one could say he makes matter disappear from it.

Man makes nothing according to nature: he is, if I dare put it this way, a ceremonious animal [un animal façonnier].[78]

It is this section – a rambling, Hegelian argument about the utility, as opposed to the utilitarianism, of art – which lies behind Baudelaire's remark in 1851 that 'art was henceforth inseparable from morality and utility'. And the next few pages of Proudhon's text, on man's double idealization of work and love, may be one source of a poem written at this time called 'La Rançon'. 'La Rançon', as Baudelaire put it in 1852, is *Socialisme mitigé*: lyrical and revolutionary, sown with biblical allusions, but pursuing a firm enough argument. Man, to pay his ransom, must till the fields of Art and Love with the ploughshare of reason – a ceaseless struggle, sweat pouring from his brow. At the Last Judgment he must show grain but also flowers – a plain harvest alongside a crop which will win favour by its forms and colours, not its food value.[79] And finally, in a last verse which he suppressed once the revolution had faded, the crops would be held in common.

> Mais pour que rien ne soit jeté
> Qui serve à payer l'esclavage,
> Elles grossiront l'apanage
> De la Commune liberté.[80]

Baudelaire found other things in the *Système des contradictions économiques*. He read there a kind of description of the proletariat – detailed and particular in the facts it reported, untrammeled in its anger, hypnotic in its rhetoric of repetitions – which marked his earliest poems of the city. Take, for example, the famous passage on the naked poor, 'dwelling in holes, like so many albinos', waiting while corpses rotted in the same room, since the price of bier and undertaker's mute could not be raised; 'the virgin and the prostitute expiring in the same state of nakedness; everywhere despair, consumption, hunger, hunger.' It is Proudhon's own version of Baudelaire's 'Crépuscule du soir'; all the more terrible for being documented step by step. And it is followed, directly, by a call for *poets* of the new order.

The mass murders of monopoly have not yet found their poets. Our versifiers, unaccustomed to the affairs of this world, without guts for the proletariat, continue to sigh for their melancholy *pleasures* by the light of the moon. And yet what a subject for *meditations*, these miseries born of monopoly.[81]

In his own way, Baudelaire took heed of Proudhon's scorn.

Finally, Proudhon's book is an attack on God. Among many other things, the *Système des contradictions économiques* is a work of theology, marked by a 'an all-invading and enigmatic theodicy',[82] reaching its climax in a hymn to Nobodaddy, to a jealous and terrible God, to a God who exists but whose name is Satan. Everyone knew the great passage in which Proudhon named his God (Wallon quoted it in his review of the *Représentant du Peuple*), and reading it recalls directly Baudelaire's 'Le Reniement de saint Pierre'. For this is Baudelaire's religion.

Your name, which has so long remained the scholar's last word, the judge's sanction, the monarch's strength, the poor man's hope, the repentant sinner's refuge, this incommunicable name, will henceforth be an object of contempt and hatred, jeered at by all mankind. For God is stupidity and cowardice; God is hypocrisy and lies; God is tyranny and wretchedness; God is Evil.[83]

There is a God, and man aspires towards him. But God in turn is jealous of his own creation, 'jealous of Adam', 'tyrant of Prometheus'. Knowledge and society are won in spite of God, against his trickery and opposition: 'each of our steps forward is a victory in which we shall crush divinity'. And the world itself is God's trap, the place where He becomes evil, in a sordid contest with his creatures:

Look, Holy Father, what you have done for our happiness, and your glory. . . . The sins for which we ask your forgiveness, *you* made us commit; the snares against which we ask your protection, *you* set up: and the Satan who assails us, that Satan is you.[84]

Proudhon's theodicy is not systematic, not even coherent – any more than Baudelaire's. (And Baudelaire's changed: the religion of 'Révolte' in *Les Fleurs du mal* – which is the religion of Baudelaire in the Second Republic – is different from that of the 1860s. Neither is Christian or Catholic, though both are built of Catholic materials.) 'Le Reniement de saint Pierre' and 'Les Litanies de Satan' suggest a thousand attitudes to God, from simple resentment to an infinitely subtle form of obedience. They do not opt for any one theology; as always they equivocate. But they equivocate in anger: they rail at the divorce of the real and the sacred, of action and dream (since one is not the sister of the other, they both become, in 'Le Gouffre', aspects of the same abyss, the same hopelessness). It is this quality Baudelaire shares with Proudhon: both of them preach a Satanism in which God's world is Hell. Many men had accused their God of cruelty; what *they* did was take the accusation to its logical conclusion. When Jesus, or the poet, addresses us in the last four lines of the 'Reniement', he does not borrow words from Proudhon (there are no borrowings, in fact). He speaks with his own voice:

> Certes, je sortirai, quant à moi, satisfait
> D'un monde où l'action n'est pas la sœur du rêve;
> Puissé-je user du glaive et périr par le glaive!
> Saint Pierre a renié Jésus . . . il a bien fait![85]

But the tone and the argument owe everything to the *Philosophie de la misère*. And the close of 'Abel et Caïn' is closer still.

> Race de Caïn, au ciel monte,
> Et sur la terre jette Dieu![86]

Do it, because God is Evil.

3. . . . *whom he . . . calls the idol of the People*

The operative word here is *peuple* and its cognate *populaire*. It is a word which appears seldom in *Les Fleurs du mal*, more often in *Le Salut public*. (Some of its force is displaced on to the word *commun*, which has special connotations for Baudelaire's poetry between 1848 and 1852. Not only the '*Commune liberté*' but the terrible equality of the common grave: in 'Spleen' the skull 'which contains more dead men than the common grave'; the sick who 'finish their destiny and go towards the common abyss'. The common ditch was a sign with many meanings for Parisians, and the fear of that final anonymity haunted the workman all through the nineteenth century: the first things he saved for were a funeral and a headstone. It was a horror that Baudelaire exploited, perhaps even shared.)

Besides Proudhon, *peuple* and *populaire* suggest Pierre Dupont: 'Poet of the people, tireless singer of songs, had the good fortune to catch the scent of the February revolution, and to add to his reputation as a bucolic poet the prestige of a revolutionary poet',[87] as Baudelaire sketched him in 1853. The two men had met in the early 1840s, and by 1846 they were close friends. Baudelaire was one of the first to hear Dupont's greatest poem 'Le Chant des ouvriers'. His reaction was immediate: 'When I heard that splendid cry of sorrow and melancholy . . . I was moved and bewildered. We had been waiting so many years for some poetry which was strong and true!'[88] If this was popular poetry – and Dupont, apprentice weaver, bank clerk, office-boy at the Academy, was nothing if not a man of the people – then popular poetry must be taken seriously. It was no longer the invention of the Fourierist press; Dupont, with his careful attention to language and his talent for rhythms which could be sung, had made it a reality.

Dupont was two things to Baudelaire. First, he was a friend: the man who moderated Baudelaire's passion in the June Days; the political influence whom Wallon and Champfleury both attacked in print (Wallon in his review of the press, Champfleury in a special article in April 1851). Second, he was a poet of some complexity, of very different moods and styles. 'Le Chant des ouvriers', or at least its opening lines –

> Nous dont la lampe le matin
> Au clairon du coq se rallume,
> Nous tous qu'un **salaire** incertain
> Ramène avant l'aube à l'enclume . . .[89]

– is the finest thing Dupont wrote, but it hardly represents him. He could be both more violent than the well-known songs suggest, and more subtly prosaic, in a

way which steers close to Baudelaire's modernity. More violent, in songs produced for the moment and never collected in book form – like this one, published in Proudhon's paper *Le Peuple* a few days before the uprising of June 1849, in the midst of the cholera epidemic (I quote the last verse only):

> La Réaction sur nos murs
> Etale son aile livide;
> Chassons les miasmes impurs
> Dégageons le marais putride.
> Nous nous plaignons du choléra
> Il nous guette dans notre gîte:
> Un coup de vent le balaîra.
> Hurrah! les morts vont vite![90]

This is clumsy and overpitched, but its very extremism is closer to Baudelaire than many of Dupont's kinder songs. Closer still, and far better poetry, is the other side of Dupont; understated, plain, particular; mimicking the monotone of labour, in the last stanza and refrain of 'Le Tisserand'.

> La propreté n'a pas de rang;
> Dieu donne le chanvre et l'eau vive.
> Faites gagner le tisserand
> Et les laveuses de lessive.
> Suffit-il pour être content
> De bien manger et de bien boire?
> Il faut avoir dans tous les temps
> Du linge blanc dans son armoire.
>
> Des deux pieds battant mon métier,
> Je tisse, et ma navette passe,
> Elle siffle, passe et repasse,
> Et je crois entendre crier
> Une hirondelle dans l'espace.[91]

That was poetry Baudelaire could learn from: not just in 'La Rançon' or the later songs like 'L'Invitation au voyage', but in the texture of many of the poems in prose.[92]

In the summer of 1851, Baudelaire wrote an introduction to Dupont's collected *Chants et chansons*. It was a strange and unaffected homage to a friend – one which Baudelaire blushed over later. It was a reply to Dupont's critics, to Champfleury who had dismissed him a few months earlier with the words 'his verse is not revolutionary – it's more like Empire! You'll find plenty of old adjectives, bought in the Faubourg du Temple, as Murger would say; high-sounding words predominate.'[93] This was accurate judgment of Dupont's weaker verse; as a judgment of his poetry as a whole it was puerile distortion. And Baudelaire replied directly. He welcomed Dupont both as poet *and* as political evidence – 'not so much because of his own value, great as it may be, as because of the public sentiments of which Pierre Dupont has become the echo'.[94] Dupont was great because he put himself

'in permanent communication with the men of his time', because 'every true poet must be an incarnation'; he was popular because of his love of virtue and humanity, because of his 'infinite taste for the Republic', because of the irrepressible joy in his works (the same joy, Baudelaire remarks slyly, that Champfleury noted in Balzac).

It is an extraordinary *credo*, and an extraordinary *mea culpa*. For the enemy of art, in this article, is pessimism, melancholy, a sense that the world is beyond help. Long ago, 'from the depths of a fictive grave', Sainte-Beuve 'strove to interest a confused society in his own incurable melancholy.' But that time is past: the genius of action has displaced it.

In fact nature is so fine and man is so great that it is difficult – if one takes a sufficiently elevated point of view – to conceive the meaning of the word 'irreparable'. . . .

So disappear, deceptive shadows of René, Obermann and Werther; vanish into the mists of nowhere, monstrous creations of idleness and solitude; like the Gadarene swine, go dive into the enchanted forests where enemy fairies lead you onwards – you sheep, attacked by the romantic vertigo. The genius of action leaves no room for you amongst us.[95]

Disappear also, Poe, de Maistre, Sade; disappear the poems of *spleen*, written or in gestation at this very time; disappear Baudelaire, disappear *Les Fleurs du mal*. But then, the Republic allows the right to contradict oneself – and the genius of action, in summer 1851, meant something other than the *coup d'état*. No wonder at least that Dupont appreciated the tribute, and took its point: that 'Baudelaire, at least, has not pretended prudery towards those songs which are called political.'[96]

4. *His views appear to me thoroughly modern . . .*

Ses vues suggests too much. What did Baudelaire think and do in the Second Republic, what were his politics?

They were personal or they were nothing. Baudelaire fought because he had a personal stake in revolution; because he was poor, because he sweated under the tutelage of a *conseil de famille*, because he hated his stepfather, General Aupick – self-made man, professional soldier (he had helped crush the Lyons uprising of 1831, and been promoted), newly appointed head of the Ecole Polytechnique. The revolution would destroy his family, so Baudelaire hoped. Hence the famous slogan he shouted in February, clutching his looted flintlock: '*Il faut fusiller le général Aupick!*'[97] (equals, roughly, 'Up against the wall Motherfucker').

But the Republic made the general an ambassador, sent him off to the delights of Istanbul! No wonder Baudelaire despised it! No wonder he still wrote, in his Dupont article, 'How many rebellious natures received their life from a cruel and punctilious soldier of the Empire!'[98]

Baudelaire fought three times in the Second Republic, perhaps four. He fought in February and in June 1848; the diary hints that he was involved in some way with the 15 May invasion of the assembly, and with resistance to the *coup d'état* in December 1851. He wrote for many newspapers, some of the Right and some of

the Left, some for money and some out of conviction. For a week in late February and early May he praised the Republic in *Le Salut public*. For two months, from April to early June, he was *secrétaire de la rédaction* on *La Tribune nationale*[99] – a newspaper which savaged the men of February, insisted on the social question but offered no solution, hated the revolutionary Left but celebrated the good sense of the workers, and veered erratically Leftwards in early June,[100] backing Proudhon, Leroux and Caussidière in the June elections (as well as stalwarts of property like Bureau-Rioffrey). What Baudelaire wrote in the newspaper, whether he merely pasted together the clippings from the rest of the press, whether he did the job strictly for money – all this is totally obscure. In any case, three weeks after the paper folded he was on the barricades.

Baudelaire, as always, fades in and out of the picture: writing to Proudhon in August; leaving for Châteauroux in October to edit another reactionary newspaper (he lasted one issue);[101] the next month publishing in *L'Echo des marchands de vin*; and the next writing to his stepfather, needing money, in fear of another insurrection, cut off from the respectable world.[102] In 1849 he visits Delacroix, helps Courbet with his preparations for the Salon, meets the revolutionary Poulet-Malassis. We know nothing else. In December he is in Dijon, working on another provincial daily (we do not know which),[103] insulting his legal guardian Ancelle by letter, insulting the lions of the local Left face to face – frightening them with talk of a terrible 'peasant Socialism, ferocious, stupid, and yet inevitable.'[104] Was he frightened himself? We cannot be sure. In 1850 a few poems in the press, a dispute with Champfleury over the latter's attempts at verse, poverty, debt, obscurity.

And then in 1851 a renewal of activity, as poet and politician – the tempo quickens as the *coup d'état* comes closer. In 1851 Baudelaire tries everything: he revises his article on caricature, and tries to get it published; he publishes 'Du vin et du hachish' and the seven poems of *Les Limbes*; he writes on Dupont, on the 'School of Common Sense', on the 'Pagan School'. He has a hand in Left-wing journalism, helping to edit *La République du peuple*; he is working on his first long study of Poe. It is the year in which Balzac is most often invoked as a hero,[105] and a time when Baudelaire moved back for a while towards the Realist circle. In the early months of 1852, just after 'the horrors committed in December', he and Champfleury collaborate again – planning a paper to be called *Le Hibou philosophique*. Two crucial instructions among the notes towards the paper: first, 'As to the novels we shall publish, they should belong to the literature of the *fantastic*, so-called, or they should be studies of manners, scenes from real life, as much as possible in a style which is easy and true, full of sincerity' (in other words, either Poe, or Champfleury writing in the style of Dupont); second, 'Avoid all tendencies or allusions which are visibly socialistic or visibly flattering to the Court.'[106] That is the prelude to withdrawal and despair, to the bitter detachment of the following March, to the last verdict of his letter to Ancelle – 'If I had voted, I could only have voted for myself.'[107]

I could add more details, but they would not help us much. What matters is the

secrecy, the gaps, the lack of substance – a Baudelaire anonymous, 'separated from honourable society', *déclassé* (the word he used to describe himself in March 1852); living off Jeanne's immoral earnings in Dijon; owing money even to eccentrics of Bohemia such as Marc Trapadoux. He is one of a mass of petty bourgeois driven downwards by the events of revolution towards the People; driven towards a tenuous, almost a resentful commitment to the working class of Paris. It is the tension between resentment and support which animates Baudelaire's actions and ideas in the Second Republic. Among all the false starts, journeys, and experiments of these four years, there are three things which do not change. First, after the brief honeymoon, his opposition to the Republic of February; second, a hatred of the bourgeoisie; third, support for the 'people' of Paris. The second of course is a kind of self-hatred, and the third is sometimes vague, sometimes tinged with distaste: 'fucking is the lyricism of the people'.[108] Yet both were real: both were dreams which led to action. And the contrast of people and bourgeoisie – they are the 'two parties' face to face in 1852 – appears in the oddest places. Even wine and hashish are part of the class war:

I shall show the disadvantages of hashish, the least of which . . . is that it is antisocial, whilst wine is profoundly human – I would almost risk saying its man is a man of action. . . .

Finally, wine is for the people who work, and who deserve to drink it. Hashish belongs to the class of solitary joys; it is made for wretched idlers.[109]

5. . . . *and altogether in the line of progress.*

Impossible not to think of Baudelaire's own remarks on the same subject, twelve years later in his *Journaux intimes*. They are banality itself, but by this time of the kind Delacroix approved: 'What is more absurd than Progress – seeing that man, as day-by-day events prove, is always in a state of savagery.' Or again, 'True progress (that is to say, moral progress) can occur only within the individual, and by individual effort alone.'[110]

Impossible not to think of these as a bitter retrospect on his enthusiasms in 1848, his '*ivresse littéraire*'. And this leads us to the problem: how are we to interpret the cryptic remarks on 1848 from *Mon coeur mis à nu*, which I put at the beginning of this section? After the interlude, when the poses were adopted again and the isolation accepted for good and all, how did Baudelaire think of revolution?

The key word in the diary entry is the one Baudelaire underlined – 'A *natural* pleasure in demolition. . . . A natural love of crime.' This is usually taken to be a gesture of outright condemnation, unequivocal disgust: but that seems to me a hasty conclusion. To correct it, we must look at three things: first, Baudelaire's scattered notes towards a philosophy of revolution; second, the meaning of nature and 'natural' for him; third, his final verdict – on 1848, on revolution in general, and on Proudhon – in the great prose-poem 'Assommons les pauvres'.

In politics – though it may seem strange to say it – Baudelaire was a man of

empirical temper. He was not much interested in abstractions like Socialism; it appears only twice in his letters, and both times qualified, made paradoxical and historically precise: 'peasant Socialism', and, after the *coup*, 'Napoleonic Socialism'. (Compare 'mitigated Socialism', describing *La Rançon*.) But he *was* interested in revolution, and remained so all his life. The experience of revolution stayed with him, and he turned to it repeatedly. Sometimes he philosophized, coining an empty aphorism – 'Revolution, through blood-sacrifice, confirms superstition.' Occasionally he was nostalgic for the Great Revolution, for strong men and the guillotine, instead of milksop phrases: 'G. Pagès and de Cormenin judged by Robespierre' (a cynical heading, referring to two contemporary politicians, which he jotted down in 1851, and crossed out). And that nostalgia lasted, since 'the Revolution was made by voluptuaries' – not a word that could be applied to Lamartine and Louis Blanc.

But what he wanted to fix in his mind – what he repeated over and over in his notes and diaries – was the fact that revolution was evil, and the fact of *his own assent to that evil*. 'Every revolution', he scribbled across the top of his own portrait by Nadar, 'has for its corollary the massacre of the innocents.'[111] It had such a corollary just because it was natural; just because natural meant criminal and destructive, filled with a taste for vengeance and a terrible folly. Revolution was the work of natural man, and the greatest revolutionary was Sade. 'One must go back constantly to Sade, that is to say, to *Natural Man*, in order to explain evil.'[112]

In June – and it was June that defined revolution for Baudelaire – he had done evil, knowing that he did so. That was better than February, with its dreams and hypocrisy, its 'misguided respect for property' (as Baudelaire called it in 1864),[113] its fear of its own nature. 'Evil knowing itself', he wrote in his notes on *Les Liaisons dangereuses*, 'was less frightful – and nearer to being cured – than evil in ignorance of itself. G. Sand inferior to de Sade.'[114] The June Days were horror, destruction, evil, 'madness of the people and madness of the bourgeoisie'; but he had fought with the insurgents and did not, could not, renounce his participation. He would face the hard wisdom of revolution, and despise its apologists, but he would remain a revolutionary. Or rather he would be like Sade: a reactionary as well as a revolutionary; pessimist and radical; the author of *Justine* and of the pamphlet of 1793 entitled *Français, encore un effort si vous voulez être républicains*: 'One more effort; since you are working to destroy all prejudice, let no single prejudice survive – it only needs one to bring back all the rest.'[115]

Baudelaire summed up his position with absolute clarity right at the end of his life. In a page written in Brussels, he discussed the 'voluntary exiles', the *quarante-huitards* who had sought refuge from the Empire in a Belgian exile. His comments end like this:

Let's add that when you talk to them of revolution in earnest, they are terrified. Old milksops! As for me, when I consent to be a republican, *I do evil, knowing that's what I do*.
 Yes! *Long live the Revolution!*
 Still! In spite of everything!

But me, I'm no dupe, I never was a dupe! I say *Long live Revolution!* as I would say *Long live Destruction!*, *Long live Expiation!*, *Long live Punishment!*, *Long live Death!* I should be glad to be the victim, but equally I should not dislike the role of executioner – so as to experience Revolution in both its guises!

Every one of us has the spirit of republicanism in his veins, like the pox in our bones; we are all democratized and syphilitic.[116]

A terrible picture – the old syphilitic, on the verge of final paralysis, frightening the politicians with talk of revolution *pour de bon*! The dandy baring his teeth.

There is one more aspect to revolution in Baudelaire's scheme of things, and it may explain the element of self-reproach in his writings of 1851: the attack on melancholy, the rejection of the 'irreparable', the acceptance of Dupont's simple 'invitation of Nature'. If the revolution is natural, and if Baudelaire takes part in it, he contradicts, absolutely, his own metaphysic. He throws overboard not just a life style, but something very like a religion: the religion of *spleen* and artifice, the cult of the dandy, the metaphysic of the city. Revolution is a double irruption, into Baudelaire's life but also into the precarious structure of his ideas. Revolution is the sudden presence of Nature in the City; and nothing could be more uncongenial, more unthinkable, to the poet of *spleen*. In the city, Nature is absent and has to be invoked, conjured, recalled by the refinements of artifice. 'Correspondances' is the poem which describes that process: a poem which begins by invoking Nature, but then portrays states of mind produced by certain perfections and accidents of artifice – colour, sound, and most important, the gamut of perfumes. In 'Du vin et du hachish' and 'Les Paradis artificiels', and in the myth of the dandy, that process is given classic form. Man recaptures Nature by artifice and ritual, by absolute pretence; and the explanation of that paradox is simple. Artifice, as Baudelaire constantly reiterates, is natural; it is nature's final fruit; and in the city, artifice is the only place where nature remains, at least in any of its old richness and depth. In the trance of wine or hashish, in a confusion of incense or benjamin, nature is disclosed, in hints and echoes and murmurs – and that, only when artifice is brought to the pitch of perfection.

In other words, artifice and nature coincide when the former becomes totally sealed and self-enclosed. Baudelaire, as G. Blin has shown us, believed first and foremost in magic, in making the whole of one's life into a spell, a secret invocation.[117] The dandy, and the writer of a strange section of the diaries called 'Hygiène', are one: they move towards a moment when nature is definitively absent, and rediscovered in its absence. Though of course those moments are temporary, exceptional; and the price of artifice is *spleen*, a grim and dreary conviction that the world itself has nothing to show us, a 'gloomy incuriosity' which is bound up with the collapse of nature. *Spleen* is the usual resonance of experience, the world's deadly mimicry of our own lassitude and despair; the images it provides of our own boredom in a dismal, inverted *correspondance*. The sky is a lid, the earth is a cell, rain imitates the bars of an enormous gaol: Nature, for the most part, is a poor imitation of the world we have made. Better pretend a total indifference, a disdain for 'sanctified vegetables'.[118]

Hence the importance of revolution. No more *spleen*, no more artificial paradise: so says Baudelaire in 1851. Instead of these, Nature itself, appearing bloody and fertile in the heart of the city. There are, say the *Journaux intimes*, 'two fine religions, immortalized on walls, the eternal obsessions of the people: a prick (the ancient phallus) and "Long live Barbès" or "Down with Philippe!" or "Long live the Republic!".'[119] In revolution both religions are celebrated, for *real* revolution is 'made by voluptuaries'. 'For three days the population of Paris has been wonderful in its physical beauty', Baudelaire wrote in February 1848. And thus the metaphysic crumbles; the dandy trembles, shouts, gesticulates; because Nature is no longer absent from the boulevards, and the phallus has replaced the 'sanctified vegetable'. Nature is no longer a mystery, disclosed to initiates – it stalks the streets, and Baudelaire goes with it.

The memory of 1848 stayed with him, as an echo in many poems:

> Esprit vaincu, fourbu! Pour toi, vieux maraudeur,
> L'amour n'a plus de goût, non plus que la dispute;
> Adieu donc, chants du cuivre et soupirs de la flûte![120]

But it was 'Assommons les pauvres' – rejected as unpublishable by the *Revue nationale* in 1865 – which gave the final verdict. It is, quite specifically, a prose-poem about 1848:

For a fortnight I had confined myself to my room, and had surrounded myself with books in fashion at that time (16 or 17 years ago); I mean those books which explain the art of making the People happy, wise and rich in twenty-four hours.[121]

Not surprisingly, he is in a state bordering on vertigo or stupidity; in his brain is the merest ghost of a new idea, something better than the ladylike proposals of the books he has been reading. And outside a tavern, as a beggar holds out his hat, the idea takes form; the voice of a daemon whispers in his ear. Like Socrates, only one better;

Poor Socrates only had a prohibiting daemon; mine is a great affirmer, mine is a Daemon of action, a Daemon of combat.

Well, his voice whispered the following words: 'Only he is the equal of another who proves it, and only he is worthy of liberty who can conquer it.'

One look round the deserted *banlieue* for the police, and Baudelaire set to work. He leapt on the beggar, 'this enfeebled old man of sixty', and beat him with fists and branch, kicked him in the back, knocked his head repeatedly against a wall.

Suddenly – O miracle! O rejoicing of the philosopher who has verified the excellence of his theory! – I saw this antique carcass turn round, straighten himself with an energy that I would never have suspected in a machine so singularly disordered, and with a look of hatred which I considered a *good omen*, the decrepit ruffian hurled himself upon me, blacked both my eyes, broke four of my teeth, and, with the same branch of the tree, beat me soft as plaster. By my energetic medicine, I had, therefore, given back to him both pride and life.

Then I made many signs to the effect that I considered the discussion at an end, and getting up, with the satisfaction of a Sophist of the Portico, I said to him, 'Sir, *you are my equal,*

be kind enough to do me the honour of sharing my purse with me; and remember, if you are a real philanthropist, that you must apply to all your colleagues, when they ask for alms, the theory which I have had the *anguish* of trying out on your back.'

He swore to me that he had understood my theory, and that he would take my advice.[122]

Thus the poem ends, though the manuscript had one more question, which Baudelaire crossed out on second thoughts: 'What do you say to that, Citizen Proudhon?'[123] Like all the prose-poems, it is perfectly explicit and perfectly ambiguous. It sums up Baudelaire's philosophy of revolution: bitter, illiberal, absolutely anti-utopian; scorning the dreams of February, smelling not so much of Cabet and Proudhon as of class warfare and the dictatorship of the proletariat. Not, of course, that the poem is prescriptive. It is, among other things, a joke – but a joke which takes on its own life in the telling, over which the joker's voice breaks and falters.

'Assommons les Pauvres', like the notes from *Pauvre Belgique*, is a statement of commitment. A commitment, self-destructive and despairing, to a revolution of and by the people, with the bourgeoisie as its enemy – the bourgeois 'revolutionary' as much as the middle-class supporter of order. A hymn to conflict, in which hatred is the best augur of equality, and branch and fist are the means to 'pride and life'. It is not a wisdom that the *Revue nationale*, or many others of Baudelaire's contemporaries, were likely to understand. But it measures up, in its sour and private fashion, to the realities of 1848; and if we look for a parallel, we must turn to the statements of Louis-Auguste Blanqui or the pages of Marx's commentary on the times, 'The Class Struggles in France'. Inappropriate bedfellows, you might think, for the poet and the dandy; but that is the way with revolutions.

Conclusion

I have tried to show that the art of Millet, or Daumier, or Baudelaire, is often more political than it looks at first sight. By this I mean that it is tied closer to the context of politics than seemed possible; its references are more specific and polemical; its edge has often been blunted by time. There is of course another sense in which a work of art could be called political. It could be seen as part of some political strategy on the part of its author; it might even be doing some particular, effective, political work. And that, to make things clear, is not what I claim for the artists studied here: rather the contrary. It is sometimes assumed that the 'generation of 1848' in the arts were all men of revolutionary good will, vague but undoubted radicals, men determined to apply their democratic principles – somehow – to their painting and sculpture. I do not think this is true of the artists that matter. There were men of good will, certainly, artists you could call *quarante-huitard*; but they are second-rate just because they try to apply an ideology – apply it like a set of instructions, or an undercoat of paint. Not so Millet or Baudelaire. The artists that matter come at the facts of politics sideways, unexpectedly, taking themselves by surprise. You could sum it up by saying that their art is more political than is commonly said, and less revolutionary.

As far as this book goes, the artists' response to 1848 is either unfinished, or never shown to the public, or bitter and retrospective, or straightforwardly reactionary. Either Couture's abandoned *Volunteers* or Millet's *Haymakers*, promised to the Salon then withdrawn. Either 'My Heart Laid Bare', notes put down in private, years after the event; or Rethel's *New Dance of Death*, six woodcuts produced at white heat, printed in thousands – and dedicated to the counter-revolution. 'The art of reaction' would not have been too gross a title for this book; it would have been more accurate than 'the art of revolution'. (That title, hard-won, is reserved for Courbet's painting in the Second Republic.)

The closest we have come to a public art in this book – an art which in some sense we could call effective, in a time of political struggle – is Daumier's Ratapoil

or Delacroix's Apollo ceiling. Even allowing for his usual hyperbole, Michelet was wrong about Ratapoil when he said, in tears in Daumier's studio, that the artist had done more for the fight against Bonaparte with that one image than all the politicians put together. Sure enough, Ratapoil was an invention of genius. But he was not, even given the limitations of caricature, a figure who generated an effective political campaign. He appeared in too motley a company, jostled by outworn symbols; he did not stalk through Paris in the manner of Daumier's Robert Macaire, going through the poses of a whole, corrupted civilization; he did not do damage directly, crudely, in the fashion of Gargantua or the Pear, those two cruel masks for King Louis-Philippe.

In some way Ratapoil was a character without a context, and that for a simple reason. The France in which he operated, the other France, the provinces, the small towns, the peasant smallholdings, was not a society Daumier knew very well. Once or twice, when Ratapoil confronted the peasant or his wife, Daumier struck home. But Daumier was a Parisian artist or he was nothing, and when politics moved out of Paris, his caricature was bound to be hit or miss.

As for the Apollo ceiling, it disguised its public metaphor and harmonized with its seventeenth-century setting – in spite of Delacroix's personal contempt for the paintings of Le Brun. And critics and public took it, sensibly, at face value. The Galerie d'Apollon opened to the public on 23 October 1851, just forty days before the *coup d'état*. But no-one tried to politicize Delacroix's ceiling: they talked about it in relation to Ovid, or Le Brun, or Duban's restoration. 'It does not matter to us,' wrote Gustave Planche in the *Revue des deux mondes*, 'that Apollo victorious over the serpent Python signifies Louis XIV victorious over Europe. One hundred and thirty-six years after the death of the great king, that allegory would carry no weight. M. Delacroix has stuck to the first book of Ovid's *Metamorphoses*.'[1] And three years after the February Days? Or a month before Louis-Napoleon is victorious over the hydra of Socialism? At the time, these questions did not occur to Parisians, even in those last tense days of the Republic. And if the allegory did not bite them, that was probably just as Delacroix wished.

The question is, finally: how could there be an effective political art? Is not the whole thing a chimaera, a dream, incompatible with the basic conditions of artistic production in the nineteenth century – easel painting, privacy, isolation, the art market, the ideology of individualism? Could there be any such thing as revolutionary art until the means existed – briefly, abortively – to change those basic conditions: till 1919, when El Lissitzky puts up his propaganda poster outside a factory in Vitebsk; or 1918, in Berlin, when Richard Huelsenbeck has the opportunity, at last, to 'make poetry with a gun in his hand'?

The problem for a revolutionary artist in the nineteenth century – perhaps it is still the problem – was how to use the conditions of artistic production without being defined by them. How to make an art-work that would not stay on an easel, in a studio, in the Salon for a month, and then on the wall of a sitting-room in the Faubourg Saint-Germain? How to invent a means of artistic distribution to bypass the art market or the exhibition? How to destroy the normal public for art, and

invent another? How to make art 'popular'? How to exploit one's privacy, and the insights it allowed, and yet escape from it?

I have said enough about State patronage for it to be clear that public art, in that sense, was no solution. What the bureaucrats require is illustration of the revolution – which quickly turns into portraits of 'leaders' and statues of dead saints. (The Anarchists were right, in 1919, to dynamite the new sculpture of Bakunin, done in a watered-down Cubist style, that the Bolsheviks had commissioned for their gallery of revolutionary heroes.) The alternative to illustration is drastic. It is what Lissitzky shows us, or the Dadaists in the Berlin revolution: a message that is uncompromisingly clear, and uncompromisingly 'experimental'. A message that cannot be disentangled from the techniques that are used to deliver it; techniques that are improvised, unlikely, extreme; techniques that tear down a discipline – pictorial, literary, theatrical – from within.

An author who teaches a writer nothing [as Walter Benjamin put it] teaches nobody anything. The determining factor is the exemplary character of a production that enables it, first, to lead other producers to this production, and secondly to present them with an improved apparatus for their use. And this apparatus is better to the degree that it leads consumers to production, in short that it is capable of making co-workers out of readers or spectators.[2]

Benjamin was thinking of Brecht, and perhaps of Surrealism in its earliest phase. In the nineteenth century, the artists I think of are Courbet and Baudelaire. Baudelaire because, having failed to discover a politics of his own, he brought to perfection the attitude of stifling contempt for the public world, and tried to make the city mere decor for a private drama; Gustave Courbet because, for a moment, he almost achieved the impossible.

In the Salon of 1851 he showed three huge pictures, the *Stonebreakers*, the *Burial at Ornans* and the *Peasants of Flagey*. He conjured out of privacy, out of the obscurity of a small-town funeral, an imagery which was public and political. Not just art that caused an outcry, but images which undermined the bourgeois sense of what was art and what was bourgeoisie, images which addressed themselves to another public, the public that crammed the Salon Carré each year, on their day off work. If any artist came close to creating the conditions for revolutionary art, it was Courbet in 1851. How he did it, and the extent of his success, I shall discuss at length in a second book. But in case there should be any mistake, let me say here that art's effectiveness, in political terms, is limited to the realm of ideology. This is a real limitation, though occasionally the nature of politics means it is not a crippling one. In other words, the political struggle *is* always, partly, a struggle of ideologies; and at times the clash of ideologies takes on a peculiar importance; it is the form of politics, for a moment. In certain circumstances, works of art can attack, dislocate, even subvert an ideology. And sometimes, rarely, that dislocation has some political significance. So that the history of Courbet's political effectiveness in 1851 will be the narrative of his art's discovery of a situation, at the centre of a web of ideologies. Or rather, not the centre so much as the weak link.[3]

In the decades after 1848, the examples of Courbet and Baudelaire, and the different responses to politics they embody, stayed obstinately alive. It is curious how many of the best artists, later in the century, tried to combine those responses, however at odds with each other they seemed. Manet in the 1860s, for example, paying homage to Baudelaire's disdain for the public life, but aping Courbet, and hoping against hope – or so the viewer feels, face to face with *Olympia*, or looking on at the *Execution of Maximilian* – for a public picture, a picture to state exactly what its audience did not want to know. Or think of Seurat in the 1880s, keeping silent about politics, in spite of the anarchism of his friends, staking his claim to artistic precedence with all the pedantry of a later avant-garde; but producing the *Grande-Jatte* or the *Chahut*, images of joyless entertainment, cardboard pleasures, organized and frozen: pictures of fashion, and thus of the places where public and private life intersect.

That was the problem, in fact: to discover the point at which public and private intersect, and thus be able to attack one by depicting the other. The artist had to begin, so it seemed, with an image of private life, since the forms of public existence were too chaotic or corrupt or windblown for depiction. (Except for Daumier in an occasional lithograph, hardly any nineteenth-century artist portrayed social conflict as such, a definite confrontation of classes.[4] And that was because in normal circumstances the classes stayed separate, each in their gloomy interiors, feeding on nightmare images of each other.) After all, this was the century of private life: even politics became private, with the advent of the newspaper and the ballot box. So it ought to be possible for private imagery to take on a public force, to hurt or encourage as much as a speech from the rostrum. That was the point, perhaps, of the century's most famous piece of art criticism: Baudelaire's call, in the 'Salon de 1846', for a painter to celebrate the heroism of modern life. We should begin, he says, by seeing the significance of our privacy and the grandeur of its uniform, the despised frock-coat and spats.

But all the same, has not this much-abused garb its own beauty and its own native charm? Is it not the necessary garb of our suffering age, which wears the symbol of perpetual mourning even upon its thin black shoulders? Note, too, that the dress-coat and the frock-coat not only possess their political beauty, which is an expression of universal equality, but also their poetic beauty, which is an expression of the public soul, an immense cortège of undertakers' mutes (mutes in love, political mutes, bourgeois mutes). We are each of us celebrating some funeral.[5]

When Courbet obliged four years later, Baudelaire did not recognize – or, at least, he did not acknowledge – his progeny. But the *Burial at Ornans* is Baudelaire's picture, sure enough: public, private, blatant, incomprehensible. It is the best image of the 1848 revolution; the most complex picture of the bourgeoisie. No wonder, when artists looked back to 1848, they could not escape from its spell. No wonder they tried to repeat the performance.

The images of 1848 make up a strange constellation: Ratapoil, Apollo in his chariot, Meissonier's bodies on the scattered barricade, *The Sower*, the beggar who

learns Baudelaire's lesson, the *Burial at Ornans*. It is hard to say precisely what they share, if anything. Not a picture of Paris, impassive backdrop to Meissonier's painting, landscape of the mind in Baudelaire's poem, absent in the rest, except when Ratapoil whips up the crowd on the Champs-Elysées, applauding a military parade. Not a location of the revolution in the countryside, not a portrait of the bourgeoisie, not even a commitment to the fact of 1848, universal suffrage, the 'social question'. Only Courbet managed any of these.

If we spread our net wider, the sense of a revolutionary art becomes still hazier. It is only by artifice that I have excluded Ingres's rouged, exquisite portrait of Baroness Betty de Rothschild, completed in 1848 – especially as the Rothschilds' château was burnt down by the mob in February – or his *Venus Anadyomene*, an ancient project which he pushed to completion in the spring of 1848, in spite of 'a revolution which has shaken me from top to toe'.[6] Rothschild appeased the people by giving 25,000 francs to the fund for the wounded of February; Ingres proudly signed his Venus *J. Ingres Faciebat 1808 et 1848*, and put it on show, privately, in his studio. Or look at Corot's work in 1848, deliberately unaware of anything besides *Un Site d'Italie*, or *Agony in the Garden*, both of them bought, gratefully, by the State. The revolution, if it touched him at all, did so by accident, in the form of farce. When his *Agony in the Garden* was sent to Langres it became a weapon in the town's fight against the deputy who had obtained it for them. The local press called it a 'great ink-blot', unworthy of the town's museum. Corot kept silence.[7]

The question of how an artist should respond to revolution remains unsolved. It seems to be an opportunity, and for those like Courbet who seize it, it seems to be intrinsic to their greatest work. It is possible to ignore the public life, but only from a position of eccentric strength, or hostility, or simplicity: the option is open to such as Ingres and Corot. For the rest, even for Delacroix, who would have liked to live in ignorance, or Baudelaire who afterwards pretended to, the revolution invades their privacy but does not take on form. It is there, but they do not know how to use it; above all, they do not know how to become part of it. Later on, artists gave new answers to that problem: 'production-art', Constructivism, *die Kunst ist tot*. But those, necessarily, were twentieth-century solutions. When it came to the next, and greatest, of French revolutions, the Commune of 1871, Courbet tried a new strategy, and paid for it dearly. He made himself part of the revolution in the simplest sense, one of its delegates, one of its victims. He was jailed, fined, hounded to death. Let us hope, at least, that he had done what his enemies accused him of, and supervised the destruction of the Vendôme column. Let us hope he had nothing to do with what his friends excused him with, the saving of Thiers's artistic treasures from the arsonists.

As for the rest of the artists, they lay low. Monet and Pissarro made off to England, to avoid the war – though Pissarro's son later claimed his father had fled in fear of arrest for his anarchist sympathies! Flaubert wrote long, angry letters to George Sand, fearful for his small estate. And Manet, when he drew his *Barricade*, was non-committal. He suppressed the action; he kept the faces out of focus.

Appendix

A random sample of 130 commissions between 1841 and February 1848 was compared with another sample of 130 commissions between February 1848 and December 1850. (The 260 cases were chosen from boxes F.21.25 *Deletang* through to F.21.29 *Feuchère*.) What interested me were the channels and methods of patronage in each case, as well as the kind of work patronized, and I divided up the 260 cases into the following categories (in some cases the differences between categories are slight, but significant):

1. Subject and artist suggested by local Deputy and/or *conseil de fabrique*, local notables, etc.; the Bureau follows both suggestions (often a means of obtaining work for a local artist in his home area).
2. Subject and location asked for by another Ministry.
3. Work solicited by a painter backed by local Deputy or notable – given a specific copy to do, but with no fixed destination.
4. Work solicited by painter backed by Deputy, by established artist (Ingres, for example), etc. – given a religious copy of his own choice.
5. Work awarded after no apparent soliciting. Given a religious copy of his own choice, or, rarely, given complete freedom of choice – and no specific destination indicated.
6. An acquisition, after a petition or suggestion from the artist.
7. Large Government decorative projects, e.g. statues for the Jardin du Luxembourg.
8. Work solicited by the artist and political backers – awarded a specific job, usually for a specific place.
9. Portrait of Head of State (Royal Family, President, etc.) asked for by local Deputy or notables for a specific location. Provided from stock or done specially.
10. An artist given a commission to do a specific original work, after no apparent soliciting. No destination indicated initially.
11. Artist petitions for work without backers – given religious copy.
12. A specific subject, often with dimensions indicated, is asked for by local notables, Deputy, etc. Bureau chooses an artist to do the job (most often a copy).
13. An acquisition, no apparent soliciting by the artist, often with a specific destination in mind.
14. Artist commissioned to do a landscape painting.
15. Picture asked for by local notables, etc., with no subject specified. Bureau chooses artist for the job.

16. Painter petitions for a specific job, in a specific place, and is given the commission. (Often an established painter using the State as a source of easy money.)

17. Government projects for symbolic political art, e.g. the Republic figures.

18. An unspecified picture asked for by local notables, etc. – the Bureau provides a picture from stock (sometimes acquires a suitable work).

19. Painter petitions for work – given commission for an original devotional painting of his own choice.

20. State acquisition as result of a request for a specific work, often seen in the Salon, by local deputy etc. Usually for specific destination.

21. Specific subject asked for by local notable, etc. – Bureau provides the subject from stock.

22. Specific subject asked for by local notables, etc. – Bureau provides a *different* subject from stock.

23. Painter solicits for work – awarded commission subject to official approval of theme and treatment.

24. A work ordered verbally, formalized later by 'acquisition'.

25. Local notables, etc., put forward local artist, but with no specific subject indicated. The artist given a religious copy or a picture of his own choice.

26. Artist commissioned to do a genre painting.

27. Work awarded after no apparent soliciting; artist given commission to do original work of his own choice.

28. Miscellaneous – medals, engravings, etc.

		1841 – Feb. '48	Feb. '48–Dec. '50
Category	1	20 cases	2 cases
,,	2	2 ,,	0 ,,
,,	3	2 ,,	2 ,,
,,	4	14 ,,	18 ,,
,,	5	3 ,,	10 ,,
,,	6	6 ,,	14 ,,
,,	7	10 ,,	12 ,,
,,	8	4 ,,	3 ,,
,,	9	10 ,,	0 ,,
,,	10	1 ,,	6 ,,
,,	11	0 ,,	3 ,,
,,	12	11 ,,	2 ,,
,,	13	8 ,,	11 ,,
,,	14	2 ,,	2 ,,
,,	15	9 ,,	0 ,,
,,	16	3 ,,	1 ,,
,,	17	0 ,,	3 ,,
,,	18	9 ,,	14 ,,
,,	19	2 ,,	1 ,,

		1841 – Feb. '48	Feb. '48–Dec. '50
Category	20	6 cases	0 cases
,,	21	0 ,,	4 ,,
,,	22	0 ,,	3 ,,
,,	23	1 ,,	3 ,,
,,	24	0 ,,	1 ,,
,,	25	4 ,,	1 ,,,
,,	26	0 ,,	1 ,,
,,	27	0 ,,	4 ,,
,,	28	3 ,,	9 ,,
Total:		130 cases	130 cases

My main conclusions from these figures – and I should stress that on their own they are of limited value – are as follows. Before and after the 1848 revolution, there is significant continuity in the commissioning of religious copies from painters with influential backers (category 4), large Government decorative projects (7), acquisitions without apparent soliciting (13), and pictures given from stock to local *notables* (18). The significant innovations of the Second Republic are in commissions (usually religious copies) awarded after no apparent soliciting (5), acquisitions as a result of petitions etc. by the artist himself (6), and the award of specific jobs to an artist, with no preceding petitions, etc., extant (10). There are *minor* innovations – in statistical terms – in the award of copying work to indigent artists with no powerful backers (11), symbolic political art (17), the provision of pictures from stock to satisfy local notables (21 and 22), verbal orders later formalized (24) and the award of an original work of his own choice to an artist who, apparently, had not gone through the official process of petitions, backers, etc. (27). Here categories 17, 24, and 27 are indications, perhaps, of Blanc's attempts to bypass official channels; and 21 and 22 show his casual attitude to the old job of satisfying the provincial powers-that-be.

The Second Republic ended or radically decreased the following kinds of patronage; the purely local patronage of a local painter backed by the gentry of his area (1), portraits of King or President (9), the finding of artists to do a specific job, or perhaps any picture, for local notables (12 and 15), and the acquisition of pictures which deputies or mayors had 'spotted' in the Salon (20).

Types of Art Patronized, 1848–50

Taking a sample of *original* works commissioned by the Republic – all commissions in Boxes F.21 12–29 – I reached the following figures.

			1848	1849	1850
Category	1.	Contemporary history.	2	1	1
,,	2.	History painting.	6	10	3
,,	3.	Portraits inc. busts for Louvre.	17	7	9
,,	4.	Religious works.	27	24	29
,,	5.	Landscapes.	16	18	15
,,	6.	Genre.	6	11	11
,,	7.	Murals.	1	3	0
,,	8.	Works of allegory or mythology, inc. 'Republics'.	20	15	5
,,	9.	Still life.	2	4	2

Again, this is a small sample; but it supports the evidence from other sources. There is an attempt to patronize landscape – though landscape came second to religious works as the most favoured genre in the last years of the July Monarchy. In part this was due to the collapse of the art market, and in any case, landscapes were still heavily outnumbered, and even more heavily outpriced, by religious and mythological works. There is very little history or contemporary history painting, both were already in decline as officially patronized genres in the July Monarchy, but there is a massive effort to encourage a kind of neo-classical revival: commissioning and buying allegorical works of all types. The attempt is especially marked in 1849, when the first flush of competitions is over but Blanc is still acquiring all manner of 'classical' works. The idea that the policy of the Bureau changed as the regime grew more reactionary in 1849 and 1850 is not supported by the figures. The dominance of religious subject-matter was constant, though the ideology which lay behind it certainly changed. Genre painting was certainly encouraged; in the last years of the July Monarchy the State had rarely bought or commissioned such work. Once again this was partly due to the collapse of the art market, and within genre painting there is utter confusion of types and styles, with the Bureau showing no clear preferences. The Bureau's policy on large-scale decorative projects remained thoroughly conventional, once the era of Festivals was over: an instance is the series of portrait busts for the Louvre commissioned in 1848 – including Poussin by Préault!

Brief Chronology

1848

22 Feb.	Procession of protest against banning of 'Reform' banquet in Paris.
23 Feb.	National Guard turns against Government.
	Evening, clash with troops on Boulevard des Capucines.
24 Feb.	Hôtel de Ville occupied. Tuileries taken. Provisional Government proclaimed.
26 Feb.	National Workshops set up.
28 Feb.	*Commission pour les travailleurs* set up.
5 Mar.	Universal Suffrage decreed.
16 Mar.	Demonstration of the *bonnets à poil* (reactionary sections of the National Guard).
17 Mar.	Counter-demonstration of the working class.
16 Apr.	Abortive demonstration of the Left-wing clubs. (It demanded postponement of the elections.)
20 Apr.	*Fête de la Fraternité.*
23–24 Apr.	Voting in election for National Constituent Assembly. Conservative victory. Left-wing uprisings in Rouen, Limoges.
15 May.	Invasion of Assembly by the Clubs. Abortive attempt to proclaim a new Provisional Government.
21 May.	*Fête de la Concorde.*
21 June.	Decree abolishing National Workshops (climax of campaign against the social measures of the Provisional Government).
23–26 June.	June Days uprising. Cavaignac made president of the Council of Ministers.
July.	New laws restricting Press freedom.
4 Nov.	New constitution adopted by the Assembly, with a single chamber and single head of government.
10 Dec.	Louis-Napoleon elected President.

1849

13 May.	Elections for Legislative Assembly. Conservative victory, but this time marked by the emergence of a 'Red France'.
13 June.	Abortive Left-wing uprising in Paris.
31 Oct.	Louis-Napoleon dismisses the Conservative Barrot ministry, puts in its place an extraparliamentary ministry of his own choosing.

1850

	Political struggle in the countryside intensifies.
10 Mar.	By-elections in Paris and the provinces. Victory for the Left.
15 Mar.	The *Loi Falloux* passed by the Assembly, reviving Church control of education.
31 May.	Law ending universal suffrage, disqualifying 3 million Left-wing militants and itinerant workers.
Summer.	Louis-Napoleon stages propaganda tours in the provinces.

1851

Jan.	Louis-Napoleon dismisses the Republican general Changarnier.
Aug.	Trial of the Lyons conspiracy.
2 Dec.	*Coup d'état* by Louis-Napoleon in Paris.
4–14 Dec.	Scattered resistance to *coup d'état* in the provinces.
21–22 Dec.	Plebiscite gives massive approval to Napoleon.
	Purge of Republican opposition.

1852

Dec.	Louis-Napoleon becomes Emperor.

Notes

Table of abbreviations:

AN. Archives Nationales.

AD. Archives Départementales.

B.C.G. Baudelaire, *Correspondance générale*, ed. Crépet and Pichois.

B.O.C. Baudelaire, *Oeuvres complètes*, ed. Le Dantec and Pichois.

Ch. Chevalier, *Classes laborieuses et classes dangereuses à Paris*.

D. Delteil, *Le Peintre Graveur Illustré* (no. following refers to Delteil's illustrations).

D.C.G. Delacroix, *Correspondance générale*, ed. Joubin.

D.J. Delacroix, *Journal*, ed. Joubin, 3rd ed.

D.O.L. Delacroix, *Oeuvres littéraires*.

M-N Moreau-Nelaton, *Millet raconté par lui-même*.

In other cases, the notes give the author's name (plus an identifying number in parentheses where necessary), and volume and page numbers. Full details will be found in the Bibliography. The exceptions to this rule are the various Salon criticisms written in newspapers or pamphlets at the time. A bibliography of the Salon of 1851 is incorporated in the notes to Chapter 3, when the critical reaction to Millet is discussed.

I have preferred to put English translations of French citations into the text, except for verse. Almost always, when the citation is from an original or inaccessible source, I have given the French text in the notes – and likewise in other cases where the texture of the French seemed vital. (The exception here is Baudelaire, where the language is always dense and extraordinary, but where the collected works and correspondence are widely available in French.) When the original French is in the main text, an English translation is provided in the notes.

1 The Picture of the Barricade (pp. 9–30)

1. Marx (1), pp. 161–2.

2. Baudelaire (7) no. 1, pp. 3–4, 'La Beauté du Peuple'.

3. B.O.C., pp. 316–17.

4. Cf. the title to Part 1 of Antal's great work on *Florentine Painting and its Social Background*. The division of the book into Foundations and Art is one I want to avoid – along with certain other assumptions that go with the terminology.

5. Notes here are kept to a minimum, as much of what I have to say is standard. The works I have used most are Duveau (2), Vigier (1), and (3), Dupeux, Gossez (2), De Luna, Pouthas, Tocqueville, and Stern.

6. Cf. Duveau's classic description of the alliance of forces in February, (2), pp. 24–5, 54–5.

7. *Journal des débats*, 18 Apr. 1832, cited Daumard, p. 519.

8. *Journal des débats*, 1831, cited Sartre (2), pp. 1924–5.

9. Cited Crémieux, p. 94.

10. See Chevalier (1) and Soboul (1) and (2).

11. Proudhon (4), p. 105.

12. On the June Days, see Schmidt, Gossez (2), De Luna, pp. 128–73, and Duveau (2), pp. 147–74.

13. The role of this 'incipient proletariat' is stressed by Rudé, pp. 176–7.

14. Tocqueville, p. 157.

15. For full discussion and sources, see Clark (3), Chapter 5.

16. In a provincial paper, *La Capitole*, cited Armengaud, p. 363, note 96.

17. *Le Peuple*, cited Tudesq (2), p. 228.

18. See Clark (3), Chapter 5.

19. See Proudhon (3), *passim*, and B.C.G., I, 157, letter to Poulet-Malassis, 20 Mar. 1852.

20. Ch., p. 47.

21. Duveau (2), p. 175. The whole chapter is fundamental.

22. Adhémar, H., p. 88.

23. See Adhémar, H., Hamilton, Lüdecke for discussion.

24. 'She is a strong woman with powerful breasts, with raucous voice and austere charms, who, brown-skinned and fiery-eyed, agile and walking with great strides, thrives on the shouts of the people and the bloody hand-to-hand fighting'. On these three sources, see Hamilton, pp. 59–61.

25. *Journal des artistes*, I, 1831, p. 443, cited Adhémar, H., p. 88.

26. 'Liberty is not a countess from the noble Faubourg Saint-Germain.' From Barbier's 'La Curée', cited Hamilton, p. 60.

27. Balzac, pp. 202–3.

28. For a summary of the social and political situation, see Vigier (2), pp. 17–21. The two phrases cited on p. 20.

29. *Journal des artistes*, I, 1831, p. 443, cited Adhémar, H., p. 88.

30. Reported by the Comtesse d'Agoult (Daniel Stern); Stern, I, p. 117.

31. Stern, p. 112, note 1. Her estimate of the number of barricades is on p. 149.

32. Stern, p. 125.

33. Cited Dolléans and Puech, p. 31.

34. Rémusat, p. 257.

35. Stern, p. 185.

36. Stern, p. 140.

37. Stern, p. 141.

38. See e.g. Bourguin and Terrier, pl. 170 (Fleurville Collection), and Bibliothèque Nationale, p. 159, no. 705, for another watercolour of the June Days (L. Wolff coll.).

39. Stern, p. 203.

40. Crémieux, pp. 475–6.

41. Flaubert (2), p. 291, who borrows the image from Stern, the closest witness – she used contemporary newspapers and her own recollections. Volume 1 was published in 1850.

42. Flaubert (2), p. 294.

43. See Maison I, 65–6, 95, 192–3, and II, 33. But cf. Larkin (2), pp. 89–91, for a less sceptical view which carries no less weight. In general Maison seems to underestimate Daumier's own hesitancy and indecision at this stage of his painting career, and is probably too ready to ascribe fumbling or inconsistent passages of paint to a later forger.

44. D. 1768, 'Prise de panique'. First pointed out by Larkin.

45. Cited Crémieux, p. 300, note 3.

46. Exhibited in the 1851 Salon, present whereabouts unknown.

47. 'Furies abominables . . . n'ayant pas même la solennelle expression des furies antiques . . . mégères acharnées et édentées, qui n'ont ni cœur, ni sexe et que l'ouvrier, l'honnête ouvrier, repousse avec dégoût, quelle que soit son opinion.' A. Dauger, 'Salon de 1851', *Le Pays*, 14 Feb. 1851.

48. E.g. F. de Lagenevais, *Revue des deux mondes*, 15 Aug. 1849, p. 575. He specifically mentions the 'jour humide et terne de février'.

49. 'Ces terribles et désastreuses journées de Juin auront produit deux chefs-d'œuvres: *Le Mot d'ordre* de Leleux, et *La Rue* de Meissonier. Sur ce tas de pavés et de cadavres, l'art a déjà fait germer deux fleurs, fleurs tristes, penchées et teintes de sang, qui seront tout ce qui restera de ces effrayantes hécatombes.' T. Gautier, 'Salon de 1849', *La Presse*, 8 Aug. 1849.

50. See Amman for the most recent account, which disposes of the once popular theory that the invasion was the work of *agents provocateurs*.

51. Normanby's account, cited Duveau (2), p. 134.

52. Tocqueville, p. 134.

53. See Duveau (2), pp. 138–9.

54. It now hangs in the Palais Bourbon. See e.g. Antal (2), pl. 22.

55. Victor Hugo in 'Choses vues', cited Duveau (2), p. 147.

56. Report in *Le Lampion*, cited *La Démocratie pacifique*, 24 June 1848.

57. See Sensier, p. 111, and below, Chapter 4. On the Republic contest, see M-N, I, pp. 72–4.

58. For further illustrations in this series see Bourguin and Terrier, ills. 187–90. They were published in Paris in *L'Illustration*, 28 July 1849, and then in fine lithograph facsimiles in 1850.

59. In *L'Artiste* III, series 5, 1849, pp. 185–6.

60. Douce, pls. 46, 41, 23, 40.

61. There seems every likelihood, given his links with Baudelaire and Champfleury at this time, that Daumier would have seen the series.

62. Cited Gréard, p. 238.

63. See Bénézit, V, 493. The well-informed critics in 1851 (such as Gautier) were clear that his intentions were pacific.

64. 'Une malheureuse pensée, une malheureuse accusation, et presque une calomnie. . . . On ne conseille pas la paix en insultant aux vainqueurs et en parlant de colère aux vaincus. On ne persuade pas de l'horreur de la guerre civile en appelant les vengeances.' A. Thierry, *L'Assemblée nationale*, 21 Mar. 1851.

65. 'Est-ce un jugement ou une protestation qu'a voulu faire l'artiste? Ni l'un ni l'autre; il a vu et il a peint, comme c'était son droit; la peinture a l'impartialité muette de la nature.' T. Gautier, *La Presse*, 8 Aug. 1849.

66. For Meissonier's account of Delacroix's enthusiasm, see Gréard, p. 109, cf. D. J., I, 270, 5 Mar. 1849. The watercolour is in a French private collection. On the withdrawal, see Meissonier's entry form for the 1849 Salon: exhibit no. 2910 is marked *retiré* in pencil. In Arch. Louvre, Salon de 1849.

67. Sabatier-Ungher, p. 56.

68. *Ibid.* Other critics saw the point of the image. Dauger wrote of it as 'si microscopiquement fait, qu'il faut se pencher, s'approcher, regarder encore et encore, pour retrouver un à un ces personnages du grand et affreux drame du juin 1848'. *Le Pays*, 14 Feb. 1851. Gautier wrote that 'le regard va du premier plan au fond sans rien trouver où s'arrêter; il glisse toujours de cadavre en cadavre, ne rencontrant que la Mort, l'épouvante et l'abandon'. *La Presse*, 8 Aug. 1849.

69. For an illustration, see Bourguin and Terrier, ill. 168. The painting is in the Musée Carnavalet, Paris.

70. 'Le *Mot d'ordre* a certainement des qualités solides, de la vie, du mouvement et de l'harmonie; mais, pour Dieu! que signifie le choix d'un pareil sujet? quelles ressources offre à un coloriste le jour humide et terne de février à Paris, et comment poétiser ces

accoutremens révolutionnaires, quelque bonne volonté qu'on y mette? Le gamin de Paris est un type qui ne devrait tenter aucun artiste. Il est généralement laid, petit, malingre; ses facultés intellectuelles ne sont développées qu'aux dépens du corps le plus chétif. De plus, dans notre boue immonde, la pauvreté est repoussante, et les haillons sont affreux. Puisque M. Leleux aime les guenilles, je lui conseille de s'en tenir à celles d'Espagne et d'Orient; là au moins un soleil splendide les empourpre et dore la misère.' *Revue des deux mondes*, 1849, p. 575.

71. Tocqueville, p. 150.

72. Cited Deutscher, p. 167.

2 *The Art of the Republic* (pp. 31–71)

1. 'Nous voudrions voir s'organiser, pour l'exécution rapide et parfaite d'immenses travaux destinés à l'ornement des édifices, tels que nous les rêvons pour la vie gigantesque de la République dans l'avenir, des camps, des armées de peintres près desquels les grandes écoles d'Italie, avec leurs nombreux élèves, ne seraient que d'étroits cénacles.

'Sans doute l'individualisme en souffrirait, et quelques-uns y perdraient leur petite originalité de détail, mais les grandes œuvres sont presque toutes collectives. Personne ne sait les noms de ceux qui ont bâti et ciselé les cathédrales: Raphaël lui-même, malgré sa valeur personnelle, résume une civilisation, et ferme un cycle de peintres dont l'entité s'est fondue dans la sienne.' *L'Artiste*, series 5, 1, vol 8, pp. 113–15.

2. Flaubert (3), p. 107.

3. Proposed by Arsène Houssaye, *L'Artiste*, 27 Feb. and 5 Mar. 1848, pp. 257–9.

4. Proudhon (5) 1, 229.

5. On the ideas for a new festival art, see e.g. 'Une Fête Républicaine', editorial in *La Démocratie pacifique*, 21 Apr. 1848. The Fourierist newspaper wanted a revival of the festivals of the Greek city-state! The paper of Théophile Thoré, *La Vraie République* (Thoré is significant for us since he was a great art critic and a lesser Left-wing revolutionary), in its comments on the preparations for the *Fête de la fédération générale*, wanted more democratic participation in the way the festivals were staged (see no. 32, 27 Apr. 1848). This was part of the paper's consistent criticism of the basic organization of State patronage – the senseless division of Art administration into Theatre, Museums, Fine Arts, Literature, Education etc., and the lack of any control by the artists themselves over the bureaucracy. But even Thoré agreed with the aim, and the viability, of the new festivals. 'Quelle belle occasion pour notre ami Charles Blanc . . . de ressusciter par des symboles vivants toutes les nobles traditions de notre passé historique, et de sacrer la jeune Révolution par la poésie et les arts.' As for the *Fête de la Concorde*, the paper naturally despised its militarism, and noted the sadness and division in the crowds that watched it (see report, 22 May 1848).

6. Clésinger proposed the giant eagle. See David d'Angers in *L'Artiste*, 1 Feb. 1849, pp. 161–2. In the same article David outlined plans for mural decorations, new buildings, new shelters in the parks – all preaching the lessons of Republican virtue, by showing 'les beaux traits de toutes les classes de la société'. He had just been dismissed by Cavaignac from the Commission permanente des Beaux-Arts.

7. On Rousseau, see Archives du Louvre, Salon de 1849, Procès-Verbaux du Jury d'Admission, 23 May. No. 3353 *Terrains d'automne* is marked R (i.e. rejected), later *admis par révision* is added.

On Préault, see *ibid.*, list of entries. No. 1295, *1 bas relief. Flavia*, and no. 1296, *1 bas relief. Ophélia*, are listed, but were never shown. This may have been a last-minute

withdrawal, but as they were already executed this seems unlikely.

8. He was by far the most popular choice of the copyists in the 1840s and early 1850s.

9. 12,000 francs, decree of 6 Oct. 1849.

10. Gérôme's *Anacréon* was bought from the 1848 Salon for 1,800 fr., 2 July 1848 (AN. F21 32 Gérôme). On Muller's picture, see Clark (3), Chapter 6. The Bonheur was commissioned 2 July 1848, and was a big success in the 1849 Salon (AN. F21 16 Bonheur). For the others, see below.

11. See *L'Artiste*, 15 Mar. 1849, pp. 217–18.

12. AN. F21 26 Diaz.

13. AN. F21 14 Baumes A.

14. AN. F21 28 Elshoect.

15. AN. F21 20 undated letter (early 1849). 'Je n'ai pas de travaux; le gouvernement peut . . . encourager la peinture d'histoire . . .' He got a commission for 2,000 fr. on 2 Feb. 1849.

16. D.C.G., II, 374–5 (May 1849).

17. On Jeanron in 1848, see Rousseau, *passim*.

18. The decree was published in the press on 15 Apr. On the Panthéon project see Sloane (2), *passim*, and my deliberately brief remarks below. There was a storm of criticism of the undemocratic way that Chenavard had been chosen, e.g. P. Mantz, 'Revue des arts', *La Vraie République*, 25 May 1848.

19. See *Moniteur universel*, 4 Mar. 1848, p. 540. The various proposals for a new art organization can be found in AN. F21 566. (Victor Hugo himself pressed the idea of an independent system of art patronage in a session of the National Assembly's Committee of the Interior, 31 July 1848, see AN. C926, p. 55. He had no success.)

20. 'Que les fonctionnaires qui, par la nature de leur emploi, exercent une action immédiate et directe sur les beaux-arts soient élus par la corporation des artistes en assemblée générale.' Reported by A. Houssaye, *L'Artiste*, 5 Mar. 1848.

21. 'Déjà toutes les corporations des travailleurs ont recueilli le bénéfice de nos institutions républicaines; sur tous les points l'industrie s'en fait représenter par les délégués de son choix: aux artistes seuls ce droit serait-il contesté?' AN. F21 566: signed by Rude, Nieuwerkerke, Jouffroy, A. Ottin, etc.

22. 'Organisez-vous vous-mêmes.' AN. F21 566, mentioned in the same letter.

23. AN. F21 566, undated letter.

24. 'La Commission élective des peintres ne peut douter que je ne sois tout disposé à m'éclairer de ses avis, que je n'attache un grand prix à ses conseils; toutefois, et cela n'a pu sans doute entrer dans la pensée d'aucun des signataires de la proposition, je ne pourrais consentir à laisser dans cette occasion et à propos d'un acte à la fois si délicat et si important se déplacer l'initiative qui, de tout temps, a été réservée à l'Administration et consentir à l'abandon des prérogatives qui lui ont été attribuées, dans l'intérêt de l'art et dans l'intérêt des artistes.' AN. F21 566.

25. On Cavaignac's purge, see the note by Lord Pilgrim, *L'Artiste*, 1 Dec. 1848, p. 116. On their spadework for the salon, *L'Artiste*, 15 Dec. 1848, pp. 126–7. There are tantalizing notes on the Commission's proceedings in Fouché. Evidently the *Procès-verbaux* were extant in 1908; I have not been able to find them.

26. On Blanc's critical career before 1848, see Rosenthal, pp. 367f., and Grate, pp. 151, 167–9, 183. His remarks on the *Samson* series, see Rosenthal, p. 141.

27. Cf. Appendix for the statistical underpinning of this section. State patronage in this period will be exhaustively studied in a forthcoming work by P. Angrand.

28. See AN. F21 42 Préault. He did Clémence Isaure for the Luxembourg gardens in 1844; a Virgin for the Chapel of the Ursulines, Nogent-sur-Seine in 1843; a *Christ en bois* for the church of Saint-Paul,

Paris in 1845, and *Un Christ* for the Eglise des Thernes in 1847.

29. 'Le légitimisme nous déborde, il tient le haut du pavé.' AN. F21 35 Henault (dossier 3). 'L'affaire de ce tableau a pris une tournure véritablement politique.' AN. F21 23 Dauzats (dossier 1). 'Il serait convenable, principalement parce que la petite ville d'Evron est habitée par une grande nombre de légitimistes, et que le Maire et ses adjoints ont le courage de soutenir contr'eux une lutte incessante en faveur des principes de notre révolution de juillet'. AN. F21 17 Boutibonne.

30. 'Une marque de sympathie à une association morale et religieuse . . . qui occupe les loisirs dangereux de la jeunesse dans une ville industrielle'. AN. F21 13 Auvray. 'La population nombreuse et ouvrière qui fréquente cette église'. AN. F21 27 Dupasquier.

31. AN. F21 34.

32. 'Les Paroissiens auxquels cette Eglise est affectée sont en général des ouvriers, et surtout des cultivateurs. Nous espérons que ce sera un titre à votre juste bienveillance.' AN. F21 20. Chassevent, letter of 10 June 1848. On the political situation in the Tarn in 1848 – it was an area of social and political effervescence, in which the Legitimists were strong but the Republicans attempted, unsuccessfully, a counter-attack via the *Commissaire* – see Armengaud, pp. 345f., 350, 355.

33. Constant, p. 7; A. Houssaye, 'Salon de 1848', *L'Artiste*, 19 Mar. 1848, p. 8.

34. Cited Dansette (1), pp. 355–6. On the mixture of religion and politics in 1848 see Dansette, Duveau, and especially the short discussion in Dupeux, who sees the religiosity of politics in 1848 as stemming essentially from the *petite bourgeoisie*, with its initial hope for general happiness. 'Cette aspiration au bonheur s'accompagne de références constantes à l'Evangile, ou plus généralement de la conviction de réaliser les desseins du Créateur. La petite bourgeoisie croit que le progrès est dans la nature des choses, et elle a foi en l'humanité. Plus que toute autre classe elle possède la mentalité "quarante-huitarde".' Dupeux, p. 380.

35. AN. F21 16 Bidaud, letter of 27 May 1850.

36. AN. F21 15 Beaujouan, note of Prefect of Rhône, Mar. 1849. AN. F21 27 Dupuis-Colson (dossier 2), letter of Desmaroux, representative of Allier, 28 Feb. 1850; AN. F21 19 Carnatte, letter from Maure, representative of Var, 10 Jan. 1850. For situation in countryside at this date, early 1850, see Clark (3).

37. 'Les seules formes de gouvernement qui aient été favorables à la grandeur de l'art, ce sont les monarchies pures ou les démocraties vigoureuses, avec cette différence que les premières ont fait de l'art un esclave ou un flatteur, tandis que les autres ont fourni presque toujours une besogne héroïque.'

'Le mécanisme constitutionnel n'éveillait dans les âmes que l'amour et la tolérance du médiocre. Ce système de division et d'isolement avait amoindri l'art dans toutes ses branches. On ne demandait plus à l'architecte que des habitations confortables, au peintre que des tableaux de chevalet, au sculpteur que des statuettes, au graveur que des illustrations. . . . La maison du citoyen, rapetissée avec le siècle, s'était divisée à l'infini comme la société elle-même, si bien qu'il ne s'y trouvait plus de place que pour l'art en miniature. La grandeur physique était aussi impossible que la grandeur morale; l'espace était aussi interdit que l'enthousiasme.'

38. 'Comment l'art italien, sorti des libertés municipales par la fresque, s'augmenta à la fin du quinzième siècle, de la peinture à l'huile, atteignit son apogée par la réunion harmonique de la fresque et de la peinture à l'huile dans les grands artistes du commencement du seizième siècle, et finit

misérablement dans l'art de cour.' Reported in *L'Artiste*, 1 Feb. 1849, pp. 170–1.

39. Story told in David d'Angers, II, 448. It is one of the ironies of 1848 that General Cavaignac owed his power in the Republic – in part at least – to the fact that he was Godefroy's brother.

40. *Le National*, 8 June 1847; on the Cavaignac monument see Fourcaud, pp. 482–3; on Cavaignac's career, *Dictionnaire de biographie française*, VII, cols. 1488–9. The links between Rude's sculpture and the late Gothic of his native Burgundy are clear: his sculpture is a brilliant *revival*.

41. We cannot be sure of the direction of the influence here, since the dating of Préault's *Ophelia* is thoroughly obscure. The bronze I use as an illustration is a much later cast, shown in the 1876 salon. But, as usual with Préault, a plaster version was shown years before in the 1850 salon. And even this does not fix a date, since Préault was showing a backlog of works 'refused' during the July Monarchy, some of them fifteen years old. On grounds of style, I would put the *Ophelia* with *Ondine*, done in the late 1830s; though perhaps the similar subject misleads me.

42. 'Un cadavre défiguré'. David d'Angers, II, 263, 6 Dec. 1848.

43. David d'Angers, II, 89, 1840.

44. 'En costume militaire'. See Bibliothèque Nationale p. 137, no. 583 *bis*.

45. Fourcaud p. 487.

46. On Couture in 1848 see Boime, *passim*, Couture, pp. 45f., and AN. F21 22 Couture. Arsène Houssaye, writing in March in favour of a museum of revolutionary scenes, noted that 'Couture et Gigoux ont déjà depuis longtemps commencé deux belles pages de ce musée'. *L'Artiste*, 5 Mar. 1848, pp. 257. I should mention here another article on Couture by M. Fried (2), which argues for profounder and more genuinely Republican motives behind the *Volunteers*. I remain unconvinced and am more dismissive of Couture than either Boime or Fried.

47. Couture, p. 45.

48. See Boime, pp. 53–60.

49. E.g. Vinchon's *Enrôlements volontaires (22 janvier 1792)* in the 1855 Exhibition, cited Boime, p. 53.

50. Tocqueville, p. 145.

51. See AN. F21 47 Préault. The plaster model for the Festival was ordered on 12 May 1848, for 7,000 francs. This was raised to 22,000 francs on 21 Sep. 1849, for a marble version. The other statues were by Daumas, Devaulx and Soitoux.

52. 'Ce groupe du cheval gaulois et son garde nous paraît présenter dans sa composition et dans son exécution si peu d'Etude et des Exagérations telles, que nous avons hésité à le considérer comme terminé.' AN. F21 47 Préault, report of 14 Jan. 1853. Whether part of the roughness of the sculpture nowadays is due to a century's weathering of poor stone is an open question.

53. AN. F21 47 Préault. Poussin bust ordered 23 May 1848, 2,500 fr.; Christ for Eglise des Thernes, ordered 5 Jan. 1850, 3,500 fr.

54. See AN. F21 15 Bezard. Letter of 4 Oct. 1850 from one of Chenavard's assistants who asks for a change of commission, since 'cet Artiste a tout à fait renoncé, et je suis autorisé à vous le dire, à l'emploi de toute espèce de peinture'. On the project in general, see my note 18.

55. In Gautier (3), entitled 'Accablement'.

56. Reprinted in Gautier (1), p. 86.

57. See Sloane (2), pp. 62–3.

58. Reply published, *Le Siècle*, 10 Mar. 1851, in AN. F21 21 Chenavard.

59. For this and other details of juries, regulations, see AN. F21 566. On the whole contest see now the study by Boime (3).

60. His letter explaining his reasons for declining – 'des circonstances indépendantes de ma volonté viennent s'y opposer' – dated 2 July 1848 is in AN. F21 26 Diaz (Diaz replaced him in the list of twenty). For Flandrin see Boime (2), ill. 110 and p. 120.

61. See Ingres's letters to Cambon, in Boyer d'Agen, pp. 393f., 28 Sep. 1848 and 12 Oct. 1848. For his final version, see Ingres, fig. 40.

62. See AN. F21 566. The initial election of the jury took place on 15 May. On 17 May a letter signed by Préault, David d'Angers, etc., protested at its undemocratic nature; and a new election took place on 31 May. The painting section seems to have been less agitated.

63. Boyer d'Agen, p. 392, letter to Gilibert, May 1848.

64. 'Il y a trois mois que nous avons chassé cette race maudite, et que la jeune République s'est dressée, chaste et radieuse, sur un trône de pavés et de cadavres.' La Vraie République, 20 May 1848. Open letter to Barbès, then in prison for his part in the 15 May invasion.

65. L'Artiste, 1 Nov. 1848, p. 84.

66. Cited in L'Artiste, 30 Apr. 1848, p. 112.

67. 'Votre composition doit réunir en une seule personne la liberté, l'égalité, la fraternité. Cette trinité est le caractère principal du sujet. Il faut donc que les signes des trois puissances se montrent dans votre œuvre.

'Votre République doit être assise pour faire naître l'idée de stabilité dans l'esprit du spectateur.

'Si vous étiez peintre, je vous dirais non pas d'habiller votre figure en tricolore, si l'art s'y oppose; mais cependant de faire dominer les couleurs nationales dans l'ensemble du tableau.'

68. Cited Tabarant, p. 124.

69. La Vraie Republique, 2 May 1848.

70. Stern, II, 349.

71. The twenty numbers are listed in order of preference in an undated report (April or May), AN. F21 566; and L'Artiste revealed the names behind some of the numbers on 15 Oct. 1848.

72. We know little about this painting's history, but the style and subject matter would suggest a date c. 1848-9.

73. Figures given by C. Isnard, L'Artiste, series 5, II, vol. 3, pp. 47-8.

74. A typical example is AN. F21 13 Appert. He had painted six pictures, all religious, for the State since 1843. In 1848-50 he did three still-lifes.

75. See AN. F21 54 Rousseau. Landscape ordered 9 May 1848, specifically for the Musée du Luxembourg.

76. Galimard, p. 122.

77. See AN. F21 23 Daubigny. His Soleil couchant was bought for 250 fr., 12 June 1848. The two facsimiles were ordered on 24 Sep. 1848, for 200 fr. and 2 Feb. 1849 for 400 fr. A 'tableau de paysage' now in the Carcassonne museum, was commissioned for 800 fr. on 29 July 1849. Les Bords de la Seine, now in Limoges museum, was acquired on 20 Sep. 1849 for 500 fr. On 11 Oct. 1850, after producing a new letter of recommendation for Guizard, he was given another commission for 500 fr. and did Paysage: îles de Bezon for Avignon museum. The Carcassonne picture, so the letter of recommendation states, was 'placé dans le cabinet de M. le Ministre' in 1849. Daubigny became one of Louis-Napoleon's favourite landscapists in the early 1850s.

78. On this influence in Daubigny's art at the time, see Herbert (3), p. 47. The simple construction and handling of this picture show the hold of Claude loosening even before 1851, which is the date Herbert suggests.

79. For a list of acquisitions from the 1849 Salon, with prices, see AN. F21 527. Out of a total of 57 acquisitions, there were twenty-one landscapes, seven classical subjects, nine religious works (including three religious genre paintings), seventeen genre paintings (including two scenes from Shakespeare and two paintings of recent history). My categories are rather different from the official ones. After Muller, who received twenty-one votes from the Jury des récompenses, Maison got 5,000 fr. and nineteen

votes for *La Messe pontificale à Saint-Pierre de Rome*; Jollivet 3,000 fr. and thirteen votes for *Persée délivrant Andromède*; Courbet the same price and votes for *L'Après-dîner à Ornans*; Leullier the same price and eighteen votes for *Une Chasse aux tigres*; Antigna the same price and sixteen votes for *Après le bain*. Other top prices went to Troyon for *Environs de Sézanne*, Boulanger for *Galathée et le berger Athis*, Corot (2,400 fr. and fourteen votes) for *Christ au jardin des oliviers*, etc.

80. 'Le tableau de M. Bonvin est entière-ment terminé, il ne manque pas de qualités comme effet en couleur mais est d'un aspect triste et peu intéressant.' AN F21 17 Bonvin, report by Garraud, 14 Oct. 1850.

81. AN. F21 24 Dehondencq. Backing letter is dated 14 Aug. 1848, and the commis-sion itself was given on 16 Aug. The *Virginie* painting is now in the Dinan museum. The *Course de taureaux* was ordered on 4 Aug. 1849 for 2,000 fr.

82. On *La ville de Paris implorant Dieu pour les victimes du choléra*, see AN. F21 24 Etex. The group was commissioned on 27 June 1848 for 20,000 fr.

83. See AN. F21 527.

84. On his role in 1851, see Dolléans p. 230.

85. See AN. F21 32 Gérôme. Commission of 7 Feb. 1850, for 5,000 fr., to paint four large figures and two medallions as decora-tion for the Bibliothèque du Conservatoire des Arts et Métiers. The sketches for these works (now lost) are in the dossier, and to my eye seem deliberately restrained and neutral. But the architect Vaudoyer was not satisfied: he complained, 4 Aug. 1851, that Gérôme had decided to 'laisser aller librement à sa fantaisie' and thus spoil the unity of the architecture. The Bureau asked for modifications, timidly. The whole story is typical of the vagaries of patronage in the Republic.

86. E.g. in debate of 3 Apr. 1849 on the Budget proposals for the Fine Arts; see AN. F21 4006.

3 Millet (pp. 72–98)

1. 'Un engrenage qui broie', letter to Sensier 1847, cited M–N, I, 65.

2. In *La Presse*, cited M–N, II, 42.

3. 'Salon de 1859', B.O.C., p. 1078.

4. Cited M–N, I, 2–4.

5. In *La Presse*, cited M–N, I, 70.

6. M–N, I, 70–1. On the loss of the 1848 version, see the letter from Moreau-Nelaton, 5 June 1919, in Arch. Louvre, P-30 Millet.

7. See Note of 4 Jan. 1852, AN. F21 98 Millet. On the question of Millet's social status, and cultural level, see Herbert (1), esp. pp. 294–5, and Lepoittevin (2).

8. See Sensier, p. 111.

9. For the sign-painting, see M–N, I, 74; on the frontispiece, Lepoittevin (2), pp. 30–1; on the commercial projects in 1851, M–N, I, 96f.

10. 'J'ai terminé le tableau que vous avez bien voulu me commander; j'ai mis à son exécution tout le soin et le con-science possible: je dois le présenter à l'exposition ou il sera possible de le juger.' See AN. F21 47 Millet. The initial commis-sion is undated, but the dossier has the note, 4 July 1848. The commission asked for 'un tableau dont le sujet et l'esquisse devront être soumis à notre approbation'.

11. The documentation in the Archives du Louvre is hopelessly confused. First there is the '*Notice des ouvrages présentés pour l'exposi-tion*', with two entries: 2654 no. 1, *Repos de faneur* – crossed out in pencil; 2655 no. 2, *Paysanne assise*, with (*admis*) written in pencil. Then the *procès-verbaux* of the *Jury des admissions*, 22–23 May. On 22 May, 2654 Millet – *Paysages* (*sic*) is listed, but no verdict, either rejection or acceptance, is written beside it. On the 23, 2655 *Millet – paysages* is listed, with *admis* written beside

it in the normal way. Finally, the *Enregistrement des ouvrages*, where the bureaucrat has given the pictures the wrong numbers: *2654 1 tableau Repos 31 cm. × 36 cm.* (the dimensions are those of *Paysanne assise*) with the cryptic note beside it *retiré* (which usually means withdrawn by the artist, but *Paysanne assise* was definitely exhibited in the Salon) and then, in addition, *(rendu)*. The last entry is usually the formula for rejection – does it here simply mean returned after the Salon? The other entry: *2655 1 tableau Paysannes (sic) 90 cm. × 1.17 m.* (the dimensions of the *Repos de faneur*) with the note *rendu*. All this is tedious and ambiguous: there are things to suggest a rejection, but more to suggest withdrawal by the artist himself. The 1849 Jury was a severe one, as we know already *à propos* of Préault and Rousseau.

12. Sensier, p. 112.

13. Cf. Corot's version of *Hagar*, exhibited in the 1835 Salon (now in the Metropolitan Museum of Art, New York), where the desert is full of floral detail, and arranged for viewing in the manner of Claude.

14. The mural was entitled *La Paix*, illustrated e.g. Marcel, pl. 29. Chassériau had already been a major influence, I think, on Millet's portrait style in the 1840s.

15. Documents on its restoration after fire damage in the 1890s are in AN. F21 47 Millet.

16. 'Je ne vois là, me disait-il, que des faubouriennes; c'est une femme du terroir qu'il me faut.' Sensier, p. 114.

17. See Ch. pp. 103–9 on the regions round the *barrières*, and Daumard, p. 207, on the location of new industry in the eastern outskirts. The new population of the *banlieue* soon became a literary theme, as Chevalier shows in the case of Victor Hugo. For further discussion, see Clark (3), Chapter 6.

18. Blanqui (1), p. 13.

19. 'Les ouvriers nomades venant isolément et à toutes les époques de l'année sont, au contraire, presque toujours chassés de leur pays par leurs vices, leurs méfaits, leur inconduite. Ce sont eux surtout qui contribuent à introduire, dans cette partie de la banlieue, les déplorables caractères de démoralisation que j'ai signalés dans la présente monographie.' Châle, p. 484.

20. See Chevalier (2), pp. 704–5.

21. In Herbert (4), pp. 34–5.

22. See Chevalier (2), pp. 394–6 and 388–90.

23. 'Pays de forêts ou pays de bocage, où vit une petite population de bûcherons et d'artisans plus ou moins démunis de terre. Il s'agit surtout de ces contrées de la Région Parisienne où de grandes exploitations productrices de blé s'étendent entre les larges districts forestiers, le prolétariat des bois venant renforcer le prolétariat des champs, en 1848 comme en 1793.' Chevalier (2), p. 201.

24. Balzac, p. 89.

25. Dupeux, p. 158.

26. Dupeux, pp. 432–3. Dupeux is talking specifically of the forest lands of the Beauce, but his conclusions probably apply rather closely to the isolated Forest of Fontainebleau. What matters in any case is the relevance of these remarks to Millet's imagery, and to the critical reaction to it in the later 1850s.

27. See AN. F21* 2793 for record of the rejections; J. Rousseau in *Le Figaro*, cited M–N, II, 41; P. de Saint-Victor in *La Presse*, 1859, cited *ibid.*, p. 66; letter of Sensier to Millet, 21 Apr. 1861, cited *ibid.*, p. 94.

28. In *L'Indépendance belge*, 1859, cited Herbert (4), p. 47.

29. In fact the evidence is ambiguous. On the one hand Sensier was urging Millet to stop painting nudes and mythologies in 1851, which suggests a certain reluctance to give them up. On the other hand, Sensier reported the sale of *Nymphe entraînée par les Amours* in a letter of 18 Oct. 1851,

for 100 francs, calling it a picture for which the artist had 'tant d'aversion'. Or was this wishful thinking on Sensier's part?

30. See M–N, II, 97–8, but cf. Lepoittevin (2), pp. 30–1, and the Catalogue of European Drawings at Yale, 1970. The full title of *Mazeppa* is *Simon Kenton alias Butler Tortured by the Indians*. It was done, finally, for a series of four lithographs published by Goupil in 1852, entitled *Annals of the United States Illustrated – The Pioneers*.

31. On *La Charrette*, see Herbert (1), p. 301, who suggests that its *contrapposto* organization shows Millet's continued interest in Michelangelo and Poussin.

32. See Herbert (4), p. 34–5, on the *Semeur's* early history.

33. Cited M–N, II, 90–1.

34. Letter from early 1853, cited M–N, II, 108–9. Sensier had obtained a commission of 1,000 fr. from the Bureau, to tide Millet over a particularly bad patch.

35. See the very helpful brief discussion of the various versions of the picture at this stage, in Herbert (3), p. 150, and also the illustration of the full-scale sketch, p. 159, no. 63. I should confess here that I know the second version of the *Sower* only through photographs: the one in Moreau-Nelaton and a newer one of the picture, before its recent restoration, obtained for me by the good offices of Professor Herbert and Mr Theodor Siegl, Conservator of the Philadelphia Museum of Art.

36. Letter to Sensier, 25 Jan. 1851, cited M–N, I, 89.

37. The 'Salons' with reference to Millet are as follows: J.-J. Arnoux, *La Patrie*, 19 Mar. 1851; P. de Chennevières, *Lettres sur l'art française*, Paris, 1851, p. 65; A. Dauger, *Le Pays*, 9 Feb. 1851; A. Desplaces, *L'Union*, 29 Jan. 1851; E.-J. Delécluze, *Exposition des artistes vivants 1850*, Paris, 1851, pp. 59–60; A.-J. Dupays, *L'Illustration*, XVIII, 73; L. Enault, *Chronique de Paris*, Art. 3, 3 Mar. 1851, p. 143; A. de la Fizelière,

Le Siècle, 15 Apr. 1851, and *Exposition Nationale, Salon de 1850–51*, Paris, 1851, p. 36; T. Gautier, *La Presse*, 15 Mar. 1851; L. de Geofroy, *Revue des deux mondes*, 1851, p. 938; P. Haussard, *Le National*, 1 Apr. 1851; F. Henriet, *Le Théâtre*, 18 Jan. 1851; P. Mantz, *L'Evénement*, 5 Mar. 1851; 'N.', *Indépendance belge*, 28 Feb. 1851; P. Petroz, *Vote universel*, 28 Jan. 1851; C. de Ris, *L'Artiste*, 1 Feb. 1851; P. Rochéry, *La Politique nouvelle*, vol. 1, p. 350–1; F. Sabatier-Ungher, *Salon de 1851*, Paris, 1851, pp. 39–40.

In rough and ready terms, Gautier, Fizelière, Dauger, Chennevières, Enault, Petroz, de Ris, Rochéry, Sabatier-Ungher, Haussard, and Mantz were favourable. Henriet, Geofroy, Dupays, Desplaces, Delécluze and 'N.' were hostile.

Arnoux regretted the absence of three smaller works which Millet had painted for sale in February 1851 – *Une Broyeuse de lin, Ramasseurs et ramasseuses de bois mort* and 'above all' *Paysan et une paysanne allant arracher des pommes de terre*, which is the painting in Glasgow Art Gallery known as *Going to Work*. These, he suggests, would have represented Millet, though in fact the sale in February went badly.

38. 'Une sauvagerie qui impose'. Dauger. 'Une sauvagerie . . . savante'. Petroz.

39. 'Pourquoi cette rudesse d'aspect, pourquoi ces teintes noirâtres et monochromes? Où M. Millet a-t-il rencontré un laboureur de mine si rebarbative, un ciel si sombre, un paysage si désolé au temps de semaille?' Desplaces.

40. 'Seul au milieu d'un sol nu et fraîchement remué, comme il paraît comprendre la grandeur de sa mission. . . . Cet homme qui, ministre du ciel, tient dans sa main et jette au vent, avec la foi de l'apôtre, les richesses de la terre; et puis là-bas, sous ce nuage, ce vol d'oiseaux rapaces qui glapissent comme une ironie, comme une menace.' Fizelière, *Exposition Nationale*.

41. 'Mais pourquoi M. Millet nous fait-il ses travailleurs hâves, maladifs et souffreteux? Voyez à quoi il s'expose! Dans leur admiration compromettante, certains critiques ont été jusqu' à voir dans l'œuvre de M. Millet la personnification du prolétariat moderne; ils y ont trouvé une *protestation*, affaire d'habitude. . . . Et les voilà qui déroulent, à propos de botteleurs, tous les lieux communs démocratiques. Pauvre M. Millet! Il a voulu faire de la fantaisie et le voilà convaincu d'avoir fait du socialisme. Ce cruel châtiment désarme notre sévérité.' Henriet.

42. 'La vérite poétique de la nature'. Petroz. 'Une etude énergique et bien mouvementée'. De Ris. 'Du grandiose et du style dans cette figure au geste violent'. Gautier. 'Le côté mélancolique des travaux champêtres'. La Fizelière, *Exposition nationale*.

43. 'Le tableau de M. Millet est certainement fait sur nature comme celui de M. Courbet, mais on y reconnaît bien plus de naïveté et de profondeur dans les impressions, un amour plus vrai de la vie et des hommes de la campagne.'

44. Of the six hostile critics, Geofroy and Delécluze dismissed Millet briefly on technical grounds; Dupays objected most strongly to his technique but also mentioned the sadness and desolation of his imagery; Henriet disliked imagery and technique about equally (he contrasted *The Sower* with the 'charming' *Winnower* of 1848!); N. and Desplaces seem to have been primarily concerned with the subject and Millet's treatment of it.

45. 'Au moins, M. Courbet fixe ses contours, il fait ce qu'il pense, les choses y sont, toutes laides et repoussantes qu'elles soient; – et après tout, c'est un mal de plus que de si bien préciser d'aussi désagréables et antipathiques machines! Quant à M. Millet, il applique le genre lâché, indécis, *flou*, comme dit l'argot, à toutes sortes de crapules qu'il appelle paysans.'

46. Three of them – Gautier, Rochéry and Sabatier-Ungher - made the comparison explicitly.

47. 'Il y a jusque dans l'âpreté de l'exécution comme un style abrupte, nerveux, qui sent l'expérience du travail et de la misère.' *Le Siècle.*

48. 'La largeur de son dessin et l'immensité de l'espace'. Petroz.

49. 'Ses figures s'enveloppent dans les vapeurs lointaines de l'horizon de façon à donner une leçon cinglante de perspective à nos modernes fabricateurs de grossiers paravents'. 'Mise en scène qui repousse ses personnages et les tient à bonne distance'.

50. 'Deux ou trois tons noirs, sales et charbonneux'. Henriet.

51. Dupays.

52. See his comments on the Crabbe collection, B.O.C. p. 1201. The reference is to Jean de la Bruyère, *Les Caractères . . .* , Paris, 1688, chapter 'De l'homme'.

53. Letter to Pelloquet, 2 June 1863, cited M-N, ii, 131–2.

54. Letter of 18 Feb. 1862, cited M-N, ii, 106–7.

55. See letter to Sensier, cited M-N, ii, 137–8.

4 Daumier (pp. 99–123)

1. James (1), p. 30.

2. Troubat (3), pp. 59–60.

3. See Osiakovski on Daumier's politics, and on the evidence of differences with *Charivari*. Osiakovski exaggerates Daumier's Left-wing commitment, but his analysis of the politics of particular lithographs, and his stress on the meaning of Daumier's silences, is often excellent. His book is ignored by Daumier scholars.

4. *Actionnaires de chemin de fer causant dividendes*, D.1736, published 28 June 1848.

5. D.1694.

6. No one knows how far Daumier was

involved with the Commune. He was old and ailing at the time, but the story that he opposed the destruction of the Vendôme column is fiction.

7. Champfleury (10), p. 72.

8. Cited Larkin, p. 30.

9. He mentions his anxiety for his family, in passing, in a letter from Sainte-Pélagie (he was in prison as a result of the anti-monarchist cartoon *Gargantua*) dated 8 Oct. 1832, cited Daumier, pp. 31–3.

10. On the break with the family and the short-lived artists' phalanstery, see Adhémar J., p. 19; on the father's death, Vincent, pp. 154–5.

11. On the artisan identity and industrialization, see Thompson, especially pp. 234–62 (it deals with the English artisan). In France, apart from the mass of material on artisans and craftsmen in the great French Revolution, see Rudé, esp. pp. 165f., and Gossez (2), pp. 449–50 on the artisans in 1848.

12. 'Chez mon papa' occurs in the letter of 1832. The 1841 debt, see Vincent, p. 84.

13. D.1157.

14. Lanquetin, p. 24, cited Daumard, p. 208.

15. Lanquetin, p. 24, cited Daumard, p. 208. See also Ch., p. 228 on the *déclassement* of this part of Paris. It did, of course, remain something of an artists' colony in the late 1840s and 1850s; but for Daumier this other facet of its history was perhaps more important. Writers on Daumier have often been misled about the Ile Saint-Louis by a passage from Zola; by the time Zola was writing, the island had reverted to gentility. (Incidentally, it ceased to be in the 9th Arrondissement early in this century and is now in the 4th.)

16. David d'Angers, pp. 292–3, dated 1849.

17. *La Presse*, 8 Aug. 1849.

18. Maison, II, 33.

19. Champfleury (2), p. 10.

20. See Léger (6), p. 30: '*l'Homme à la pipe*, crayon noir (1845) qui appartiendra à Daumier, et sera exposé à l'Ecole des Beaux-Arts en 1882'. A cryptic note, but not improbable.

21. On the 1849 holiday, see Larkin (2), p. 80; D.J., I, 331, 12 Jan. 1850; on Michelet, see Daumier, 85–91. The plans came to nothing.

22. D.1743, 1744, 1746.

23. See below, Chapter 5, for full discussion.

24. D.1761–8.

25. D.1768.

26. D.1769–1774, and 1794.

27. B.O.C., p.1007.

28. D.1778.

29. D.1780.

30. James (1), p. 32.

31. James (1), p. 23.

32. D.2146.

33. E.g. D.2156, 2158 (Ratapoil plus other villains); D.2000, 2136, 2153 (with Suffrage or the Republic).

34. D.2157.

35. This is true, esp. of D.2000, 2079, 2080, 2131, 2150, 2167, but also of D.1937, 2008, and 2014, and even of D.2153.

36. D.2002; D.2082.

37. D.2161, 2092, 2117, 2118.

38. James (1), p. 23.

39. 'M. Daumier n'est qu'une manière d'ouvrier en facéties, point inventif, dépourvu de grâce, avec de l'habileté au bout des doigts et qui rencontre parfois une pincée de gros sel. Mais quel rire! quelle odeur de fromage et de gros vin! quelle main faite pour déchirer les gazes de Paul de Kock.' *L'Univers*, 2 Apr. 1851.

40. 'Que ce rire bestial que vous soulevez dans les cabarets ne retentisse pas au-delà de votre dernière heure'. *L'Univers*, 2 Apr. 1851.

41. In the first category: *La République*, *L'Emeute* (ex-Rouart coll.), *Tête d'homme*

(oil study for *Famille sur les barricades*), *Tête d'homme* (drawing of same subject), *La Madeleine au désert*, *Silenus* (drawing), *Ratapoil* (sculpture), 3 Drawings for Henry Martin History, and the drawing *Saint Sébastien* in Metropolitan Mus. of Art, New York. In the second category: *Le Meunier, son fils et l'âne*, 3 versions (we cannot be certain that these were not done well before the 1849 Salon, when one version was shown); *Les Fugitifs* (sculpture, 2 versions); *Les Fugitifs* (drawing with wash); *Les Femmes poursuivies par des satyres* (1851 Salon, but probably retouched later); *Les Fugitifs* (Montreal, Van Horne coll.); an early version of the subject *Le Fardeau*, seen by Poulet-Malassis in 1852 (perhaps the one in the Jäggli-Hahnloser coll., Winterthur); *Don Quixote et Sancho dans les Montagnes* (Paine coll.); *Le Baiser* (drawing). Other works possibly dating from this period will be mentioned in the text. Here as elsewhere in the question of dating I have lent heavily on Maison's catalogue, though sometimes diverging from it.

42. *La Vraie République*, 2 May 1848.

43. *Le National*, 8 June 1848.

44. *L'Artiste*, 1848, pp. 108–9.

45. AN. F21 23 Daumier.

46. Arch. Louvre, Salon de 1849, Notice de la Peinture no. 3430. The entry originally read *La Madeleine au désert*, but Daumier changed it.

47. In Arch. Louvre, Enregistrement des Ouvrages no. 3430. *La Madeleine* is marked *retiré* – probably by Daumier himself.

48. Note of Poulet-Malassis, in Louvre, Moreau-Nelaton bequest, cited Adhémar J., pp. 44–5.

49. The various letters are in AN. F21 23 Daumier.

50. T. de Banville, *Mes Souvenirs*, cited Daumier, pp. 145–53.

51. 'La jeune société républicaine est encore comme un martyr garotté et percé de flèches. Les saintes femmes qui viendront arracher les flèches et parfumer d'huiles bienfaisantes les blessures du peuple martyr sont: La Liberté, L'Egalité, La Fraternité.' *Vraie République*, 13 Apr. 1848.

52. See Mistler, p. 22.

53. 'Il m'a parlé des difficultés qu'éprouve Daumier à finir'. D. J., I, 258, 5 Feb. 1849. See the quotation at the beginning of Chapter 5 of this book.

54. 'Touché avec la verve d'un grand coloriste, mais froid de ton et monotone de couleur'. 15 Aug. 1849.

55. *La Presse*, 8 Aug. 1849.

56. Reported by Alexandre, p. 344.

57. See De Luna, pp. 154–5.

58. 'Like those which, vanquished by triumphant death, the Emperor breathed forth from his dying breast'. Baudelaire (5), p. 376; see below, Chapter 5, for full discussion.

59. On technique in *Ratapoil*, see Wasserman, pp. 17–21, 161–9; on *Les Emigrants*, *ibid.*, p. 174–8, see the discussion of the two versions of this relief. The Ashmolean drawing was done probably in connection with the Henry Martin project, though the subject is in doubt – some have called it *Destruction of Sodom*.

60. Contact with sculptors is stressed by Adhémar, J., pp. 39–40.

61. The *Don Quixote* is lost. It is not, as Maison suggests, the picture in the Paine collection, whose dimensions do not remotely correspond to the figures in the Salon register, 90 cm. × 100 cm.

62. *Sancho Panza sous un arbre*, Vienna, and *Don Quixote et Sancho dans les montagnes*, Paine collection, Boston.

63. David d'Angers, II, 329–30.

64. The early *Saltimbanques* is in Washington, National Gallery. The others mentioned are in the Victoria and Albert Museum, Burrell Collection, Glasgow, Wadsworth Atheneum, Hartford, Museum of Fine

Arts, Budapest, the De Hauke Collection and the Musée du Petit Palais, respectively.

65. 'Cette classe nombreuse et pauvre de saltimbanques et de musiciens ambulants'. AN. F7 12238, Prefect of the Eure. The man with 18 assistants appears in an 1855 petition – his scale of business was favoured by the new regulations.

66. 'When, twisting your scarf, you gloated over some athlete in tights, a shapely Alcides, whom the bourgeois admire and the police tear to pieces.' It appeared in *La Silhouette*, 27 Sep. 1849; see B.O.C., p. 224.

67. 'Je pense, au surplus, qu'il serait fort utile d'appliquer la même interdiction à tous les joueurs d'orgue, musiciens ambulans, etc., qui sont les auxiliers naturels des établissements socialistes, et ne sont en réalité que des mendiants.' AD. Doubs. M 734.

68. 'Dans leurs annonces au public et dans leurs parades, les saltimbanques, bateleurs etc., devront s'abstenir de toutes démonstrations contraires au respect dû à la religion, aux bonnes mœurs et aux convenances.' AN. F7 12238, Article 8 of Gers Arrêté.

69. 'Il est ami de l'ordre et à l'exemple des gens de bien, il s'attache au Gouvernement de l'Empereur sur qui reposent et son avoir et le bonheur de tous.' AN. F7 12238, petition of 15 Dec. 1854.

70. 'Il m'a paru indispensable de leur laisser le faculté d'exercer leur industrie, dans cette saison, jusqu'à huit heures du soir. Leur véritable journée, celle qui est lucrative pour eux, ne commence en effet dans les grands centres de population, comme Nantes, qu'à sept heures du soir, au moment où les ateliers se ferment et où les ouvriers rentrent dans leurs domiciles. L'interdiction pour les saltimbanques d'exercer leur industrie après six heures du soir, eût été équivalente à une prohibition

complète.' AN. F7 12238, letter to Min. of Interior.

71. E.g. AN. F7 12238, Ariège Prefect in his circular of 2 Jan. 1854: 'Les Saltimbanques sont presque toujours accompagnés d'enfants qui leur ont été confiés ou qu'ils ont même souvent dérobés à leurs parents. Pour empêcher ces enlèvements criminels . . .', etc.

72. 'Le fils d'un soldat prolétaire'. Petition by Anglade, Paris, 23 Nov. 1854. AN. F7 12238.

5 Delacroix and Baudelaire (*pp. 124–77*)

1. D.J., I, 258–9.

2. D.C.G., II, 363–4, 1 Sep. 1848.

3. D.C.G., II, 353–5, 4 Aug. 1848.

4. D.O.L., II, 177. The article appeared in the *Revue des deux mondes*, 1 Sep. 1848. He worked on it in July and August.

5. D.J., I, 281, 5 Apr. 1849.

6. D.C.G., II, 383, (21 June) 1849.

7. Adèle Hugo, *Journal*, 27 Mar. 1856, cited Georgel, p. 176.

8. D.C.G., II, 344.

9. Thoré, pp. 561–2, 'Salon de 1848'.

10. *La Vraie République*, 23 Apr. 1848.

11. D.C.G., II, 348, 8 May 1848. On the *Fête de la Concorde*.

12. D.C.G., II, 343–4.

13. See D.C.G., II, 345, 3 [Mar.], to Pierret; pp. 345–6, 28 [Mar.], to lithographer Mouilleron; p. 360, Aug. 1848, to Villot – he has seen Jeanron at the *jury des récompenses* and Jeanron says it is up to Villot to arrange the rehanging of *Liberty*.

14. See Delacroix's draft of letter to James, 6 Jan. 1849, D. J., I, 252–4.

15. The story is told by Champfleury (11), pp. 296–7.

16. D.J., I, 270, 5 Mar. 1849.

17. 'L'intervention des artistes est indispensable dans toutes les circonstances où il s'agit de leur situation, de l'emploi de leurs talents et de la gloire de la peinture française.' 'Du principe et de l'action démocratique'. AN. F21 566 n.d.

18. Cf. D.C.G., II, 392, 25 Aug. 1849, to Dutilleux: 'cette position me met souvent dans la nécessité d'être en opposition avec l'administration'. Fouché reports that Ingres and Delacroix both supported a proposal to put an end to the Jury and have a system by which 'les artistes se jugeassent eux-mêmes et sans intermédiaire et . . . les exposants designassent eux-mêmes ce qui doit être admis ou refusé'.

19. D.C.G., II, 347, 8 May 1848, to Soulier.

20. D.C.G., II, 356–7, 8 Aug. 1848, to de Mornay.

21. D.C.G., II, 364–5, 4 Sep. 1848.

22. D.J., II, 320, 16 Oct. 1849.

23. 'Nous avons été ici, bourgeois et manants, fort occupés de la suite de tout cela . . . nous avons donc monté la garde et arrêté plusieurs de ces gredins.' D.C.G., II, 352, 2 June 1848, to Madame de Forget.

24. D.C.G., II, 369.

25. D.C.G., II, 373, 6 Feb. 1849, to Dutilleux.

26. D.C.G., II, 380–1, 9 June 1849, to L. Riesener.

27. The first is Robaut no. 1072, coll. Miss Adelaide Milton de Groot, New York; the second Robaut no. 1041, Philadelphia Museum of Art. See Delacroix (4), pp. 33–4, for discussion by L. Johnson.

28. New York, E. V. Thaw and Co. See Serullaz (2), pp. 298–9.

29. Robaut no. 1171; in 1851 Salon; coll. H. W. Pillow, Montreal.

30. Montpellier, Musée Fabre. This picture and the Othello were both in the 1849 Salon.

31. Private Coll., Paris; in 1851 Salon; see Serullaz (2) p. 313–4. The Pietà is Robaut no. 1173, National Gallery, Oslo; the date is not certain, but 1850 is probable. We know from the Journals (D.J., I, 296) that Le Bon Samaritain was blocked in in June 1849, and the Pietà seems to be a pair to it.

32. Rosenthal, p. 125.

33. Taine, p. 283, cited Rosenthal, p. 125.

34. Rijksmuseum, Amsterdam; see Serullaz (2), pp. 324–5.

35. D.C.G., III, 13.

36. D.C.G., III, 18, to Mme de Forget.

37. D. J., I, 362.

38. D. J., I, 366.

39. 'Je les vis arriver toutes deux, la mouche acharnée sur son dos et lui portant des coups furieux; après une courte résistance, l'araignée a expiré sous ses atteintes; la mouche, après l'avoir sucée, s'est mise en devoir de la traîner je ne sais où, et cela avec une vivacité, une furie incroyables. Elle la tirait en arrière à travers les herbes, les obstacles, etc. J'ai assisté avec une espèce d'émotion à ce petit duel homérique. J'étais le Jupiter contemplant le combat de cet Achille et de cet Hector. Il y avait, au reste, justice distributive dans la victoire de la mouche sur l'araignée; il y a si longtemps que l'on voit le contraire arriver. Cette mouche était noire, très longue, avec des marques rouges sur le corps.' D.J., I, 367–8.

40. D.J., I, 369.

41. See D.J., I, 222, 3 May 1847, for initial idea; see Delacroix (4), no. 159, p. 61, ill. 84, for the sketch.

42. D.O.L., II, 50.

43. D.O.L., II, 25.

44. See Delacroix (4), no. 167, p. 62, ill. 79.

45. See e.g. D.O.L., II, 52–3, and the quote from Michelangelo's letter on his servant, p. 54.

46. D.J., I, 363.

47. 'La politique ne m'arrive pas heureusement; c'est une des raisons qui me colle ici peut-être un peu trop longtemps. Elle prend une si vilaine tournure que je recule le moment de rentrer dans le gouffre où elle s'agite. Les paysans ici paraissent détestables: mais c'est ce maudit Paris qui est cause de leur trouble.' D.C.G., III, 15, to Mme de Forget.

48. D.J., I, 365.

49. D.J., I, 365–6, 11 May.

50. See Georgel, pp. 168–71, for further evidence that Delacroix rejected such a *quarante-huitard* reading when Vacquerie presented it to him.

51. 'Un Attila égalitaire et dévastateur', from the prefatory note to *Révolte* which Baudelaire later repudiated, see Baudelaire (2), p. 507. 'Les Attilas de la démagogie', from an article entitled 'Actuellement' in *Représentant de l'Indre*, 20 Oct. 1848, cited Bandy and Mouquet, p. 65. It is probably by Baudelaire, though its sincerity is very doubtful.

52. 'Je suis paresseux, dégoûté, flâneur, et je songe déjà à me tirer de cette confusion.' Cited Dolléans and Puech, p. 31.

53. 'Mon ivresse en 1848. De quelle nature était cette ivresse? Goût de la vengeance. Plaisir naturel de la démolition. Ivresse littéraire; souvenir des lectures. Le 15 Mai: – Toujours le goût de la destruction. Goût légitime si tout ce qui est naturel est légitime.
'Les horreurs de Juin. Folie du peuple et folie de la bourgeoisie. Amour naturel du crime.' B.O.C., p. 1274.

54. On Wagner, see letter in support of a German 'qui dut quitter Dresde, à la suite des journées révolutionnaires', which mentions 'notre commune admiration pour Wagner', B.C.G., I, 112–3, 13 July 1849 (around the time of Baudelaire's closest contact with Courbet).

55. B.C.G., I, 152, letter to Ancelle, 5 Mar. 1852; *ibid.*, p. 157, to Poulet-Malassis, 20 Mar. 1852.

56. B.C.G., II, 319, letter of 16 May 1859.

57. On the dating, see Pichois, pp. 86–92.

58. B.O.C., pp. 1001–2.

59. Levavasseur's account, cited Crépet, p. 82.

60. B.O.C., pp. 1004–5.

61. B.O.C., p. 618, in 'Les Drames et les romans honnêtes', published 27 Nov. 1851 in *La Semaine théâtrale*.

62. B.O.C., p. 873.

63. See Baudelaire (5), pp. 377–8 for this version.

64. See Droz pp. 332–3 for a suggestion that it *was*. Droz dates the picture before 1844, Adhémar gives 1860, and Maison suggests 1870–3! The picture is now lost; it was once in the coll. of Dr Hirschland.

65. 'In the depths of those dark and tortuous districts, where shivering households live in their thousands, sometimes in the sombre light of the street-lamps, which the night wind torments in their glass cases, one sees a rag-picker making his crooked way homeward, bumping and falling over himself like a maker of verses, and free, without regard for the grim night-patrols, he pours out his soul in the midst of the shadows.' Baudelaire (5), p. 376.

66. 'Here is one who, in the sombre light of the street lamps, tormented by the night wind, climbs one of those long, tortuous streets on the Montagne Ste-Geneviève, inhabited by small households. He is wearing an osier shawl with his number seven upon it. He arrives, wagging his head and stumbling over the kerb-stones, like young poets who spend all their days wandering and looking for rhymes. He speaks to himself, all alone; he pours out his soul into the cold and shadowy night air.' B.O.C., p. 327, 'Du Vin et du hachish, comparés comme moyens de multiplication de l'individualité'. First published in *Messager de l'assemblée*, 7–12 Mar. 1851.

67. 'Often, in the red light of a street lamp, its flame battered by the wind, and

its glass panes tormented, in the heart of an old *faubourg*, filthy labyrinth where humanity seethes in tempestuous ferment: one sees a rag-picker coming along, wagging his head, stumbling and bumping against the walls like a poet, and without taking heed of the police-spies, his subjects, he unburdens his heart of his glorious projects.' B.O.C., p. 101.

68. 'From where one can contemplate the town spread out, hospital, brothel, purgatory, hell, the jail, where every enormity flourishes like a flower.' B.O.C., p. 310.

69. Wallon, p. 114.

70. 'Cynique et lugubre comme une chanson populaire'. Baudelaire (2), p. 489.

71. Wallon, p. 24.

72. B.O.C., p. 613.

73. 'Un ami passionné et inconnu *veut absolument vous voir*, non pas seulement pour s'instruire et pour user quelques minutes de votre temps, ainsi qu'il en aurait peut-être le droit, mais aussi pour vous instruire des choses que vous pouvez ignorer relativement à votre sûreté. . . . J'ai longtemps lutté avec ma paresse pour vous écrire une très longue lettre; mais j'ai préféré oser m'attaquer directement à vous Si vous ne trouvez pas excentrique qu'un misérable inconnu demande un mot de réponse immédiate à un homme pressé de travail et d'occupation comme vous – dans ce cas-là, j'attendrai *indéfiniment* au café restaurant du coin de la rue de Bourgogne.' Paris, Bib. Nat., mss. Nafr. 14825, fol. 3–7, published by J. Suffel, *Le Figaro littéraire*, 13 Sep. 1958, p. 8. The first letter is dated 21 Aug. 1848, the second probably comes a few days later. This is three weeks after Proudhon's *Proposition financière* in the Assembly, his verbal duel with Thiers (remember Delacroix's request for a copy of Thiers's speech) and his condemnation by the Assembly in a massive vote against his proposals.

74. 'Celui qui vous écrit ces lignes a une absolue confiance en vous, ainsi que beaucoup de ses amis, qui marcheraient les yeux fermés derrière vous pour les garanties de savoir que vous leur avez données.'

75. 'Une immense affiche . . . tirée à un nombre immense d'exemplaires et COMMANDANT au peuple de ne pas bouger. Votre nom est actuellement plus connu et plus influent que vous ne le croyez. Une insurrection peut commencer par être légitimiste, elle finit par être socialiste; mais aussi la réciproque peut avoir lieu.'

76. Cited Bandy and Mouquet, p. 21.

77. Proudhon (2), II, 374.

78. Proudhon (2), II, 375.

79. B.O.C., pp. 155–6.

80. 'But that nothing should be sown which would go to pay for slavery, they will swell the property of the Common liberty.' Baudelaire (5), p. 321. The capital C is important, and sometimes omitted, e.g. B.O.C., p. 1574.

81. Proudhon (2), I, 269. *Voluptés* refers to a work by Sainte-Beuve, *Méditations* to the finest book of Lamartine.

82. 'Théodicée envahissante et énigmatique'. Droz, p. 13, cited in Haubtmann, p. 223.

83. 'Ton nom, si longtemps le dernier mot du savant, la sanction du juge, la force du prince, l'espoir du pauvre, le refuge du coupable repentant, eh bien! ce nom incommunicable, desormais voué au mépris et à l'anathème, sera sifflé parmi les hommes. Car Dieu, c'est sottise et lâcheté; Dieu, c'est hypocrisie et mensonge; Dieu, c'est tyrannie et misère; Dieu, c'est le mal.' Proudhon (2), I, 383–4.

84. Proudhon (2), I, 383–4, cited Haubtmann, p. 226. Haubtmann's whole discussion of Proudhon's theodicy is excellent.

85. 'Certainly I shall leave this world, where action is not the sister of dream, gladly. May I use the sword and perish by it!

St Peter denied Jesus. He did well!' B.O.C., p. 115.

86. B.O.C., p. 116. Baudelaire's interest in Proudhon survived into the 1860s. See the letter to Ancelle, 8 Feb. 1865, which is very far from being a dismissal of Proudhon, at least as an economist. Proudhon, in fact, stalks the pages of *Pauvre Belgique* – he is almost, appropriately, its hero!

87. In a letter of 15 Mar. to Champfleury, giving Baudelaire's 'key' to various characters in Champfleury's *roman à clé*, *Les Aventures de Mlle Mariette*, B.C.G., I, 188.

88. Preface to Pierre Dupont's *Chants et chansons*, written and published in 1851, B.O.C., pp. 609–10.

89. 'We whose lamps are lit again each morning at cock-crow, all of us that an uncertain wage brings back before dawn to the anvil'. Cited B.O.C., p. 610.

90. 'Reaction spreads its livid wings on our walls; let's rid ourselves of the filthy spectres. Let's pull ourselves out of the putrid swamp. We complain of cholera, it lies in wait for us in our homes: A breath of wind will clear it away. Hurrah! dead men go fast!', in *Le Peuple*, 13 June 1849.

91. 'Cleanness knows no fine distinctions; God gives hemp and running water. Let the weaver earn his keep, and the washerwoman. Is eating well and drinking well enough to make men happy? Since time began there has been need of white linen in the dresser. Plying my trade with my own two feet, I weave, and my shuttle passes, she whistles, passes, passes again, and I think I hear the voice of the swallow in the sky.' Dupont, II, 51.

92. On the specific connections between *Invitation au voyage* and Dupont's *La Promenade sur l'eau* (which Baudelaire cited in his later, cooler essay on Dupont) see Grojnowski.

93. In an article in *Le Messager de l'assemblée*, 29 Apr. 1851, cited Bouvier, p. 173.

94. B.O.C., p. 605.

95. B.O.C., p. 613.

96. Dupont, I, 187.

97. Letter of J. Buisson, cited Pichois, pp. 40–1.

98. B.O.C., p. 608.

99. See Bandy and Mouquet for a partial reprint of the paper. But the authors' conclusions as to what, if anything, Baudelaire actually wrote in the paper seem to me erratic. They also accept the label 'reactionary' too easily – the paper is certainly against *Le National*, Socialist dogmatism, etc., but its alternatives are never clear. At one point (p. 205) it asks for a revolution having a 'signification sociale'; at another (pp. 210–11) it welcomes De Falloux's hostile report on the National Workshops. Its attitude to Proudhon is equivocal, especially in the 'Revue de la presse' (which is most probably by Baudelaire), e.g. pp. 301–2. There are other aggressively Right-wing attitudes displayed – the 'Revue de la presse' constantly sneers and snipes at *La Commune de Paris* and Thoré's *Vraie République* (e.g. pp. 226, 279). But of course Thoré and Baudelaire had already clashed, over the interpretation of *Justice of Trajan* in the 1846 Salon!

100. See Bandy and Mouquet, pp. 237–40 and p. 279. In the first section, the paper published an Address to the Workers using an altogether new and more aggressive phraseology; in the second, an attack on the Republic ends with a premonition of civil war (in the same issue the 'Revue de la presse' savages the *Vraie République* for exactly the same premonition – p. 279 – which indicates at least the paper's panicky confusion by the beginning of June!).

The paper gets more sympathetic to Proudhon as the weeks pass. In its final number (pp. 301–2), the 'Revue de la presse' has a long quote from Proudhon's paper, and the editorial gives cautious

backing to the notorious proposal for a Bank of Exchange.

101. The evidence that he did so in *October* now seems to add up, especially since the letter of 19 Oct. asking for copy from P. de Chennevières was published, in B.C.G., v, 6. Cf. Starkie (2), pp. 200–2 for the contrary argument.

102. See B.C.G., I, 108–9 and Clark (3), Chapter 1. There is a possibility that he is writing to his mother; as usual, nearly everything is in doubt.

103. See AN. F18 262 for a list of Dijon papers drawn up 17 Sep. 1850. There is no mention of Baudelaire's name in the scrupulously detailed list of succeeding *propriétaires et gérants*.

104. B.C.G., I, 113–4, [Dec.] 1849, and full text in Clark (3), Chapter 5.

105. In the Dupont preface, in 'L'Ecole Païenne', in 'Les Drames . . .', and in both parts of 'Du Vin et du hachish'.

106. B.O.C., p. 630.

107. B.C.G., I, 152.

108. 'La fouterie est le lyrisme du peuple'. 'Mon cœur mis à nu', B.O.C., p. 1296.

109. B.O.C., pp. 333, 343.

110. B.O.C., pp. 1260, 1276.

111. For reproduction see Pichois and Ruchon, p. 38.

112. 'Plans et projets', B.O.C., p. 521.

113. B.C.G., IV, 276–7, letter to Thoré 20 June 1864 – he is complaining of the dispersal of the Musée Espagnol.

114. B.O.C., p. 640.

115. Sade, p. 67.

116. 'Pauvre Belgique', B.O.C., p. 1456.

117. See the great essay 'Recours de Baudelaire à la sorcellerie', Blin, pp. 75–100.

118. Baudelaire's phrase in a letter to F. Desnoyers, 1855, B.C.G., I, 321–3.

119. B.O.C., p. 1294.

120. 'Vanquished, worn out mind! For you, old hack, there is no more pleasure in love, or in an argument; Farewell then, songs of brass and sighings of the flute!' 'Le Goût du Néant', B.O.C., p. 72.

121. B.O.C., pp. 304–5.

122. B.O.C., p. 306.

123. 'Qu'en dis-tu, citoyen Proudhon?' B.O.C., p. 1619.

Conclusion *(pp. 178–82)*

1. Article of 15 Nov. 1851, cited in Serullaz (1), p. 121.

2. Benjamin (3), p. 93.

3. None of this means, incidentally, that a work of art is effective, or even good, by virtue of its ideas. I am discussing here the field of operation of a work of art, not its mode of operation. It clearly does not attack/dislocate/subvert an ideology by means borrowed from the realm of ideology: it has its own, aesthetic, *modus operandi*.

4. This was pointed out to me in conversation by Theodore Zeldin.

5. B.O.C., p. 950.

6. Boyer d'Agen, p. 392.

7. For the State acquisitions, see AN. F21 22 Corot. For the trouble at Langres, see Robaut (2), II, 214.

Select Bibliography

1. Primary Sources

ARCHIVES NATIONALES. Especially Series BB18. – Justice. Correspondance générale de la division criminelle. (Including dossiers 1449, Colportage et crieurs publics, 1849–50; 1470, Délits de presse, 1848–50; 1472, Sociétés secrètes, 1832–50; 1482, Emblèmes et insignes séditieux, 1849–50; 1487 et seq. Poursuites contre la presse, 1850–52.)

BB30. – Cabinet du ministre de la Justice. (Contains the invaluable *Rapports politiques des procureurs généraux*, 1849–68, dossiers 370–382.)

C944–967. – Assemblée Nationale, Enquête sur le travail de 1848.

F1C III. – Esprit public et élections. (Especially F1C III Besançon, 8. Correspondance, etc.)

F7. 12238. – Police générale. Dossier sur les saltimbanques, etc.

F18.262. – Imprimerie, Presse etc. Etats des journaux, 1849–51.

F21. – Beaux-Arts. (Among a mass of material, the most useful were: Dossiers 12–60, Commissions, etc., 1841–50; 61–112, Commissions, etc., 1851–60; 519–22, Exposition de 1855; 527, Salons, 1848–53; 566, Competition for Republic figure; F21* 2793–7, Exposition de 1855; 4006, Budget des Beaux-Arts, 1849.

ARCHIVES DÉPARTEMENTALES, Doubs. Especially Series M. – Police, Esprit Public (Including dossiers 734, Rapports et correspondance des préfets et sous-préfets, 1849; 735, Correspondance ministérielle, visite présidentielle, 1850; 736, Préfets, sous-préfets, police, 1850; 738–40, Préfets, sous-préfets, 1851.)

ARCHIVES DU LOUVRE. Documentation on the Salons of 1848, 1849, 1850–51: including the artists' *Notices* for their entry, Registers of pictures received, and 'Procès-verbaux des Juries d'Admission'.

BIBLIOTHÈQUE NATIONALE, MANUSCRITS.

BIBLIOTHÈQUE NATIONALE, SALLE DES ESTAMPES.

2 Secondary sources

This book and my forthcoming study of Courbet, listed below, were researched together and therefore share a bibliography.

ABE, Y. (1) 'Un Enterrement à Ornans et l'habit noir baudelairien', *Études de langue et littérature françaises*, 1, Tokyo, 1962.

— (2) 'Baudelaire face aux artistes de son temps', *Revue de l'art*, 4, 1969.

— (3) 'Les Relations de Baudelaire et de Courbet (1): Avant 1850'. Chapter Two of unpublished thesis on Baudelaire and Realism, n.d.

ADHÉMAR, H. 'La Liberté sur les barricades de Delacroix, étudiée d'après des documents inédits', *Gazette des Beaux-Arts*, 43, Feb. 1954.

ADHÉMAR, J. *Honoré Daumier*, Paris, 1954.

ALEXANDRE, A. *Honoré Daumier, l'homme et l'œuvre*, Paris, 1888.

AMMAN, P. 'A *Journée* in the Making: May 15, 1848', *Journal of Modern History*, 42, no. 1, March 1970.

ANGRAND, P. 'L'Etat-mécène, période autoritaire du Second Empire (1851–1860)', *Gazette des beaux-arts*, May–June 1968.

ANTAL, F. (1) *Florentine Painting and its Social Background*, London, 1948.

— (2) *Classicism and Romanticism, with Other Studies in Art History*, London, 1966.

ARAGON, L. *L'Exemple de Courbet*, Paris, 1952.

ARMENGAUD, A. *Les Populations de l'Est-Aquitain au début de l'époque contemporaine (vers 1845–vers 1871,)* Paris, 1961.

BALZAC, H. DE *Les Paysans*, ed. J.-H. Donnard, Paris, 1964. 1st pub. in book form 1855, 1st serialized in part 1844.

BANDY, W., AND J. MOUQUET *Baudelaire en 1848*, Paris, 1946.

— AND C. PICHOIS *Baudelaire devant ses contemporains*, 2nd edn, Paris, 1967.

BAUDELAIRE, C. (1) *Les Fleurs du mal*, ed. J. Crépet, Paris, 1922.

— (2) *Les Fleurs du mal*, ed. J. Crépet and G. Blin, Paris, 1942.

— (3) *Correspondance générale*, ed. J. Crépet and C. Pichois, 6 vols., Paris, 1947–53.

— (4) *Œuvres complètes*, ed. Y.-G. Le Dantec and C. Pichois, Paris, 1961.

— (5) *Les Fleurs du mal*, ed. J. Crépet, G. Blin and C. Pichois, 1st vol., Paris, 1968.

— (6) *Catalogue de l'exposition Baudelaire*, Petit Palais, Paris, 23 Nov. 1968–17 Mar. 1969.

— (7) *Le Salut public, reproduction en fac-similé*, ed. F. Vanderem, Paris, n.d.

BÉNÉZIT, E. *Dictionnaire critique et documentaire des peintres, sculpteurs, dessinateurs et graveurs*, 8 vols., Paris, 1948–55.

BENJAMIN, W. (1) 'Paris – Capital of the Nineteenth Century', *New Left Review*, 48, Mar.–Apr. 1968.

— (2) *Illuminations*, London, 1970.

— (3) 'The Author as Producer', *New Left Review*, 62, July–Aug. 1970.

BERGER, K. 'Courbet in his Century', *Gazette des beaux-arts*, 24, 1943.

BIBLIOTHÈQUE NATIONALE. *La Revolution de 1848, exposition organisée par le comité national du centenaire*, Paris, 1948.

BLACHE, N. *Histoire de l'insurrection du Var en décembre 1851*, Paris, 1869.

BLANC, C. *L'Œuvre de Rembrandt, décrit et commenté par M. C. Blanc*, Paris, 1853.

BLANQUI, A. (1) 'Tableau des populations rurales de la France en 1850', *Journal des économistes*, 28, Jan. 1851, and 30, Sep. 1851.

— (2) 'Les populations rurales de la France', *Annales provençales d'agriculture*, 1851.

Blin, G. *Le Sadisme de Baudelaire*, Paris, 1948.

Boime, A. (1) 'Thomas Couture and the Evolution of Painting in Nineteenth-century France', *Art Bulletin*, 51, March 1969.

— (2) *The Academy and French Painting in the Nineteenth Century*, London, 1971.

— (3) 'The Second Republic's Contest for the Figure of the Republic', *Art Bulletin*, 53, March 1971.

Bonnemère, E. *Histoire des paysans*, Paris, 1857.

Borel, P. (1) *Le Roman de Gustave Courbet*, 2nd edn, Paris, 1922.

— (2) *Lettres de Gustave Courbet à Alfred Bruyas*, Geneva, 1951.

Bouillon, J. 'Les démocrates-socialistes aux élections de 1849', *Revue française de science politique*, 1956. no. 1.

Bourguin, G. and M. Terrier, *1848*, Paris, 1948.

Boyer d'Agen. *Ingres d'après une correspondance inédite*, Paris, 1909.

Bouvier, E. *La Bataille réaliste (1844–57)*, Paris, 1914.

Bruyas, A. (1) *Salons de peinture*, Paris, 1853.

— (2) *Explication des œuvres de peinture du cabinet Alfred Bruyas*, Montpellier, 1854.

Buchon, M. (1) *Poésies*, Arbois, 1843.

— (2) *Poésies allemandes de J.-P. Hebel, Th. Koerner, L. Uhland, H. Heine*, Salins, 1846.

— (3) *Poésies complètes de J.-P. Hebel, suives de scènes champêtres*, Paris, 1853.

— (4) 'Le Matachin', *Revue des deux mondes*, 6, 2nd ser., June 1854.

— (5) 'Le Gouffre-gourmand', *Revue des deux mondes*, 8, 2nd ser., Oct. 1854.

— (6) *Recueil de dissertations sur le réalisme*, Neuchâtel, 1856.

— (7) *Noëls et chants populaires de la Franche-Comté*, Salins, 1863.

— (8) *Poésies franc-comtoises*, 3rd edn, Besançon, 1868.

Cassagne, A. *La Théorie de l'art pour l'art en France*, Paris, n.d.

Cassou, J. *Le Quarante-huitard*, Paris, 1948.

Castagnary, J. 'Fragments d'un livre sur Courbet', *Gazette des Beaux-Arts*, Dec. 1911–Jan. 1912.

Châle, T. 'Débardeur et piocheur de craie de la banlieue de Paris', *Les Ouvriers des deux mondes*, t. 2, 1858.

Champfleury (J.-F.-F. Husson) (1) *Essai sur la vie et l'œuvre des Lenain, peintres laonnois*, Laon, 1850.

— (2) *Les Excentriques*, 2nd edn., Paris, 1877, 1st pub. 1852.

— (3) *Contes domestiques*, Paris, 1852.

— (4) *Contes d'été*, Paris, 1853.

— (5) *Les Aventures de Mlle Mariette*, Paris, 1853.

— (6) *Les Oies de Noël*, Paris, 1853.

— (7) *Contes d'automne*, Paris, 1854.

— (8) *Grandes figures d'hier et d'aujourd'hui*, Paris, 1861.

— (9) *Nouvelles recherches sur la vie et l'œuvre des Frères Le Nain*, Laon, 1862, 1st pub. in *Gazette des beaux-arts*, 1860.

— (10) *Histoire de la caricature moderne*, Paris, 1865.

— (11) *Histoire de l'imagerie populaire*, Paris, 1869.

— (12) *Souvenirs et portraits de jeunesse*, Paris, 1872.

— (13) *L'Usurier Blaizot* (original title in *feuilleton*, *Les Trois Oies de Noël*, then in book form *Les Oies de Noël*), 2nd edn, Paris, 1880.

CHAMPFLEURY (14) *Œuvres posthumes. Salons 1846–51*, ed. J. Troubat, Paris, 1894.

CHEVALIER, L. (1) *La Formation de la population parisienne au XIXᵉ siècle*, Paris, 1950.

— (2) 'Fondements économiques et sociaux de l'histoire politique de la région parisienne (1848–1852)', unpub. thesis, Paris, 1951.

— (3) *Classes laborieuses et classes dangereuses à Paris pendant la première moitié du XIXᵉ siècle*, Paris, 1958.

CHEVILLARD, V. *Un Peintre romantique, Théodore Chassériau*, Paris, 1893.

CHIRICO, G. DE *Gustave Courbet*, Rome, 1926.

CLARK, T. J. (1) 'A Bourgeois Dance of Death: Max Buchon on Courbet – 1', *Burlington Magazine*, CXI, April 1969.

— (2) 'A Bourgeois Dance of Death: Max Buchon on Courbet – 2', *Burlington Magazine*, CXI, May 1969.

— (3) *Image of the People: Gustave Courbet and the 1848 Revolution*, London, forthcoming (1973). USA edn., *Gustave Courbet and the 1848 Revolution*, Greenwich, Conn., forthcoming (1973).

COBBAN, A. 'The Influence of the clergy and the "instituteurs primaires" in the election of the French Constituent Assembly, April 1848', *English Historical Review*, 1942.

Compte rendu du dernier procès du Démocrate franc-comtois, Besançon, 1850.

CONSTANT, ABBÉ. *La Dernière Incarnation*, Paris, 1847.

COOPER, D. (1) 'The Challenge of Courbet', *Times Literary Supplement*, 27 June 1952.

— (2) 'Courbet in Philadelphia and Boston', *Burlington Magazine*, 102, 1960.

Courbet dans les collections privées françaises, Galerie Claude Aubry, Paris, May–June, 1966.

COURTHION, P. (1) *Courbet*, Paris, 1931.

— (2) *Courbet raconté par lui-même et par ses amis*, 2 vols., Geneva, 1948 and 1950.

COUTURE, T. *Thomas Couture, 1815–1879, sa vie, son œuvre, son caractère, ses idées, sa méthode, par lui-même et son petit-fils*, Paris, 1932.

CRÉMIEUX, A. *La Révolution de février: étude critique sur les journées des 21, 22, 23, et 24 février 1848*, Paris, 1912.

CRÉPET, E. AND CRÉPET, J. *Baudelaire*, Paris, 1907.

CROUZET, M. *Un Méconnu du réalisme: Duranty 1833–80*, Paris, 1964.

DANSETTE, A. (1) *Histoire religieuse de la France contemporaine*, 2 vols., Paris, 1948.

— (2) *Louis-Napoléon à la conquête du pouvoir*, Paris, 1961.

DAUMARD, A. *La Bourgeoisie parisienne de 1815 à 1848*, Paris, 1963.

DAUMIER, H. *Daumier raconté par lui-même et par ses amis*, ed. P. Cailler, Geneva, 1945.

DAVID D'ANGERS, P. J. *Les Carnets de David d'Angers*, ed. A. Bruel, 2 vols., Paris, 1956.

DELACROIX, E. (1) *Œuvres littéraires*, 2 vols., Paris, 1923.

— (2) *Correspondance générale*, ed. A. Joubin, 5 vols., Paris, 1936–38.

— (3) *Journal de Eugène Delacroix*, ed. A. Joubin, 3 vols., 3rd edn., Paris, 1960.

— (4) *An exhibition of paintings, drawings and lithographs*, The Arts Council, intro. L. Eitner, catalogue L. Johnson, London, 1964.

DELTEIL, L. *Le Peintre-graveur illustré*, Paris, 10 vols., 1925–30.

DE LUNA, F. *The French Republic under Cavaignac, 1848*, Princeton, 1969.

DELVAU, A. *Histoire anecdotique des cafés et cabarets de Paris*, Paris, 1862.

DEMETZ, P. 'Defenses of Dutch Painting and the Theory of Realism', *Comparative Literature* 15, Spring 1963.

Desaunais, A. 'La Révolution de 1848 dans le département du Jura', in *Volume du centenaire de 1848 dans le Jura*, Lons-le-Saunier, 1948.

Dessal, M. 'Le Complot de Lyon et la résistance au coup d'état dans les départements du Sud-Est', in *1848 et les Révolutions du dix-neuvième siécle*, 1951.

Deutscher, I. *The Prophet Armed, Trotsky: 1879–1921*, Oxford, 1970.

Dictionnaire de biographie française, vol. 7, Paris, 1956.

Dolléans, E. *Proudhon*, Paris, 1948.

Dolléans, E. and J.-L. Puech *Proudhon et la révolution de 1848*, Paris, 1948.

Douce, F. *Holbein's Dance of Death*, London, 1858.

Droz, E. *P.-J. Proudhon (1809–1865)*, Paris, 1909.

Droz, W. 'L'inspiration plastique chez Baudelaire', *Gazette des beaux-arts*, 1957.

Duchartre, P. and R. Saulnier *L'Imagerie populaire*, Paris, 1925.

Dumensil, A. *La Foi nouvelle cherchée dans l'art, de Rembrandt à Beethoven*, Paris, 1850.

Dupeux, G. *Aspects de l'histoire sociale et politique du Loir-et-Cher, 1848–1914*, Paris, 1962.

Dupont, P. *Chants et chansons, poésie et musique*, 4 vols., Paris, 1852–9 (publication dates proper uncertain, 1st vol. probably pub. 1851).

Durrieux, A. *Monographie du paysan du département du Gers*, Paris, 1865 (written 1860–1).

Duveau, G. (1) *Raspail*, Paris, 1948.

— (2) *1848*, Paris, 1965.

Estignard, A. *G. Courbet, sa vie et ses œuvres*, Besançon, 1896.

Exposition des œuvres de G. Courbet à l'école des Beaux-Arts, Paris, 1882 (with supplement by Castagnary).

Exhibition et vente de 40 tableaux et 4 dessins de l'œuvre de M. Gustave Courbet, avenue Montaigne, 7, Champs-Elysées, Paris, 1855.

Exposition Gustave Courbet, 1819–1877, Musée des Beaux-Arts de Besançon, Aug.–Oct. 1952.

(Fernier, R.) (1) 'Une Œuvre inconnue de Courbet', *Les Amis de Gustave Courbet: Bulletin No. 4*, 1948.

Fernier, R. (2) 'En marge de l'enterrement d'Ornans', *Les Amis de Gustave Courbet: Bulletin No. 10*, 1951.

— (3) *Gustave Courbet*, London, 1970.

Flaubert, G. (1) *Correspondance* (vol. 6 of *Les Œuvres de Gustave Flaubert*), Lausanne, 1964.

— (2) *L'Éducation sentimentale*, ed. E. Maynial, Paris, 1964 (1st pub. 1869).

— (3) *Madame Bovary*, ed. J. Suffel, Paris, 1966 (1st pub. 1857).

Fouché, J.-L. 'L'Opinion d'Ingres sur le salon. Procès-verbaux de la commission permanente des Beaux-Arts, 1848–49', *Chronique des arts*, Mar. 1908.

Fourcaud, L. *François Rude*, Paris, 1904.

Frey, H. *Max Buchon et son œuvre*, Besançon, 1940.

Fried, M. (1) 'Manet's Sources. Aspects of his Art, 1859–1865', *Artforum*, Mar. 1969.

— (2) 'Thomas Couture and the Theatricalization of Action in Nineteenth-Century Painting', *Artforum*, June 1970.

Gaillard, J. 'La Question du crédit et les almanachs autour de 1850', *Études, bibliothèque de la Révolution de 1848*, t. 16.

Galimard, A. *Examen du salon de 1849*, Paris, 1849.

Gauchat, R. 'L'Urbanisme dans les villes anciennes: les faubourgs de Dijon', *Mémoires de la commission des antiquaires de la Côte d'Or*, t. 23, 1955.

Gautier, T. (1) *L'Art moderne*, Paris, 1856.

— (2) *Emaux et Camées*, new edn, Lille-Geneva, 1947.

GAUTIER, T. (3) *Œuvres érotiques*, Paris, 1953.

G. Courbet, Paris, Petit Palais, 1955.

GEORGEL, P. 'Delacroix et Auguste Vacquerie', *Bulletin de la société de l'histoire de l'art français*, 1968.

GOSSEZ, R. (1) 'Les quarante-cinq centimes', *Études de la société de l'histoire de la Révolution de 1848*, 1953.

— (2) 'Diversité des antagonismes sociaux vers le milieu du XIXe siècle', *Revue économique*, no. 3, 1956.

GRATE, P. *Deux Critiques d'art de l'époque romantique, Gustave Planche et Theophile Thoré*, Stockholm, 1959.

GRÉARD, V. *Meissonier. His Life and Art*, London, 1897.

GROJNOWSKI, D. 'Baudelaire et Pierre Dupont – La Source d'inspiration de l'Invitation au voyage', *Europe*, no. 456–7, Apr.–May 1967.

GROS-KOST, E. *Gustave Courbet, souvenirs intimes*, Paris, 1880.

GUILLEMIN, H. (1) *Lamartine en 1848*, Paris, 1948.

— (2) *La Tragédie de quarante-huit*, Geneva, 1948.

GUINARD, P. *Dauzats et Blanchard peintres de l'Espagne romantique*, Paris, 1967.

GUINARD, P., AND R. MESURET. 'Le Goût de la peinture espagnole en France', in *Trésors de la peinture espagnole*, Musée des Arts Décoratifs, Paris, Jan.–Apr. 1963.

Gustave Courbet (1819–1877) Exposition à l'Académie de France, Villa Medici, Rome, 1969–70.

Gustave Courbet, 1819–1877, Philadelphia Museum of Art, Museum of Fine Arts, Boston, 1959–60.

HAMILTON, G. 'The Iconographical Origins of Delacroix's "Liberty Leading the People"', *Studies in Art and Literature for Belle da Costa Greene*, Princeton, 1954.

HAUBTMANN, P. *P.-J. Proudhon, genèse d'un antithéiste*, Paris, 1969.

HEMMINGS, F. *Emile Zola*, 2nd edn, Oxford, 1966.

HERBERT, R. L. (1) 'Millet Revisited – 1', *Burlington Magazine*, July 1962.

— (2) 'Millet Revisited – 2', *Burlington Magazine*, Sep. 1962.

— (3) *Barbizon Revisited*, catalogue of exhibition in San Francisco, Toledo, Cleveland and Boston, Boston, 1962.

— (4) 'Millet Reconsidered', *Museum Studies*, 1, 1966.

— (5) 'City vs. Country: The Rural Image in French Painting from Millet to Gauguin', *Artforum*, Feb. 1970.

INGRES, J.-D. *Peintures. Ingres et son temps*, Exhibition catalogue (Inventaire des collections publiques françaises, no. 11), Montauban, 1965.

JAKOBSON, R. 'Two Aspects of Language and Two Types of Aphasic Disturbances', in JAKOBSON, R. AND M. HALLE, *Fundamentals of Language*, The Hague, 1956.

JAMES, H. (1) *Daumier, Caricaturist*, new edn., London, 1954.

— (2) *The Golden Bowl*, new edn, Harmondsworth, 1966.

JEAN-AUBRY, G. *Eugène Boudin d'après des documents inédits. L'homme et l'œuvre*, Paris, 1922. Illustrated edn in English, London and Greenwich, Conn., 1969.

KLINGENDER, F. 'Géricault as seen in 1848', *Burlington Magazine*, 1942.

LABROUSSE, E. (1) '1848–1830–1871. Comment naissent les révolutions', in *Actes du congrès historique du centénaire de 1848*, Paris, 1949.

— (ed.) (2) *Aspects de la crise et de la dépression de l'économie française au milieu du dix-neuvième siècle, 1846–1851*, Bibliothèque de la Révolution de 1848, Paris, 1956.

LACAN, J. *Écrits*, Paris, 1966.

LARKIN, O. (1) 'Courbet and His Contemporaries, 1848–67', *Science and Society*, 3, Winter 1939.

— (2) *Daumier: Man of his Time*, London, 1967.

LASTEYRIE, F de. *Le Paysan. Ce qu'il est – Ce qu'il devrait être*, Paris, 1869.

LAURENT, R. *Les Vignerons de la 'Côte D'Or' au 19ᵉ siècle*, Dijon, 1958.

LECOUTURIER, F. *Paris incompatible avec la République*, Paris, 1848.

LEFEBVRE, G. 'La Révolution française et les paysans', in *Études sur la révolution française*, Paris, 1954.

LÉGER, C. (1) *Courbet selon les caricatures et les images*, Paris, 1920.

— (2) 'Courbet, ses amis et ses élèves', *Mercure de France*, 1928.

— (3) *Courbet*, Paris, 1929.

— (4) 'À la découverte de Courbet. Documents inédits', *L'Amour de l'Art*, No. 10, Oct. 1931.

— (5) 'Baudelaire et Courbet', *Mercure de France*, 1939.

— (6) *Courbet et son temps*, Paris, 1948.

LEMANN, B. 'Daumier and the Republic', *Gazette des Beaux-Arts*, 1945.

LEPOITTEVIN, L. (1) *Catalogue de l'exposition Millet*, Musée Thomas-Henry, Cherbourg, July–Sep. 1964.

— (2) 'J.-F. Millet, mythe et réalité', *L'Œil*, 119, Nov. 1964.

Les Ouvriers des deux mondes. Etudes sur les travaux, la vie domestique et la condition morale des populations ouvrières des diverses contrées, 5 vols., Paris, 1857–75.

LÉVI-STRAUSS, C. *The Raw and the Cooked. Introduction to a Science of Mythology: 1*, London, 1970.

LÉVY, C. 'Notes sur les fondements sociaux de l'insurrection de décembre 1851 en province', *Information historique*, Sep.–Oct. 1954.

LÓPEZ-REY, J. *Velasquez. A Catalogue Raisonné of his Œuvre*, London, 1963.

LÜDECKE, H. *Eugène Delacroix und die Pariser Julirevolution*, Berlin, 1965.

LUKÁCS, G. 'Balzac: The Peasants' in *Studies in European Realism*, London, 1950.

MACHEREY, P. 'Les Paysans de Balzac; un texte disparate', in *Pour une théorie de la production littéraire*, Paris, 1966.

MACK, G. *Gustave Courbet*, London, 1951.

MAC ORLAN, P. *Courbet*, Paris, 1951.

MAISON, K. *Honoré Daumier: Catalogue Raisonné of the Paintings, Watercolours and Drawings*, 2 vols., London and New York 1968.

MALLARMÉ, S. *Correspondance 1862–1871*, ed. H. Mondor, Paris, 1959.

MANDROU, R. *De la culture populaire aux 17ᵉ et 18ᵉ siècles*, Paris, 1964.

MARCEL, H. *Théodore Chassériau*, Paris, 1911.

MARLIN, R. (1) 'L'Élection presidentielle de Louis-Napoléon Bonaparte dans le Doubs', *Annales littéraires de l'université de Besançon*, 2, fasc. 3, 1955.

— (2) *L'Epuration politique dans le Doubs à la suite du coup d'état du 2 Déc. 1851*, Chazelle-Dole, 1958.

MARX, K. (1) 'The Class Struggles in France', reprinted in *Karl Marx and Frederick Engels, Selected Works*, vol. 1, Moscow, 1962.

— (2) 'The Eighteenth Brumaire of Louis Bonaparte', reprinted *ibid*.

MELTZOFF. S. 'The Revival of the Le Nains', *Art Bulletin*, 24, 1942.

MIETTE DE VILLARS. *Mémoires de David, peintre et député à la convention*, Paris, 1850.

MISTLER, J. *Les Origines de l'imagerie populaire*, Paris, 1961.

MISTLER, J., F. BLAUDEZ AND A. JACQUEMIN. *Epinal et l'imagerie populaire*, Paris, 1961.

MODESTE, V. *De la Cherté des grains et des préjugés populaires qui déterminent des violences*, Paris, 1850.

MOLL, L. *Excursion agricole dans quelques départements du Nord de la France, entreprise aux frais du gouvernement*, Paris, 1836.

MOLOK, A. 'Les Mouvements révolutionnaires dans les banlieues de Paris pendant l'insurrection de juin 1848', *Annuaire d'études françaises*, Moscow, 1964.

MOREAU-NÉLATON, E. (1) *Millet raconté par lui-même*, 3 vols., Paris, 1921.

— (2) *Bonvin raconté par lui-même*, Paris, 1927.

MURGER, H. *Scènes de la vie de bohème*, Paris, 1851.

NICOLSON, B. (1) 'Courbet at the Marlborough Gallery', *Burlington Magazine*, 95, 1953.

— (2) 'Courbet's "L'Aumône d'un mendiant"', *Burlington Magazine*, 104, 1962.

NIÉPOIVIÉ. *Études psychologiques sur les grandes métropoles de l'Europe occidentale*, Paris, 1840.

NISARD, C. *Histoire des livres populaires ou de la littérature de colportage depuis l'origine de l'imprimerie jusqu'a l'établissement de la commission d'examen des livres de colportage*, Paris, 1854.

NOCHLIN, L. (1) 'The Development and Nature of Realism in the Work of Gustave Courbet: A Study of the Style and its Social and Artistic Background', unpublished Ph. D. dissertation, New York University, 1963.

— (2) 'Innovation and Tradition in Courbet's *Burial at Ornans*', in *Essays in Honour of Walter Friedlaender*, New York, 1965.

— (3) 'Gustave Courbet's *Meeting*: A Portrait of the Artist as a Wandering Jew', *Art Bulletin*, 49, Sep. 1967.

— (4) 'The Invention of the Avant-Garde: France 1830–80', in *Art News Annual*, 34.

NOLLE, Y. 'Dijon au début du Second Empire, 1851–58', *Annales de Bourgogne*, 24, 1952.

NORMANBY, LORD. *Une Année de révolution*, 2 vols., Paris, 1857.

NOVALIS. *The Novices of Sais*, New York, 1949.

OSIAKOVSKI, S. 'Some Political and Social Views of Daumier as shown in his Lithographs', unpublished Ph. D. thesis, London University, 1957.

PICHOIS, C. *Baudelaire, études et témoignages*, Neuchâtel, 1967.

PICHOIS, C. AND F. RUCHON. *Iconographie de Charles Baudelaire*, Geneva, 1960.

POE, E. A. *Selected Writings of Edgar Allan Poe*, ed. D. Galloway, London, 1967.

POUTHAS, C.-H. *La Révolution de 1848 en France et la Seconde République*, Paris, 1952.

Précieux livres, reliures et manuscrits ... lettres et manuscrits de Charles Baudelaire, Sale Catalogue, Hôtel Drouot, Paris, 1963.

PRÉCLIN, E. 'La Révolution de 1848 en Franche-Comté', in *Etudes d'histoire moderne et contemporaine*, 2, 1948.

PROUDHON, P.-J. (1) *Du Principe de l'art et de sa destination sociale*, 2nd edn, Paris, 1875 (1st pub. 1865).

— (2) *Système des contradictions économiques ou philosophie de la misère*, 2 vols., ed. R. Picard, Paris, 1923 (1st pub. 1846).

— (3) *La Révolution sociale démontrée par le coup d'état du 2 décembre*, ed. E. Dolléans and G. Duveau, Paris, 1936 (1st pub. 1852).

— (4) *Philosophie du progrès*, ed. Th. Ruyssen, Paris, 1946 (1st pub. 1853, written Dec. 1851).

— (5) *Carnets de P.-J. Proudhon*, ed. P. Haubtmann, S. Henneguy and J. Faure-Fremiet, Vol. 1, 1843–6, Paris, 1960, Vol. 2, 1847–48, Paris, 1961.

Quelques Vérités sur le commerce des enterrements à Paris, Paris, 1848.

REFF, T. (1) 'Pissarro's Portrait of Cézanne', *Burlington Magazine*, 109, Nov. 1967.

— (2) '"Manet's Sources": A Critical Evaluation', *Artforum*, Sep. 1969.

RÉMUSAT, C. DE. *Mémoires de ma vie*, vol. 4, 1841–1851, Paris, 1962.

RIAT, G. *Gustave Courbet, peintre*, Paris, 1906.

ROBAUT, A. (1) *L'Œuvre complet d'Eugène Delacroix*, Paris, 1885.

— (2) *L'Œuvre de Corot*, 4 vols. Paris 1905.

Romantisme et politique 1815–1851. Colloque de l'École Normale Supérieure de Saint-Cloud, 1966, Paris, 1969.

ROMIEU, MME *Des Paysans et de l'agriculture au XIXᵉ siècle*, Paris, 1865.

ROSENTHAL, L. *Du Romantisme au réalisme*, Paris, 1914.

ROUSSEAU, M. 'La Vie et l' Œuvre de P.-A. Jeanron, peintre, écrivain, directeur des musées nationaux', unpublished thesis, Archives du Louvre, F.8, 1936.

RUDÉ, G. *The Crowd in History 1730–1848*, London, 1964.

SADE, D. A. F., MARQUIS DE *Français, encore un effort si vous voulez être républicains*, preceded by M. Blanchot, *L'Inconvenance majeure*, Paris, 1965.

SAND, G. *La Petite Fadette*, edition introduced by G. van den Bogaert, Paris, 1967 (1st pub. 1849).

SARTRE, J.-P. (1) *Baudelaire*, London, 1964 (1st pub. 1947).

— (2) 'La Conscience de classe chez Flaubert', *Les Temps Modernes*, 240–241, May–June 1966.

SCHANNE, A. *Souvenirs de Schaunard*, Paris, 1866.

SCHAPIRO, M. 'Courbet and Popular Imagery. An Essay on Realism and Naïveté', *Journal of the Warburg and Courtauld Institutes*, Apr.–June 1941.

SCHARF, A. *Art and Photography*, London, 1968.

SCHMIDT, C. *Les Journées de juin 1848*, Paris, 1926.

SENSIER, A. *La Vie et l'œuvre de Jean-François Millet*, ed. P. Mantz, Paris, 1881.

SERULLAZ, M. (1) *Les Peintures murales de Delacroix*, Paris, 1963.

— (2) *Mémorial de l'exposition Eugène Delacroix*, Paris, 1963.

SILVESTRE, T. (1) *Histoire des artistes vivants, français et étrangers*, Paris, 1857.

— (2) *Les Artistes français*, Brussels and Leipzig, 1861.

SLOANE, J. (1) *French Painting Between the Past and the Present*, Princeton, 1951.

— (2) *Paul-Marc Chenavard, Artist of 1848*, Chapel Hill, 1962.

SOBOUL, A. (1) 'La question paysanne en 1848', *La Pensée*, nos. 18–20, 1948.

— (2) 'Documents, Les Troubles agraires de 1848', *1848*, 39, 1948.

— (3) *Les Sans-culottes parisiens en l'An II: mouvement populaire et gouvernement révolutionnaire*, Paris, 1958.

— (4) 'The French Rural Community in the eighteenth and nineteenth centuries', *Past and Present*, 10, Nov. 1958.

STARKIE, E. (1) *Petrus Borel, the Lycanthrope*, London, 1954.

— (2) *Baudelaire*, 2nd edn, London, 1957.

STERN, D. (Comtesse d'Agoult). *Histoire de la révolution de 1848*, 3 vols., Paris, 1850–53.

TABARANT, A. *La Vie artistique au temps de Baudelaire*, Paris, 1963.

TAINE, H. *Notes sur Paris: vie et opinions de Thomas Graindorge*, 2nd edn, Paris, 1867.

TCHERNOFF, I. *Associations et sociétés secrètes sous la Seconde République (1848–1851)*, Paris, 1905.

TÉNOT, E. *La Province en décembre 1851*, Paris, 1865.

THIAIS, D. DE *Le Paysan tel qu'il est, tel qu'il devrait être*, Poitiers, 1856.

THOMPSON, E. *The Making of the English Working Class*, Vintage edn, New York, 1966.

THORÉ, T. *Salons de T. Thoré, 1844, 1845, 1846, 1847, 1848*, Paris, 1868.

TOCQUEVILLE, A. DE. *Souvenirs*, Paris, 1944.

TRAPADOUX, M. *Histoire de saint Jean de Dieu*, Paris, 1844.

TROUBAT, J. (1) 'L'Art à Montpellier. Un portrait de Baudelaire par Courbet', reprinted in *Plume et Pinceau*, Paris, 1878 (1st pub. 1874).

— (2) *Une Amitié à la d'Arthez. Champfleury, Courbet – Max Buchon, suivi d'une conférence sur Sainte-Beuve*, Paris, 1900.

— (3) *Un Coin de littérature sous le second empire. Sainte-Beuve et Champfleury. Lettres de Champfleury*, Paris, 1908.

TUDESQ, A.-J. (1) *Les Grands Notables en France (1840–1849)*, Paris, 1964.

— (2) *L'Élection présidentielle de Louis-Napoléon Bonaparte*, Paris, 1965.

TUIN, H. van der. *L'Évolution psychologique, esthétique et littéraire de Théophile Gautier*, Amsterdam, 1933.

VALLÈS, J. (1) *Les Réfractaires*, Paris, 1865.

— (2) *Le Cri du peuple, février 1848 à mai 1871*, ed. L. Scheler, Paris, 1953.

VEUILLOT, L. *Mélanges réligieux, historiques, politiques et littéraires*, 2nd edn, 4, Paris, 1861.

VIDALENC, J. (1) *Louis Blanc*, Paris, 1948.

— (2) *La Société française de 1815 à 1848: 1. Le Peuple des campagnes*, Paris, 1970.

VIGIER, P. (1) *La Seconde République dans la région alpine. Etude politique et sociale*, 2 vols., Paris, 1963.

— (2) *La Monarchie de juillet*, 2nd edn, Paris, 1965.

— (3) *La Seconde République*, Paris, 1967.

VILLERMÉ, L. 'La Propriété rurale en France', *Revue des deux mondes*, 32, 15 Mar. 1861.

VINCENT, H. *Daumier and his World*, Evanston, 1968.

WALLON, J. *La Presse de 1848*, Paris, 1849.

WASSERMAN, J. *Daumier Sculpture. A Critical and Comparative Study*, Harvard, 1969.

WEINBERG, B. *French Realism: The Critical Reaction*, New York, 1937.

WEY, F. (1) *Manuel des droits et des devoirs. Dictionnaire démocratique*, Paris, 1848.

— (2) *Le Bouquet de cerises, suivi des souvenirs de l'Oberland*, 3rd edn, Paris, 1862.

WOODCOCK, G. *Pierre-Joseph Proudhon: A Biography*, London, 1956.

Photographic Acknowledgments

Archives Photographiques, 22, 23, 24, 25, 29, 44, 46, 47, 51, 53, 57, 66, 80, 90, 91, 92, 96, 97, 99. Bulloz: I, III, 5, 6, 30, 41, 45, 70. Courtauld Institute of Art: 50, 56, 63. Giraudon: 32, 37, 40. Service de Documentation Photographique: 10, 16, 36, 38, 39. Collection Viollet: 7, 14, 19, 34. John Webb, VII.

Measurements are given in inches and centimetres, height before width, unless otherwise stated.

ANDRIEUX, PIERRE (1821–92)
8 *Men Carrying a Corpse, 23 February 1848*, 1848. Gouache, black lead, 10⅝ × 8⅞ (27 × 22·5). Musée Carnavalet, Paris.

ANONYMOUS
3 *Fighting in Paris*, c. 1830. Engraving. Bibliothèque Nationale, Paris.
7 *Proclamation of the Republic*, 1848. Lithograph.
19 *Invasion of the Assembly, 15 May, 1848*. Lithograph.
26 *Popular Image of Jesus Christ*, 1848. Engraving. Bibliothèque Nationale, Paris.
34 *The Funeral Procession for the Victims of the June Days*, 1848. Lithograph.
48 Petition to Charles Blanc, signed by Delacroix, Decamps, Corot, Nanteuil, Perignon and Dauzats, 1848. Archives Nationales, Paris.
49 Page of signatures of the parishioners of Graulhet (Tarn), petitioning for a picture for their church, 10 June 1848. Archives Nationales, Paris.

BONHEUR, ROSA (1822–99)
25 *Animals in a Meadow*, 1849. 4′ 4″ × 8′ 7″ (1·32 × 2·60 m). Musée Rosa Bonheur, Fontainebleau.

BONVIN, FRANÇOIS (1817–87)
45 *The School for Orphan Girls*, 1850. Musée des Beaux-Arts, Langres.

BOULANGER, LOUIS (1806–67)
4 *Allegory of July 1830*, 1831. 31½ × 25⅜ (80 × 64). Musée Carnavalet, Paris.

CAMBON, ARMAND (1819–85)
39 *The Republic*, 1848. 28¾ × 20⅞ (73 × 53). Musée Ingres, Montauban.

CAVELIER, PIERRE-JULES (1814–96)
22 *Truth*, 1849–53. Marble. Jardin des Tuileries, Paris.

CHENAVARD, PAUL (1807–95)
33 *Romulus and Remus*, c. 1850–52. Drawing. Musée des Beaux-Arts, Lyon.

COUTURE, THOMAS (1815–79)
28 *Enrolment of the Volunteers in 1792*, c. 1848–50. Unfinished. Musée des Beaux-Arts, Colmar.
35 *Enrolment of the Volunteers in 1792*, c. 1848–50. 23¼ × 40⅜ (59 × 102). Museum of Fine Arts, Springfield, Mass.

DAUBIGNY, CHARLES (1817–78)
24 *Banks of the Seine*, 1850. Musée de Limoges.

DAUMIER, HONORÉ (1808–79)
II *The Miller, his Son and the Ass*, c. 1848–59. 51⅜ × 38⅜ (130 × 97). The Burrell Collection, Glasgow Art Gallery and Museum.
III *The Republic*, 1848. 28¾ × 23⅝ (73 × 60). Louvre, Paris.
IV *We want Barrabas . . .*, c. 1850. 63 × 50 (160 × 127). Museum Folkwang, Essen.
V *Saltimbanques Moving On*, c. 1855–60. Charcoal, crayon and stump, pen and wash, chalk and watercolour. 14⅜ × 10⅝ (36·5 × 27·1). Wadsworth Atheneum, Hartford, Conn. Ella Gallup Sumner and Mary Catlin Sumner Collection.
10 *The Uprising*, c. 1848. 35⅝ × 27½ (91 × 70). Lost.
11 *Family on the Barricades*, c. 1849. 36¼ × 28¾ (92 × 73). Národní Galerie, Prague.
12 *The Uprising*, c. 1849. 34⅝ × 44⅞ (88 × 114). Phillips Collection, Washington, D.C.
15 *The Urchin in the Tuileries*, published 4 March 1848. Lithograph. By courtesy of the Trustees of the British Museum, London.
67 *You have the floor: explain yourself; you're free*, published 14 May 1835. Lithograph. By courtesy of the Trustees of the British Museum, London.
68 *Everyone told the Government . . .* published 5 July 1848. Lithograph. By courtesy of the Trustees of the British Museum, London.
69 *Where can that band of armed men be going?*, published 10 April 1848. Lithograph. By courtesy of the Trustees of the British Museum, London.
70 *The Soup*, c. 1860. Pen and ink over crayon, wash, watercolour. 11 × 15¾ (28 × 40). Louvre, Paris.
71 *Les Divorceuses*, published 4 August 1848. Lithograph. Howard Vincent Collection.
72 *Ratapoil and Casmajou*, published 11 September 1851. Lithograph.
73 *Blow, blow, you will never extinguish it*, 1835. Lithograph, with Grandville (Jean-Isidore Gérard). Bibliothèque Nationale, Paris.
74 *Neither the one nor the other . . .*, published 24 October 1851. Lithograph. By courtesy of the Trustees of the British Museum, London.
75 *1851, Year 4 of the Republic*, published 16 January 1851. Lithograph. Bibliothèque Nationale, Paris.
76 *The People holds the Ring*, published 18 November 1851. Lithograph. Bibliothèque Nationale, Paris.
77 *Ratapoil Making Propaganda*, published 19 June 1851. Lithograph.
78 *The fat Deputy over the road . . .*, published 21 August 1849. Lithograph. By courtesy of the Trustees of the British Museum, London.
79 *The Repentant Magdalen*, c. 1849–50. 16⅛ × 13 (41 × 33). Private collection.
80 *Silenus*, 1850. Crayon, charcoal and stump, heightened with white gouache, on board. 16⅞ × 24 (43 × 61). Musée de Calais.
81 *St Sebastian*, c. 1849–50. Charcoal. 12⅝ × 7¼ (32·2 × 18·6). The Metropolitan Museum of Art, New York.
82 *Archimedes and the Soldier*, c. 1850. Charcoal. 16½ × 15¼ (42·6 × 38·9). Hungarian National Gallery, Budapest.
83 *Ratapoil* c. 1850–51. Plaster, h. 17¾ (45). Albright-Knox Art Gallery, Buffalo, N.Y.
84 *The Refugees*, c. 1850. Bronze relief. 14⅝ × 30⅛ (37·2 × 76·5). National Gallery of Art, Washington, D.C., Rosenwald Collection.
85 *The New St Sebastian*, published 25 December 1849. Lithograph. By courtesy of the Trustees of the British Museum, London.
86 *The Uprising*, c. 1850. Gouache, 22¾ × 17 (58 × 43). Ashmolean Museum, Oxford.
87 *The Heavy Burden*, c. 1850–55. Oil on panel. 15¾ × 12⅜ (40 × 31·4). The Burrell Collection, Glasgow Art Gallery and Museum.
88 *The Fugitives*, c. 1853. Oil on paper laid on canvas, 15⅛ × 27 (38·5 × 68·5). Sammlung Oskar Reinhart am Römerholz, Winterthur.
89 *Saltimbanques*, c. 1855–60. Pen and ink and watercolour, 13 × 15¾ (33 × 40). Victoria and Albert Museum, London.
90 *Saltimbanque*, c. 1855–60. Pen and ink, crayon, wash and watercolour, 16⅛ × 12⅝ (42 × 32). Private collection, Paris.

92 *Street Singers*, c. 1855–60. Water-colour, $13\frac{3}{8} \times 10\frac{1}{4}$ (34 × 26). Petit Palais, Paris.

DAVID D'ANGERS, PIERRE JEAN (1788–1856)
27 *Christ Writing on the Globe, c.* 1848. Gouache. Private collection.

DEHONDENCQ, ALFRED (1822–82)
23 *Bull-fight,* 1849–50. Musée de Pau.

DELACROIX, EUGÈNE (1798–1863)
VII *Attila Followed by the Barbarian Hordes Tramples Italy and the Arts,* 1838–47. Oil and wax, 24′ 1″ × 36′ 1″ (7.35 × 11 m). Library of the Palais Bourbon, Paris.
IX *A Basket of Flowers and Fruit on a Pedestal,* 1849. $41\frac{3}{8} \times 55\frac{1}{8}$ (105 × 140). Johnson Collection, Philadelphia Museum of Art.
X *Marphisa and Pinabel,* 1852. $32\frac{1}{4} \times 39\frac{3}{4}$ (82 × 101). Walters Art Gallery, Baltimore.
5 *Study for Liberty Guiding the People,* 1830–31. Pencil and chalk, $12\frac{5}{8} \times 9$ (32 × 23). Louvre, Paris.
6 *Liberty Guiding the People,* 1831. 8′ 7″ × 10′ 8″ (2.60 × 3.25 m). Louvre, Paris.
91 *Geraniums,* 1849. Private collection.
93 *The Good Samaritan, c.* 1849–50. $12\frac{5}{8} \times 11$ (35 × 28). Private collection.
94 *The Agony in the Garden,* 1851. 13 × 16½ (33 × 42). Stedelijk Museum, Amsterdam.
95 *Michelangelo in his Studio,* 1850. $15\frac{3}{4} \times 12\frac{5}{8}$ (40 × 32). Musée Fabre, Montpellier.
96 *Samson and Delilah,* 1849. 16¼ × 22⅜ (41 × 57). Private collection.
98 *Woman Combing her Hair,* 1850. $17\frac{3}{4} \times 14\frac{1}{8}$ (45 × 36). Private collection.
97 *Studies for Woman Combing her Hair and an Adam and Eve, c.* 1847. Black lead, 10 × 15½ (25.6 × 39.3). Courtesy of Count Antoine Seilern.
99 *Sketch for Apollo Victorious over the Serpent Python, c.* 1850–51. Oil. $51\frac{1}{4} \times 38\frac{1}{4}$ (130 × 97). Musée Royal des Beaux-Arts de Belgique, Brussels.

ETEX, ANTOINE (1808–88)
47 *The City of Paris Beseeching God on behalf of the Victims of Cholera,* 1848–52. Marble. Hôpital de la Salpêtrière, Paris.

GÉRICAULT, THÉODORE (1791–1824)
36 *Roman Horse-race,* 1817. 17¼ × 23⅝ (45 × 60). Louvre, Paris.

GÉRÔME, JEAN-LÉON (1824–1904)
46 *Anacreon, the Child Bacchus and Love,* 1847. Musée des Augustins, Toulouse.

GRANDVILLE (JEAN-ISIDORE GÉRARD) (1803–47)
1 'The People has won a victory; these gentlemen share the spoils'. 1831.

Lithograph. Bibliothèque Nationale, Paris.

HOLBEIN, HANS (1497/8–1543)
21 *The Waggoner – from The Dance of Death, c.* 1538. Woodcut.

INGRES, JEAN-AUGUSTE-DOMINIQUE (1780–1867)
42 *The Iliad, c.* 1848–49. $23\frac{1}{2} \times 21\frac{1}{4}$ (59.5 × 53.5). Private collection.

LANDELLE, CHARLES (1812–1908)
38 *The Republic,* 1848–49. Lycée Saint-Louis, Paris.

LELEUX, ADOLPHE (1812–91)
13 *The Departure,* 1850. Engraving of lost work. Bibliothèque Nationale, Paris.
16 *The Password,* 1849. $36\frac{5}{8} \times 22\frac{7}{8}$ (93 × 58). Musée de Versailles.

MANET, EDOUARD (1832–83)
2 *The Barricade,* 1871. Watercolour, 18¼ × 12⅞ (46.2 × 32.5). Hungarian National Gallery, Budapest.

MEISSONIER, JEAN-LOUIS-ERNEST (1815–79)
I *The Barricade (Souvenir of Civil War),* 1849. $11\frac{3}{8} \times 8\frac{5}{8}$ (29 × 22). Louvre, Paris.
14 *The Barricade,* 1849. Watercolour, $11\frac{3}{8} \times 8\frac{1}{4}$ (29 × 21). Private collection.

MILLET, JEAN-FRANÇOIS (1814–75)
VI *Going to Work,* 1850–51. $21\frac{3}{4} \times 18\frac{1}{8}$ (55.5 × 46). Glasgow Art Gallery and Museum.
VIII *The Shooting Stars,* 1847–48. 7 × 13 (17.7 × 33). National Museum of Wales, Cardiff.
17 *Liberty on the Barricades, c.* 1848. Pastel. Present whereabouts unknown.
40 *Mother and Children, c.* 1848. Musée des Beaux-Arts, Oran.
41 *Equality, c.* 1848. Charcoal, $7\frac{7}{8} \times 5\frac{1}{8}$ (20 × 13). Musée des Beaux-Arts, Reims.
50 *Woman Carding Wool, c.* 1855. Etching. The Burrell Collection, Glasgow Art Gallery and Museum.
51 *Men and Women Trussing Hay, c.* 1849–50. $21\frac{1}{2} \times 25\frac{1}{2}$ (54.5 × 65). Louvre, Paris.
52 *Man with a Hoe,* 1859–62. $31\frac{7}{8} \times 39\frac{3}{8}$ (81 × 100). San Francisco, private collection, on loan to California Palace of the Legion of Honour.
53 *The Winnower, c.* 1848. $31\frac{1}{8} \times 23\frac{1}{4}$ (79 × 59). Louvre, Paris.
54 *The Quarrymen, c.* 1846. $29\frac{1}{8} \times 23\frac{5}{8}$ (74 × 60). The Toledo Museum of Art, Toledo, Ohio. Gift of Arthur J. Secor.
55 *Hagar and Ishmael in the Desert,* 1848–49. 4′ 11″ × 7′ 9″ (1.46 × 2.36 m). Mesdag Museum, The Hague.
56 Sheet of Studies, including a *Hay-makers Resting, c.* 1849. Pen and ink, 5½ × 4¾ (14 × 12). Louvre, Paris.
57 *Haymakers Resting,* 1849. 35 × 45⅝ (89 × 116). Louvre, Paris.

58 *The Diggers, c.* 1855. Wood engraving after Jean-François Millet. Bibliothèque Nationale, Paris.
59 *Women Gathering Faggots,* 1850–51. Charcoal, $11\frac{3}{8} \times 18\frac{1}{2}$ (28.9 × 46.9). Museum of Fine Arts, Boston.
60 *Nymph Dragged along by Cupids,* 1851. On panel, 15½ × 9½ (39.4 × 24.2). Lord Clark Collection.
61 *The Lovers, c.* 1846–50. Black chalk, $12\frac{3}{4} \times 8\frac{5}{8}$ (32.5 × 22). Art Institute, Chicago.
62 *The Waggon, c.* 1851. Chalk and pencil, 26½ × 19½ (67.3 × 49.5). Private collection.
63 *The American Mazeppa, c.* 1851. Charcoal, $13\frac{3}{4} \times 20$ (35 × 51). Done for *Annals of the United States Illustrated – the Pioneers;* published 1852. Private collection.
64 *The Sower, c.* 1849–50. $39\frac{3}{4} \times 32\frac{1}{2}$ (101 × 82.5). Museum of Fine Arts, Boston.
65 *The Sower,* 1850. $39\frac{1}{2} \times 31\frac{3}{4}$ (100.4 × 80.6) after restoration. Provident National Bank, Philadelphia.
66 *Sketch for 'Ruth and Boaz', later called 'Harvesters' Meal',* 1851–52. Pencil, watercolour, oil and pastel, $18\frac{7}{8} \times 33\frac{5}{8}$ (48 × 86). Louvre, Paris.

MULLER, CHARLES-LOUIS (1815–92)
43 *Lady Macbeth,* 1849. Engraving of painting which measured 8′ 5″ × 8′ 11″ (2.56 × 2.72 m). Bibliothèque Nationale, Paris.

PRÉAULT, AUGUSTE (1810–79)
29 *Silence,* 1848 (?). Marble relief, diameter 19⅝ (50). First version for tomb of Jacob Roblès, died 1842, Père Lachaise, Paris. Musée Bonnat, Bayonne.
32 *Ophelia,* 1876 Salon. Bronze relief, 29½ × 78¾ (75 × 200). (Plaster model shown in 1850 Salon.) Musée des Beaux-Arts, Marseille.
37 *Gallic Horseman,* 1850–53. Stone. Pont d'Iéna, Paris.

RAVERAT, VINCENT NICOLAS (1801–65)
18 *Death of the Archbishop of Paris,* 1848. Lithograph. Bibliothèque Nationale, Paris.

RETHEL, ALFRED (1816–59)
20 *New Dance of Death,* 1848. Woodcut.

ROUSSEAU, THÉODORE (1812–67)
44 *The Avenue,* 1849. $39\frac{3}{4} \times 32\frac{1}{4}$ (101 × 82). Louvre, Paris.

RUDE, FRANÇOIS (1784–1855)
30 *The Marseillaise,* 1832–34. High relief, stone, 41′. 8″ × 19′ 8″ (12.70 × 6 m). Arc de Triomphe, Paris.
31 *Monument to Godefroy Cavaignac,* 1845–47. Bronze, h. 78¾ (200). Cimetière du Nord, Paris.

SÉGUIN, GÉRARD (1805–75)
9 *The Sentinel of February,* 1848. $51\frac{1}{8} \times 38\frac{1}{2}$ (130 × 98). Musée de Valence.

Index

Numbers of plates *italic* or ROMAN NUMERALS

allegory in art 18, 26, 49, 59, 68, 70, 119; Baudelaire on 163; in Daumier 105-6, 112-13; in Delacroix 133, 140, 141 *and see* Liberty, representations of, Republic, image of
Ami de la Religion, L' 63
Andrieux, Pierre: *Men Carrying a Corpse* 21; *9*
Arago, Etienne 19, 63
Artiste, L' 10
Aupick, General 171, 172
avant-garde in 2nd Republic 31, 32, 49, 69

Babeuf, François-Emile 10
Baldung Grien, Hans 116
Balzac, Honoré de 18-19, 79, 171, 172
Banville, Théodore de 112
Barbès, Armand 125, 175
Barbier, Henri-Auguste 17, 18
Barbizon, Millet at 75, 82
barricades: in February revolution 10, 11, 16, 17, 20, 126; in June revolution 13, 25-6, 165; Millet in 75; barricades in art 16-17, 22-4, 25-8, 103, 117, *and see* Delacroix, Meissonier, Millet, Rethel; in popular prints 16-17, 20-1
Barye, Antoine-Louis 50
Baudelaire, Charles
life and views of: bourgeoisie, hatred of 143, 144-61, 164, 165, 173, 177; and Champfleury 172; and Courbet 164, 165, 172; and 1851 *coup d'état* 16, 142, 144, 171, 174; admires Daumier 102, 103, 144, 161-3; on Daumier 104, 108, 113, 116, 124, 142-3, 144-61; on Delacroix 141, 142, 161; visits Delacroix 124-6, 132, 142, 172; in Dijon 172, 173; admires Dupont 161, 169-71, 172, 174, 175; and February revolution 9, 71, 124-6, 141-2, 166, 169, 171, 172, 173, 174, 175-7; and God 168-9; on Ile St-Louis 101, 102, 144; in June revolution 143-4, 165, 169, 171, 174; in May invasion 171; on Millet 73, 97; death of 166; and the People 124, 125, 169-70, 173, 175-7; political activities of 171-3; politics of 163-9, 178, 180, 181, 182; and Proudhon 124, 163, 164-9, 171, 173, 177; admires Rethel 26; and revolution 9, 16, 71, 173-7; and Socialism 163-4, 165, 167, 172, 174; on spleen 169, 171, 175

work of: 120; cult of Dandy 143, 164, 175, 176; as poet of the City 161-4, 167, 173, 175; on Poe 142, 172; and Realism 172 works referred to: 'Assommons les pauvres' 176-7; 'Correspondances' 142, 164, 175; 'Crépuscule du soir' 167; *Les Fleurs du mal* 161, 162, 164, 168, 169, 171; 'La Guerre civile', notes for 10, 26; *L'Ivrogne* 164; *Journaux intimes* 141, 173, 175, 176; *Les Limbes* 163-4, 172; 'Quelques caricaturistes français' 143, 144; on Salons 1845, 1846 58, 143, 144, 181; *Le Salut public* 22, 166, 169, 172; *Le Spleen de Paris* 142, 163, 169, 171, 175; 'Le Vin des chiffonniers' 116, 161-2, 163; 'Du vin et du hachish' 141, 162-3, 172, 173, 175; 'Le Vin de l'Assassin' 164
Beaux-Arts, Bureau des 32, 49-50, 51; and charity 49-50, 51-2, 56, 70; confusion within 56-7, 71; and Couture 60, 178; and patronage 52, 70 *and see* patronage, State; *and see* Salon
Beaux-Arts, Commission Permanente des 50, 51, 130
Beaux-Arts, Ecole des 51
Benjamin, Walter 180
Bible, source for art 112-13; for Daumier, 108, 112-13; for Millet 82-93, 98
Blanc, Charles: 62, 71; and Bureau des Beaux-Arts 49, 50, 51, 52-7, 71, 129; and Couture 59; dismissal of 56; and patronage 52-4, 69, 71, 130; petition to 48
Blanc, Louis 10, 12, 24, 51, 70, 125, 174
Blanqui, Adolphe 13-14, 78, 125
Blanqui, Louis-Auguste 24, 177
Blin, Georges 164, 175
Bonheur, Rosa: *Animals in a Meadow* 32; *25*
Bonhomme Richard, Le 164
Bonvin, François 103, 107; *School for Orphan Girls* 70; *45*
book illustration: 25; Daumier's 113, 115; Millet's 75
Boulanger, Louis: *Allegory of July 1830 4*
bourgeoisie, the:
and revolution: in 1830 16, 17, 19; in February 9-10, 20, 21; in June 13, 99-100, 165, 174; symbols of 16, 17
views of: Baudelaire's 143, 144-

61, 164, 165, 173, 177; Courbet's 180; Daumier's 22, 99-100, 105, 143, 144; Delacroix's 130-1, 139-40; Gautier's 74; James's 99, 102, 105
Brecht, Bertolt 180
Buonarroti, Philippe-Michel 10

Cabet, Etienne 10, 124, 177
Cambon, Armand 63, 67; *Republic* 67-8; *39*
Caricature, La 100
caricaturists 51, 64; Baudelaire on 142-3, 144; *and see* Daumier
Caussidière, Marc 171
Cavaignac, Godefroy 58-9
Cavaignac, General Louis-Eugène 14, 51, 58, 104, 165
Cavelier, Pierre-Jules 71; *Truth* 32, 70; *22*
censorship 14, 15, 100, 104, 143
Cézanne, Paul 132
Champfleury (Jules Husson): and Baudelaire 172; on Balzac 171; and Daumier 99, 100, 101, 103, 107; and Dupont 169, 170; on Rethel 26; and Wallon 164
Champmartin, Charles-Emile Callande de 49
Champrosay, Delacroix at 126, 130, 133, 139
Charivari 99-100, 101, 104, 105, 106, 107
Chassériau, Théodore 74, 77
Châteauroux, Baudelaire at 172
Chenavard, Paul Marc Joseph: designs for Panthéon 50, 62-3; *33*; and image of Republic 108
Chennevières, Philippe de 95, 144
Chevalier, Louis 79
cholera epidemic, 16, 49, 70, 76, 103, 113, 170
Christophe, Ernest 58
classicism 49, 58, 67, 68, 70, 71, 108; Daumier and 108, 111, 118; Millet and 74, 76-7, 81, 98, 108
Claude Gellée (Claude Lorraine) 69
Clésinger, Jean-Baptiste 51, 117
Cogniet, Léon 11, 63
Commune of Paris, 1871: Courbet and 182; Daumier in 100; Manet and 16; Millet attacks 72
Communism 12, 106, 121, 131, 180 *and see* Marx, Karl
Constant, Benjamin: *Adolphe* 136
Constructivism 182
Cooper, James Fenimore 81
Corot, Jean Baptiste Camille 129, 182
Corsaire, Le 112

coup d'état of 1851 9, 71, 118;
Baudelaire and 142, 144, 171, 174
Courbet, Gustave: and Baudelaire
164, 165, 172; and bourgeoisie
180; and Commune 182; and
critics 94, 95, 96; and Daumier
103, 107; and Salon 172, 180;
Realism of 98, 164; and revolu-
tion 178, 180–2
After Dinner at Ornans 32, 70;
Burial at Ornans 95, 96, 164, 180,
181, 182; drawing of Wallon 163
Couture, Thomas 50, 74; *Enrolment
of the Volunteers in 1792* 49, 58,
59–61, 178; *28, 35*
Crémieux, Adolphe 10
Cubism 180

d'Agoult, Comtesse *see* Stern
Dadaism 180
Dandy, Baudelaire's cult of 143,
164, 175, 176
Dante Alighieri: *Inferno* 74, 136
Daubigny, Charles-François: *The
Banks of the Seine* 32, 69; *24*
Daumier, Honoré
life and views of: background of
100–2; Baudelaire admires 102,
103, 144, 161–3; Baudelaire on
104, 108, 113, 116, 124, 142–3,
144; and bourgeoisie 22, 99–100,
105, 143, 144; in Commune 100;
and 1851 coup d'état 144; enemies
of 107; on Ile St-Louis 101–2,
123, 144; and June Days 99–100,
119, 143; politics of 99–100,
103–7, 119, 122–3, 143 *and see*
Ratapoil; invents Ratapoil 105–6,
116–17, 178–9, 181, 182; and
revolution 16, 71, 103–4, 106,
119, 181; and Republic, image of
63, 103, 107–8; and Salon 103,
107–11, 114, 115, 118
work of: cartoons 104–5, 113,
143, 144, 181; *68–78, 85*; and
classicism 108, 111, 118; colour,
use of 114–15, 118, 119; critics of
114; lithographs 22, 99–100, 101,
103–5, 113, 114, 115, 117, 122;
paintings 103, 107–11, 113, 117–
19 *and see Liberty Guiding the
People*; Paris life, artist of 101–3,
104, 107, 120, 122–3; religious
works of 56, 108–11, 112–13;
sculpture of 27, 105, 107, 113,
116–17, 118 *and see Ratapoil*; style
of 104, 105, 106, 108, 111, 113–
16, 117–18, 119
works referred to: *Alarmists* 22,
104; *69*; *Ancient History* series
144; *Bathers* 113–14; *'Blow, blow,
you never will extinguish it'* 106;
73; *Archimedes and the Soldier*
118; *82*; *Les Divorceuses* 104; *71*;
Don Quixote series 117, 118, 119;
'Everyone told the Government . . .
99; *68*; *Family on the Barricades* 23,
103, 117; *11*; *The Fugitives* 118–
19; *88*; *Heavy Burden* 118; *87*;
The Kiss 111, 118; *The Miller, his
Son and the Ass* 114–15; *II*;

Neither the one nor the other
107; *74*; *The New St Sebastian*
113; *85*; *Nymphs Pursued by Satyrs*
115, 118; *The Ragpicker* 161;
Ratapoil 27, 103, 105, 113, 116–
17; *83*; *Ratapoil and Casmajou*
105; *72*; *The Refugees* 113, 115,
117, 118; *84*; *The Repentant Mag-
dalen* 108–9, 111, 112, 113–14;
79; *The Republic* 63, 64, 67, 68,
106, 107–8, 113–14, 117; *111*; *St
Sebastian* 111, 112, 113; *81*;
Saltimbanques series 118, 119–23;
v, 89, 90, 92; *Silenus* 111, 113,
115–16, 118; *80*; *The Soup* 103,
123; *70*; *Theatre* series 122; *The
Uprising* 22–3, 113–14, 117, 118;
10, 12, 86; *The Urchin in the
Tuileries* 22; *15*; *We Want Barab-
bas* 112, 113, 115, 118; *iv*; *'1851,
Year 4 of the Republic'* 106; *75*;
'You have the floor . . .' 100, 123;
67
Daumier, Mme Honoré (Marie-
Alexandrine Dassy) 101, 102, 103
David, Jacques Louis 27, 49, 57, 70,
77, 103; *Les Horaces* 58
David d'Angers, Pierre Jean 27, 31,
51, 54, 58, 102, *27*
Decamps, Alexandre-Gabriel 51,
63, 74, 94, 103, 129
Dehondencq, Alfred: *Bull-fight* 32,
70; *23*
Delacroix, Ferdinand Victor Eugène
life and views of: Baudelaire visits
124–6, 132, 142, 172; at Champ-
rosay 126, 130–1, 133, 139; visits
Daumier 103; and February
revolution 124–9; pessimism,
crisis of 133–40; and revolution
of 1830 126, 129; politics of 9,
16, 71, 124–31, 136, 139–40, 141,
173; and Proudhon 124, 182; and
Salon 50, 51, 126, 130, 131–3,
work of 70; Baudelaire on 141,
142, 161; colour, use of 119;
flower and fruit paintings 131–3
history painting 125; revolution,
as artist of 9, 16, 71, 126–9, 133,
140, 141, 178–9; Romanticism of
126; religious paintings 132, 133;
style 131–3; influence 89, 113
works referred to in text:
The Agony in the Garden 133; *94*;
*Attila Followed by the Barbarian
Hordes* 119, 141; *VII*; *A Basket of
Flowers and Fruit on a Pedestal* 132;
IX; Galerie d'Apollon ceiling 133,
140–1, 178–9; *99*; *Geraniums* 132;
91; *The Good Samaritan* 132, 133;
93; *Liberty Guiding the People*
17–19, 20, 22, 25–6, 29, 59, 126,
129, 140, 141; *5, 6*; *Marphisa and
Pinabel* 137; *X*; *Massacre at Scios*
18, 77; *Michelangelo in his Studio*
137, 138; *95*; *Othello and Desde-
mona* 132, 133; *Pietà* 132; *The
Road to Calvary* 133; *Saint-Sul-
pice* murals 133; *Samson and
Delilah* 136, 137; *96*; *Ugolino and
his Children* 136; *Woman Combing

her Hair* 137–8; *97, 98*; *Women of
Algiers* 124, 132
Delaroche, Paul 50, 63, 68, 70
Delavigne, Casimir 17–18
Delécluze, Etienne-Jean 94
Démocratie pacifique, La 26, 142
Deschamps, Marie 17, 18
Deutsch, Niklaus Manuel 116
Diaz, Narcisse 49, 50, 51, 56, 64, 74,
107
Dubufe, Claude-Marie 129
Dumas, Alexandre 81
Dumesnil, Alfred 57
Dupeux, George 80
Dupont, Pierre: 141, 144, 164–5;
Baudelaire admires 161, 169–71,
172, 175; *La Rançon* 170, 174
Duval, Jeanne 173

Echo des Marchands du Vin, L' 163, 172
elections 1848 12, 14, 166, 172
El Greco (Domenikos Theotoko-
poulos) 116
eroticism: in Millet 75, 81; Proud-
hon on 166
Esquiros, Alphonse 166
Etex, Antoine 71; *The City of Paris
beseeching God . . .* 70; *47*

Faure, Philippe 11
February revolution 9–10, 20, 71,
182; art of 20–3, 54, 169; Baude-
laire and 9, 71, 124–6, 166, 169,
171, 172, 173, 174, 175–7; Daumier
on 104; Delacroix and 124–9;
the People on 20, 21, 22, 24;
prints of 20–1; Proudhon and
20, 141, 165
festivals 25, 32, 58, 61; Delacroix
on 126–9
Figaro, Le 72
Flandrin, Hippolyte 63, 67, 107
Flaubert, Gustave 31, 21–2, 182
Flocon, Ferdinand 10
Fontainebleau, forest of 76; workers
in 79–80, 81
Fourier, Charles 11, 164, 166
Fourierism 28, 67, 142, 144, 164,
169

Garde Mobile in June revolution
13, 26, 75
Gautier, Théophile: 'Art in 1848'
24, 31; on Chenavard 62; on
Daumier 103, 115; on machines
11; on Millet 74; on *The Pass-
word* 27–8
General Assembly of Artists 31, 50,
63; Delacroix and 129–30
genre painting 69–70
Geofroy, critic 94
Géricault, J.-L.-A. Théodore 51,
59–60, 129; *Roman Horse-race* 60,
61; *36*
Gérome, Jean-Léon 67, 70, 71, 96;
Anacreon 70; *46*
Girardin, Saint-Marc 11
Goethe, Johann Wolfgang von 138
Grandville (Jean-Isidore Gérard) 106;
'The People has won a Victory . . .'
10; *73*
Graulhet, letter from 54; *49*

Graf, Urs 115
Greek revival 67, 70
Gros, Baron Antoine-Jean 125
Guermann-Bohn, Auguste 52
Guizard, Clémence 56
Guys, Constantin 102

hashish 101; Baudelaire on 173, 175
Haussard, Prosper 107, 126
Hautpoul, General 116
Hegel, Georg Wilhelm Friedrich 166, 167
Hibou philosophique, Le 172
history paintings 53, 59, 69, 125
Hittorf, Jacques-Ignace 62
Holbein, Hans: Dance of Death 25–6, 81–2, 116; 21
Hôtel de Ville 10, 16, 24, 54, 101
Huelsenbeck, Richard 179
Hugo, Victor: and coup d'état 71; on Delacroix 126; and Peace Congress 105

Ile Saint-Louis 101–2, 123, 144
Impressionists 102
Indépendance Belge 95
industrialization 10, 52, 100–1, 164
Ingres, Jean-Auguste-Dominique 50, 51, 60, 70; and image of Republic 63–4, 68; revolutionary art of 182; and Salon 130
Apotheosis of Homer 67, 68; 42

Jacques, Charles 76
James, Henry: on bourgeoisie 99, 102, 105; on Daumier 99, 101, 102
Jean Raisin, Revue joyeuse et vinicole 161
Jeanron, Philippe-Auguste 50, 63
Johannot, Tony 28
Jongkind, Johan Barthold 50
Journal des Artistes 18
July Monarchy 10, 16, 20; art during 52; Daumier attacks 105, 143; Salon during 32
June revolution (1848) 9, 13–14, 25, 59, 78, 106; art of 23–30; Baudelaire in 143–4, 165, 169, 171, 174; Daumier and 99–100, 119, 143; Millet and 25, 26, 27, 75; peasantry in 13, 14, 59, 130–1
June uprising (1849) 76, 170

Lagenevais, F. de 29
Lamartine, Alphonse de 10, 24, 54, 36, 174
Lamennais, Félicité Robert de 14, 54
Landelle, Charles: The Republic 67, 68; 38
landscape painting 69; Daubigny's 32, 69; Millet's 73, 79, 94
Le Brun, Charles 140, 179
Ledru-Rollin, Alexandre-Auguste 50, 54, 63, 64, 74
Le Gillou, Jenny 136
Legitimism 52, 116, 165; Delacroix and 130
Leleux, Adolphe: The Departure 23, 27–8, 29; 13; The Password 24, 27, 29; 16
Le Nain brothers 51
Leroux, Pierre 166, 172
Le Vavasseur, Cyprien 144
Liberty, representations of 17–18, 19, 21, 22, 25–6, 64, 68 and see Delacroix: Liberty Guiding the People; Millet: Liberty on the Barricades
Lissitzky, El 179, 180
lithography: Daumier's 99–100, 101, 103–5, 113, 114, 115, 117; effects on Daumier 101, 114, 122; 129; and see prints
Louis-Napoleon see Napoleon III
Louis-Philippe, King of France 60, 140; and Diorama 16; on February revolution 20; fall of 103; 'the Pear-King' 105, 175, 179
Louvre, Palais du 17, 52, 69, 129; Galerie d'Apollon, Delacroix decorates 133, 140, 178–9; 99; guarded in June revolution 50, 144
Lyon 129; workers' risings in 11, 52, 165, 171

Macaire, Robert 105, 179
Maistre, Joseph de 142, 171
Manet, Edouard 181; The Barricade 16, 182; 2
Mannerism 27, 115
Marrast, Armand 51
Martin, Henry: Histoire de France Daumier illustrates 113, 115
Marx, Karl; on 1848 revolutions 9, 13, 14, 177; Misère de la Philosophie 166
Meissonier, Ernest: 63; Street (The Barricade) 24, 27–8, 129, 181–2; 1, 14
Melville, Herman 142
Metaphysical painting 68
Michelangelo Buonarroti 67, 73; source for Daumier 117, 123; Delacroix paints 137–8; 97; source for Millet 96, 97
Michelet, Jules 57; and Daumier 103, 116, 117, 179
Millet, Jean François
life and views of: at Barbizon 75, 76, 78, 81–2, 123; at Cherbourg 77, 98; and Commune 72; finances of 75–6, 81, 93; in June revolution 25, 26, 27, 75; and revolution 71, 178; and Salon 75–6, 79, 80, 82, 93, 94–5, 97, 178; Socialism and 81, 93, 95, 97, 98, 123; and State patronage 75–6
work of: book illustrations 75, 81; and classicism 74, 76–7, 81, 98, 103; colour, use of 74, 77, 96, 97; critics of 73, 74, 94–6, 97–8; landscapes 73, 79, 82; as 'peasant painter'; 72, 73–4, 76, 78–80, 81, 93–4, 95–6, 97; and Realism 98; search for style 73–5, 76, 78, 81, 82, 96, 97–8; technique of 74–5, 76–8, 79, 81, 82–5, 93–4, 95, 96–7
works referred to: The American

Mazeppa 81; 63; The Angelus 80, 81, 94; Captivity at Babylon 74; Death and the Woodcutter 80; The Diggers 80; 58; Equality 68, 75; 41; The Gleaners 73, 80; Going to Work 96–7; VI; Hagar and Ishmael in the Desert 75–6, 76–7; 55; Haymakers Resting 76, 77–8, 79, 93, 178; 56, 57; Liberty on the Barricades 26, 64, 68; 17; The Lovers 81; 61; The Man with a Hoe 72, 73, 80, 81, 82, 94, 97, 123; 52; Men and Women Trussing Hay 72, 73, 74, 79, 94, 95; 51; Mother and Children 68; 40; Nymph Dragged along by Cupids 81; 60; Oedipus Cut down from the Tree 73–4; The Quarrymen 74, 78; 54; Ruth and Boaz 79, 96–8; 66; The Shooting Stars 74–5; VIII; The Sower 79, 82–93, 93–6, 181; 64, 65; The Waggon 81–2; 62; The Winnower 74; 53; Woman Carding Wool 72, 73; 50; Women Gathering Faggots 80; 59
Monet, Claude 17
Moniteur universel 56–7
Montaigne, Michel de 138
Montalembert, Charles comte de 54–6, 63, 107
Muller, Charles-Louis: Lady Macbeth 69–70, 132; 43
Murillo, Bartolomé Esteban 32
Musée Cosmopolite 17

Nadar (Félix Tournachon) 142, 175
Nanteuil, Célestin 75, 129
Napoleon I 61, 16–17, 125
Napoleon III (Louis-Napoleon): 1851 coup d'état 9, 71, 118, 142, 144, 171, 174; Daumier and 100, 104, 179; Delacroix and 130, 140, 141; as 1st President 14, 105, 116, 121; and Socialism 14, 141, 179; supporters of 15, 79, 161
National, Le 10, 13, 58
National Guard: in 1830 11, 19; in February revolution 10, 11, 20, 21, 23; in June revolution 15, 25–6, 27, 30, 75; at Rouen massacre 143
National Workshops 12, 13, 49–50, 99
Nieuwerkerke, Baron de 80

Panthéon 58; decoration of 32, 49, 50, 62–3
Papety, Dominique 67
Parliament, invasion of May 1848 24, 25, 59, 130, 171
patronage: informal 52–4; state: 31–7, 58–9, 60, 62–8, 69–70, 71, 130, 180, 182; and Daumier 107–12, 113; and Delacroix 50, 51, 133; and Millet 75–6
peasantry: art for 54; Balzac on 18–19; Blanqui on 78; and elections 12, 14; Daumier and 106, 179; Delacroix and 130–1, 139, 140; in June revolution 13, 14, 59, 130–1; Millet and 72, 73–4, 76, 77, 79–80, 82–96, 97; peasant

painters 51 and see Millet; in 2nd Republic 15–16, 68, 79–80, 131, 139–40; in volunteer army, 1792 59, 61
People, the: Baudelaire and 124, 125, 169–70, 173, 175–7; and coup d'état 161; Daumier and 17–19, 106, 120; definition of 11; Delacroix on 130; in February revolution 20, 21–2, 24; in June revolution 23–4, 25, 26, 27–30, 61, 99; on 15 May 24–5; and Napoleon Bonaparte 125; in revolution of 1830 10, 17, 19, 120; poetry of see Dupont, Pierre; George Sand on 30; and see proletariat, workers
Peuple, Le 170
Petroz, Pierre 96
Pissarro, Camille 72, 182
Planche, Gustave 179
Plato 31
Poe, Edgar Allan 142, 171, 172
politics and art 54, 56–8, 61, 62–3, 71, 94, 95, 163, 178–82; Daumier and 99–107, 119, 121 and see Ratapoil; Dupont and 171; Proudhon on 167
Politique Nouvelle, La 95
Poulet-Malassis, Paul Auguste 111, 118, 144, 172
Poussin, Nicolas 70, 73, 97
Préault, Auguste: 32, 50, 117; Gallic Horseman 61–2; 37; Ophelia 58; 32; Silence 58; 29
Presse, La 24
Presse de 1848, La 163
prints, popular 16, 17, 19, 20–1, 25
proletariat: in February revolution 10; in elections 12; in Millet's art 95, 98; in 19th century 100–1; Proudhon on 167; in 2nd Empire 122; 'of the woods' 79; and see peasantry, People, workers
propaganda, art as 26, 56, 179
Proudhon, Pierre-Joseph: Baudelaire admires 163, 164–9, 171, 177; Baudelaire on 124, 173; bust of 70; and Cavaignac 14; Delacroix and 124–5; and Empire 16; in February revolution 20, 141; and God 168; in June revolution 13; on Museums 31–2; on Napoleon 14; Le Peuple 170; Philosophie de la Misère 166–8
provinces: in June revolution 13, 14; in 2nd republic 15, 179; and see peasantry
Prud'hon, Pierre 54
Pyat, Félix 63

Raphael (Raffaello Sanzio) 51
Rapatel, General 116
Ratapoil, Daumier invents 105–6, 116–17, 178, 181, 182; statue of 27, 103, 105, 113, 116–17; 72, 77, 83
Raverat, Vincent Nicolas: Death of the Archbishop of Paris 25, 29; 18

Realism: 70;; Baudelaire's 164, 172; Champfleury's 100; Courbet's 98, 164; Millet's 98
Reforme, La 10
religious paintings: 31, 32, 49, 52, 54, 56, 63, 69, 70; by Daumier 56, 108–11, 112–13; by Delacroix 132, 133
Renaissance, art of 57
Republic, image of, contest for 31, 63–9, 75
République du Peuple, La 172
Rethel, Alfred: Death on the Barricade 26–7; New Dance of Death 25, 116, 178; 20
Revolution of 1789 14, 16, 25, 59; art of 57
Revolution of 1830 10; art of 17–20; Delacroix in 126, 129 and see Delacroix, Liberty Guiding the People
Revolutions of 1848 see February revolution, June revolution, Parliament, invasion of
Revue des deux mondes, La 29, 179
Revue Nationale, La 176, 177
Robespierre, Maximilien de 14, 174
Rodin, Auguste 133
Romanticism 25, 58, 75, 126
Rouen massacre 104, 143
Rothschild, Baroness Betty de 182
Rouget de Lisle, Claude Joseph 165
Rousseau, Théodore 32, 69, 76; The Avenue 69; 44
Rubens, Sir Peter Paul 115–16, 133
Rude, François: 59, 60; tomb sculpture 58; 31; The Marseillaise 58, 60, 102; 30

Sade, Marquis de 142, 164, 171, 175
Sainte-Beuve, Charles Augustin 142, 171
Saint-Sulpice, Delacroix's murals for 133
Saint-Victor, Paul de 73
Salon: of 1831 19; of 1845 51; of 1846 143, 144; of 1848 69, 70, 74, 126; of 1849 24, 28, 32, 51, 58, 69–70, 70–1, 75, 103, 131, 172; of 1850 93, 111; of 1851 28, 70, 71, 72, 118, 180; of 1852 75, 97; of 1859 80, 133;
and avant-garde 31, 32; and Courbet 172, 180; and Daumier 103, 107–11, 114, 115, 118; and Delacroix 50, 51, 126, 130, 131–2, 133; and Millet 75–6, 79, 80, 82, 94–5, 97, 178; and patronage 51–4 and see Beaux-Arts, Bureaux des; and Préault 32, 51–2; without judges 50, 130
saltimbanques 119–21; persecuted 120–2, 123
Sand, George: Baudelaire on 174; Delacroix and 125, 126, 129; Flaubert and 182; Millet compared with 95–6; Proudhon on 166; on workers 30
Sand, Maurice 129
Scheffer, Ary 51, 67
Schnetz, Jean Victor 63

sculpture 50–1; Daumier's 27, 105, 107, 113, 116–17, 118; Etex's 70; Préault's 61–2; Rodin's 133; Rude's 58, 60
Second Empire: ambiguousness of 16; art under 62, 69
secret societies 10, 15
Séguin, Gérard: The Sentinel of February 11; 9
Seurat, Georges 181
Socialism; Baudelaire and 163–4, 165, 167, 172, 174; in June revolution 144; and feminism 104; Louis-Napoleon and 14, 141, 179; Millet and 81, 93, 95, 97, 98 Proudhon and 166; and saltimbanques 120–1; during 2nd Republic 12, 15, 51, 56; and see Fourier, Fourierism
Staël, Mme de 14
Stern, Daniel (Comtesse d'Agoult) 20, 21, 67
Sue, Eugène, 139
suffrage, universal 12, 15, 106
symbols: of the Republic 64, 68, 70, 105–6, 113 and see Ratapoil
Système des Contradictions Economiques: Philosophie de la Misère (Proudhon) 166

Temps, Le 115
Thierry, Auguste de 27
Thiers, Adolphe 106, 107, 125, 182
Thoré, Etienne Joseph Théophile: and Delacroix 126; and Millet 93; and Republic, image of 63, 74–7, 107, 113
Tocqueville, Alexis de 13–14, 24–5, 29–30, 61
Trapadoux, Marc 173
Trotsky, Leon Davidovich 30
Tuileries, invasion of 11, 21, 22, 24, 25

Van Gogh, Vincent 97, 132
Véron, Louis 107, 113
Veuillot, Louis 54, 107
Vigny, Alfred de 144
Villot, Frédéric 139
Vincent, Pierre 25

Wagner, Richard 142
Wallon, Jean 163–4, 168, 169
Winterhalter, Franz Xavier 52, 54
women: Delacroix and 125, 136–8, 140; and divorce 104; in revolutions, 1848 23
workers, art for 51, 52, 54; Daumier and 22, 23, 104–5, 106; in February revolution 10, 20, 21, 22, 23; on Ile St-Louis 101–2; in June revolution 13, 14, 23, 25, 30, 59, 78, 106; in Lyon rising 11, 165; Millet and 74, 78; and Napoleon Bonaparte 125; worker poets see Dupont, Pierre; George Sand on 30; in 2nd Republic 51, 52, 78, 169; symbols of 16; in revolution of 1830 17, 19

Ziégler, Jules Claude 67